The Royal Arts of Africa
The Majesty of Form

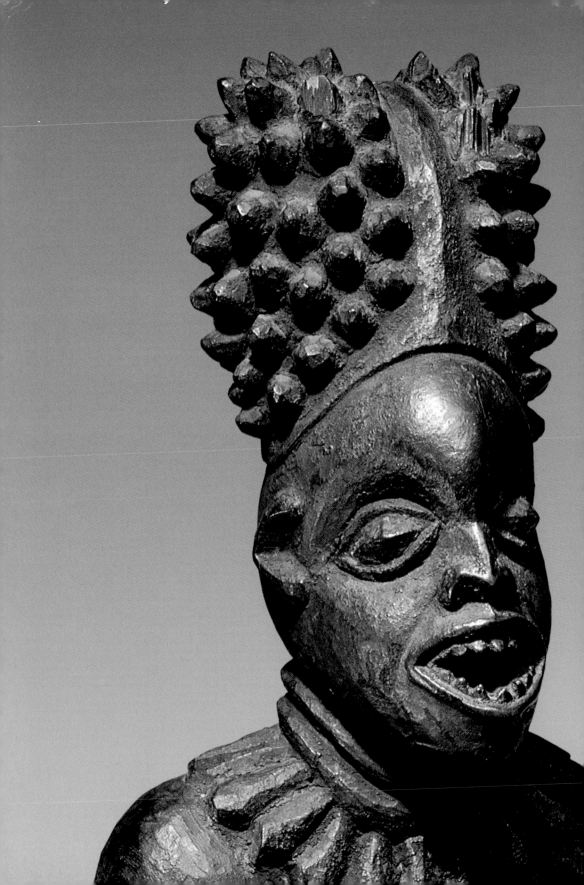

The Royal Arts of Africa
The Majesty of Form

Suzanne Preston Blier

PERSPECTIVES

PRENTICE HALL, INC.,

To Rudy with love

Frontispiece Banga (Cameroon). Figure of a king, page 168 (detail)

Series Consultant Tim Barringer (University of Birmingham)
Series Manager Eve Sinaiko
Senior Editor Kara Hattersley-Smith
Designer Karen Stafford
Cover Designer Judith Hudson
Picture Editor Susan Bolsom-Morris

ISBN 0-13-184181-5

This book was produced by Laurence King Publishing Limited, London

Printed and bound in Hong Kong/China

Contents

Kingdoms of Africa

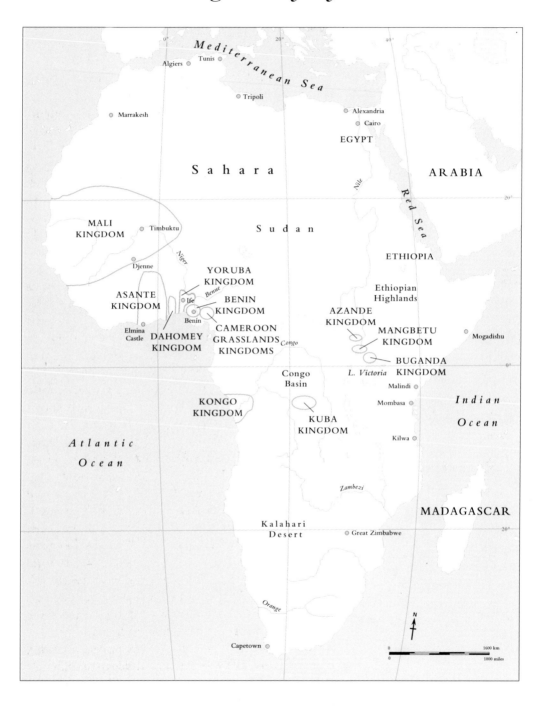

Preface

I have many people to thank for helping to bring this book to fruition, among these the various African scholars who read chapters in their areas of specialization and helped locate related photographs: Monni Adams, Barbara Blackmun, Christraud Geary, Barry Hallen, Wyatt MacGaffey, John Picton, Doran Ross, and Enid Schildkrout. I am also grateful to those who aided along the way in tracking down sources and illustrative materials, among these, Paula Ben-Amos, Sue Bolsom-Morris, Elizabeth Cameron, Alison Deeprose, Jean Fitts, Alissa Lagamma, John Mack, Marya Madura, Michaella Maloney, Dominique Malaquais, Joseph Nevadomsky, Simon Ottenberg, Janet Stanley, Virginia Webb, Ivor Wilks, and Mimi Wolford. For helping to smooth prose and issues of evidence in the course of various drafts, my thanks to Aimée Bessire, Randy Bird, Steve Nelson, and Katharine Ridler.

No doubt errors remain, and where I have sought to weave the text through competing interpretations, certain views have been privileged over others. In some cases I have also offered new interpretations, mindful that African royal arts, like the great arts of other world civilizations, are at once rich and open to differing avenues of explication. With a subject as complex as this one, where intellectual issues embrace a wide variety of disciplines – art history, anthropology, history, religion, philosophy, folklore – to name but a few, new data also are being continually uncovered and perspectives on these arts are always changing.

The narrative structure I have chosen for this overview I hope will help to bring these spectacular arts and kingdoms alive, particularly for non-specialists. Such a structure, however, conveys a greater sense of cohesiveness (as regards both history and culture) than is generally found in the associated literature. If this is true of any such narrative, it is particularly strongly felt in the field of African art. Scholars in this field also stress the importance of studying arts at the periphery as well as at the royal center. Against these concerns, however, is my belief that Africa's great kingdoms – like others around the world – deserve a meta-narrative, even if as scholars we may be all too aware of the complexity (and variability) of its underlying fabric.

Sometimes the most difficult part of any project is putting it to bed. In this regard, I owe a debt of gratitude to the infinitely polite and ever patient Lesley Ripley Greenfield. My love as always to Jocelyn, whose songs, stories, pictures, and hugs cheered me all along the way.

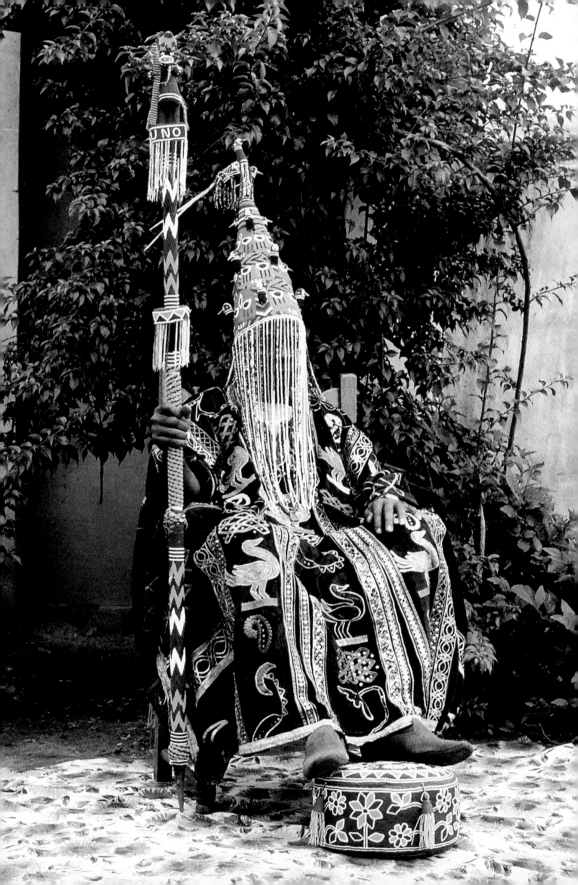

Paradoxes of Rule

1. Yoruba (Nigeria). The ruler of Orangun-Ila, Airowayoye I, in beaded crown and other regalia, 1977.

The most important part of a Yoruba king's regalia is the crown (*ade*), whose beaded fringe shields the face of the ruler, not only to obscure his identity, but also to protect the viewer from the power of the king's direct gaze. The symbolic power of the crown is reinforced by figures of birds surmounting the crown, which refer to the great "mothers" or witches whose potent supernatural force the ruler was held to share, co-opt, and surmount. The bird itself is said to represent the royal *okin* (paradise flycatcher), a small whitish bird that is an apt royal signifier because the adult male grows majestic long white tail streamers. The prominent positioning of this bird on the royal crown thus appears to strengthen the king's difference in power and status from other people. The striking height of these crowns also underscores royal and sacred authority.

F ew subjects are as fascinating as kingship. Few subjects are more complex. In art and ceremony, kings and queens are clearly different from the rest of us. Because these differences are not manifested in physical features, the unique status of these rulers is defined through other external visible means. Art and architecture (FIGS 1 and 2) play a critical role in this and, in part for this reason, kings and queens historically have been important patrons of the arts. African royal arts with their emphasis on themes of power and their display of rare, prestigious, and expensive materials, underscore the political authority of rulers. While definitions of kingship vary widely, the principal characteristics of royal rule include force (military authority); legitimacy (ritual sanctification); status (social hierarchy); and wealth (material difference) – all qualities that are revealed in royal arts.

Prominent African royal signifiers include not only dangerous animals (especially leopards and elephants), handsome weaponry, and impressive palaces marked by their beauty and labor-intensive construction, but also a corpus of sculptures, jewelry, and costumes whose materials are at once costly, scarce, and in many cases ritually charged. While similar metaphors found expression in many kingships around the world, African royal arts display these ideas through the visual and symbolic idioms that characterize African art more generally.

Surveying African Royal Art

A brief discussion of the structure of this book, its aims, and limits is in order. The subject of African royal art is a vast one, and there are several ways to approach such a broad topic. One is by theme, with different chapters focusing on key royal topics such as thrones, crowns, palaces, regalia, coronation rituals, and funerary arts across a range of contexts. This approach has the advantage of allowing for provocative cross-cultural discussion on

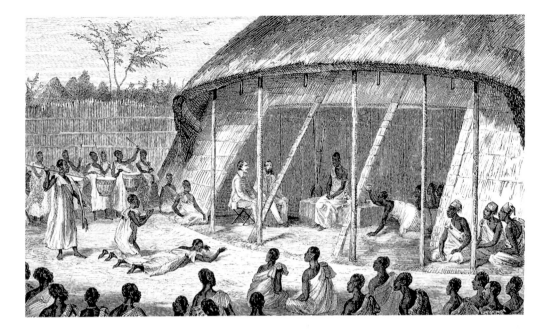

2. Buganda (Uganda). King Mutesa I in his palace audience hall meets the British explorers John Hanning Speke (1827–64) and James Grant (1827–92). Grant's drawing was published in Speke's *Journal of the Discovery of the Source of the Nile* (1864).

The king sits inside a large open portal punctuated by vertical support posts which at once separate and confine the king. The royal council members are positioned to the front and sides of this entry-cum-enclosure. Drum-playing musicians perform nearby, for drums were one of the most important icons of a king's power and prerogative in many African kingdoms.

a number of themes. To its detriment, however, such a framing often leaves the reader with little sense of the distinctive features of individual African kingdoms and their arts. The complexities of historical context and the particular contributions of specific rulers or artists – increasingly important subjects in African art scholarship – are necessarily left to one side.

Another approach is to explore a small number of African kingdoms in detail and to examine related royal themes. The advantage of such a perspective is that it offers a much fuller view of the individual kingdom and its art in action and through history. This is the approach which I have chosen. What sets the present volume apart from other books on African royal art that have been similarly organized, however, is a fuller examination of the individual royal art works as against the generic exemplar. The distinctive histories and arts of these kingdoms, as opposed to a more "timeless" reading of related forms, is stressed where possible. In each chapter I have emphasized the significance of palaces and architectural decoration alongside sculpture and textiles. And, in part reflecting my own background as an art and architectural historian, I have focused both on the contributions of individuals – monarchs, queens, queen mothers, ministers, artists – and on the broader social and political circumstances which have led to the creation of these works.

While this more individualized approach to African royal art has much to offer, its disadvantage, which is especially regret-

table, is that I have necessarily left out a large number of vital royal art traditions, both historical and contemporaneous. These omissions are made even more difficult by the necessary space limitations imposed by a book of this size. The kingships I have chosen to explore, however, include some of Africa's most artistically exciting and diverse, representing a mix of both West African (Asante, Yoruba, Dahomey, Benin) and Central African (Bamun, Kongo, Kuba) cultures. Several East African kingships (Buganda, Mangbetu) are treated peripherally in the introduction as well.

I have chosen to focus on kingdoms which have flourished in the last 500 years (although in several cases dynastic links date earlier) because of the generally greater wealth of archival and ethnographic data for these arts and cultures. I have also tried to select kingdoms at different moments in their royal histories, both those in their primacy and those whose florescence has long passed. The kingdoms examined represent mid-sized political entities (30,000 to 95,000 square miles or roughly 50,000 to 150,000 square kilometers) – comparable in size to England or the larger German principalities – among them Yoruba (Oyo – 95,000), Benin (62,500), Kongo (80,000), Asante (62,500), and Dahomey (50,000 square miles). Such figures have little real meaning, however, for the scale of associated monarchies varied considerably over time, as did the cohesiveness of control from capital to periphery. The historian John Thornton, whose figures are cited above, nonetheless notes that more than half of all people residing in Atlantic Africa lived in mini-states of this sort. Complex road, sound, and symbolic systems that were often rich in art served to integrate the diverse areas of the realm. Initiation into religious associations (as in Dahomey and Yoruba), political associations (Bamun), or age grade associations (Kuba) also played important unifying roles.

Territorial size as an index of royal autonomy or identity must be examined from the perspective that the criteria for defining kingship have been framed largely by European traditions. In Africa, size as such often mattered little, or certainly far less than might be assumed. What counted instead was relative loyalty to the monarch (or the larger ideology of rule) and the kingdom's ability to control key resources and markets. In the West African kingdom of Dahomey, where I have undertaken research, the leader of a tiny village who was defeated by the king is referred to in the royal histories by exactly the same term, "king" (*ahosi*), as the rulers of powerful and sizable competing kingdoms (western Yoruba city states, for example). Their defeat at the hands of the Dahomey troops was treated with equally glowing accolades. Issues of class in the various African kingdoms also varied

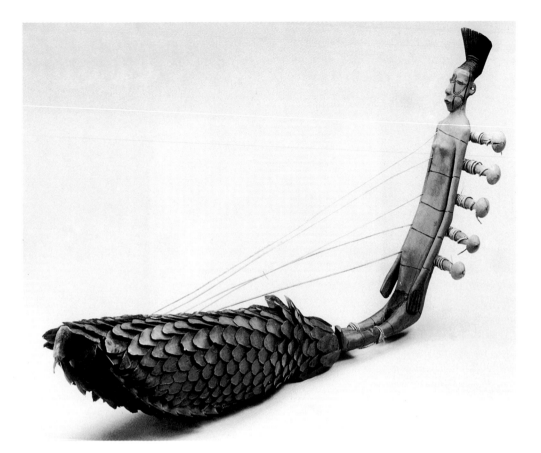

3. Mangbetu (Dem. Rep. of Congo). An anthropomorphic harp collected at Niangara, Dem. Rep. of Congo, in 1910. Wood, pangolin scales, and mixed media, length 22¼″ (8.75 cm). American Museum of Natural History, New York.

The female figure surmounting the harp is said to represent the Mangbetu queen Nenzima. Similar anthropomorphic harps were made by neighboring peoples such as the Azande.

broadly. In some areas such as the ancient Songhai state of Mali in northwestern Africa or the eastern lake region of Burundi and Rwanda, salient social differences between rulers and vassals have remained in the twentieth century, often underscored (if sometimes in reverse) by colonial policy. In Dahomey, however, where close relatives of the early kings were accorded little status in later dynasties, where a female war prisoner could become queen mother, and where male war prisoners sometimes rose to high ministerial posts, concepts of class (status and family rank) were far more fluid.

In most African courts, special forms of scepters, crowns, musical instruments (FIGS 3 and 4), food or drinking vessels, furniture, and palace ornamentation (FIG. 5) conveyed ideas of status and power. African royal portraits in turn usually present a highly idealized view of the monarch as someone in the prime of life, the face both stylized and generic. Individual features were usually avoided in favor of consistency with local portraiture. The institution of kingship thus was shown to be more important than the

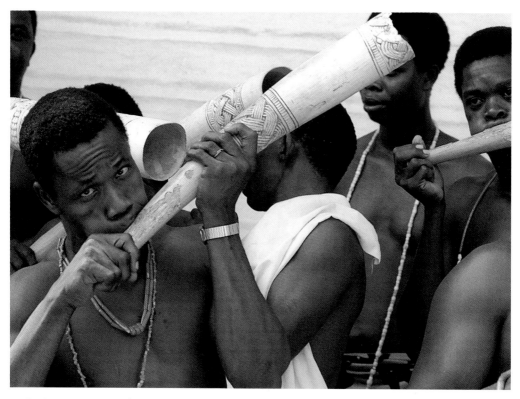

4. Benin (Nigeria). Horn players announce the arrival of the king at the Igue ceremony at the palace, Benin City, 1980.

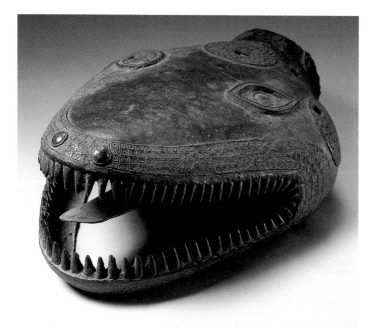

5. Benin (Nigeria). A python head, eighteenth century. Brass, height 16½" (42 cm). Museum für Völkerkunde, Berlin.

The turrets of important Benin palace buildings were decorated with the undulating bodies of pythons, heads down, with tooth-filled mouths wide open, ready to devour (and transport) those who passed to another realm. Two different python species appear to be represented in these striking palace sculptures.

individual ruler, who might occupy the throne for a comparatively brief period of time. In many cases, artists had special residences in the capital and produced works for foreign patrons – European (FIG. 6) and African. Some kings gained renown as artists and queens, princesses, and the queen mother, were active in the production of elite arts, such as textiles.

To point out these broader aspects of African royal art is not to overlook the striking differences that distinguish the arts of one African kingdom from another. In Dahomey, for example, the most important royal regalia comprised the king's sandals; in the Kuba area of Zaire a woven "basket of wisdom" had analogous significance. In Yoruba kingdoms in southwestern Nigeria, crowns were the privileged genre. As a result of marriages to foreign women, and access to distant trade goods, royal art works frequently changed over time. In cases in which royal guilds maintained a degree of stylistic uniformity, as in the Nigerian kingdom of Benin, symbols came to hold very different meanings in later periods, a figure of a merchant, for example, taking on the identity of a priest.

African palace architecture has shown similar changes. These elite structures frequently evince striking differences from other royal residences around the world. Because in many African kingdoms a new ruler was obliged to create his own new palace complex, or in some cases a new entry and section of the old palace, African royal precincts were made of materials which could be easily rebuilt, altered, or transported. Ancient African palaces too, such as those of Mali, Ethiopia, and Kanem, were characterized by mobility. The development of more permanent capitals in some African kingdoms coincides with the development of fixed market sites, with central trading areas and palaces often being closely linked. There was little doubt, however, that the most important palaces – whether created from less permanent or more durable materials – were residences of powerful, wealthy kings and queens. They were often enormous structures with hundreds of courtyards and buildings. Elaborate sculptural programs reinforced the power and splendor of the monarchy. Broad avenues and wide parade grounds, where the population gathered for royal ceremonies, also distinguished many capitals.

African Courts and the Colonial Legacy: Buganda and Mangbetu

Buganda palace precincts in what is today Uganda epitomize African court architecture. Each king (kabaka) built his capital on one of the hill tops around Kampala, the present capital. Early

6. Benin (Nigeria). Salt cellar, sixteenth century. Ivory, height 12″ (30.5 cm). British Museum, London.

Ivory salt cellars were commissioned by Portuguese explorers from African artists as objects of elite status at home. This work, which was probably made by members of the royal ivory carvers guild at the Benin court, portrays a group of Portuguese men in contemporary dress. A Portuguese carvel with crow's nest and lookout surmounts the lid. Placed on European dining tables, such salt cellars represent one of Africa's first "tourist art" forms. At the same time, as a representation of the Portuguese, the work reveals something of the Benin view of the world and the unusual place of the Portuguese within it.

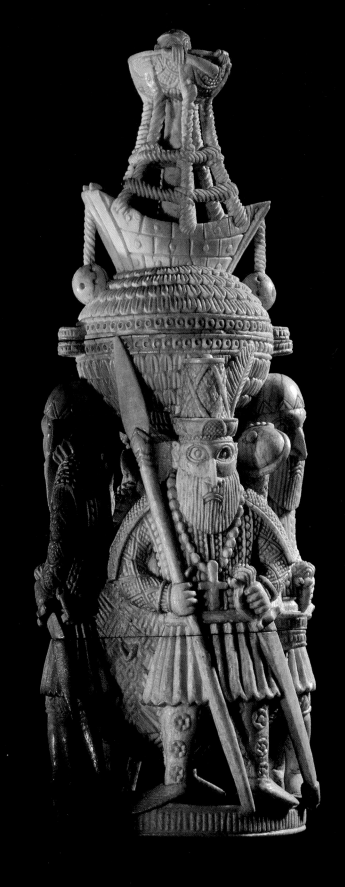

7. Buganda (Uganda).
Plan of the royal capital of
King Mutesa at Kusabi,
c. 1880. Published in John
Roscoe's *The Baganda*
(1911). Buganda kings
moved their courts with
some frequency, hence the
need for transportable
materials.

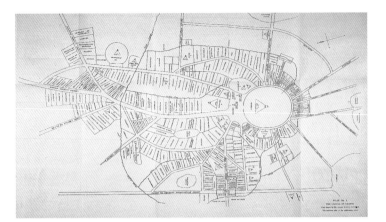

travelers remarked on the kingdom's network of broad avenues, many of these framed by cane fences (FIG. 7). About 450 buildings made up the royal precinct. The main palace, a spacious structure of finely woven thatch (see FIG. 2), necessitated the labor of over two hundred men working for about two months. Apart from scale and ornamental details, the palace was similar in style to the surrounding houses; basketry traditions of both the Buganda (FIG. 9) and their neighbors complement this architecture.

The engraving of the European explorers John Speke and James Grant who traveled to the court of King Mutesa in 1863 (see FIG. 2) gives a sense of the importance of the palace as a stage for royal ceremony. Because Buganda royal tombs (FIG. 8) look very similar to palaces, and were correspondingly positioned at the ends of a grand court, the architectural setting of the king identified him as someone who was at once living and a part of the larger lineage of now deceased kings, a figure of the present but also a part of the past.

8. Tomb of the last three
kings of precolonial
Buganda.

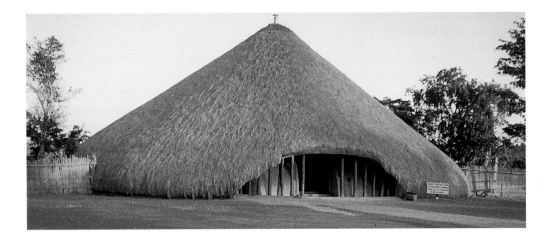

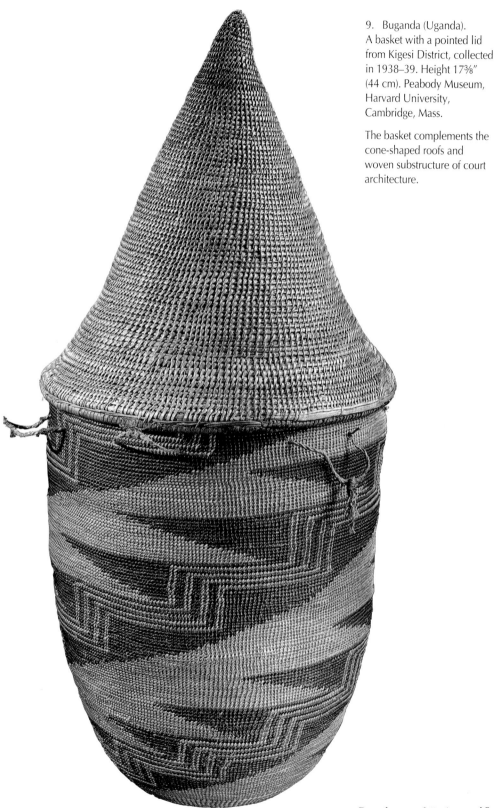

9. Buganda (Uganda). A basket with a pointed lid from Kigesi District, collected in 1938–39. Height 17⅜" (44 cm). Peabody Museum, Harvard University, Cambridge, Mass.

The basket complements the cone-shaped roofs and woven substructure of court architecture.

While African royal art and architecture reinforce the close relationship of royalty, power, status, and religion, they also offer tantalizing clues that the display of wealth and power was not exclusively royal. Some Yoruba smith staffs (FIG. 10) dedicated to Ogun, the god of iron and war, incorporate distinctively royal signifiers, for example. If such works suggest the important links between royalty and ironworking they also reveal the ways in which both royal and non-royal art forms are sometimes conflated. Some non-royal arts have thus been mislabeled over time as royal (Ethiopian churches, for example, being recast as palaces and mundane objects such as fishing shrines assuming the name of crown). At the same time, a number of seemingly ordinary artifacts and materials assumed vital royal importance – among these a simple stool such as a Dahomey enthronement seat and a packet of herbs placed inside the Yoruba beaded crown (see FIG. 1).

Royal regalia and art forms could also feature in non-royal contexts, particularly in the coastal areas that engaged in European commercial exchange. Local trading heads often presented themselves in regalia that suggested their equivalent status to inland monarchs; in contemporary photographs it is sometimes hard to tell the difference between such "monarchs" of coastal trade and the dynastic leaders of Africa's once powerful (and historic) kingdoms. Many European travelers actively promoted these royal misreadings by referring to local heads as "kings," exaggerating their own status in the process. So too in meetings with sanctified kings, Western illustrations make a point of showing European travelers close to the ruler (see FIG. 2), suggesting that they have far higher status than court officials or other ranking subjects. That many African kings dressed far less elaborately in the past than they do today can fuel misreadings: kings such as those from Dahomey (FIG. 11) look remarkably plebeian to the unschooled observer.

10. Yoruba (Nigeria). A bronze staff carried by a high-ranking smith, nineteenth century. From a workshop in the Abeokuta area. Bronze, height 17⅛" (43.8 cm). Museum für Völkerkunde, Berlin.

The "crown" coiffure, flanking bird figures, and beaded scepter of the seated figure of the smith recall royal regalia.

European and North American art collecting practices have significantly changed the royal art milieu in Africa. When the German botanist Georg Schweinfurth (1836–1925) reached the court of the Mangbetu king Mbunza in northeastern Zaire in 1870 and published illustrations in his *The Heart of Africa* in 1874 (FIG. 12), the magnificence of the court that he described fired the imaginations of many people, including scientists and patrons at the American Museum of Natural History in New York. One of the former, Herbert Lang (b. 1880), and his assistant James P. Chapin (b. 1893), organized a massive collecting and documentation trip into the area 35 years later. During the five years of their expedition, begun in 1909, over 38,000 porters were needed to pack and transport the various specimens that were collected. Animals, ivories, figural arts

11. Fon (Republic of Benin). King Guezo and his son, the future King Glele, in 1856. From Richard Burton, *A Mission to Gelele, King of Dahomey* 1864. Both Glele, who kneels to show respect for his father, and the reigning king, Guezo, wear protective *bo* necklaces. Skulls of defeated enemies are attached to the royal drum and throne.

12. Mangbetu (Dem. Rep. of Congo). King Mbunza, as portrayed by Georg Schweinfurth in the frontispiece to volume 2 of his *The Heart of Africa* (1874). Royal objects including knives and a pot are positioned on their own stools because they were not allowed to touch the ground.

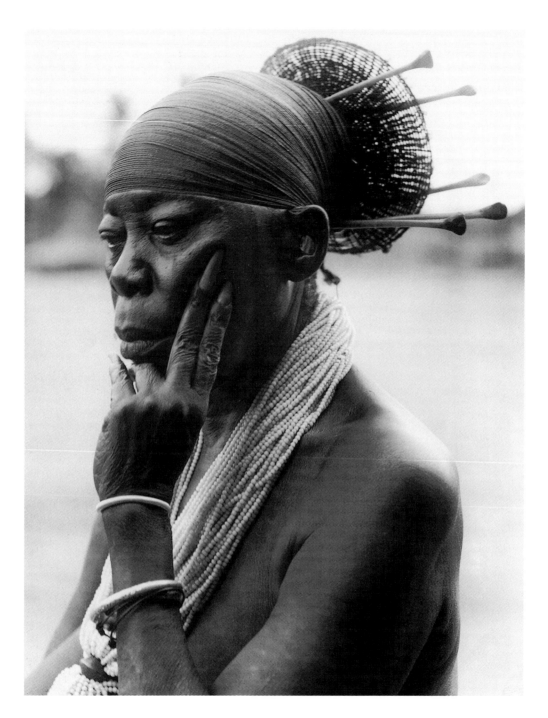

13. Mangbetu (Dem. Rep. of Congo). Queen Nenzima in her husband Chief Okondo's village, 1910.

Long fingernails indicated high status and Queen Nenzima's gift of hers to Herbert Lang signified trust, since possession of part of a person's body conferred power on the owner.

(see FIG. 3), and decorative works amounting to 54 tons were brought to the United States, including a necklace made from the fingernails of the reigning queen Nenzima (c. 1840–1926; FIG. 13), which she gave Lang as a sign of trust; Lang responded by leaving the Queen his thumbnail.

Lang and Chapin had a striking impact on local artistic production. Having seen Schweinfurth's earlier illustrations of the lofty and elegant Mangbetu palace (FIG. 14), these explorers bemoaned the lack of a more glamorous edifice, and before long a new one had been built, it seems in part to meet their expectations. A great many ivory works collected by the expedition were new, indicating that during their visit Lang and Chapin replaced local court members as the preeminent art patrons: they furnished artists with raw materials and monetary support, then acquired the finished works for their museum. Mangbetu artistic production largely ceased after their departure (confirming the often erroneous but still widespread assumption that great art no longer is being produced in Africa). In these cases, the founding (and filling) of ethnographic museums in the West coincided with the colonial division of Africa (the American Museum of Natural History dates to 1869; the Belgian Musée Royale de l'Afrique Centrale dates to 1898). Sometimes, it was thought that African royal arts confiscated in the course of the Western

14. Mangbetu (Dem. Rep. of Congo). The interior of the palace Great Hall, showing King Mbunza gesturing in a royal dance before an audience comprised of his wives, drawn by Georg Schweinfurth and published in *The Heart of Africa* (1874), vol. 2. Mangbetu court women displayed elaborate coiffures and body decoration.

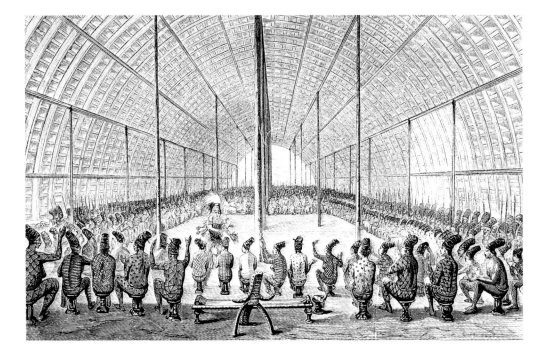

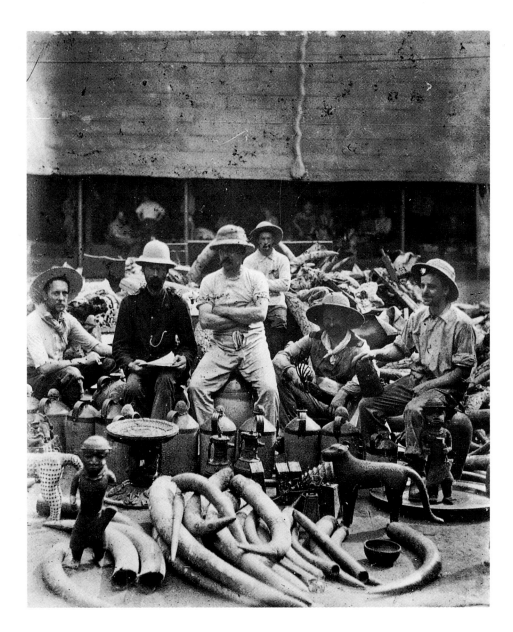

incursions, such as the British attack on Benin (FIG. 15) or the French conquest of Dahomey, could help to defray costs of museum displays or, more generally, the colonialization effort.

Studies in African Kingship

Two early Western scholars writing on African kingship and art shaped much of the seminal scholarship on related subjects, Sir James Frazer (1854–1941), an anthropologist interested in religion

and folklore, and A. M. Hocart (1884–1934), an anthropologist who wrote on the monarchy. The kings of Africa, Frazer argued, like the kings of ancient Italy, Asia Minor, the Far East, and many other parts of the world, were divinely sanctioned. Their power was as much religious as political. According to Frazer, in these areas,

> Kings were revered in many cases not merely as priests, that is, as intercessors between man and god, but as themselves gods, able to bestow upon their subjects and worshippers those blessings which are commonly supposed to be beyond the reach of mortals, and are sought, if at all, only by prayer and sacrifice offered to superhuman and invisible beings.

Hocart, too, was interested in the broader questions raised by royalty. Tracing the institution of kingship to the ancient Middle East, Hocart sought to show how societies developed from the segmented to the centralized, from egalitarian to hierarchical. Both Frazer's and Hocart's theories have now been largely disproven: kings are clearly different from gods (however sacrosanct their power) and monarchies are as likely to contract as they are to expand or consolidate – and not only in Africa. The writings of Frazer and Hocart, however, encouraged a number of scholarly publications on Africa, many of which focused on the rituals, institutions, and arts of the continent.

In the 1960s and 1970s many African scholars turned their attention to the larger dualities which were seen to characterize the royal art forms. Other scholars at this time emphasized the ways in which kingdoms and their arts had historically functioned. It is this latter orientation which informs the first book on the subject, the groundbreaking *African Art and Leadership* of 1972, edited by Douglas Fraser and Herbert Cole.

Contemporary studies have examined the ceremonial arts which serve to "socialize" rulers into their positions of power, such as coronations, state pageants, and royal funerals. The role art plays in promoting new histories about the dynasty's past is widely discussed, as is the use of art in the expansion and perpetuation of royal power; the ways in which royal power has been constructed, manipulated, and resisted through art; and Western colonial practices which have shaped our conception of both African art and royalty.

The inherent contradictions which exist between individual rulers and the institution of kingship, specifically the dilemma of the monarch as both human (someone who is born, ages, dies) and the symbol of an enduring state structure have become another subject of interest. A range of "master fictions" – paradoxical

15. Members of the British Punitive Expedition of 1897 in the Benin palace (Nigeria) with the treasury of royal ivory, brass, and other arts which were removed to London.

Note the serpent winding its way down the palace roof, a feature of earlier Benin royal roofs.

beliefs that are held by society – have frequently developed in conjunction with these dilemmas, with interesting complements in the arts. The rest of this introduction will focus on some of the more striking of these royal paradoxes as seen through affiliated arts because they reveal much about royal art concerns.

The Sacred King as Sinner King

Whether or not kings were explicitly divine or sacred, royal ceremonials and religious practices in Africa are closely related. Many monarchs and their families lived in massive constructions which incorporated central features of a temple, emphasizing

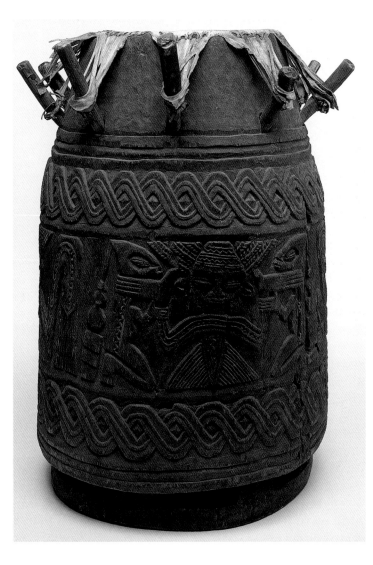

16. Yoruba (Nigeria). A royal drum, from the Ijebu area, nineteenth or twentieth century. Wood and skin, height 35″ (89 cm). Völkerkundemuseum der Universität, Zürich.

Drums of this sort were played for kings. The central figure of a woman grasps the necks of the two kneeling flanking figures, a motif also found on drums used in the Ogboni (Oshogbo) society dedicated to the earth and its patron deity, Odudua. The coiffures terminating in gourds of the two kneeling figures suggest that they represent Eshu, the messenger god, important in both royal and religious communication.

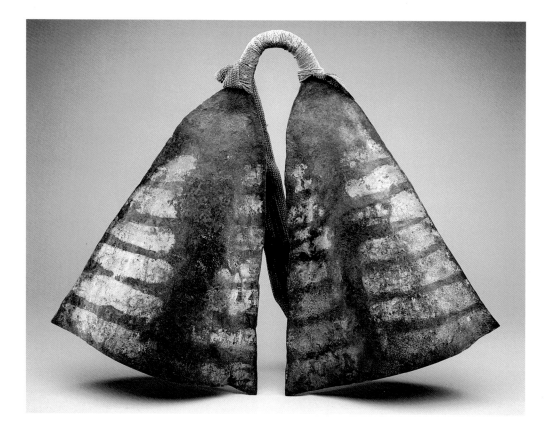

comparable attributes of orientation, sacred presence, and aesthetic elaboration. Historically, most royal subjects prostrated themselves before their kings as if before a god. Royal and religious arts also share key features (FIG. 16). In many kingdoms, double gongs of iron (FIG. 17) took on special ritual importance. Because they were made of indigenous metal, had prominent twinned shapes, and seemed to share formal characteristics with prehistoric stone axes – which in many areas were identified with lightning, rain control, and royal authority – such gongs figured prominently in court ceremonies.

African enthronement rites in turn made use of religious icons and regalia forms, which identify the king as responsible for the health, wealth, and well-being of his people. Looking generally plump in full court regalia if not in body, African rulers often conformed to the dictum (originally expressed for the Dahomey monarch) that if the king was well fed, the kingdom would necessarily prosper. The prominent use of horse and cow tail fly whisks complemented the king's vital role in chasing bad spirits who threatened the realm. To wash away the sins of the state, the kings of Dahomey and Madagascar were given a yearly

17. Mangbetu (Dem. Rep. of Congo). A double bell, from Rungu, collected in 1913. Iron, plant fiber, and wood, height 23½" (60.2 cm). American Museum of Natural History, New York.

Similar double bells of iron are associated with royal authority in many African kingdoms.

18. Yoruba (Nigeria). *Edan ogboni* (*Osugbo*) staffs from the Ijebu area, nineteenth or twentieth century. Brass, height 11" (30 cm). The University of Iowa Museum of Art.

Female Ogboni figures hold their breasts, an allusion to the roles which mothers and the earth fulfill as life givers and nurturers of their children. Male *edan ogboni* figures, in contrast, often demonstrate the characteristic Ogboni gesture of the left fist surmounting the right, the left hand's closed fingers hiding the extended right thumb. This gesture may suggest both the importance of left (ritual power) over right (physical power) and the primacy of popular law over that which is identified with the king.

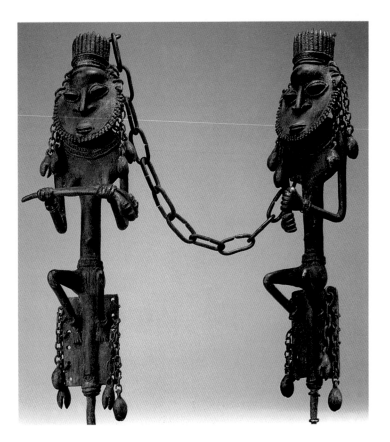

ritual bath. If things went wrong, a king might be accused of desecrating his divine authority and a replacement would be sought.

At the same time as being divinely sanctioned, many African kings (whether or not they were actually considered divine) also carried the burden of being stigmatized. They were closely identified with the breaking of fundamental religious as well as social laws. The heavy regalia which many African kings wore in public festivals to underscore their supernatural sanctioning and control of vast resources also evoked ideas of incarceration. Iconically and aesthetically complex royal art conveyed ideas not only of extraordinary opulence and social distance but also of imprisonment within this lush surround. Symbolically, rulers became the captives of the subjects whom they "served." Except for a yearly outing, many rulers could not leave the palace; most could never touch the ground. Nor generally could they eat, drink, or speak in public except through (or accompanied by) an interpreter, linguist, or spokesperson – despite the fact that many African rulers as early as the sixteenth century were fluent in several languages, including those of Europe.

Architectural screens or face-covering crowns (see FIG. 1) reaffirmed this visual distance and imprisonment, as did the often heavy costumes which made it difficult for kings to move. In some monarchies, local institutions served as checks on royal authority, among which the Yoruba Ogboni society (FIG. 18) acted as a counterfoil to the king. Related works offer evidence that African kings were often far less autocratic than were many of their European and Middle Eastern counterparts.

Many royal traditions even identify the king with acts that defy established laws. Incest, whether real, ritualized, or mythological, was an essential component in African royal beliefs and rituals (in the Kuba and Dahomey kingdoms, for example), marking the rulers as breakers of social and religious taboos. Necrotomy – the dissection of the king's body after death – and the separate burial or ceremonial use of key parts of the body was a royal practice. Kingly traditions of law breaking identified the rulers as preeminent takers of human life, dangerous not only to their enemies but also to opposing subjects within the kingdom. Those who were found guilty of capital offenses were usually brought before the king (in principle, he or his delegates were the only ones who could take human life). Traditions of human sacrifice in turn assumed the shared onus of punishment for grave offenses, a public display of royal power, and a sacrosanct offering to the kingdom's gods and ancestors (FIG. 19). Again, in contravention of social norms, kings could oversee the break-up of their own families: at the new king's accession, the dead king's widows and mother sometimes followed him to death. So, too, the new king's brothers and other potential family rivals might be sent to distant territories. Their exile helped to disseminate royal authority and art through the display of courtly regalia.

The King as All-Knowing and the King as Fool

In the same way that African kings could be both sacrosanct and stigmatized, so too royal African arts frequently depict the king as simultaneously all-knowing and outside of real knowledge: for example, the founding kings of several kingdoms have been credited with the knowledge of blacksmithing. Among the Kuba, royal migrations through different ecological zones were seen to convey to the king and his office knowledge about the world

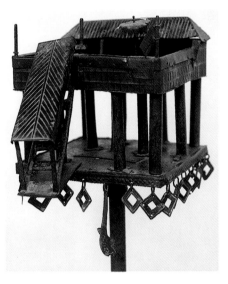

19. Fon (Republic of Benin). A royal *asen* memorial sculpture, dedicated to King Agaja (1708–40) but probably nineteenth century. Iron, brass, height 4'2" (1.27 m). Musée Historique, Abomey, Republic of Benin.

The raised *attoh* platform was built for the royal *huetanu* festivities where the king would observe events and distribute textiles, liquor, and cowrie shell currency to the gathered populace below. Persons guilty of capital offenses also were sent to their deaths from these *attoh* structures in order to carry news of the Dahomey kingdom to the world of the dead. This unusual ceremonial structure is said to have been first introduced by King Agaja and may be derived from pole platforms traditionally constructed in the fields at harvest time to protect the crops from animals or thieves.

and its properties. Many African palaces took on the appearance of a museum or zoo of foreign forms. Peacocks and Scottish sheep wandered through the Dahomey palace; the famous stone house of the Asante king in present-day Ghana was used to store European artifacts; and leopards were among the many "foreigners" to grace the palace of the Benin king. The royal quest for knowledge found expression in regalia that incorporated a rich display of exotica.

The roots of royal prerogatives and powers are diverse. According to one theory of the Madagascar kings, royal regalia and ritual developed out of the ordinary and commonplace, an elaboration of what was already in existence, but for kings was marked by greater abundance and force. According to another theory, conceptualized especially among the Swazi in southern Africa, the king was thought of as a stranger, the outsider who brings order and civilization to the local populace. Royal arts to some degree support both points of view. They include distinctively local materials such as leopard skins, eagle feathers, iron, and related flora and fauna, but much of the regalia also displays a predilection for foreign symbols of wealth and power − coral, cowries, imported beads, silver, brass.

Moreover, no known human or animal ever looked like African rulers in their court regalia: their unusual appearance increased both the curiosity and concern about them. With a distinctive silver, feline nose mask, Dahomey leaders personified fierce man-leopards. African enthronement rituals in turn successively transformed the king into a superhuman "thing," making him more than and different from an ordinary person.

In many African courts there was a provocative connection between kings and acceptable ignorance. Sometimes this was given institutional grounding, as in the figure of the court fool or jester who, in Dahomey, displayed attire and ceremonial rituals in many respects like the king, but distorted and destabilized.

The ruler as symbol of both knowledge and that which remains unknowable finds visual and ritual complements in various divination arts. In some cultures (the central African Luba, for example) rulers had their own special divination forms. In other areas − Yoruba, Fon, Benin, and Bamum in West Africa most importantly − royalty relied on court diviners who played a critical role not only in the selection of a new king but also in determining important royal actions − marriage, birth, the timing of ceremonies, and war (FIG. 20). Because court diviners were under obligation to the monarch, they also may have been called on to give their approval to royal decisions already in play.

20. Dahomey (Fon; Republic of Benin). This warrior, perhaps by the artist Ganhu Huntondji, personifies the war god Gu. Commissioned by King Glele (r. 1858–89) and dedicated to his father King Guezo (r. 1818–58). Brass, wood, overall height 41½" (105 cm). Musée Dapper, Paris.

The bright brass from which the sculpture is made was said to derive from the shells of spent bullets. Gunpowder purportedly was smoothed over its surface during ceremonies before war. Important features of this work coincide with King Glele's divination sign.

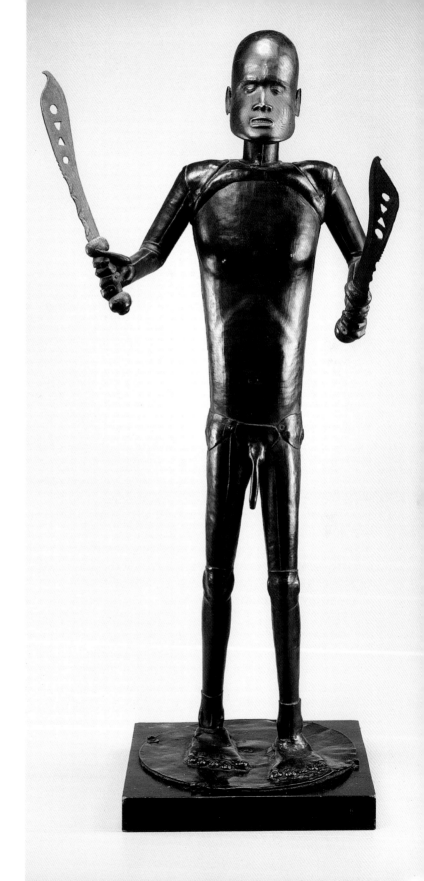

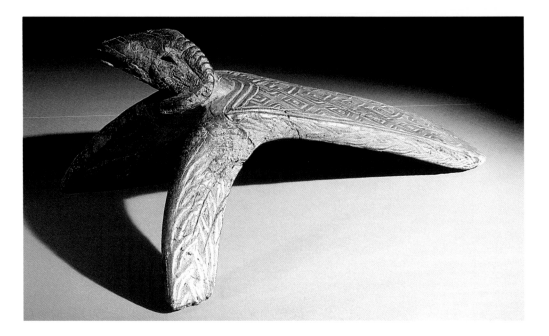

The Model King as an Idiom of Royal Imperfection

With their smooth shiny surface, calm demeanor, and full fleshy features, African royal portraits such as those of Dahomey, Kuba, and Benin often show the king as the epitome of bodily perfection and beauty, neither too old nor too young, too heavy nor too thin. They convey an image of the king as someone who never ages, gets ill, or succumbs to the strains of the office. This concern with continuing youth makes such portraits somewhat different from royal representations elsewhere in the world. And, if portraits of African kings generally show them to be strikingly handsome, it is partly because physical perfection was one of the many prerequisites of rule. Candidates to the throne could be ruled out if in height or other features they failed to meet the standards. Paralysis, an extra digit, or an unusual tooth are known to have precluded some from taking power.

It is somewhat surprising in this light to note the ways in which themes of physical imperfection have influenced various types of African royal ceremony and art. Forbidden by ritual to speak in public, kings assumed aspects of a mute; too sacred (or dangerous) to touch the ground, they were transported on hammocks, stood with their arms supported by courtiers, moved extremely slowly, or held court while lying prone on special back rests (FIG. 21), all characteristics signaling at once disability and physical

21. Kuba-Bushoong (Dem. Rep. of Congo). A royal backrest, early nineteenth century, collected at the Kuba capital, Msheng, in 1909 by Emil Torday. Wood, 14⅛ x 19 ⅝ x 33½″ (36 x 50 x 80 cm). British Museum, London.

Special backrests were provided for the king to lean against when he was holding court. This is decorated with the head of a ram, a royal attribute identified with power, force, and leadership. The complex surface patterning recalls that of Kuba textile arts.

inability to stand independently. In the Benin, Yoruba, Dahomey, and Kuba kingdoms, moreover, people suffering from congenital deformities were sometimes associated with royal priesthoods and would reside in or near the palace. As prominent court affiliates, they were a frequent subject of royal art (FIG. 22). Eunuchs were also common palace residents. Physical peculiarities also frequently featured in African dynastic origin myths: the founding Dahomey kings, for example, were described as having claws instead of fingernails.

The expense and artistic attention paid to royal memorial arts and architecture make it clear that kings, while ostensibly never aging, do eventually die, whether from "normal" human conditions such as old age or from external causes such as defeat by an adversary. Royal arts therefore incorporate references to military losses, internal opposition to rule (FIG. 23), and *coups d'état*. The wealth of royal memorial arts suggests, however, that while an individual king may meet his death, the kingdom itself will survive. The complexity and artistic richness of court funerals and installment rituals offered vital evidence of the kingdom's durability to the local population. Royal tombs thus became special ritual centers where judicial decisions and religious rites for the well-being of the state took place; Benin, Asante, Bamum (grasslands Cameroon), and Kongo traditions are particularly noteworthy in this regard. Important art works distinguished these royal tombs or related memorial structures. The reality of royal death is similarly manifested in the lavish attention paid to the king's corpse prior to burial. In Asante, the king's body was covered with gold dust;

22. Benin (Nigeria).
A dwarf figure from the kingdom of Benin, seventeenth–eighteenth century. Brass, height 23½" (59.5 cm). Museum für Völkerkunde, Vienna.

Dwarfs assumed importance in ritual roles at the Benin court.

23. Fon (Republic of Benin).
An *asen* memorial, late nineteenth–early twentieth century. Iron and brass, 40⅛" (102 cm). Musée Historique, Republic of Benin.

The *asen* is dedicated to King Tegbesu (1740–74) whose royal icon, a buffalo wearing a shirt, refers to the opposition of his brothers to his accession. They are said to have put poisonous plants into his coronation robes in an unsuccessful attempt to get him to remove it.

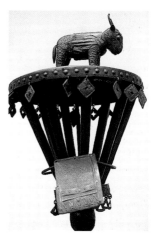

among the Kuba his remains were heavily bathed in red camwood powder and wrapped in beautiful cloth.

The Healing King as Sorcerer and Transsexual

In both life and death, African kings were credited with vital healing and restorative powers. Their full, heavy bodies potently signaled not only their own well-being but also their ability to convey plenty to others. In many African kingdoms – Dahomey and Bamum among others – a special hearth was constructed with a fire kept perpetually burning to symbolize the life and vitality of the kingdom and its ruler. At the time of a king's death, the fires throughout the realm were extinguished, to be rekindled only when a new king was named. In a related tradition, many African palaces and royal capitals were given calendrical and cosmological importance through features of their orientation, landscaping, and ritual use.

As potent as the restorative, healing, and cosmogonic powers of kings were assumed to be, they were counterbalanced to some degree by the associations of kings with individuals thought to play havoc on local fields and families, namely sorcerers. Like sorcerers, kings were thought not only to be able to "see" into various realms, but also to transgress normal social mores and boundaries with impunity. Kings could kill at will (through war and other means), steal (misappropriate the property of others), and abduct members of other kin groups. Thus the same beaded crown (see FIG. 1) that announced the Yoruba king as a sacral authority also made visible through its "gathering birds" iconography the complementarity between royal power and witchcraft, since the birds were associated with sorcerery.

Similar to sorcerers, African rulers were believed capable of transforming themselves into other beings – leopards, elephants, birds, hippopotami, snakes, flies – to escape from enemy threat or to witness for themselves the private and public acts of people in the realm. And, since to some extent success was equated with sorcery – in other words, the innate ability to succeed against one's competitors – the king's power both to accede to the throne and retain it gave evidence of his innate, superhuman hold over the world at large. Another prominent royal tradition saw the doubling of kingly identity in the form of a ritual king or "bush king" – as in Dahomey and Kuba – a priestly ruler who lived outside the capital and fulfilled sacromagical functions by strictly following royal proscriptions for dress, habitation, food consumption, or celibacy. Paired with the public official king, this ruler double also

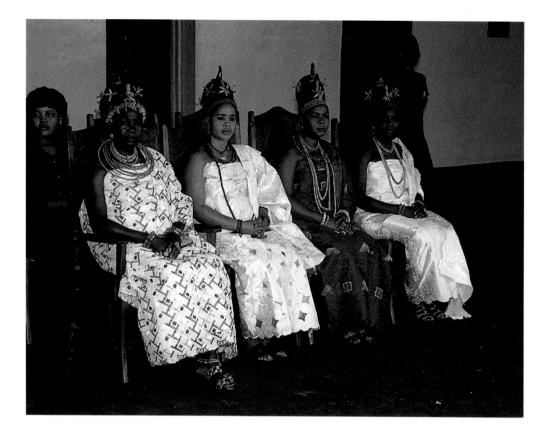

embodies sorcery-related ideas of four-eyed vision – two in front and two at the back, two visible and two invisible, two in this world and two in the world of supernaturals. The tradition of royal doubling suggests parallels with European and other conceptions of the king as symbolically inhabiting several bodies.

There also is a striking element of cross-gender identity among many African rulers. One greets a Dahomey king by asking after his house, much as if he were the symbolic housewife of the state. The term of address for this king, *Dada* or "older sister," also indicates a link to women. After death, Dahomey, Luba, and some other kings were reincarnated by women. A similar aspect of royal cross-gendering is found in some portrayals of African rulers – as among the Kuba – with hermaphroditic features such as female breasts, coiffures, and pronounced (pregnant) bellies. The androgyny of such kings underscores not only royal dualism and preternaturalism but also royal surplus.

Women themselves played strikingly powerful roles at court (FIG. 24) and in artistic production; the many women represented in court sculpture affirm their political significance. Among

24. Benin (Nigeria). The wives of the king, 1997. Their elaborate "chicken beak" coiffures are a prominent feature of arts identified with Benin royal women.

the most important was the queen mother, who was often regarded not only as the creator of the monarch, but also as a promoter of ideas and artists from her home community. The queen mother's court was also a place of refuge for critics of the king. In the context of matrilineal societies (in which the king traced his inheritance and power through his mother's line), as among the Asante, the mother's identity as the royal wellspring carried additional ritual and political authority.

The Progenitor King as Royal Appropriator

One of the most potent symbols of royal wealth and power was the number of the king's supporters, affiliates, and wives, the last in some cases extending into the thousands. The numbers of these women were far too great for one man to know individually, much less intimately. Often they represented an important source of labor. In some courts, such as Dahomey, these women prepared much of the court food, spun thread for court textiles, braided clusters of cowries into cords having currency value, and served in the military. Royal wives and their offspring also were seen to symbolize the ruler's virility as paradigmatic father of his people. In Bamum court architecture, images of frogs figured prominently as markers of the king's powers of fertilization. Royal increase was reflected in seemingly unrelated activities such as pipe smoking: in Bamum and the nearby Cameroon grasslands courts, when the king smoked tobacco he was believed to be fertilizing his subjects and their crops.

The king as a forceful military ruler is frequently portrayed in African royal arts. Rare indeed are the sculptures, photographs, or engravings of kings which do not show them with some form of weaponry – a lance, axe, sword, throwing stick – whether militarily or ritually based (see FIG. 12). The expansionist royal wars of the last five hundred years – in some cases linked to the European slave trade in the sixteenth to nineteenth

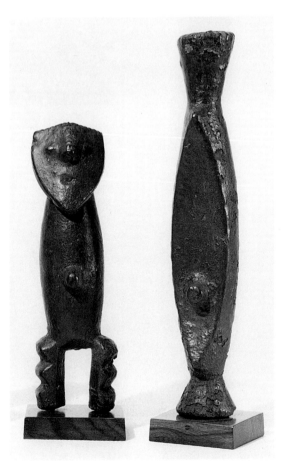

25. Azande (northeastern Dem. Rep. of Congo). Yanda figures, early twentieth century. Wood, heights 8 and 10½" (20.4 and 26.5 cm). Collection of Marc and Denyse Ginzberg, New York.

centuries – was a vital source of royal military competition. Thrones, palace architectural decoration, and regalia readily displayed icons of both battle and beauty. Following key military successes, chiefs of newly secured territories often were required to demonstrate their political allegiance and submission by displaying artifacts identified with the victors, thus changing the visual landscape far from the palace. Yet some sculptural traditions created in these kingdoms suggest if not popular opposition to the king, then a desire to protect oneself from the often dangerous course of royal power (FIGS 25 and 26).

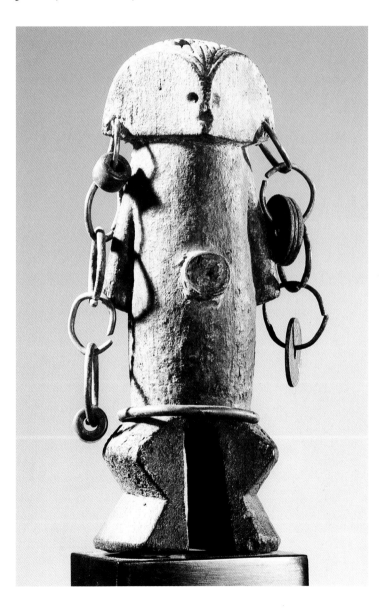

26. Azande (northeastern Dem. Rep. of Congo). Yanda figure, early nineteenth–twentieth century. Wood and mixed media. Dallas Museum of Fine Arts.

Yanda figures were used in the local secret society both to offer protection against witchcraft and to serve as buffers between individuals and persons of authority.

Royal power bound up with artistic innovation was a particularly prevalent feature of various African kingships. Although longstanding Western misconceptions have tended to see African arts as largely "traditional" and slow to change, the vital innovativeness of rulers such as King Njoya (1870–1933) of Bamum or King Glele (1858–89) of Dahomey are noteworthy. Not only were many African rulers required to create new palaces when they came to power, but they also were encouraged to invent artistic works, the melting down and recasting of gold jewelry as part of the Asante royal Odwira festival being but one example. In turn, a common outcome of royal expansionist wars was an influx to the capital of foreign artists, who introduced new art forms and styles. Indeed, the great court art traditions that we now identify as distinctively Asante, Dahomey, Bamum, and Mangbetu in style were made largely by artists who came from

different areas: Azande artists, for example, made many of the Mangbetu court art works.

In the same way that African kings were great artistic innovators, they also were great collectors and integrators of outside artistic forms and ideas, acquiring foreign imagery from African as well as European and Islamic sources. In this way they incorporated the power of foreigners into the royal sphere. Lions, coats of arms, and representations of Queen Victoria were a frequent subject in both royal and non-royal communities in nineteenth- and early twentieth-century Africa. A vital ancillary feature of these foreign interests was the prominent use of large protective ditches or walls around the capital. Their role was clearly intended as much to keep the wealth – of people, gods, and material goods – inside the capital and kingdom as it was to keep opposing foreign military powers at bay. The maze-like configuration of many African palaces served a similar role.

African kingdoms maintained contact with one another through a range of diplomatic and ceremonial links: ambassadors from the Asante court were frequent visitors at the Dahomey court, and emissaries from the Yoruba royal city of Ife traveled to the Benin court. "Traditional" stylistic boundaries were extensively reshaped during these contacts, making the royal arts of Africa not only extraordinarily varied but also highly complex in terms of stylistic grounding. The changing political climate and upheavals of the early and later colonial era added their impact, which was frequently a creative one in that it provided new and less centrally defined means for expressing individual power and identity. It has been pointed out that for the Ga of Ghana, indeed, the proliferation of royal regalia closely coincides with a decline in overall royal power and control. The twentieth-century expansion and elaboration of Yoruba beaded crown and regalia forms (FIG. 27; see also FIG. 1) – among many other examples – can be seen to dovetail with a fundamental lessening of the rulers' power in the colonial era. In a complementary recognition of these regalia as markers of the highest status, European monarchs and political leaders were keenly interested in Africa's royal art (FIG. 28).

In earlier times as well, some of the richest regalia appear to be linked to periods of relatively less power, suggesting that kings sought to display visually what they could not convey politically. There has been a concomitant move in many kingdoms toward the creation of regalia which today are more culturally specific than in the past. In many Western engravings and photographs of African kings (see FIGS 2 and 11) royal regalia showed far less specificity than was true in later periods. By the 1950s and 1960s

28. Benin (Nigeria). A pair of leopards, probably nineteenth century. Ivory, coral, copper, and glass, height 32″ (81.5 cm). Collection of Her Majesty Queen Elizabeth II, on loan to the British Museum, London.

Live leopards were among the many denizens of the Benin palace. On important ceremonial occasions (see FIG. 40), the leopards were paraded in public. This pair of ivory leopards, with copper spots and glass eyes, was carved from five separate elephant tusks, underscoring the status and power of the leopard as a royal animal. Around their haunches, both leopards wear necklaces of coral, a mark of ritual allegiance and political loyalty in the Benin kingdom.

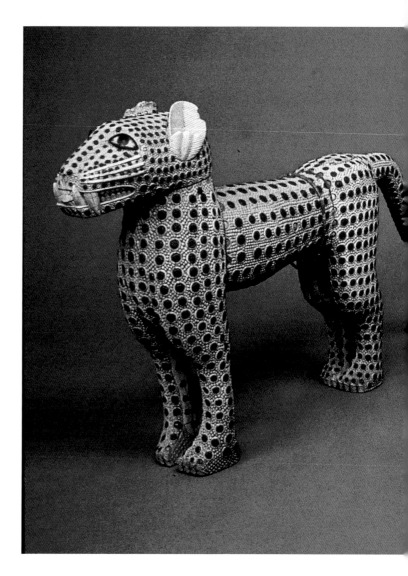

when many of the lush color photographs of African rulers were taken (and a century or so after ideas of separate, individualized "tribes" and styles had been reinforced in the West), Yoruba kings looked more "Yoruba," Asante rulers looked more "Asante," and Dahomey monarchs looked more "Dahomey"-like.

Royal art histories also have been recycled recently in new ways. In the Benin kingdom, Western art books with photographs of seventeenth- and eighteenth-century objects now in European or American collections have become important models for contemporary court art and dress. And modern national leaders in many parts of Africa have appropriated historic royal

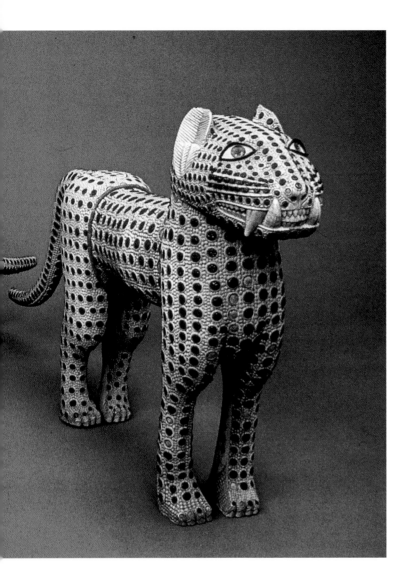

idioms. The political head of the Benin Republic (ex-Dahomey) occupies a palatial structure with elegant tile decorations in the form of pythons, which recall imagery in the Dahomey royal city of Abomey. The ex-political head of the Democratic Republic of Congo often presented himself publicly with a leopard-skin hat and cane of authority, which complement the regalia of the great Kongo kings of the past. In the context of African royal art, past and present continue to inform each other in interesting and provocative ways. The following chapters address the diversity of these arts as well as the aesthetic and iconic concerns that make them so extraordinary.

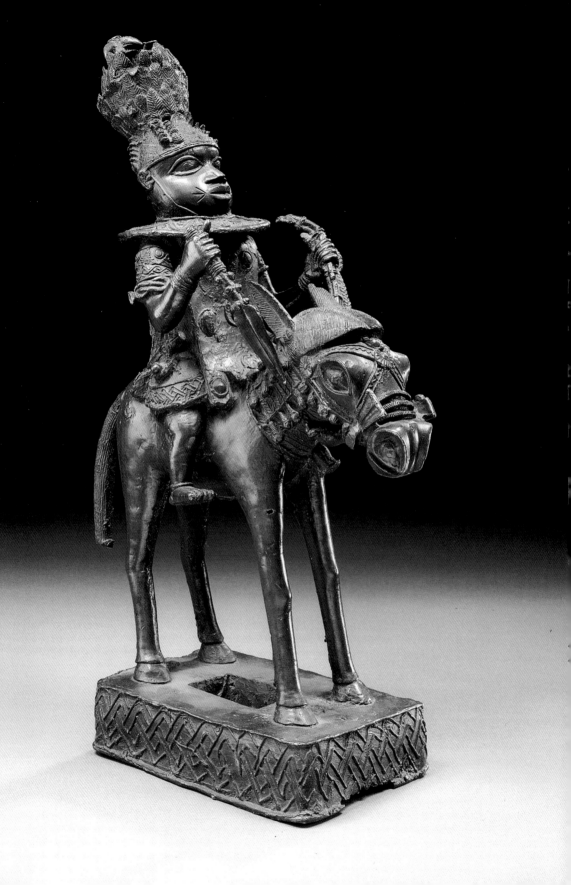

ONE

The Benin Kingdom: Politics, Religion, and Natural Order

29. Benin (Nigeria). An equestrian figure, eighteenth century? Brass, height 18⅞" (48 cm). British Museum, London.

This handsome figure may personify Oranmiyan, the prince who left Ife to found Benin's second dynasty. Oranmiyan is also credited with the introduction of horses at Benin. Another interpretation suggests that it represents a northern ruler (perhaps the Igala king, the Atah of Idah); Oranmiyan is said in some accounts to have come from the north.

For more than a thousand years the kingdom of Benin was a political power in the southern forests of present-day Nigeria. Identified with a range of Edo-speaking peoples (along with nearby Yoruba, Igbo, Ijaw, Itsekiri, and Igala groups who came under their control), Benin saw the rise of two important dynasties. The first of these, called Ogiso ("Rulers of the Sky") is believed to have been founded around 900. The second and current dynasty is thought to have come into existence in the thirteenth century after the arrival of a warrior prince named Oranmiyan (FIG. 29) from the ancient Yoruba capital of Ife. Oranmiyan renamed this center *ibini* ("land of vexation"), the root of the term Benin. The importance of Yoruba deities and religious forms (see Chapter Two) in Benin derives both from this early contact and from later military and cultural interchanges. Because Benin arts are relatively naturalistic and made from expensive import metals these works were highly prized by early Western collectors.

Dynastic Heads and Models of Status

Benin rulers (or *oba*) were credited with great metaphysical and spiritual power, their authority being reinforced by traditions of handsome heads (*uhumwelo, uhunmwun-elao*) of brass placed on

KINGDOM OF BENIN

ancestral altars. These heads (FIG. 30) serve as potent visual references to each ruler's destiny (*ehi*), authority, wisdom, success, and happiness, reflecting Benin associations of the head with knowledge, intelligence, character, judgment, and family leadership. Royal ceremonies were performed each year to strengthen the king's head.

Brass heads of this sort are said to have been first introduced during the reign of Oba Oguola in the late fourteenth century, but the earliest surviving such works have been dated by style to the early fifteenth to mid-sixteenth centuries in the years following Oguola's reign. These early-style heads are distinguished by their thin casting (appropriate to an era when the European import brass was scarce). They also display relatively naturalistic features, minimal necks (with coral necklaces), and stylized hair patterns rather than crowns. While some early heads may represent kings, most are thought to depict important fallen enemies – Igbo and others. Such representations of foreigners, which may have been placed on special war shrines, served to validate Benin military success in the early "warrior king" period of territorial expansion.

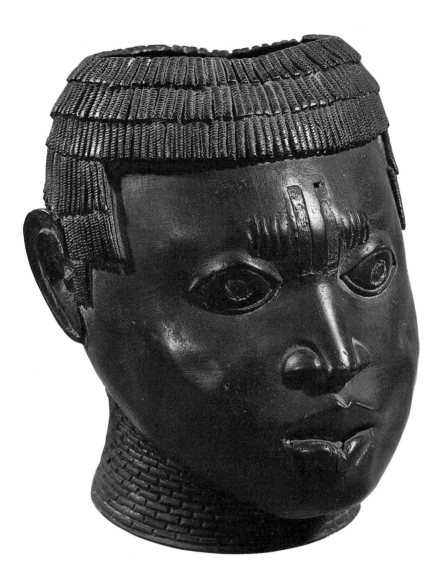

30. Benin (Nigeria). A royal head from an altar, probably fifteenth century. Brass and iron, height 8¼" (21 cm). University of Pennsylvania Museum, Philadelphia.

The brass used here and in other Benin castings suggests permanence and protection since the metal's distinctive shininess and red surface was thought to distance evil. The iron irises of the eyes are said to convey both the mystical authority of indigenous forged metal and the enduring stare of one whose nature is in part divine (one of the local names for the iris is "ray or menace of the eye"). Parallel iron bars set into the forehead invest the head with the sacrosanct potency of indigenous iron; sacrifices aimed at renewing royal power are placed on the bars. The raised marks (*ikharo*) along the eyebrow are a form of cultural marker, three for men, four denoting women or foreigners.

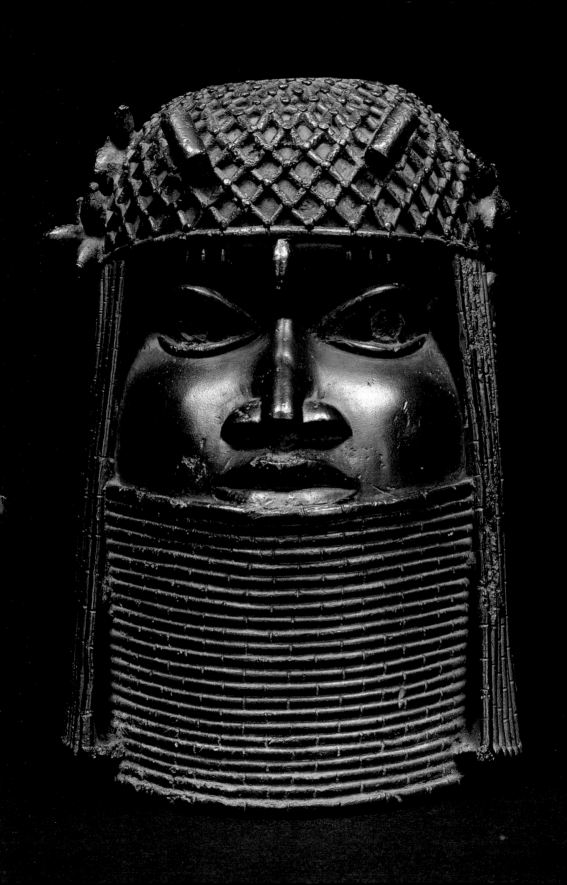

Those Benin heads which generally are attributed to the late sixteenth to mid-eighteenth centuries are assumed to portray only Benin royalty (FIG. 31). These works are distinguished not only by their thicker casting and greater height and scale, but also by their larger necks and taller coral bead covering. Coral, which derives from the Mediterranean Sea, was an important feature of Benin royal costumes (FIG. 32) and was believed to make the king's words come to fruition. Historically at Benin such beads were sewn together with elephant-tail hair, an animal closely identified with both royalty and physical force. Later heads, dated to the mid-eighteenth through the late nineteenth centuries, are characterized by even taller necks encased in wide rows of stylized coral bead strands that cover both the neck and the chin. They display wide bases; winged extensions at the temples, a feature introduced by King Osemwende (r. 1815–50); horizontal bar-like projections at the sides of the face (said, among other things, to suggest the barbells of mudfish); and vertical extensions like feathers above the ears.

31. Benin (Nigeria). A head, late sixteenth century? Brass and coral, height 10¾″ (27 cm). British Museum, London.

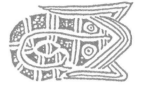

SYMBOL OF COILED MUDFISH

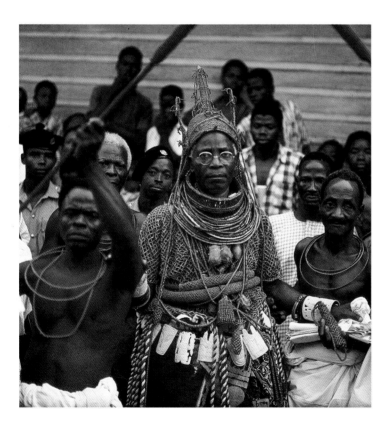

32. Benin (Nigeria). King (Oba) Akenzua II (1933–78) in coral regalia during a palace ceremony, 1964.

Because of coral's red blood-resembling color, the beads may recall the deadly power of the king and the close kin-like bond between the ruler and the populace. Similar coral beads were distributed by the king to key individuals in the state. Because of their political and ritual associations, to lose such a bead was considered a grave insult. An annual coral ritual at the palace reinforced political ties to the crown.

33. Benin (Nigeria).
Queen mother head,
c. 1500–50. Brass, height
15½" (39 cm). British
Museum, London.

Such heads differ from
those portraying male
royals by their "chicken's
beak" crowns, which
resemble coiffure worn by
court women (see FIG. 24).

Brass heads representing queen mothers (FIG. 33) were placed on special altars dedicated to these women both at the royal palace and at the queen mother's residence. As with other royal altar heads, the expense and red shininess of the brass underscores the queen mother's power and prestige. The first queen mother heads are thought to date to the early sixteenth-century reign of King Esigie, the ruler who first established the office of queen mother for his mother Idia. The fish shown on the base of one such head honors Idia for her help in pressing the attacking Igala back across the Niger River.

Surmounting the altars of the first dynasty or Ogiso kings are said to have been heads made of terracotta (baked clay). Although the brass arts associated with the Ogiso appear to have comprised primarily small objects such as bracelets or bells, Ogiso traditions of terracotta heads may have served as models for later royal brass heads. Most oral traditions, however, credit artists arriving from the Yoruba city of Ife with the creation of the first such brass heads. Like the early cast heads, most of the Benin terracotta altar heads are characterized by their relatively naturalistic facial features and short necks. The choice of terracotta for these works may reveal not only status differences between first and second-dynasty kings, but also the continuing ritual and technological importance of clay within the brass casting process more generally. In related lost-wax castings, the finished works take the shape of the clay model. After a thin layer of wax and a finishing coat of clay are applied to the clay core, the surface of the sculpture is heated, the wax layer flows out and molten brass is poured into the mold, replacing the wax and assuming the shape of the initial clay core. In part for this reason, terracotta heads also decorate the altars of the royal brass casters. In a related tradition, the terracotta head which would eventually be cast into the late king's commemorative brass head was used as a temporary support for the new ruler's crown during the rites of enthronement.

Heads made of wood instead of brass or terracotta were employed by Benin chiefs on their family altars (FIG. 34). The heads of especially important chiefs might incorporate thin sheets of brass

to accentuate areas such as the neck or cap, which in life were decorated with coral. In addition to being made of wood, chiefly altar heads also are distinguished from royal examples by the carving of a vulturine fishing eagle feather on one side of the headdress. These feathers were worn by chiefs as a mark of longevity, status, and achievement.

In the same way that brass, terracotta, and wood mark status differences in Benin altar arts, subject matter also was important. Figures of hens, for example, were placed on the altars of maternal ancestors; sculptures of roosters were displayed on the altars of the chief's junior members. Descriptions from the seventeenth and eighteenth centuries suggest that rams, goats, and bullocks were represented on altar heads created for high-ranking commoners and foreigners (FIG. 35).

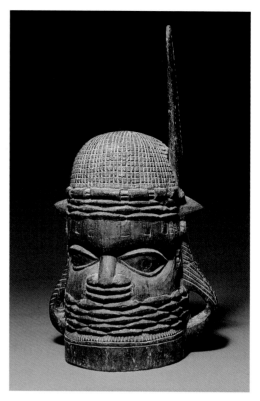

34. Benin (Nigeria). Memorial head, nineteenth century. Wood, height 11¾" (30 cm). Staatliches Museum für Völkerkunde, Münich.

Although wooden heads of this sort are said to have been introduced in the Ogiso period as memorials for carvers, their chiefly use is relatively new. Around 1830, local chiefs are said to have received permission to commission wooden imitations of royal brass heads to honor a chief who had been killed by the king.

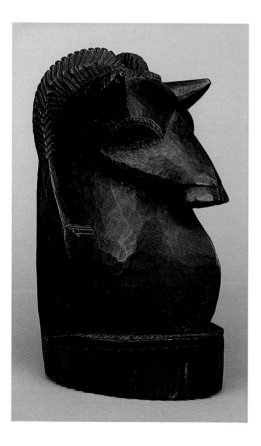

35. Benin (Nigeria). Ram head, eighteenth–nineteenth century. Wood, height 13¾" (35 cm). British Museum, London.

Ram heads served as memorials for high-ranking commoners and foreigners (Yoruba, Ishan, and others) whose cultures were brought into the Benin sphere through war.

Art and Architecture in the Reign of Ewuare

Palace architecture reflects similar concerns with status and authority. While research continues, local sources suggest that following the establishment of Benin's second (and current) dynasty in the thirteenth century, a new high-walled palace was built. The construction of this building was considered so significant that its creation has been ritually reenacted at each royal enthronement. In the mid-fifteenth century, the royal capital was consolidated and the palace moved and enlarged by the great warrior king Ewuare after a fire had destroyed part of the capital. Ewuare renamed the now centrally planned city Ob-Edo (FIGS 36 and 37) after an heroic supporter named Edo whose life-saving efforts had allowed Ewuare to take the throne. Edo, the widespread cultural and language term for this area, also appears to derive from this source.

As part of his capital plan, Ewuare oversaw the digging of a moat six-miles (9.5 km) long around the inner city. Marked by nine wooden gates, the moat was intended in part to prevent residents unhappy with Ewuare's new laws from fleeing. The new second-dynasty palace was located near the city center, at the terminus of three broad avenues leading in from the east, north, and west. The palace faced north, the direction of Ogiwu, the god of thunder and death. The east is linked to Osanobua, the sky god; to the west lives Olokun, god of the sea, to the south reside the

36. Benin (Nigeria). Plan of Benin City in the nineteenth century.

Benin City was divided into two main sections. The inner city (Ogbe) housed the first- and second-dynasty palaces along with the houses of related functionaries; the outer city (Ore Nokhua) contained a large group of compounds for the indigenous residents associated with Benin's first (Ogiso) dynasty. The titled successors to these Ogiso founders, known as *uzama*, served as royal counselors and kingmakers, the most senior *uzama* presenting the crown to the new ruler during the coronation. As guardians of history, the powerful *uzama* held the rights to key traditions otherwise associated with the kings, among these the right to their own palaces and priests. The crown prince (*ediaken*) was included among the *uzama*.

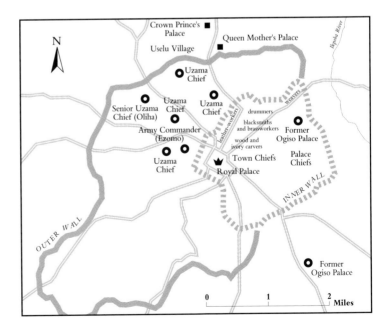

The Benin Kingdom: Politics, Religion, and Natural Order

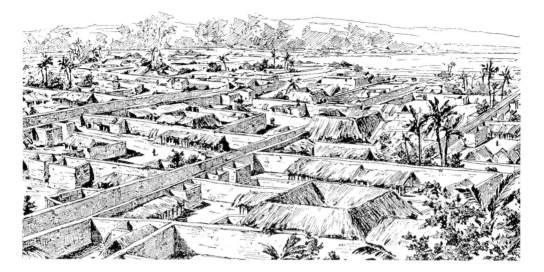

health supernaturals, Osun and others. The prominent cardinal positioning of the palace no doubt reinforced the king's identity with temporal and cosmological power. History was also underscored in royal planning by placing the house of the town chief (symbolizing the oldest local family) opposite the palace.

The Benin queen mother had her own palace, described as a "beautiful house outside the city." The queen mother residences were located in the once separate village of Uselu, several miles to the north of the capital (see FIG. 36). The queen mother's independence and power as a titled chief was such that she could give refuge to people out of favor with the court. Although she was never allowed to see her son once he had become king, the two were in frequent contact through messengers. As noted in a seventeenth-century Dutch description of Benin, the king "undertakes nothing of importance without having sought her counsel." Near the queen mother's residence was the palace of the crown prince. The residences of other adult royal princes were often located in distant administrative centers where they would pose less of a political threat to the crown.

In addition to his interest in capital and palace planning, King Ewuare is credited with revolutionizing Benin politics by creating a series of new town and palace chief positions, and with promoting new rituals and a number of innovations in art, clothing, and jewelry. The houses and workshops of the various court guilds – iron workers, brass workers, wood sculptors, weavers, ivory carvers, leather workers, embroiderers, drummers – were located in special wards east of the palace (see FIG. 36), their proximity

37. Benin (Nigeria). View of Benin City in 1891.

After military victories deep in the Yoruba area, Ewuare introduced Yoruba-style rectilinear houses made of packed earth, which are said to have replaced earlier raffia-pole constructions. A Dutch report of about 1600 describes the capital's plan as spacious and well laid out, with thirty 120-foot wide (36.5 m) avenues intersected by shorter narrow streets forming a grid. The houses, according to the report, were "washed and polished until they gleam," the bottom three feet (1 m) or so of each being painted a deep black.

The Benin Kingdom: Politics, Religion, and Natural Order 51

38. Benin (Nigeria). The pendant plaque shows a king with two attendants (most of the right-hand one now missing), late sixteenth century. Brass, height 15¼" (39.2 cm). Benin Museum Collection, Benin City, Nigeria.

In royal court compositions of this sort showing the king (here, perhaps Ewuare) flanked by two figures, the person on the right may represent an Osa priest, who specialized in mystical protections against military threat. He lived in the capital's ironworking quarter near the armaments workshops. The Osuan priest on the left occupied his own quarter to the south of the palace, where he helped to assuage various medical and birth problems.

denoting their importance to Ewuare and later Benin kings.

An extraordinary semicircular brass pendant (FIG. 38) was identified by the early twentieth-century Benin historian Chief Egharevba as representing King Ewuare. The possible association with Ewuare is an intriguing one (however tenuous) since the casting includes a mixture of Ife and Benin stylistic elements; the dot and lozenge skirts and the interlace design around the pendant's outer perimeter are simplified versions of forms which typify later Benin art. The main scene portrays a king flanked by two individuals. Although the figure on the right is missing, scholars today identify paired royal support figures of this sort as representing the court priests Osa (on the right) and Osuan (on the left). Both priests were court ritual experts created by King Ewuare to oversee the gods Uwen (Unwe) and his wife Ora, two deities said to have originally come from Ife with Oranmiyan. The close identity of the Osa and Osuan priests with war protection on one hand and healing on the other suggests that these and other similarly shaped works may have been identified with rites to safeguard the king and his supporters from harm. They may also allude to the king's divine authority and specifically to his power to manipulate the mysterious forces of the natural world.

The king flanked by two priests, chiefs, or subordinates was a common sight at coronations and other palace rituals and this tripartite form is prominent in royal architecture and sculpture. The grouping suggests both royal control and constriction, for the two subordinates can be seen not only to support the king but also symbolically to restrain him. The disproportionate height of the king beside the figures of flanking priests reflects the common Benin practice of employing greater size to indicate persons or objects of greater prestige and power.

In the plaque the king is shown with a medicine ball amulet or protective bead around his neck, suggesting Ewuare's reputation as a healer. The ram-headed mask on his hip may suggest Ewuare's descendance from Oranmiyan, the Yoruba founder of

The Benin Kingdom: Politics, Religion, and Natural Order

Benin's second dynasty, for ram heads were prominently displayed on the ancestral altars of elite foreigners (see FIG. 35). The staff in his right hand bears a disk-like terminus resembling neighboring Igbo and Ife-Tado staffs. They are generally associated with family succession in Benin, themes appropriate to Ewuare, whose long life and importance to the dynasty is emphasized in oral traditions. But they may also refer to Ewuare as the powerful military leader who conquered both Igbo and Yoruba centers.

SYMBOL OF *OBA* WITH *OSA* AND *OSUAN* PRIESTS

Directly beneath the ruler's feet two mudfish curve outward, prominent Benin symbols of transformation and power. Below this scene are alternating grasshoppers and frogs. In nature, these two species are not only nocturnal and noisy but also transcend physical boundaries by going through striking body changes in the course of maturation; among other things, earthbound young grasshoppers grow wings, while waterbound tadpoles acquire legs. The frog species shown here, with its long strong legs and generally slim body, probably represents a kind of tree frog (*hyla*) whose arboreal habitat again suggests transcendence of standard boundaries. Because the frog's reproductive cycle is linked closely to rain, this water denizen also may recall the changing seasons. Grasshoppers when swarming are associated with environmental change, bringing vast destruction to fields and ruining harvests.

Taken together, it is tempting to speculate that the grasshoppers and frogs beneath the king allude to natural order, transformation, boundary transition, and danger, all of which are critical to the ideology of Benin kingship. These two forms may also specifically refer to Ewuare, who is said in oral traditions to have been both a great magician (healer) and the creator of *osun*, a powerful nature spirit whose arts often display frogs and other transformational themes.

In many respects, the most unusual feature of this handsome and complex work is the pattern of vertical lines covering the king's face: they are closely identified with the ancient Yoruba capital of Ife. Early second-dynasty Benin kings, this casting suggests, may have had the markings of ancient Ife, the culture of Benin's second-dynasty founder Oranmiyan – an idea implicit in Chief Egharevba's identification of works with similar facial markings with Ewuare. Oral traditions stating that King Ewuare introduced distinctively Edo-form cicatrice (scarification) marks at Benin are interesting in this light, implying that Ewuare may have been the last Benin ruler to bear the Ife marks. Dated on stylistic grounds to the end of the sixteenth century, this pendant perhaps was commissioned by King Ehengbuda, a ruler who, like Ewuare, was recognized both as a powerful healer-magician

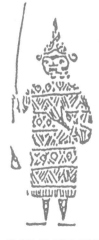

SYMBOL OF *OSUAN* PRIESTS

SYMBOL OF LEOPARD

39. Benin (Nigeria). Leopard vessel, late sixteenth century. Brass, height 12" (30.5 cm). British Museum, London.

Leopard aquamaniles have been identified with King Ewuare. Tradition maintained that one day as he was sleeping underneath a tree, a leopard lying on one of its upper branches dripped blood down on him. On waking, Ewuare killed the leopard and began a yearly tradition of sacrificing leopards to promote royal destiny. The danger and quickness of the leopard served as a potent metaphor for royal power, Benin kings often being referred to as "leopards of the house." Leopard teeth and pelts were given by Benin monarchs to important chiefs and military leaders under their command. Another leopard vessel displaying circled cross-form spots may be the work of a Benin brasscaster eponymously known as the "Master of the Circled Cross."

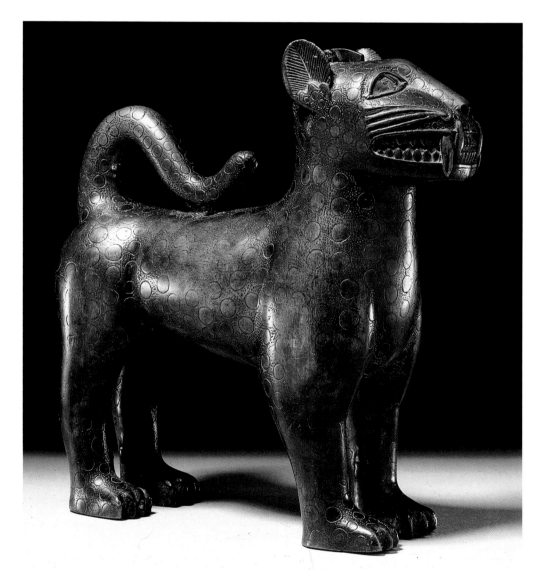

and as a great warrior, achieving parallel successes over both the Yoruba and the Igbo. Following these victories, Ehengbuda like Ewuare is said to have focused his attention on the creation of elaborate court rituals and displays of "supernatural" power.

The association of Ewuare with new ritual forms is evidenced in a pair of vessels in the form of leopards (FIG. 39) which are identified with this king, although probably made after his rule. Such vessels or aquamaniles were used at court for ritual washing. The linking of aquamaniles to Ewuare coincides with oral traditions that he acquired the first such vessels while visiting the palace of Olokun, the god of wealth and the sea, perhaps a reference to Ewuare's contact with European ships that had dropped anchor off the coast of Benin during this period. That the leopard aquamaniles made at Benin appear to be modeled in part on European aquamaniles reinforces this idea. Leopard vessels of this sort are said to have been a prominent feature of the palace altar dedicated to Ewuare. During the annual coral ceremony, all persons in the realm to whom a coral bead had been granted as a mark of allegiance were asked to return to the palace to sanctify them at the altar of King Ewuare. This rite, which was intended to renew Benin sacral and political bonds, also served to recall Ewuare's acquisition of the first beads from the sea god Olokun and through European trade.

The Benin Palace Complex and Bird Imagery

The most important edifice in the capital was the palace complex. A Dutch description of this palace in about 1600 published by de Marees offers some details of its appearance:

> The castle of the king is square. ... It is indeed so large as the city of Harlem, and is completely surrounded with a special wall. It is divided into many magnificent apartments, and has beautiful and long square galleries which are about as large as the Exchange in Amsterdam. ... Most royal apartments are covered with palm leaves ... and every gable is adorned with a turret, ending in a point. On it stands a bird, cast in copper, with extended wings, artistically made after a living model.

In addition to the extraordinary bird-ornamented turrets, this description conveys a sense of the palace's enormous size and striking beauty, which were compared favorably with architecture in the author's native Holland. According to period descriptions,

40. Benin (Nigeria). A royal procession in front of the palace, Benin City, illustrated in Olfert Dapper's *Naukeurige Beschrijvinge der Afrikaensche Gewesten*, 1668.

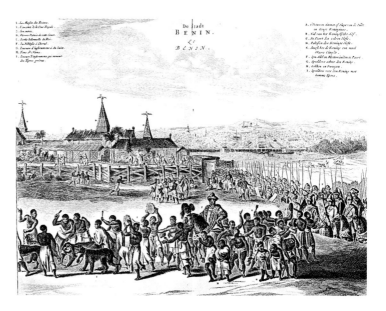

We see the Benin king in a leopard-skin cloak riding a horse on one of his rare public appearances. The ruler is preceded by leashed leopards, leopard handlers, and drummers. Walking beside him are a group of dwarfs (see FIG. 22), a lame man, and a hunchback, perhaps in their roles as court officials and ritual experts. Next come court musicians playing ivory horns, drums, and other instruments. Following them are armed nobles in leopard-skin tunics, some of whom ride horses, while those at the rear have just left the palace. These nobles are described by Dapper as "feudal lords;" probably, they represent Town Chiefs and Palace Chiefs, both of whom had increasing military power at this time. Shortly after the illustration was made, a devastating twenty-year civil war broke out between these two chiefly groups, the latter of whom was closely allied with the king.

the royal harem was housed in a separate quarter at a distance from the king's residence and was said in the eighteenth century to be surrounded by a 70-foot high (21 m) wall.

An engraving of the palace (FIG. 40) published in 1668 by a Dutch compiler of travel lore named Olfert Dapper provides additional details of its form and decoration. Dapper, who never

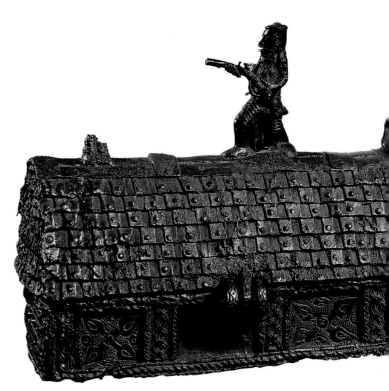

actually visited Benin, based both his descriptions and accompanying illustrations on the writings of those who had. The most striking aspect of this engraving is the palace complex itself, a massive structure that as shown here (and in a 1704 written description) included three main galleries. Although written accounts indicate that the palace was reconstructed and repositioned frequently over time, the number and general placement of the main galleries seem to have been relatively constant. Following the 1704 description, the three main palace galleries included an entrance hall (shown apparently here at the front right), the altar gallery (probably that in the center), and the king's audience hall and residence (positioned probably at the rear left).

The Dapper engraving shows us the enormous metal birds with outstretched wings which were once poised on the main turrets. A brass box representing one of the palace galleries (FIG. 41) suggests additional birds at the gallery ends. The identity of these birds is debated – the ibis, vulture, fishing eagle, white-tailed thrush, and pin-tailed whydah have been suggested. It is more likely that they are large hornbills (in particular, ground hornbills and black-casque hornbills), their massive beaks and broad wings closely resembling this species (FIG. 42), which shares important features with the local "bird of destiny."

41. Benin (Nigeria). The palace in the form of a box, seventeenth–eighteenth century. Brass, 12½ x 24" (32 x 61 cm). Museum für Völkerkunde, Berlin.

The dramatic positioning of hornbills on the palace roof may underscore the king's role as overseer of human destiny.

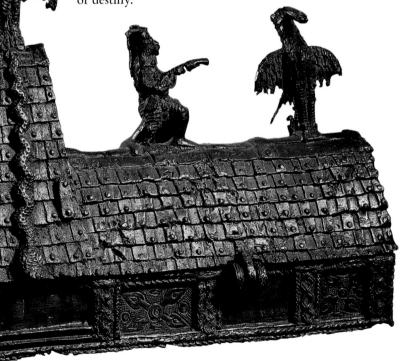

42. **Above** ground hornbill (Bucovus abyssinicus), drawing; **below** marabou stork (Leptoptilos crumeniferus, drawing.

Another large bird portrayed in Benin art, the marabou stork, a carrion-eating water bird with a wide wing span (see FIG. 42), also seems to be alluded to in the palace roof imagery. As an iconic pairing symbolizing oppositional values of well-being and danger, it is tempting to speculate that these birds reinforce the king's contradictory associations with promoting life on the one hand and bringing danger and death on the other. Similar zoological pairings distinguish Benin portrayals of mudfish, crocodiles, and snakes. Although these zoological identifications and their symbolic links necessarily are tentative, they also suggest that Benin artists were cognizant both of the physical attributes of related species and of their larger iconic meanings.

Behind the royal palace in the Dapper engraving we see a number of other buildings in the capital. In the middle rear, a Christian church is shown, twin crosses surmounting its turret. Just behind and to its right, the queen mother's palace at Uselu is indicated, and beside it, presumably, the turreted residence of the crown prince. Also to the rear of the palace it is possible that the buildings indicated are the houses of the first-dynasty *uzama* chiefs. Like the main palace complex, these residences are shown in this engraving to be distinguished by tall turrets, one of which (perhaps that of the Ezomo military leader) is ornamented with a bird. Large trees punctuate the scene: in Benin, mythic heroes – particularly "magicians" and healers – were said to be transformed into features of the landscape, including trees, these becoming a focus of religious worship.

Despite the many distinctively local Benin features in the Dapper engraving, the northern European identity of the artist is apparent in details such as the horse-drawn plow, the split-rail palace fence, the end-blown (rather than side-blown) ivory horns and the characteristic northern European "bird's-eye view" perspective. Costume features also may be in part Western inspired for, rather than wearing leopard skins as shown here, Benin kings and chiefs characteristically wore coral tunics and cloth wrappers. Town and Palace Chiefs for their part more recently have appeared in red flannel (an item of European trade said to have been introduced by Ewuare) or the skins of pangolins, the latter marking the chiefs' ability to oppose the king without harm.

Turret Pythons: Icons of Transition

In addition to birds, the palace once displayed giant brass serpents which zigzagged down its trapezoidal turrets (see FIG. 41). Descriptions of these snakes go back to the eighteenth century with

one 1778 source noting that the altar turret was ornamented by a beautiful 30-foot long (9 m) snake which "glide[s] the length of the [turret] to enter into the [king's] grave" below. As late as 1897 a metal snake decorated the audience hall roof of the palace when it was photographed during the British Punitive Expedition (see FIG. 15). The serpent peers down at the treasure trove of royal art and the group of British officers who had taken the king prisoner and appropriated the royal treasury, effectively ending the autonomy of this once wealthy kingdom. The timing of the Punitive Expedition – the annual New Yam festival which signaled the end of the Benin year – was both a sad and ironic one, for themes of death and renewal are key features of such rites.

The python images which dominate the palace roofs are referred to locally as *omwasomwa*, meaning "all people are not equal," in recognition of status difference in Benin. Stretching the length of the turret, these pythons also function as a visual link between earth and sky. In life, similarly, pythons not only swim and move readily on land, but also mount trees. From this latter position, they fall on their prey, suffocating them in their coils before swallowing them whole. With the turret python's mouth open, it no doubt gave the impression to those entering the palace that they too were being transported to another time and place. Their positioning over the royal tomb reinforced this idea.

The Benin palace serpent heads (see FIG. 5) appear to portray two distinct types of pythons, both of which show this species' distinctive upper and lower thornlike recurving teeth which in nature help to advance the python's prey into its mouth while swallowing. Several extant python heads have somewhat pointed shapes, angled eyes, and large disk-like spots suggesting the bright copper-colored ovoid spots which stand out against the dark brown or black skin of the royal or ball python. This relatively timid and non-aggressive python, which rarely exceeds four feet (1.5 m), appears to be that represented on two brass wall plaques (FIG. 43) portraying palace galleries. Other serpent heads found in Benin have somewhat rounded heads, straight eyes, and prominent scaling. In one case a chain-like pattern runs down the center of the head, suggesting the chain-like pattern of irregular marks of the rock or sebae python. The brass box palace (see FIG. 41) which appears to depict this python shows an actual chain in the analogous snake position on the opposite side of the turret. Rock pythons, which can reach thirty feet (9 m) in length, are decidedly aggressive and are known to kill and consume large mammals, including antelopes, leopards, and sometimes humans. Like the sky-spanning and wealth-bearing rainbow (*ikpin ama,*

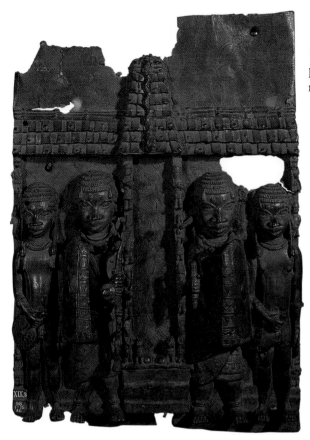

"rain python") which was said in Benin to swallow up and kill unwary humans, the iconically paired royal and rock pythons on the palace turrets may thus represent the king's opposing qualities of well-being and danger.

Pillars of Brass: History and Ceremony in the Palace Plaques

Olfert Dapper, in addition to his famous illustration of the Benin capital, provides us with a description of the striking brass bas relief plaques which once decorated key palace compounds. The pillars were covered "from top to bottom ... with cast copper, on which are engraved the pictures of their war exploits and battles." Late nineteenth-century accounts suggest that the rafters and doors also bore carvings and figurated brass sheeting. One of the cast plaques (see FIG. 43) appears to represent the central palace altar gallery with its sculpture-decorated pillars. Two eighteenth-century accounts of the altar gallery pillars as bearing images of "merchants, soldiers, wild beast hunters" (1704) and "great men in their ceremonial dress when attending the king's council" (1778) are consistent with this image. The prominent placement of "thunderstones" in the middle of the altar coincides with their iconic importance in royal ancestral altars. Two shield-carrying religious chiefs stand in front of the altar compound, flanking the paired stones. Beside them are two fan-carrying pages, naked because pages purportedly received their first clothing only after the king had given them permission to marry and leave his service.

The palace altar gallery, this plaque indicates, incorporated a multi-stepped rectangular platform with a raised center. In the open space above the altar, the plaque shows a swirling flame pattern, suggesting perhaps the altar's potent, religiously charged air. Since both the stone axes and the adjacent leopard aquamaniles are associated with King Ewuare, this plaque may represent the altar of that famous king.

Another plaque (FIG. 44) shows one of the many ceremonies which marked the Benin ritual year. Two agile men swing from ropes attached to the upper branches of a tree. They are participants in the annual Isiokuo festival. During this rite, which was the last ceremony before the annual New Yam festival, acrobats performed a flight-resembling dance while suspended from a tree near the palace. Dedicated to Ogun, the god of war and iron, this festival has been described as a ritual "war against the sky." The sacred importance of this "war" is clarified by the probable identity of the birds on top of the trees as marabou storks, their carrion-eating habits identifying them with malevolence. On the palace box (see FIG. 41), the highly unusual inclusion of two warriors astride the palace roof, their rifles aimed at the birds, may suggest a similar scene of ritual combat. That these two warriors appear to represent Portuguese is of further interest, for these foreigners had important liminal (transitional) status in Benin as persons associated with the watery land of the dead. The marabou's ability to move between the realms of sky and water in turn finds parallels in the symbolic identity of the palace and the royal capital as a cosmological meeting place of sky, earth, and water.

The background decoration of this and other plaques (see FIG. 43) contributes to its meaning. The incised leaf pattern – a common feature of plaques dated to Benin's middle to late period (about 1650–1750) – is said to represent a river plant (ebe-ame) with healing properties and connections to the sea god Olokun. Since the Edo word for leaf also refers to book and paper, Benin artists may have been suggesting links between their plaques and European books as comparable sources of historical, social, and ritual information. Interestingly, the first brass plaques are said to have been introduced during the reign of the early sixteenth-century king Esigie, who not only acquired substantial brass from European trading vessels but could also read and speak Portuguese. It is likely that local earthen wall reliefs also served as models for the brass plaques as similar reliefs are found both on temples and elite residences.

While metal wall plaque production at Benin is said to have come to an end during the reign of King Ahenzae, a mid-seventeenth-century ruler who was so poor that he could not purchase the necessary brass, the style of the regalia depicted in the plaques indicate that such works were manufactured through the mid-eighteenth century. Plaques from the middle to late phases of this production (see FIGS 43 and 44) show relatively high-relief casting and compositions filled with energetic, somewhat

Opposite
43. Benin (Nigeria). A plaque with a python turret and four figures, sixteenth–seventeenth century. Brass, height 17¾" (45 cm). British Museum, London.

The plaque depicts a palace altar compound, perhaps that dedicated to King Ewuare. Pythons are identified with Olokun, god of wealth and the sea. They also appear to be linked to Ogiwu (or Ogiuwu or Otiwu), the Benin god of lightning, death, and swift punishment, whose control of human blood and the sap of trees could also bring ill-health, sterility, and crop failure. Not only does the python's zigzag form evoke Ogiwu's lightning, but "thunderstones" (stone axes) are positioned on the royal altar beneath the snake's mouth, suggesting that the stones were left there by Ogiuwu's lightning. During Ewuare's reign, Ogiwu purportedly vexed the area, and Ewuare is credited with using a powerful medicine to break the "thunderstones" into tiny pieces. Since the metal birds and serpents decorating the palace served in part as lightning rods, frequent palace lightning strikes may have emphasized the links between Benin royalty and this dangerous celestial power.

44. Benin (Nigeria). A wall plaque with marabou storks and acrobats, seventeenth–eighteenth century. Brass, height 16¾" (43 cm). National Museum of Nigeria, Lagos.

An enormous tree is surmounted by three large birds, probably marabou storks. The carrion-eating marabou's long, massive, powerful beak, distinctive dangling air-filled breast pouches, tall, thin, and smooth wading legs, and broad wings are prominently indicated (see FIG. 42). With their often bloody, bald heads and habit of nesting in colonies on stick platforms at the summits of trees, these birds may have carried associations with sorcery, as perhaps also did their guttural croak, clacking beak, and alternately erect and hunched appearance. Here, as in other portrayals, the marabou's wings are shown extended with angled elbows, a position frequently assumed by this bird while flying in search of food.

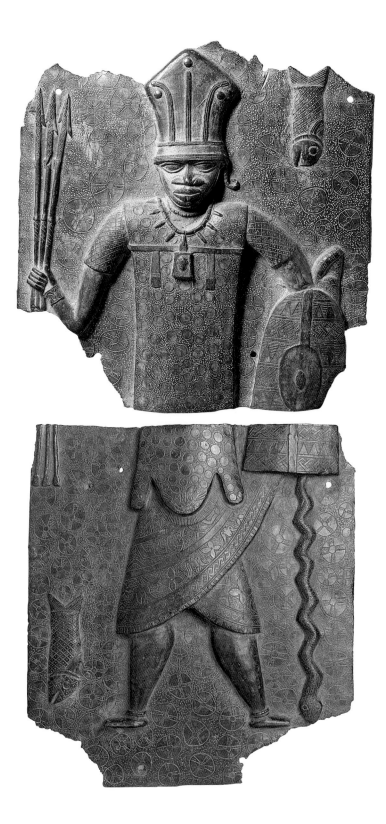

45. Benin (Nigeria). A warrior on a pair of brass plaques, probably late sixteenth century. Total height 30½″ (77.5 cm). Upper part: Museum für Völkerkunde, Berlin; lower part: Hamburgisches Museum für Völkerkunde, Hamburg.

The plaques are attributed to the "Master of the Circled Cross" because of the characteristic background motif and the artist's preference for relatively flat relief casting, uncrowded scenes, and monumental figures which tend to be tall, lanky, fully frontal, and wear relatively simple regalia.

SYMBOL OF A WARRIOR

compact figures in rich attire and a range of views – frontal, three-quarter, and profile. These features coincide with a period of both considerable European trade (hence greater quantities of brass) and increased court hierarchy, in which rulers and their courts sought to define their power through complex regalia and ceremonials. Because the metal plaques had been taken down from the palace long before their appropriation by the British Punitive Expedition in 1897, their context is now lost, but at that time they served as an archive that was consulted for rituals and regalia.

One of the few extant examples of early plaque production (FIG. 45) shows a Benin military chief in a leopard-skin tunic. He wears a royal coral choker, leopard-claw collar, and a decorative leopard chest panel. These leopard accoutrements signify not only the ferocity of this military leader and the authority granted to him by the king to take human life, but also the protective power which leopards offer to those associated with the court. A bell, spears, headdress, and shield complete the attire. The bell, worn here as a pectoral, incorporates a miniature Benin head. An icon of royal authority, its form recalls those on the royal altar. Pendant bells of this sort were worn in battle to frighten the enemy, to promote protection from the powerful ancestors, and to ring out a victory. Because sound travels broadly, these bells also evoke the permeating presence of the king.

New forms of palace decoration have been introduced in the twentieth century. King Akenzua II (see FIG. 32), seeking to revitalize arts in Benin, commissioned the artist Ovia Idah to decorate the palace facade with an elaborate composition of clay and cement reliefs showing figures from Benin history. As head of the Arts and Crafts School in Benin City, Idah encouraged other artists in both traditional and European techniques and helped them to find new patrons and audiences in the post-court era of the mid-twentieth century.

Sixteenth-Century Ritual Gongs and the Art of Body Masking

An extraordinary sixteenth-century ivory sistrum or double gong (FIG. 46) showing the king grasping crocodiles offers insights into Benin ideas of royal power and ritual authority. Other double gongs in iron (see FIG. 17) figure as rulership icons in many African royal contexts. The crocodiles held aloft by the king not only are dangerous but also are said to serve as Olokun's messengers and as signifiers of chiefs coming into this world from the land of the ancestors. The placement of these crocodiles has been

SYMBOL OF A CROCODILE

interpreted as pulling the king across the ocean from the spirit world. The Benin king's links to Ogiwu may also be relevant here, for crocodiles are said in one early source to personify thunder, Ogiwu's dangerous complement. As with the royal birds and pythons, two crocodile sub-species are recognized in Benin – one short-muzzled and relatively benevolent, the other long-muzzled, bigger bodied, and more aggressive. Like the royal birds and pythons, these reptiles appear to portray opposing aspects of the king.

The king's supernatural power is underscored by the trans-formation of his legs into mudfish, a reference to Olokun and the early fifteenth-century king Oba Ohen, who became crip-pled. In addition, mudfish are identified variously with both beneficence and danger, symbolizing well-being because of their abundant flesh but also danger because of their fatal spines and ability to deliver electric shocks (the latter perhaps linking the fish via the god of lightning, Ogiwu, to the king). Indeed, tradition holds that whenever the ruler's feet touch the ground, disaster is certain to follow. Like the king, the mudfish was con-sidered to be a "master of mysteries," able to metamorphose and transcend natural and spiritual boundaries by its functional lungs and ability to estivate, that is, repose as though dead in dried-up streams, seemingly coming back to life with the new rains.

Other symbols from nature linked to transformation are por-trayed on the sistrum: giant sea turtles, seen at the sides and bot-tom, come ashore to lay their eggs. Between the turtles and the king is a bird-like creature with a prominent beak and talons whose wings are transformed into snakes. Long a subject of debate, this snake-winged bird may in part represent a type of nightjar, the males of which grow long streamer feathers from the middle of each wing during the breeding season (FIG. 47). These striking and unusual feathers convey an impression of snakes in the air as the male cir-cles above the female during display. The head crest shown on this particular sistrum bird distinguishes the equally spectacular par-adise flycatcher (see FIG. 47), the male of which bears elongated ser-pent-like tail feathers in its fourth or fifth year. These unusual birds together appear to be associated not only with royalty and status difference, but also with transition and transformation.

Other icons of transformation such as the two crocodiles' mouths turned into hands or the king's phallus transformed into a fist also appear in double gongs in brass that were used in court rituals: offerings are said to have been placed in the gong-shaped metal cups, recalling the vessel-holding figures on both sides of the ivory sistrum rim.

46. Benin (Nigeria). Double gong or sistrum, probably sixteenth century. Ivory, height 14¼" (36 cm). British Museum, London.

The gong may have been rhythmically tapped during Emobo rites when the king used his mystical powers to drive away evil.

The Benin Kingdom: Politics, Religion, and Natural Order 65

Royal History and Ritual in the Reign of Esigie

Another important work in ivory is a mask (FIG. 48) dating to the early sixteenth century and the reign of King Esigie. In the mask's crown are a series of Portuguese heads alluding in part to the help the Portuguese gave Esigie in his critical victory over the Igala people in the north who according to Benin tradition attacked the kingdom threatening its very existence. In a related mask, these heads alternate with figures of mudfish. Like the mudfish's ability to be "reborn" after estivating, the Portuguese were thought to have come from the watery world of the dead bringing with them wealth and luxury items. The extraordinary ability of mudfish to both swim and move ("walk") on land, also finds parallels in the equal ability of the Portuguese to travel on land and sea. Cast or carved images of Portuguese travelers also appear prominently in other Benin arts carrying a range of European trade objects, including rifles (see FIG. 41) and the brass bracelet manillas that were melted down by Benin artists to make plaques and other brass objects. Some Portuguese are shown holding books, presumably recalling those used in early missionary activities.

Themes of shared familiarity and strangeness are displayed in complementary Benin portrait masks, which were worn as pectorals (FIG. 49) by local and foreign chiefs. The latter included the Igala (Idah), Ishan, Igbo, and Yoruba rulers who were brought into the Benin hegemony during the reign of Esigie and other warrior kings in the fifteenth and sixteenth centuries. As with the faces that decorate the pectoral bells worn by Benin military officers (see FIG. 45), this and other chiefly face masks reinforce ideas of royal watchfulness.

As with the face mask worn by the king of Igala, a brass ideophone (*ahianmwen-oro*) surmounted by a bird (FIG. 50) is closely identified with Esigie's early defeat of the Igala kingdom. The bird is said to be the "bird of prophecy" whose portentous cry prompted Esigie to halt his campaign against the Igala. When Esigie pressed forward and was victorious, he had the ill-boding bird killed. In some ideophones the beak is shown clasping a small pebble-shaped object, identified as the *awase* amulet used when cursing and blessing.

Esigie's reign has been linked by scholars to a group of unusual cross-wearing and "axe"-wielding brass figures with unique "cat whisker" scarifications at the corners of their mouths (FIG. 51), although they are assumed to date to the late sixteenth through seventeenth centuries. These works have been interpreted variously

47. **Above** Standard-winged nightjar; **Below** Paradise flycatcher.

48. Benin (Nigeria). Ivory mask, c. 1520. Height 9¾" (25 cm). British Museum, London.

The mask is believed to represent King Esigie's mother Idia, who helped to end a civil war at the beginning of Esigie's reign. It is said to have been worn on Esigie's hip to commemorate Idia during the royal memorial ceremonies.

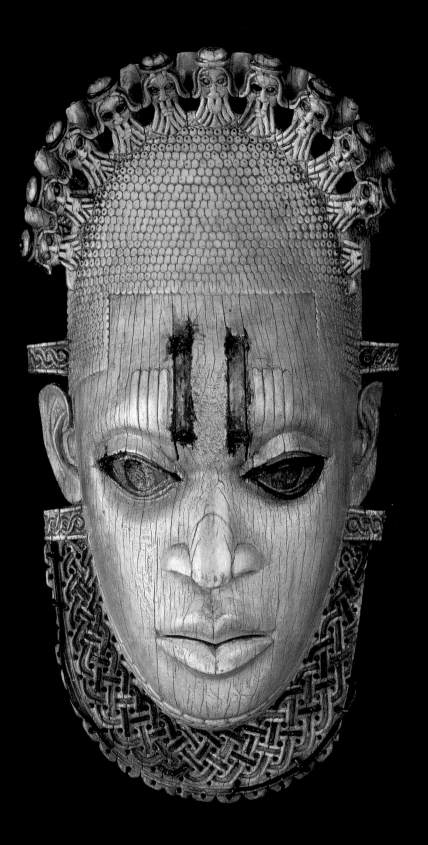

as cross-wearing palace officials introduced by Esigie to wake the king each morning; or, messengers from Ife who came to Benin to confirm Esigie as well as later second-dynasty rulers – the pectoral cross referring to Benin's second-dynasty founder, the Ife prince Oranmiyan; or, "axe"-bearing iron workers linked to Esigie because of his support of the smithing arts; or, priests of the Benin creative god Osanobua, whose worship increased during Esigie's reign.

Another possible interpretation clarifies these disparate ideas – that the figures represent Osa priests during the annual New Yam festival, which, as we have noted, was created by Esigie and took place each year in October–November following the yam harvest. The first part of the ceremony consisted of a seven-day fast in which Benin residents were obliged to remain indoors. Then the new yams were offered to promote the fertility of Benin farms and families. Because this was the last rite of the ceremonial year, it marked the transition from one year to the next. During the initial fast, cross-bearing Osa priests are said to have threatened anyone venturing outside with metal axe-form implements recalling that held by the figure. Similar iron hammers were displayed at the king's coronation (hence the link to Ife) and were carried by Osa priests when announcing decrees.

The Royal Altar: The Art of Dynastic Display

As with many other types of royal Benin art, the cross-bearing figures appear to have been once a prominent part of the royal altar. Each Benin ruler was identified with his own commemorative altar compound (see FIG. 43). In 1897, there were about fifteen royal tomb altars in the palace, each identified with a different king, although only two or three were considered principal places of worship. The earthen walls of the palace altar gallery (like those of other important Edo buildings) featured raised horizontal lines, the number being regulated by rank (see FIG. 52). Running along the base of the altar wall we see a carved panel showing offerings to the royal dead, among these harnessed cows ready for sacrifice. At the bottom are depictions of mudfish and Ofoe, a messenger of the death god Ogiwu. Ofoe's head is portrayed in the middle of his body; hands and feet issue directly from it. Ofoe images sometimes were sent by the king as a death warning to individuals who committed infractions; Ofoe's presence on this altar panel probably coincides with the tradition that people condemned to death for capital offenses were brought to the palace.

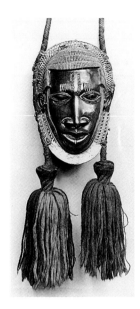

49. Benin (Nigeria). A royal portrait mask, late fifteenth or early sixteenth century. Bronze, height 11½" (29 cm). Collection of King of Igala.

This pectoral mask is owned by the current Attah of Igala, a northern ruler whose ancestor was defeated by the Benin king Esigie and his mother Idia. Masks such as this one were given to foreign rulers throughout a large area of southern Nigeria who came to be associated with the Benin monarchy.

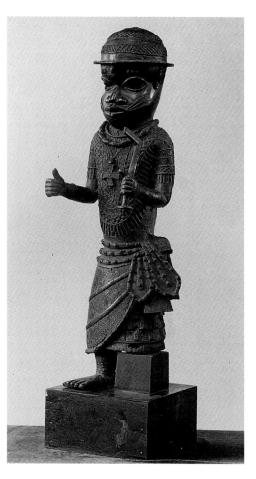

Left 50. Benin (Nigeria). An ideophone representing a royal "bird of prophecy," seventeenth–eighteenth century. Brass, height 4'3" (1.3 m). Museum für Völkerkunde, Vienna.

The bird's enormous beak, neck wattles, scaly legs, sloping wing shape, and uneven contour feathers identify it as a large ground hornbill (see FIGS 41 and 42). Benin traditions of tapping the beak during the rite of Ugie Oro may recall the extraordinary strength of the hornbill's beak. The bird's clamorous non-stop nasal cry (*oum oum*) coincides with the local interpretation of this "bird of prophecy"'s danger signal, *oya o oya.*

Above right 51. Benin (Nigeria). Altar figure holding an axe, seventeenth–eighteenth century. Brass, height 25" (63.5 cm). University of Pennsylvania Museum, Philadelphia.

Osa priests and other participants in the New Yam festival carried "axes" and wore large crosses around their necks or on their cloth wrappers. The cross traditionally symbolizes the cosmos and temporal transition in Benin, but may also here be linked to Christianity, as the Osa cult and priesthood is known to have adopted certain Christian motifs and practices. The first Christian churches in Benin are said to have been built in Esigie's reign.

The Benin Kingdom: Politics, Religion, and Natural Order

Today only one altar compound remains at the palace. It includes both a traditional rectangular altar collectively commemorating the kings of preceding reigns and a number of semicircular altar platforms dedicated to twentieth-century rulers. Serving as a backdrop for the main court religious ceremonies, oath-taking rites, and judicial procedures, the altars historically were positioned at the back of a field large enough to hold several thousand spectators. When viewed during the various royal ceremonies, these altar arts served both to reinforce the prestige of the royal office and to underscore the accomplishments of Benin's various kings.

Positioned at the very center of the royal altar was a multifigured tableau showing the ruler and accompanying retinue. In the middle of this work is an empty open area where offerings of kola nuts and other goods were given to the deceased king. Altarpieces of this sort were placed directly above what was once the tomb of the ruler. In the altarpiece dedicated to King Ovonramwen (r. 1888–97; FIG. 52), the figure's right hand holds an *eben*, a leaf scepter which is said to symbolize life, peace, and chieftaincy. In his left he carries a double gong scepter with extending blades. Known as *isevbere-igho*, this scepter recalls in its form ivory sistra (see FIG. 46) and is said to enhance royal oaths. It

is carried by the king's doctors during the coronation. In the larger altarpiece, as in many other royal sculptures, right and left hands signify opposing values of life and death.

A quite different scene is shown in the altarpiece of King Ewuakpe II (r. c. 1690–1713; FIG. 53), a ruler who played an important role in the critical middle period of Benin history. Coming to power during one of Benin's devastating civil wars, Ewuakpe has been described as a gentle if somewhat melancholy person, a good husband, and a devoted son. In the period following his mother's death, Ewuakpe requested extensive sacrifices which precipitated a revolt of local chiefs. They refused Ewuakpe key materials and entered the palace and assumed control of the royal property. Devoid of political and material support, Ewuakpe was reduced to manual labor, living meagerly in his mother's village. After his only remaining wife, Iden, killed herself as an offering to the gods, Ewuakpe made an agreement with the chiefs. They were granted the right to keep their family inheritances and key royal prerogatives were returned to the king. To avoid future civil wars over competition for the throne, the king was given the right to name his eldest son as successor.

The staff held by Ewuakpe in this altarpiece represents a type of art that was otherwise positioned along the back of royal altars (FIG. 54 and see FIG. 52). These ukhurhe staffs are made of brass, wood, or ivory, and are essential items for the establishment of ancestral altars and for consecration rites during palace ceremonies. Some palace staffs incorporate royal portraits and may have served as maces in court judicial proceedings. One of the most extraordinary of these (FIG. 54) represents King Akenzua I (r. c. 1715–35), the son of Ewuakpe. Key motifs of this staff refer specifically to Akenzua I's reign, a period marked initially by civil war as the laws of primogeniture put into play by Ewuakpe were disregarded by key princes supported by the town chiefs. In the end, Akenzua I prevailed, and this portrait mace celebrates that success. He is shown in his royal coral tunic and crown, surmounting (and standing victorious over) an elephant, an animal which represents the town chiefs, since their leader came from the village of royal elephant hunters. The king holds a royal oath-enhancing stone axe in his left hand and a miniature version of a royal portrait staff in his right.

Art in the Reign of Eresonyen

Once the civil wars which plagued Akenzua I's early reign came to an end, renewed European trade made Akenzua I and his

52. Benin (Nigeria). The palace altar to King Ovonramwen (r. 1888–97).

As part of the coronation rituals, each new Benin king established an altar to his father and commissioned a range of arts to decorate it. The new king then poured the first crucible of metal for the casting of related works. These new (and in some cases antique) altar arts were intended not only to honor the late king, but also to serve as a locus for ancestral contact, with the new king becoming the principal priest and intercessor for his late father. Beside the neolithic stone axes at the front and center of the altar, brass heads and bells were positioned along the altar's sides. Rung throughout royal ceremonies, the bells' continuous sound symbolized continuing spiritual presence.

Ivory tusks were inserted into the open crowns of the late Benin heads and display religious, political, and historical subjects, their meanings in some cases shifting over time. The most important motifs were positioned in the center, reading from bottom to top. The tusks' identity with elephants reinforces ideas of physical power and wealth.

53. Benin (Nigeria). An altarpiece representing King
Ewuakpe (r. c. 1690–1713), mid-nineteenth century? Bronze,
height 23″ (58 cm). Museum für Völkerkunde, Berlin.

Ewuakpe is seen in simple, even humble, attire consisting
of a shortened coral collar, two simple strands of chest
beads, a European-style rounded hat, and a cloth
wrapper. Such attire is spartan compared to that of
other altarpiece portraits (see FIG. 52), which
generally include a thick body-covering coral tunic,
an X-form coral chest harness, and a tall *ede* coral
crown. Other motifs, particularly those on
Ewuakpe's textile wrapper, suggest the
well-being that his reign eventually
came to represent – a cross (referring to
cosmological order), a crescent moon
(symbol of joy and coolness), an *eben*
ceremonial sword (symbol of chiefly
rank and peace), and a Portuguese
head (referring to European trade).
Hieratic display in this and other
altarpieces is noteworthy: in the same
way that the king is the tallest figure in
the grouping, his head is proportionately
larger than his body, taking up roughly a
third of the whole.

Ewuakpe carries in his left hand (the
hand of danger) a stone axe, sign of swift
punishment and the potency of Ogiwu,
god of death. When held blade up, as
here, the stone is believed to intensify
royal curses and blessings. The yam-
pounding *ukhurhe* staff held in
Ewuakpe's right hand, in contrast,
was employed both to annul
curses and to resolve conflict. The
king is flanked by two naked,
emaciated attendants with half-
shaved heads. A man stands
on the right, a woman on the left. The female holding a
rectangular mirrored object to deflect danger is said to
represent the female ritual expert Ekpte, who carries this
form in palace ceremonies. A fly whisk, an important
emblem of eldership, is draped over the shoulder of the
male. Both figures have three vertical marks beneath the
eyes, perhaps identifying them as Yoruba. Their emaciation
and heavily wrinkled brows have led to the suggestion that
they may have been originally slaves, an idea in keeping
both with Ewuakpe's poverty and with his eventual use of
slaves to run the palace. It was largely as a result of these
slaves that Ewuakpe is said to have regained wealth and
power in his later life.

54. Benin (Nigeria). A royal *ukhurhe* rattle staff, c. 1735–50. Copper alloy, full height 5'4" (1.63 m). The Metropolitan Museum of Art, New York.

The staff is believed to have been created in honor of Akenzua I (r. c. 1715–35) during the reign of his son, King Eresonyen (r. c. 1735–50), as part of the ceremonies to set up the late king's tomb altar.

It is fitted with an internal clapper, which is sounded during prayers to call the attention of key deities or ancestors and to underscore related blessings and curses.

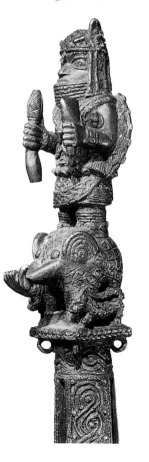

55. Benin (Nigeria). An altar to the hand (*ikegobo*), eighteenth century. Brass, height 18" (45.7 cm). British Museum, London.

Altars to the hand are said to have been introduced by the mid-fifteenth century military king, Ewuare. This altar however, appears to be associated with the powerful eighteenth-century ruler Eresonyen and commemorates his military success. A cross-wearing and axe-carrying figure on the back (see FIG. 51) may refer to Eresonyen's role in the creation of the Agwe New Yam festival.

At the top of Eresonyen's altar to the hand stands a king at once flanked and supported by two figures who in similar scenes are generally identified as the priests Osa and Osuan. These figures are shown without royal crowns recalling Ewuakpe's edict that only the king and his eldest son could wear the crowns. Two leopards and a stone axe are positioned in front of them in a manner suggesting a royal altar.

The Benin Kingdom: Politics, Religion, and Natural Order 73

56. Benin (Nigeria). The throne of King Eresonyen, mid-eighteenth century. Brass, 15¾ x 16" (40 x 40.5 cm). Museum für Völkerkunde, Berlin.

In this throne, a python both separates and spans the upper and lower sections complementing the pythons on the palace turrets. The tight knot of the python recalls the position assumed by the Royal Python when protecting itself against attackers; as such it suggests royal omnipotence over the natural world.

successor Eresonyen (r. c. 1735–50) two of the wealthiest kings in Benin history. Eresonyen is said to have used his wealth in part to commission a new palace, purportedly covering its walls and floors with cowries (local currency). Heavy brass altars to the hand (*ikegobo*; FIG. 55) are also an important reflection of his wealth. Cast brass *ikegobo* were created for the king, queen mother, and royal war chief (*Ezomo*). While originally linked to success in war, these altars came to be identified with a variety of other achievements in fields as varied as art, medicine, agriculture, commerce, and politics where accomplishment was largely defined by individual achievement.

Eresonyen's throne (FIG. 56) is a work of particular beauty. Purportedly modeled after a throne made by the Portuguese for his ancestor King Esigie two centuries earlier, its symbolism recalls distinctive features of Eresonyen's own reign as well as Benin kingly powers more generally. Thrones of this type, called *ekete*, are said to have been first introduced in Benin at the beginning of the fourteenth century, when Oranmiyan replaced the rectilinear thrones of the earlier Ogiso dynasty with a circular model. *Ekete* thrones are generally kept near the royal altar and because of their sanctity are covered with a white cloth.

Two crocodiles and mudfish are shown on one surface of this reversible throne, images related to

57. Benin (Nigeria). A helmet mask (*ododua*), probably mid-eighteenth century. Brass, height 22" (56 cm). British Museum, London.

The mask may represent an Osa priest and/or an affiliated god, Uwen, who accompanied Oranmiyan from Ife to serve as his health specialist. The tall headdress recalls both the palace turret and the *ede* crown which Oranmiyan is said to have brought to Benin from Ife.

water; cosmological signs (sun, moon), weapons, and smithing tools are on the opposite side (here hidden from view), recalling forces of the earth and sky. Shown in higher relief on the intermediary surfaces are complementary forms – a bound pangolin, a tree frog, two fish (perhaps bichir), and a skull; opposite these (and not visible) are tree frogs, chimpanzee heads, and elephant trunks. Taken together, these motifs suggest the king's control of the cosmos in all of its dimensions and complexities.

During Eresonyen's reign a new royal masquerade known as *ododua* was introduced as part of an auxiliary New Yam festival which Eresonyen oversaw. *Ododua* maskers wearing awesome brass masks (FIG. 57) and carrying crosses and axe-shaped staffs (see FIG. 51) performed in rites to honor the royal dead. Marking a crossroads in the year, *ododua* masks sometimes display crosses on the chin or cheeks. As with several other art works associated with Eresonyen's rule, these masks incorporate important Yoruba references perhaps to recall Eresonyen's military successes over that culture. The name of the mask, *ododua*, for example, refers both to the Yoruba earth god and to the purported founder of the ancient Yoruba capital of Ife.

Ododua masks had political meanings, for Eresonyen is said to have outlawed the local village-based Ovia society in order to replace it with an association more closely tied to royal interests. Royal symbolism figures prominently in *ododua* masks in part for this reason. Whereas the rural (and to some degree counter-royal) Ovia and affiliated Ekpo masks (FIG. 58) were largely made from local materials such as wood and straw, *ododua* masks use precious brass. Striking features of the *ododua* mask, said to personify a mythic healer or spirit of health, are the crocodiles and serpents that crawl across the chin and cheeks, creating a terrifying image that is emphasized by the mask's taut, drawn-back lips and clenched teeth. This grim image suggesting the facial paralysis of fatal snake bites (among other causes) affords us a striking image not only of ill-health and the power of the king over life and death (and his ties to Ogiwu, the deity of mortality and affliction), but also the importance of cosmological transformation linked to the year's end and beginning.

Similar features are found in Benin *osun* "spirit head" altars (FIG. 59), whose imagery expresses the king's powers of spiritual transformation and ability to harness the power and life force of the forest for the benefit of his people; in associated ceremonies potent medicines from the forest are applied to the king's body as a means of controlling the forces of nature. In keeping with this idea, the eyebrows of the *osun* head take the unusual shape of

The Benin Kingdom: Politics, Religion, and Natural Order **75**

58. Benin (Nigeria). Ekpo masquerades at the king's palace, Benin City, 1979.

59. Benin (Nigeria). A royal *osun* "spirit head," early eighteenth century. Brass, height 10½" (27 cm). British Museum, London.

Spiritual transformation is suggested by the snakes or other reptiles emerging from the nostrils, ears, and eyes. Portrayals of royal herbalists display comparable features, such as vines growing from the mouth or serpents emerging from the head. Snakes issuing from facial orifices are said to signify curses.

leaves, suggesting the medicinal properties of plants. Knots may refer to the permanence and force of the spirit world, while stone axes denote Ogiwu as deity of death, disease and lightning. Such stones were kept in *osun* shrines, and offerings to Ogiwu were made to counter epidemics such as influenza or smallpox.

The relationships of royalty, cosmological order, and the natural world are underscored in these magnificent Benin royal art and architectural forms. Their materials of brass, iron, coral, terracotta, and wood reveal differences of status and ritual functioning. Benin arts also encode the complex symbolic links between certain animal species – birds, snakes, reptiles, and fish, most importantly – and royal power. Court ritual and religious arts play a central role in the construction of royal identity, revealing the complex links between Benin political dynamics, history, and world view.

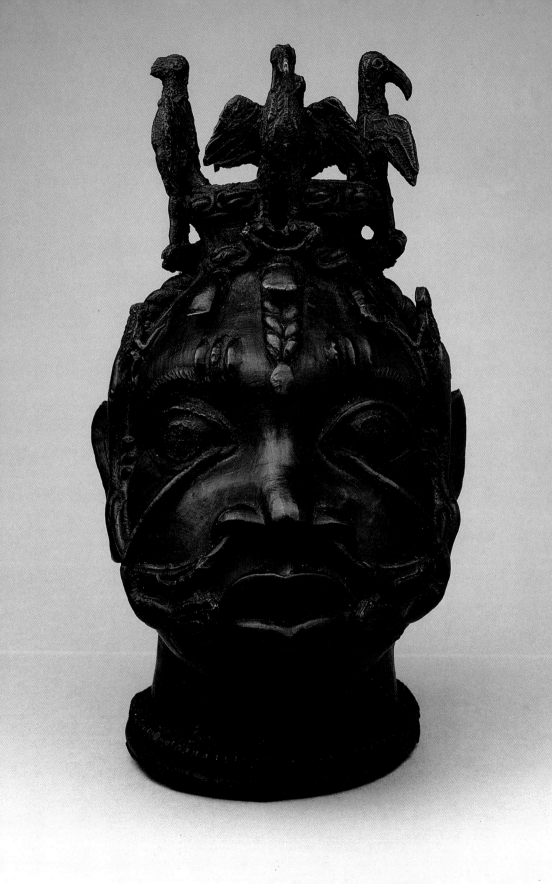

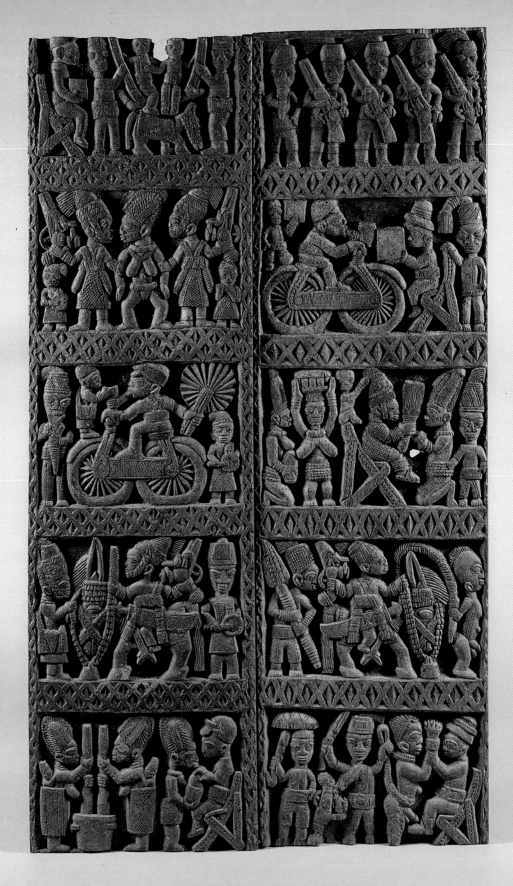

TWO

Yoruba and Dahomey: Divine Authority and the Arts of Royal History

More than eleven million Yoruba live in southwestern Nigeria and the neighboring Benin Republic (formerly Dahomey), an area historically ruled by kings whose authority was legitimized by the sacred ruler of Ife, the Yoruba holy city where, according to myth, the world was first created. Archeological evidence at Ife indicates that by the twelfth century this city was a flourishing artistic and political center. The nearby Dahomey (Danhomè) Kingdom of the Fon people, west of Nigeria, which came into prominence in the late seventeenth century, had frequent, often clashing contact with its Yoruba neighbors. While these two kingdoms share important cultural and artistic forms, there are striking differences. In this chapter we shall look first at Yoruba royal arts, examining themes of ritual authority, then at Fon (Dahomey) royal traditions and the impact of history on changing visual forms, in each case through the arts of powerful rulers.

60. Yoruba (Nigeria). A palace door panel from Osi-Ilorin by Arowogun (1880–1954), early twentieth century. Wood, height 5′11½″ (1.82 m). Fowler Museum of Cultural History, University of California, Los Angeles (see FIG. 67).

Yoruba Beadworking Arts: Dressing the King

Yoruba kings (or *oba*; see FIG. 1) when dressed for important ceremonies in royal beaded regalia convey an image of majesty, power, wealth, and beauty. Tradition maintained that originally there were sixteen sacred crowns, each identified with one of

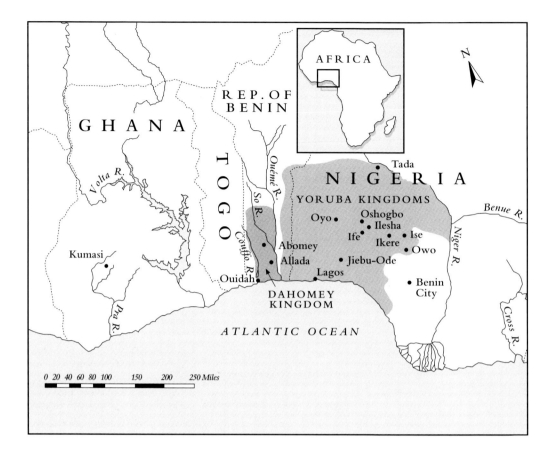

the original city states that traced its heritage back to Ife. Other rulers politically linked to the Yoruba sometimes also wore crowns of this type (FIG. 61). The tall conical shapes of the royal beaded crowns give visual prominence to the head, in accordance with the central place of the head in Yoruba ideas of destiny (*ori*), spiritual power (*ase*), character (*iwa*), and beauty (*ewa*).

In the late nineteenth and early twentieth century, when Yoruba royal authority was much diminished as a result of the growing Western colonial presence, the number of Yoruba rulers who wore beaded crowns increased considerably, along with the amount and complexity of related beaded attire. This development closely coincided with a general loss of traditional authority. Today the royal beaded regalia includes not only crowns and scepters, but also gowns, leggings, boots (see FIG. 1), and the large cushions on which the ruler could elevate his feet while sitting. Beadwork of this sort was made by a specialized guild of itinerant artists who worked under royal and priestly patronage over much of the Yoruba area.

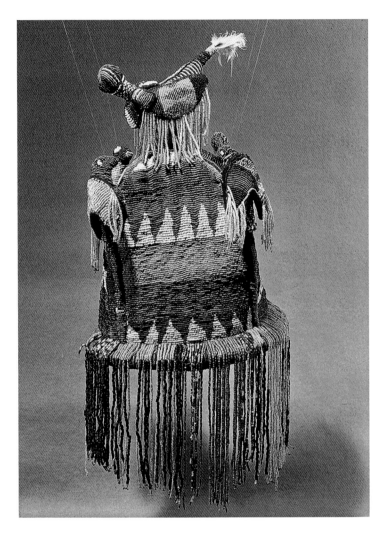

61. Dahomey (Republic of Benin). Yoruba-style beaded crown, nineteenth century. Beads and mixed media, height 17¾" (45 cm). Musée de l'Homme, Paris.

This beaded crown, which is said to have once belonged to Dahomey king Glele (1858–89), conforms closely to the model of Yoruba beaded crowns (see FIG. 1). A special family of royal beadworkers lived outside of Abomey near the homes of the area's first rulers, suggesting the importance of this tradition from the time of the kingdom's foundation. Because of the prominence of beads in the construction of local shrines, the crown also underscores the sacrosanct identity of the ruler. Despite the ritual importance of these beaded crowns to the Dahomey monarchs, rulers there rarely if ever wore them in public, preferring a variety of other headgear, especially caps decorated with appliqued dynastic symbols.

The front and sometimes sides of these beaded crowns display stylized human faces, identified variously as the kingdom's first ruler (and Ife's founders, Odudua or Obalufon). These faces also allude to destiny (*ori*) in relation to Yoruba kingly authority.

Linked sometimes with the god Obalufon (god of beadworking, weaving, and coronations) and sometimes Olokun (god of the sea), beads carry ritual potency in royal Yoruba art. Bright colors add to their ritual significance and visual appeal, each color (or combination of colors) being associated with a different empowering god (*orisha*). A packet of potent medicinal plants and other materials (*oogun ase*) is placed inside the crown's peak by a diviner, to empower both the crown and the king. A prominent Yoruba saying, "the king's power resembles that of the gods," reflects the divinity granted the king through this crown.

62. Yoruba (Nigeria). A bead composition entitled *Osun Goddess and the Children* by Jimoh
Buraimoh, 1994. Beads and mixed media on canvas, 48 x 24" (121.3 x 60.4 cm).

Buraimoh (b. 1943) is one of a group of Yoruba artists working in the city of Oshugbo, who has
translated traditional religious and mythological themes into new artistic genres. Working in
mosaics, paintings, prints, etchings, embroidery, batik, and theatrical productions, these artists
transformed the area into an international art center. The catalyst for this movement was an
Austrian artist named Susanne Wenger whose reconstruction of area shrines brought local artists
into contact with the new art and patronage.

 An annual festival is dedicated to Oshugbo's patron deity, Osun (Oshun), the subject of this
composition. The city's founder (and first king) is said to have once met the river goddess at the
river's edge where they made a pact of mutual aid. The Oshugbo king still bears the title Ataoja,
"born with a fish in his hands," in commemoration of the role Osun played in founding the city.
Near the river are found a number of flat, pitted rocks said to be her indigo-blue dying pots –
perhaps indicated here at the edge of the canvas. Osun is also known to help women bear children
and Buraimoh portrays her as a youthful mother of two.

So essential was this beaded headdress to the king's authority that if he was instructed by the kingmakers to remove it and gaze into its interior, this meant that not only had he lost the authority to rule but also that death would soon follow. Indeed, the act of looking into the crown was to some degree equated with the tradition that the king should commit suicide when serious failure marked his reign. Contemporary artists, including those working at the famous artists' school in the Yoruba town of Oshogbo (Nigeria), have continued an interest in both the ritual and regal importance of beads and the vitality of Yoruba mythic order (FIG. 62).

Yoruba religious forces (*orisha*) give shape to the physical and social world. According to the early twentieth-century German traveler to the area, Leo Frobenius, four of the most important of these gods were linked to the cardinal directions, their shrines being positioned accordingly. The associated colors of these gods are represented in religious iconography.

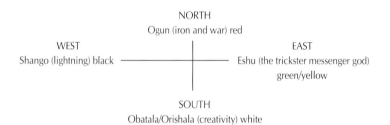

NORTH
Ogun (iron and war) red

WEST
Shango (lightning) black

EAST
Eshu (the trickster messenger god)
green/yellow

SOUTH
Obatala/Orishala (creativity) white

Palaces and Royal Prerogative

An urban people who were also excellent agriculturalists, the Yoruba historically lived in large cities with populations in some cases reaching the hundreds of thousands. At Ilesha (FIG. 63), twenty miles (32 km) northeast of Ife, and a number of other royal cities, a massive wall (with adjacent dry moat) circumscribed the city center, the main portals of which were positioned roughly at the cardinal points, and bore heavy doors which were closed each night. These vast city

63. Yoruba (Nigeria). Plan of the royal city of Ilesha.

Most Yoruba palaces (*afin*) were positioned at the center of the city at the intersection of four or more broad avenues leading in from the main city gates. Built by the local citizens, the palace was by far the largest, tallest, and most complex edifice in the area: the Owo palace 40 miles (64 km) to the southeast of Ilesha spanned 108 acres (44 hectares); that at Old Oyo some 100 miles (160 km) to the northwest was said to have once exceeded 642 acres (260 hectares). At Ilesha, across from the main palace entry was the city's main market, its locale underscoring the role that the king assumed as overseer of the economic vitality of his people. The compounds of key ministers or chiefs were sited near the palace.

ILESHA: The location of the Palace in relation to both the town & the compounds of important Chiefs

REFERENCES
City Wall
Palace wall built after 1941
Built-Up Area

Compounds of Important Chiefs
1 Chief Saloro 6 Chief Obanla
2 Chief Lejoka 7 Chief Ogboni
3 Chief Odole 8 Chief Loro
4 Chief Obaqdo 9 Chief Arapete
5 Chief Bisawe 10 Chief Elejopi

To Ijebu Ijesha

PALACE (AFIN)

To Benin

From Ife

From Ife

SCALE IN FEET
1000 0 1000 2000 3000 4000

N

64. Yoruba (Nigeria). The palace at Oyo in front of which stand the king's son and palace officials, early twentieth century.

While the palace was occupied by successive kings, during the investiture ceremonies a new entry was usually cut for the new king's use; at his death the door was closed. Earth (mixed with palm oil for durability) historically was used for these buildings, but today cement, zinc roofs, and European architectural elements are a far more frequent sight.

ramparts once circumscribed the city and safeguarded its power. Like the universe, which according to local belief takes the form of a closed calabash, Yoruba cities were encircled by a protective barrier.

Tall cone-shaped entry turrets capped with a thick thatch of palm leaves historically framed the palace entry (FIG. 64), these visually complementing both the royal crowns and umbrellas. Yoruba palaces were largely focused inward with open "impluvial" courts and rectilinear buildings around the perimeter as in the palace of Ikere, some 20 miles (32 km) southeast of Ilesha, in the northern Yoruba (Ekiti) area (FIG. 65). Here a magnificent group of veranda posts was carved in 1910–14 by the man who is considered to be one of the greatest Yoruba artists of this century, Olowe of Ise (d. 1938). A similar grouping of architectural supports was created by Olowe for the palace at Ise, 18 miles

65. Yoruba (Nigeria). A partial isometric drawing of three courtyards in the palace at Ikere.

The most important palace courtyards often displayed carved roof supports.

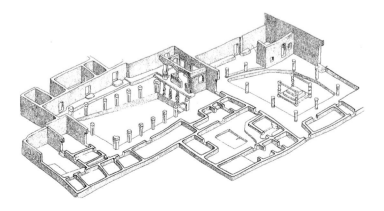

(c. 30 km) away. Monumentality, polychrome surfaces, and elongated figures carved in high relief characterize Olowe's oeuvre, as do the sharply contrasting scale of his figures and the intricate detailing of features such as coiffure. The Yoruba aesthetic values of clarity, straightness, balance, youthfulness, luminosity, and character all appear in these sculptures.

Working with as many as fifteen assistants in a room reserved for him in the palace, Olowe became such a royal fixture that he was given the title of royal *emese* (messenger). One of the *oriki* (praise poems) created by his wives in his honor identifies him as:

> Handsome among his friends.
> Outstanding among his peers.
> One who carves the hard wood of the iroko
> tree as though it were as soft as a calabash.
> One who achieves fame with the proceeds of his carving.

Olowe's center-most carving in a triad for the Ikere palace roof supports (in this case a non-supporting caryatid; FIG. 66) figures the king in a traditional cone-shaped beaded crown surmounted by birds; he is seated in front of his senior wife. The striking scale of this woman (particularly with regard to the king) may allude to the hidden, and indeed sometimes sorcery-related, attributes that powerful women are believed to assume in Yoruba society. The height differences, along with the strong verticality of the king's beaded crown, reinforce ideas of royal power and sacred authority. Appropriate to its vision of royal status and courtly composure, the corresponding sculpture at the palace in Osi, some thirty miles (48 km) northeast of Ilesha,

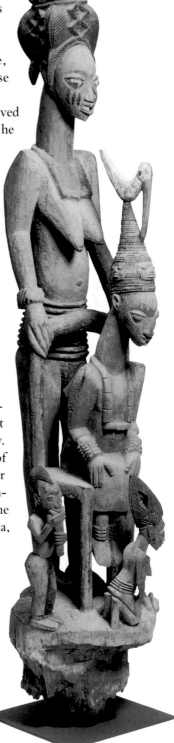

66. Yoruba (Nigeria). A sculpture from the palace of Ikere by Olowe of Ise (d. 1938), 1910–14. Wood and pigment, 60⅞ x 13¼″ (154.9 x 33.7 cm). The Art Institute of Chicago.

The king's senior wife, who is shown standing, displays the characteristic Yoruba scarification marks of parallel cheek lines. The towering size of this woman indicates her great status as the king's senior wife, someone who not only had responsibility for placing the crown on the new king's head at the coronation, but also oversaw the state treasury, royal insignia, and the harem. In front of the king, a diminutive woman kneels in the posture of respect and obeisance. At the king's side, an equally small court messenger plays a flute.

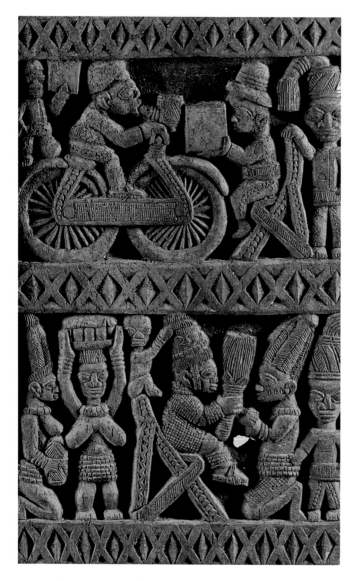

deity Eshu, a trickster and messenger god who is said to be on hand to receive a part of every offering. The portrayal of Eshu in this pose suggests not only Arowogun's playfulness, but also his enormous sense of self, for in this scene he is publicly portraying (on a palace door, no less) the precarious nature of royal authority. By a mere flick of the hand (and trick of fate), Eshu could remove the king's crown, bringing on an unexpected calamity.

The two panels which frame this scene show, below, a mounted warrior advancing with a bound prisoner, followed by a man on foot who carries the warrior's spear (see FIG. 60). In the panel immediately above the king, we see a seated man in a colonial helmet holding out a book toward a pipe-smoking cyclist. Whereas the seated man probably represents a government official (and the book, a code of laws), the rider suggests at once a modern city traveler and the trickster Eshu, who is often shown with a pipe. At the far right stands a court messenger; at the far left is a school child with an open book. Together these two panels suggest the sources of traditional and modern authority, war below and written law above. The top and bottom frames of the door allude to the force that is needed to promote a stable society (see FIG. 60). At the top is a group of rifle-bearing policemen accompanied by the ever-present Eshu, here playing a flute. At the bottom, a seated judge rules on the guilt of a bound and naked prisoner. An armed guard with a royal umbrella completes the scene.

67. Yoruba (Nigeria). A palace door panel from Osi-Ilorin by Arowogun (1880–1954), early twentieth century (detail, see FIG. 60). Wood, whole door height 5′11½″ (1.82 m). Fowler Museum of Cultural History, University of California, Los Angeles.

The right frame of Arowogun's door is dominated by the figure of a king seated in profile, his crown and fly whisk marking his royal status. Kneeling in front of this ruler is a woman who presents him with a gift. Another woman stands behind the king carrying a drum, while a third kneels with a vessel. Together this grouping suggests the preparatory arrangements for a royal ceremony. The small figure seated behind the king, who is depicted in the highly unusual (and exceedingly unlikely) gesture of grasping the royal crown, probably personifies the child-resembling

served as a backdrop for important court ceremonies, when the king positioned himself directly in front of it.

Some of the most extraordinary of the Yoruba royal arts are solid wooden doors which once ushered visitors into the main courtyards inside the palace (FIG. 67; see FIG. 60). A prolific artist from Osi-Ilorin named Arowogun (or Areogun; 1880–1954) created some of the most handsome of these doors in the Ekiti area northeast of Ife. His name, which means "he who gains money in the service of Ogun" (god of iron), suggests his expertise in the traditional iron tools of his profession (see FIG. 10). As was common for doors of the sort shown here, they are generally divided into registers separated by textile-like patterns. Inside each frame were displayed one or more scenes relating to rulership, contemporary life, and the history of the dynasty. Arowogun's style is characterized by condensed, story-like compositions filled to capacity with ebullient figures in flat relief. While not intended to be read as narratives, palace doors of this sort often conform to an internal hierarchy of centrality and distance, the most important scenes being carved in or near the middle. As a grouping, the five panels on this door point to the importance of law, order, and royal ritual in maintaining social well-being.

SYMBOL OF OGUN WORSHIPPER

Arts of Divination and the Fate of Kings and Commoners

Themes of power, authority, and ritual participation are played out in the divination arts identified with the god of wisdom, Orunmila, the agent of divination, Ifa, and the messenger-trickster god, Eshu. In the course of divination, a diviner (babalawo) at the behest of a client seeks information from Ifa to help resolve specific problems or questions – personal, medical, social, political, and religious – through the agency of Ifa. The centerpiece of divinations is a rectilinear or round board (opon ifa) on which the diviner marks the response. The small figures carved around the raised border portray subjects of importance to divination practice and life in general (FIG. 68). The board from the Yoruba-influenced Ayizo town of Allada in Benin Republic is dated around 1650 and has an unusually rich iconography, which suggests to me that the artist and patron were seeking to produce a didactic text that would help to clarify the Ifa divinatory system to an unfamiliar audience. (This finds support in nearby Dahomey traditions that maintain that Ifa divination, though practiced here earlier, was officially recognized only later in the area during the reign of Dahomey's King Agaja (1708–40)).

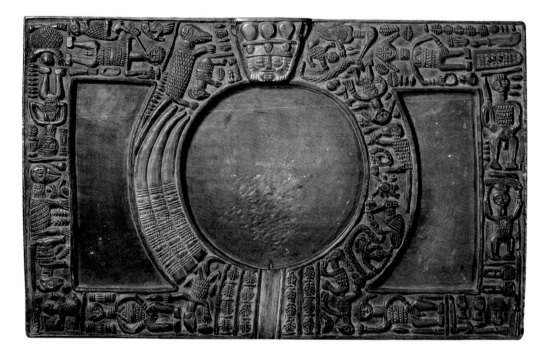

In the Ifa divination process, the diviner passes the sixteen palm nuts (16 as a multiple of 4 is a critical number in Yoruba numerology) from one hand to the other, after which he notes the number retained within his hand (always 1 or 2). This number is then noted on the powdered surface of the Ifa board for eight "passes" in succession. The patterning of marks delimited in this rather complicated process results in the selection of a specific *odu* (sign), one of 256 such signs, each with a unique story, and several proverbs, phrases, or songs about the lives of gods, humans, and animals. Ifa divination plays a critical role in Yoruba and related societies in determining not only which royal candidate will come to the throne (and what actions should be taken in the course of his reign) but also what life holds in store for the many subjects. Many of the *odu* signs themselves refer to royalty, reminding rulers how they should act with respect to their subjects, and how non-royal individuals should proceed when in the presence of those with greater power. The specific *odu* sign which emerges during the divination session is said to be revealed to the diviner through the medium of the ubiquitous Eshu (FIG. 69), whose face is shown at the top of the board. As the bearer of divination messages between the worlds of gods and humans, Eshu represents human fate as being always in balance. In key decisions, the diviner might position himself toward the east, the direction most closely associated with Eshu. Other important arts associated with Ifa

68. Ayizo (Republic of Benin). Ifa divination board (*opon ifa*), collected in the Ayizo town of Allada, under Yoruba control, c. 1650. Wood, 13½ x 21½" (34.7 x 55.5 cm). Weickmann Collection, Ulmer Museum, Ulm.

Eshu's face is centrally positioned at the top as messenger god, trickster, and symbol of life's diverse consequences. Powder-filled gourds (*oogun ase*) in his hair refer to his mystical power. At the bottom are carved the palm nuts used in divination. The small tusk-like forms to the right of the central circle represent the wood and ivory tappers employed to get the god's attention before divination begins.

69. Yoruba (Nigeria). A figure of Eshu, collected in 1958. Wood, cowries, and mixed media, height 20" (50.7 cm). Indiana University Art Museum, Bloomington.

A row of calabash gourds, representing the powder-filled calabash vessels used by Eshu to help to alter events for personal or family benefit, are positioned along the top of Eshu's head. Long braids of cowries (the traditional currency) attached to the figure's neck recall Eshu's prominent place in human exchange and the location of his principal shrine at the city market, because of its association with the uncertainties of social and monetary interchange.

Eshu, as with royal messengers (*emese*), is often shown in sculptural form with a long headdress or coiffure (one side of the latter sometimes being shaved) which extends down the back. Eshu's head, often terminates in a gourd, knife, or braid. Two other and interrelated attributes comprise a whistle (or flute, both signify communication with the spirit world) and the infantile gesture of sucking the thumb, since Eshu is the youngest god, a deity whose acts are often mischievous. In Eshu's links to the royal *emese*, the sometimes difficult relationships of rulers, court officials, and subjects are embodied.

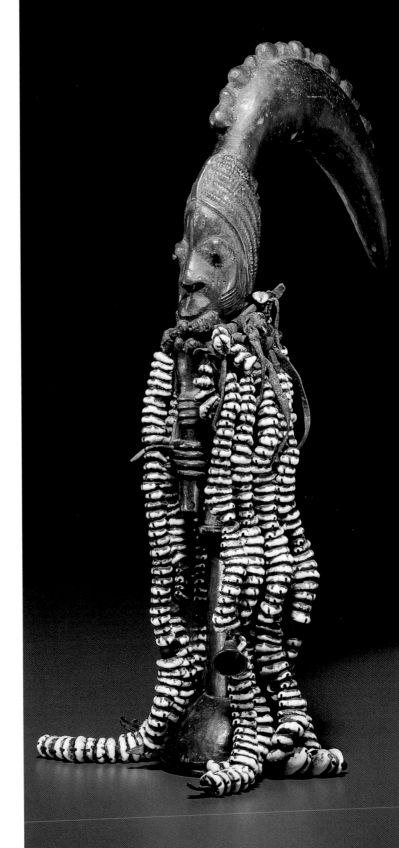

70. Yoruba (Nigeria). An ivory tapper in Owo style, eighteenth century. Height 17¾" (45 cm). Musée de l'Homme, Paris.

The tapper, used in Ifa divination, was collected in the Dahomey (now Republic of Benin) capital of Abomey by General Dodds during the French conquest of 1890–92. Dahomey monarchs commissioned important Ifa divination arts from their Yoruba neighbors. This work portrays a kneeling woman surmounted by a hornbill. Since the hornbill was said in Dahomey to be one of nature's best diviners, the tapper signifies revelatory knowledge in both its use and imagery.

71. Yoruba (Nigeria). A vessel by Agbonbiofe (d. 1945) or another member of the Adesina family, from Efon-Alaye, Ekiti (northern Yoruba). Wood, height 13⅝" (34.9 cm). Collection Ian Auld, Halstead, England.

The palm nuts used in Ifa divination are stored in handsomely carved vessels. Containers of this sort also held shrine offerings and kola nuts presented to visitors in important households. The kneeling woman has been identified as a messenger to the gods, although her posture of respect is common in religious, political, and familial contexts. The chicken, which is large in comparison to both the woman and the smaller kneeling figure at the front corner, is a frequent offering to the *orisha* deity.

divination include special ivory tappers (FIG. 70) to call the attention of the gods, and beautifully carved vessels (FIG. 71) where the palm nuts are stored.

The diviners' vast knowledge of nature (human, animal, and plant-related) and the secret restorative and protective powers which the forests hold are used in their ancillary role as specialists in pharmacology and healing, for which they employed iron staffs known as *opa osanyin* (Osanyin, god of health, sculptures; FIG. 72). Like miniature trees, the staffs are surmounted by birds which allude both to the forests as a source of medicines, and to the negative forces of witchcraft (viewed as the "gathering of birds"), which diviners are committed to counteracting through both divination and ritual healing.

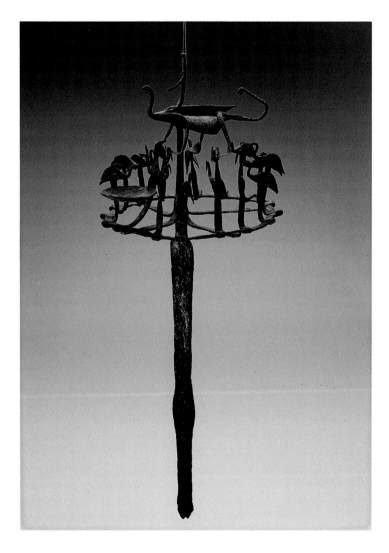

72. Yoruba (Nigeria). An iron staff for Osanyin, collected before 1970. Height 22½" (57 cm). Fowler Museum of Cultural History, University of California, Los Angeles.

The gathering birds motif also characterizes many Yoruba beaded crowns. Messengers associated with the Yoruba court at Oyo also were identified with bird-surmounted iron staffs, these serving as important markers of their status.

Gods of Thunder and Twins

Shango, the Yoruba god of thunder, lightning, and the heavy storms which bring seasonal rains, is linked to royal prerogative, Shango himself having once been a ruler in the northern Yoruba kingdom of Oyo. His thunder and lightning have their conceptual complements in the booming sounds and fire of rifles. By nature quick to anger and quick to cool (devotees of Shango often wear red and white beads), the god's temperament is said to have been shared by Oyo's King Shango. The god Shango's ability to take or mark human life and property by lightning also suggests parallels between him and royalty; traditionally, Oyo kings were crowned at the Shango temple.

Shango temples complement Yoruba palaces in their elaborately carved doors, figured roof supports, and impluvial courtyards. A temple interior (FIG. 73) with several equestrian roof supports, displays a group of covered vessels against the back wall. These hold the neolithic stone axes – or meteorites, as they are identified locally – sacred to Shango, which purportedly fall to earth whenever lightning strikes. Elegantly carved dance staffs (*oshe shango*) dedicated to Shango usually depict female devotees kneeling in respect and homage to address both gods and kings (FIG. 74). The dark blue-black indigo surface – a royal color – indicates Shango's link with royalty.

Twins (*ibeji*), known metaphorically as children of Shango, are the subjects of special memorial carvings when they die. Sometimes they are given garments elaborately decorated with beads or

73. Yoruba (Nigeria). A Shango temple in the city of Ibadan, 1910.

The decorated leather bags (*laba shango*) hanging from the roof were used to carry the sacred stones, thought to be meteorites brought to earth by lightning. The mounted horsemen roof supports recall the powerful cavalry which once was victorious over competing royal centers as far away as Dahomey. Shango dance staffs decorate the earthen bas-reliefs of this temple.

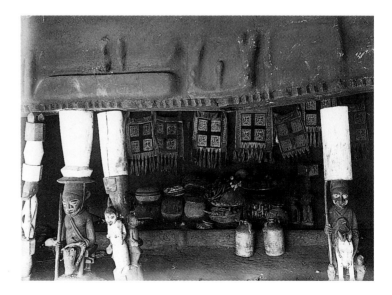

74. Yoruba (Nigeria). A Shango shrine figure holding a dance staff (*oshe shango*), by Abogunde of Ede, nineteenth century. Wood and beads, height 21½″ (54.6 cm). Collection Ian Auld, Halstead, England.

On her head the devotee balances a double axe to suggest the act in Shango initiation in which the initiate balances a vessel of fire on top of her head, to demonstrate Shango calmness in the face of danger. The devotee's nudity alludes to ritual purity. In her hands she holds her own *oshe shango* staff. The triangular forms at the top of the staff represent the stones sacred to Shango. The red and white beads suggest Shango's hot fire and cooling rain.

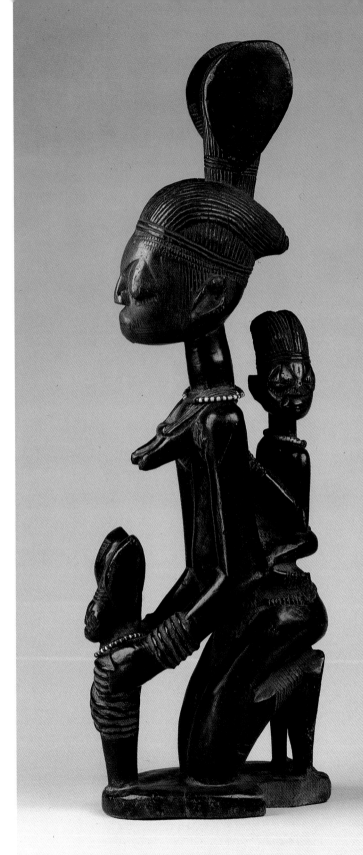

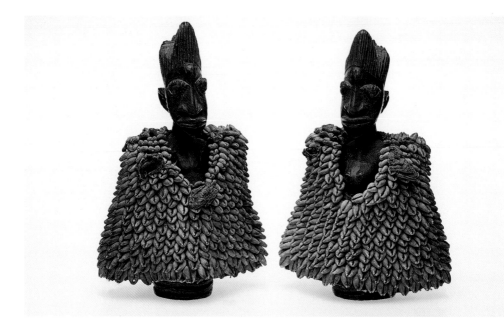

75. Yoruba (Nigeria). Twin figures, early twentieth century. Wood, cowries, and mixed media, height 10¼ and 10½" (26.2 and 26.5 cm). Fowler Museum of Cultural History, University of California, Los Angeles.

Figures memorializing deceased twins are fed, clothed, carried, and cared for as if they were still living.

cowries (FIG. 75) to mark their association with Shango or royalty. The richness of the attire complements the belief that twins promote plenty as part of their doubling identity. Important twin ceremonials take place in the main market opposite the palace.

Masked Personifications of Royal Authority

Evoking the shared power and pageantry of kingship and religion through a quite different visual icon in the northeastern Yoruba area of Ekiti are complex masks known as *Epa* (FIG. 76). The dances for which the masks are worn are tests of physical endurance since the masks sometimes weigh 60 to 80 pounds (about 25 to 35 kg). As a group, these masks are dedicated to the great Ekiti carver Oleko, who created the first such objects. Worn in processions to honor important Ekiti ancestors, the compositions of the masks thus can be appreciated in the round. At other times, the masks are displayed inside temples where they are the focus of a more quiet and intimate engagement. *Epa* compositions are remarkable for their iconic richness, usually portraying either female chiefs – the powerful women who represent the interests of women in dealings with the king and the senior chief's council – or the great warrior kings who established monarchy in the northern Yoruba region of Ekiti.

Other important regional masking traditions include Gelede (FIG. 77). Members of the Gelede society, which was particularly

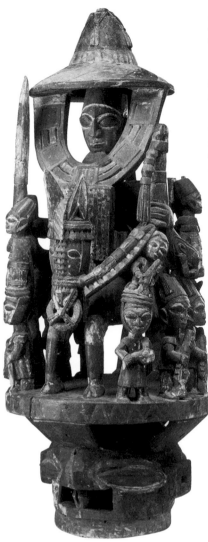

Left 76. Yoruba (Nigeria). An *Epa* mask headdress portrays a warrior king, by Bamgboye (d. 1978), from Odo-Owa, in Ekiti. Wood, height 3'11⅞" (1.22 m). Detroit Institute of Arts.

Bamgboye was an artist known for his exceptional carving skills, tight compositions, and imaginative integration of figural elements. Here the mounted king is surrounded by a large retinue of followers, among them a wife and child, a drummer, and warriors. Shaded by a wide-brimmed hat based on the attire of Muslim Fulani kings to the north, *Epa* mask depictions of Yoruba rulers, many of whom converted early to Islam, epitomize regal authority and equanimity.

Right 77. Yoruba (Nigeria/Republic of Benin). A Gelede mask, twentieth century. Wood and pigment, c.17¼" (6.8 cm).

When seen together during the performance, the Gelede masked pair suggests an image of four-eyed, spiritually charged vision. Gelede mask compositions are diverse. The rich market women who controlled much of the trade in this area are a common theme of Gelede masks. Contemporary scenes also appear, as in this grouping of figures inside a car. Such motifs point up not only artistic interest in contemporary themes, but also in this case, perhaps, the potential threat to society of persons of disproportionate wealth and power.

prevalent in the southwestern Yoruba area, performed in masked pairs during festivals aimed at countering malevolence by appeasing the spiritual force of elderly women and other powerful members of the society. As leaders who are imbued with *ase* (spiritual charge), kings also were believed to have this power, which they could use for the benefit (or detriment) of themselves or their people. This force, which was equated to some degree with sorcery, was often referred to by the idiom of four eyes – two worldly and two spiritual – an image which is reinforced when the king wears his crown.

Badges of Counter-Royal Authority

Looking at the larger corpus of royal arts, it is difficult to imagine that Yoruba rulers did not have near absolute autonomy. Far from it. Specially designated kingmakers selected the ruler from a long list of candidates, choosing the monarch from one of several royal families (affirmed by divination), who met physical and moral standards but also was willing to listen to and address their people's concerns. This check on royal authority was maintained by a yearly Ifa divination consultation to determine if the *orisha* still supported the king. The powerful society of elders known as Ogboni (Oshugbo) also played a critical role as a counterweight to the king. Reflecting their power in the city of Ilesha, the Ogboni compound was prominently positioned opposite the palace entrance. The society, which represented both the native inhabitants and the gods who oversaw their land, was dedicated to the earth deity Odudua, for whom the spilling of blood on the earth's surface was a sacrilege. Ogboni drums and royal drums (see FIG. 16) have key features in common.

The name Ogboni (meaning "thirty" or "wisdom") refers to the thirty wise members of the society who judged cases of moral infraction, royal and otherwise. Various badges mark Ogboni membership at different levels, among them rings, bracelets, and crowns. By far the best-known emblems, however, are paired brass sculptures called *edan* (FIG. 78; see FIG. 18), which portray male and female figures joined together by a chain. They allude to the shared importance of men and women in Yoruba social governance, and may also point to Odudua's own double-faced image.

An unusual feature of these *edan ogboni* (or *oshugbo*) is the core of clay or earth that is retained in the interior after casting has been completed, another link to the earth. The curative and protective features of *edan ogboni* appear in part to stem from this source and from the small iron stakes in the base of the figures. These

spikes, while suggesting the sacred potency of the earth's iron-rich interior, help to secure the figures in the ground. They were positioned on the spot where blood had been spilt as a sign that those involved should appear before the Ogboni. *Edan* figures were also placed on the earth during judgments, their contact with the ground legitimating the decisions.

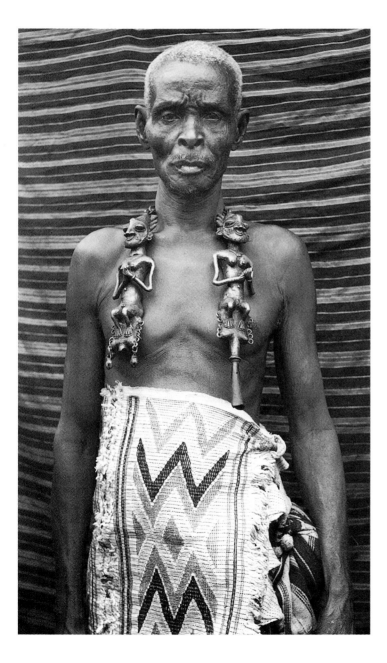

78. Yoruba (Nigeria). An Ogboni (Oshogbo) society elder with paired brass sculptures (*edan* Ogboni) over his shoulders, 1949–50.

When worn around the neck of the Ogboni member, the *edan* grouping constitutes a triad: three was an important number in Yoruba earth worship, calling to mind the three stones which are positioned on the earth to support cooking pots on the fire.

79. Fon (Republic of Benin). The ex-king Agoli Agbo (1896–1900) wearing the silver leopard-nose mask invented by his father Glele.

This photograph was taken in the 1950s after Agoli Agbo's return from forced exile to Gabon. The umbrella shows an appliquéd image of his royal icon, a foot stumbling on a rock. The appliqué banners which frame the ex-king incorporate other royal signs: a drum and lage bird (Ganye Hesu, c. 1620); a lighter (Dako Donu, c. 1625–45); a fish and net (Huegbadja, c. 1645–85); a pig (Akaba, 1685–1705); a ship (Agaja, 1708–1732); a buffalo with a cloth wrapper (Tegbesu, 1732–74); a bird (Kpengla, 1774–89); a pineapple (Agonglo, 1789–97); a buffalo (Guezo, 1818–58); and a lion and sword (Glele, 1858–98). Agoli Agbo carries a *makpo* scepter on his right shoulder; his right arm is encircled by a serpent-form armband. Another Agoli Agbo symbol is a broom, the latter a reference to his role in cleaning up the kingdom in the wake of the French conquest. White and black appliquéd cloth like that around the king's waist was worn only on special ceremonial occasions such as the annual rites of *huetanu.*

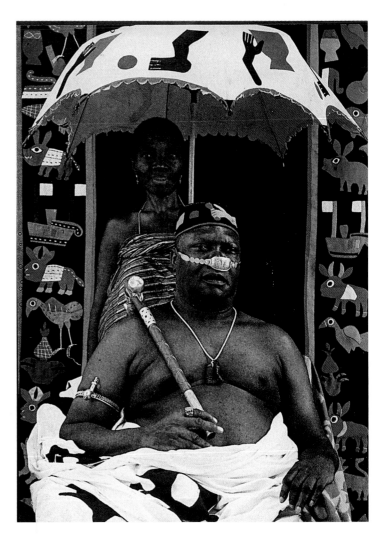

Dahomey: "Leopard" Rulers and the Arts of Dynastic History

Royal myths trace the origins of the neighboring Dahomey (Danhomè) kingdom of the Fon people in the southern Republic of Benin to a coupling between a leopard and a princess from the ancient city of Tado (in Togo to the west). The myth constitutes a central trope within the royal Dahomey ethos, legitimating the drive and dangerous force for which these kings eventually became known. While they continually drew on Yoruba religious and political traditions, including beaded crowns (see FIG. 61), most Fon works reveal very different artistic roots. In the nineteenth century, Dahomey rulers starting with King Glele (1858–89) wore striking silver nose masks (FIG. 79) in the shape of a leopard's

80. Fon (Republic of Benin). The Guede ceremony dedicated to the indigenous rulers of the area, 1986. The Guede priest, as the ritual authority for the early residents of the area, sits on the royal *djandeme* throne; his feet rest on the small but ritually important *keteke* stool. A stool of this type was kept in a town outside of the capital where the royal stool carvers resided, and was brought into the palace for the enthronement of each new king. A title of the leader, *zinkponon*, "owner of the stool," reflects the importance of these stools. Similar seats were employed by royal women, court ministers, and regional chiefs. Because the stools are considered sacrosanct, they are brought out from family temples for use only during important ceremonies. The appliquéd umbrella shown above the Guede priest incorporates symbols referring to the early leader Ganye Hesu (the bird) and the foundation of Danhomè (a snake).

or lion's pug nose. Their practical purpose was to keep dust from impeding the king's breathing during energetic dances at court, but they also set the ruler apart from others in the realm, as a figure at once wealthy and wild. The great power of the Dahomey monarchs is also suggested by the tradition that royal sandals made by court leather workers of Hausa (a northern Nigerian culture) were fashioned from the skins of dangerous animals such as leopards, elephants, and lions. In keeping with this idea, the wearing of sandals was the exclusive right of Dahomey rulers.

Dahomey's first dynastic head was Huegbadja (Wegbadja), "the fish escaped the cage," a leader who consolidated power in what became the Dahomey capital in the late seventeenth century. Later, when the capital was given a central plan, Huegbadja's house marked the middle. While two early leaders, Ganye Hesu and his brother Dako Donu, are credited with the kingdom's inception, they were probably local chiefs whose powers were usurped by Huegbadja and his successors. The descendants of these early leaders today have charge of the royal throne (FIG. 80).

Tall, elegant *asen* sculptures such as the one to Huegbadja (FIG. 81; see FIG. 19) were set up in family shrines as memorials to the dead. Offerings were placed on the ground in front of the staff. Status was indicated by the height of the shaft and by the material used to create the commemorative scene or symbol at the top; of these materials, silver and secondarily brass were the most prestigious. Royal *asen* such as Huegbadja's were made by the family

SIGN FOR KING HUEGBADJA

81. Fon (Republic of Benin). A memorial sculpture in the form of a house, late nineteenth century. Iron and brass, 70⅞" (180 cm). Musée Historique, Abomey.

The house in this *asen* sculpture is dedicated to the dynasty-founder Huegbadja and symbolizes the state; the closed calabash vessel represents the world, an offering container, and the mysteries and rights of rulership. A cord joins these two motifs to suggest royal descendance and Huegbadja's importance as dynastic founder. The *asen* thus credits the king not only with fathering the royal line, but also with organizing the world, and creating its various supernatural powers (*vodun*). The cross at the top is a traditional Dahomey sign for the meeting of religious forces, although it also appears frequently as a symbol of Christianity and contact with the West.

82. Fon (Republic of Benin). A staff or roof finial in the form of a ship, possibly late eighteenth century. Silver on wood, 8¾ x 5⅜" (22.6 x 13.8 cm). Musée Africain, Lyon.

The finial is dedicated to King Agaja (r. 1708–40), but the date of manufacture is not certain, for later rulers often commissioned works in honor of earlier kings. Similar metal finials decorated royal tombs and the *asen* shrines of important individuals.

of royal jewelers and smiths, called Huntondji, who were distant or adopted relatives of the king said to have come into the area during the reign of Huegbadja's son Agaja. The small pendants (*aflefle*) hanging from the *asen* served in some cases as artist's "signatures." Initially a mainly royal tradition, figural brass *asen* began to be commissioned by non-royal families in the twentieth century when the power of Dahomey kings had been largely dissipated. *Asen* appear to have their visual roots both in bird-ornamented *osanyin* staffs (see FIG. 72) used by Yoruba Ifa diviners and certain court ministers as well as the local importance of calabash gourds (*sinuka*, an alternative term for *asen*) as containers for key remains of the deceased. Dahomey iron memorial staffs also are placed on Fa (Ifa) divination shrines to commemorate deceased diviners.

SIGN FOR KING AGAJA

Royal Ritual and Architectural Planning under King Agaja

Three of Huegbadja's children ruled after his death, including a daughter, Tassi Hangbe. The third of these children, Agaja, was one of Dahomey's most important kings, governing during the critical period of 1708 to 1740. Agaja's royal icon of a European sailing ship signals one of his greatest accomplishments, the military push to the coast where he was able to gain access to the European trading ships and their wealth of goods. A handsome ship of hammered silver (FIG. 82) may have once served as a finial (*hotagantin*, "metal roof tree" or roof decoration) for the *djeho* ("house of pearls") dedicated to King Agaja. The *djeho* is a small round earthen structure built after a king's death to house his soul (FIG. 83).

Hotagantin were affixed to *djeho* and other important shrine roofs principally during the annual "customs" or *huetanu* ceremonies that Agaja is credited with introducing. Agaja's mother, who died during his march to the coast, is believed to have been the focus of his first *huetanu* rites, which also celebrated his military victory. For this occasion, Agaja commissioned an

83. Fon (Republic of Benin). A royal *djeho* (house for the soul), published by Skertchly in 1874.

Beads, palm oil, and sacrificial blood were among the materials added to the earth of the *djeho* walls. Elegant metal sculptures surmounted the roofs.

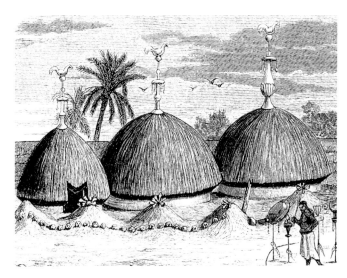

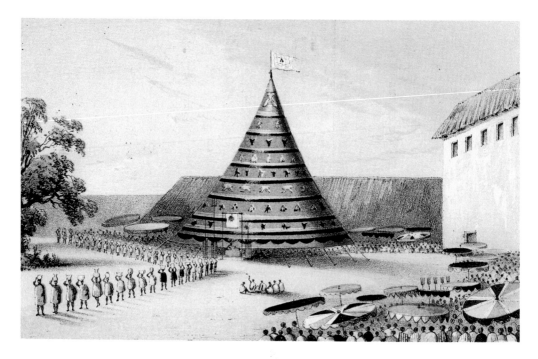

84. Fon (Republic of Benin). The parade of the king's wealth during the annual *huetanu* ceremonies, published in Frederick E. Forbes's *Dahomey and the Dahomans* (1851).

Under Guezo, a giant appliquéd tent was assembled for these ceremonies beside the new palace, a large palace just south of the ancient palace precinct (in the preceding reigns after Agaja, only a new door appears to have been cut into the existing palace walls for each king.) Guezo's palace entrance, Singbodji, consisted of a two-story structure modeled after the coastal trading house of his Brazilian friend Francesco de Souza, a wealthy slave trader living in the port city of Ouidah.

elevated *attoh* platform (see FIG. 19) for related offerings. During *huetanu*, royal arts and other cultural icons from the palace were paraded to the market, transported by members of the court and priests and priestesses in front of the admiring public, high-ranking visitors, and the king. A British visitor in 1850 estimated that six to seven thousand people carried the vast treasury of royal goods in this procession (FIG. 84).

In the course of his long reign, Agaja is said to have created Dahomey's first palace, Atakinbaya (FIG. 85), to the east of the house of his father, Huegbadja. During *huetanu* and other important occasions, the entrance walls of Agaja's palace were said to have been covered with long strings of cowrie shell currency. The lavish display of these shells symbolized not only Agaja's access to the coast and the goods which he could acquire directly from European sailing ships, but also his increasingly dominant role in the international slave trade, in which cowries became a partial medium of exchange.

A great architectural patron and innovator, Agaja commissioned new palaces both in Allada (the ancient capital of the Ayizo, whom he had defeated in 1724 in his drive to the coast) and in Cana (the kingdom's "country seat" and sacred gateway town where all visitors had to stop on their way to the capital). Palace buildings here and in Abomey were constructed of red earth mixed at least in later years with palm oil and palm fiber for durability.

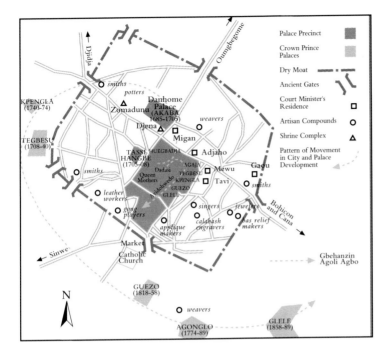

85. Fon (Republic of Benin). Plan of the Dahomey palace and capital.

The Dahomey royal palace in Abomey eventually came to cover more than 108 acres (44 hectares), with each ruler constructing a new entrance and buildings generally to the south of his predecessor, following the royal dictum that both the palace and the kingdom should expand with each new rule. Where possible, palace entrances faced east, the direction of the rising sun, because of the sun's identity with life and well-being. Red fruit-bearing *lise* trees were planted in front of each palace portal, to increase the strength and longevity of the palace residents.

People living in outlying villages were charged both with acquiring the necessary thatch and with overseeing yearly repairs.

Key palace buildings were distinguished by their whitewashed upper walls and lower walls of black pigment. The king's sleeping room, royal "soul house" (*djeho*), and tomb were circular in plan. Most other palace structures were rectilinear, the more important being positioned around large open courts. One of the most striking of these buildings was the veranda-fronted *adjalala* or reception hall (FIG. 86), where the king sat to witness important

86. Fon (Republic of Benin). The annual palace ceremonies taking place in front of the *adjalala* building of King Glele (r. 1858–89). Court ministers are seated in two groups in front of the ruling prince, Langafin, 1986.

Complementary ministerial positions were held by women from the time of Tegbesu, it is said. This innovation reflects in part the political importance of Tegbesu's own mother, Naye Wandjele. Both the female and male court ministers wore special appliquéd patches sewn onto their robes.

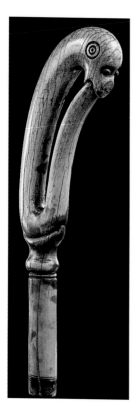

court ceremonies. Smaller rectilinear structures nearby housed the royal war shrines. The integration of both rectilinear and circular structures within the palace suggests both Dahomey's position at the intersection of savanna and forest, and the kingdom's long-standing use of indigenous and foreign forms.

At the rear (west) of the palace stand the queen mothers' residences and the houses of women who were called to serve as the queen mother "place sitters" after the queen mothers' deaths. These women assume the identity of their namesakes for important court ceremonies. "Place sitters" personifying various "female kings" (*dadasi*) reside in a special compound at the palace center and are believed to be reincarnations of Dahomey's deceased rulers.

A sacrosanct area in the center of the palace called *ayido hwedo* ("the rainbow") marked the space between the male and female areas. Here important offerings were made to the serpentine rainbow deity, Dangbe Ayidohwedo, who promoted wealth and well-being. Because the name Dan ("serpent") also refers to a local resident on whose stomach it is said the palace foundation was built when he opposed its expansion, the serpent (often shown biting its tail) also came to represent the kingdom in general. Indeed, the name of the kingdom, Dahomey (Danhomè) means "in the stomach or middle [*homè*] of the serpent [*dan*]."

The tail-biting serpent is prominently displayed in palace bas reliefs, *asen*, finials on canes (FIG. 87), and other arts as a symbol of the kingdom, its prosperity, and its strength. A British traveler to Dahomey in the eighteenth century, during the reign of King Agonglo, noted that court ministers carried clubs of ivory, each carved from a single tusk. These ministers, many of whose positions were first created by Agaja, along with important court artists – jewelers, appliqué makers, calabash engravers, leather workers, singers, and gong players – lived in high-walled compounds near the palace. Court diviners, priests, and temples dedicated to new gods brought back from the wars were also located close to the palace.

In addition to his remarkable military successes, ceremonial innovations, and building projects, Agaja is credited with creating the first plan for the kingdom's burgeoning capital. Marking the periphery of this capitaline space was a dry moat (FIG. 88) and an adjacent twenty-foot-high (about 9 m) wall, protected by cacti, the whole like an enormous ditch or hole (*agbo*) – the source of the city's name, Abomey, from *agbome* meaning inside (*me*) the moat (*agbo*). The purpose of this moat appears to have been as much to keep the wealth of the capital (human and spiritual) from escaping as it was to stop advancing enemies.

87. Fon (Republic of Benin). A finial in the form of a serpent biting its tail, late nineteenth century. Ivory, height 9¾" (25 cm). Musée Dapper, Paris.

Canes (*kpoge*) of ivory and less valuable materials were employed by important family heads (including kings) to signify not only their great stature but also their ritual ties to the leaders of the past.

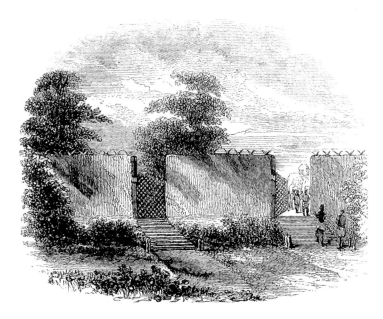

88. Fon (Republic of Benin). The walled moat leading into the capital Abomey, with gates for the king and commoners, published in Frederick E. Forbes's *Dahomey and the Dahomans* (1851).

Six paired entries, including four positioned roughly at the cardinal points, once led across this moat into the capital. One gate at each entrance was reserved for the king, the other for everyone else. The skeletal remains of elephants and sacrificial materials were placed beside the portals.

Ayidohwedo, the moisture-loving rainbow python, is also linked to this moat which was seasonally filled with rain, recalling the watery realm that was imagined to surround and protect the world. At the very center of the capital, where its two main avenues intersect, stands the house of Agaja's father, Huegbadja.

The origins of Agaja's plan for the capital are not clear, but there are obvious parallels with Yoruba cities. However, the paired gates and the generally square (rather than circular) shape of the enclosing moat here are unique. Abomey's plan, a cross inside a square, may symbolize the Dahomey icon for the cosmos (*weke*). This symbol (sometimes a cross within a circle) is displayed prominently on Dahomey royal seats, umbrellas, bas reliefs, and jewelry, and refers not only to the cosmos but also to the centrality and cohesion of the Dahomey kingdom as a divinely sanctioned space. A separate high-walled palace in the nearby town of Hwahwe housed the king's sacred counterpart, Daho, a ritual priest (sometimes called a "bush king") linked to the autochthonous leaders of the area whose powers had been usurped by Dahomey's founder Huegbadja.

King Tegbesu: Political and Ritual Organizer of the Court

Agaja's son Tegbesu (r. 1740–74) was in many respects an unlikely king, for in his youth he had once belonged to a party of Dahomeans sent by King Agaja to the Yoruba court at Oyo as part of

SIGN FOR KING TEGBESU

the annual tribute. Eventually he escaped and returned to Abomey, where he faced considerable opposition from his many brothers when he was put forward as a candidate for the throne. With the help of his powerful mother, Naye Wandjele, Tegbesu eventually prevailed. His royal icon, a buffalo wearing a shirt (see FIG. 23), served as a reminder that his brothers had put a skin-irritating plant inside his coronation tunic in the vain hope that Tegbesu would remove the garment, thereby disqualifying himself from rule. A ring of trees in Tegbesu's palace area marks the place where several of these brothers lost their lives as punishment for their *coup d'état* attempt.

During his long reign, Tegbesu is credited with reorganizing the Dahomey court along Yoruba lines and giving both men and women ministers greater responsibilities in the management of the kingdom. Temple histories in the Abomey area suggest that Tegbesu also made significant changes in court religion, including the creation of the shrine complex known as Djena, which is dedicated to the gods Lisa (heavenly light), Age (forests), and Gu (iron and war). He reorganized a local cult of the springs dedicated to deities known as Tohosu ("king of the water") into a temple for Dahomey royals (called in this context Nesuhwe) which was intended in part to promote the reincarnation of royal children. Annual ceremonies focused on the collection of fresh spring water to alleviate problems of birth, infant mortality, and physical deformities. The main royal Tohosu/Nesuhwe temple was set up in memory of one of Tegbesu's brothers, who was born with special attributes of speech. The main symbol of Tohosu/Nesuhwe worship, a long-legged water bird with a fish in its beak, appears prominently on temple wall paintings and other objects (FIG. 89).

Women and men priests dedicated to Tohosu are distinguished by their elaborate attire, which include not only rich textiles, metal canes, and scepters recalling Dahomey's rulers, but also elegant beaded and silver jewelry (FIG. 90). Together the Tohosu religious forms reinforce the wealth, refinement, and beauty of the court and its sponsoring deities.

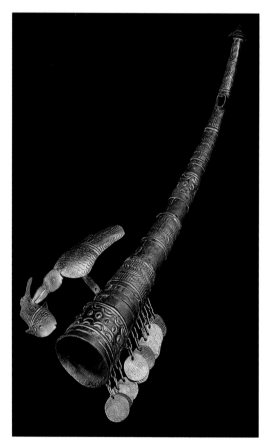

89. Fon (Republic of Benin). A bird with a fish decorates this Tohosu/Nesuhwe horn, late nineteenth–early twentieth century. Ivory and brass, length 21″ (54 cm). Musée d'Ethnographie, Neuchâtel.

The horn was probably played during royal funerals and *huetanu* rites.

90. Fon (Republic of Benin). A sculpture of a man with fins, late nineteenth–early twentieth century. Silver on wood, height 18″ (46 cm). Indianapolis Museum of Art.

This work of hammered silver over a wooden core was associated with royal Tohosu/Nesuhwe worship, as were many other sculptures in this material. The face of the figure is obscured by stylized cowrie chains similar to those which hid the faces of *vodun* (deity) devotees during initiatory rites. Chains of coins and miniature calabashes hang from the head. Around the neck several necklaces are displayed similar to those worn by Tohosu women priests as well as court ministers and royal women. The extensions at the shoulders suggesting fins may refer both to the Tohosu (as aquatic kings) and to the late nineteenth-century King Gbehanzin – whose icon is a shark.

The Artist King: Agonglo

During the short reign (1789–97) of Tegbesu's grandson, King Agonglo, much of the latter's efforts were focused on art. On the occasion of *huetanu*, quantities of new art were commissioned for display, including jewelry made from hammered silver, a material derived largely from European coins, which came into the kingdom in increasing abundance in Agonglo's reign. Among the works which are said to have been introduced by Agonglo are the royal thrones called *jandeme*, which are based on Asante prototypes. Agonglo's throne, said to have been carved by him, was called *kpatagan* (silver) after its silver covering. *Jandemen* thrones differ markedly from the three- or four-footed circular stool known as *keteke* (see FIG. 80) which had been used by the indigenous rulers.

SIGN FOR KING AGONGLO

That type is still employed today in the royal
investiture of the Dahomey kings. The cross
within a circle, square, or diamond incised
on the seats of both *keteke* and *jandeme*
stools is said to represent *weke* (the
world), and serves in part to identify
these seats as *vodun* (gods), whose sit-
ters thereby are imbued with sacred power.

Reinforcing this idea and the political prominence of stool own-
ers, during palace enthronements the candidate is required to pose
three times on his or her official stool, much as a new Dahomey
baby is introduced three times to its mother by the midwife before
she can acknowledge it as her own.

Another artistic tradition credited to Agonglo is the royal
scepter (*makpo*, "staff of fury"), a sculpturally elaborated form of
the hoe, axe, or throwing-stick weapon introduced under Hueg-
badja. As in Agonglo's scepter, which bears his royal icon of a
pineapple (*agon*, a pictograph of his name; FIG. 91), most royal
makpo scepters bear the distinctive symbol of the commission-
ing or commemorated king. When a king appeared in public,
he would carry his *makpo* scepter on his shoulder (see FIG. 79). Dur-
ing court dances, the scepter became a dance prop, its weapon-
like form punctuating the air with each gesture. Court dele-
gates carried a copy of the royal *makpo* as a substitute for the king
when on court business, and people would kneel before it as if
in the actual presence of the king. To be presented with such a
makpo meant that a person had to come to court immediately. Sim-
ilarly, Europeans arriving at the coast often sent figurative canes
to the Dahomey capital to indicate their desire to do business with
the king.

In addition to thrones and scepters, King Agonglo is said to
have encouraged other arts and artists, one of whom, Akati Akpele
Kendo, became a famous sculptor (*atinkpato*). Textile arts increased
and looms were set up in compounds around Agonglo's princely
palace. Some of the more beautiful of these textiles combined raffia
and cotton threads. Many incorporate figurative icons referring

91. Fon (Republic of Benin). The royal scepter (*makpo*) dedicated to Agonglo
and bearing his icon of a pineapple, late nineteenth century. Silver on wood,
2' (63.2 cm). The Metropolitan Museum of Art, New York.

This *makpo* was probably made during the reign of King Gbehanzin (1889–94),
since Agonglo was his sponsoring ancestor. In priestly scepters of a similar shape,
the appropriate deity symbol is incorporated instead of the king's.

to rulers and important court families and offices similar to those seen on appliqué arts (see the hat in FIG. 79), again said to have been promoted by Agonglo. Today, such cloths are commissioned by court and family ministers to be worn during the elaborate installation ceremonies at the palace.

Court weavers under Agonglo and later kings created vibrant multicolored tunics called *kansawu* (FIG. 92), which were worn by the king and important male and female military leaders in battle. While reminiscent of tunic traditions of the northern Bariba in the Republic of Benin and the Yoruba of Nigeria, *kansawu* decorative elements are decidedly local.

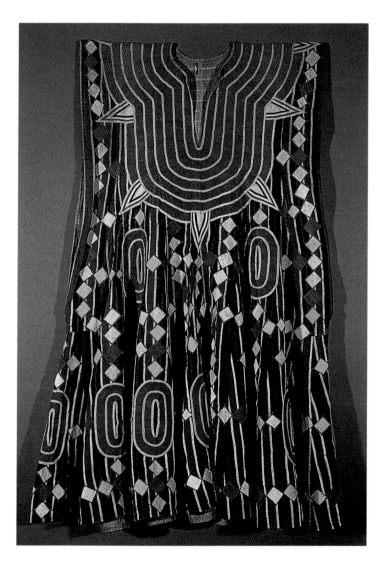

92. Fon (Republic of Benin). A royal war tunic (*kansawu*), late nineteenth century. Embroidered cloth, height 34¼" (87 cm). Musée de l'Homme, Paris.

The rank of the wearer is indicated in part by the number of rings embroidered around the tunic's neck. The tunics frequently display red embroidered dentate patterns around these rings, and the triangles are said to recall the claws of the dangerous royal progenitor, the leopard. Red, a traditional royal color in the area, is linked in important ways to ideas of life, death, blood, danger, and the heat of empowerment, features of critical significance both to kings and to war.

SIGN FOR KING GUEZO

King Guezo: Royal Usurper and Political Strategist

A bold *coup d'état* in 1818 removed Agonglo's successor Adandozan from the throne and ushered in his younger brother, Guezo (d. 1858; see FIG. 11). Though dethroned, Adandozan continued to live in the old palace precinct, and the "soul house" (*djeho*) constructed after Guezo's death alludes to his shared kingship role with Adandozan, incorporating two circular buildings within a single oval enclosure. Although originally a usurper, today Guezo is identified as one of Dahomey's most powerful kings. He was also interested in the popular perception of the courts, using art

93. Fon (Republic of Benin). An *asen* altar from Ouidah, mid-nineteenth century. Iron, 63 x 17" (160 x 43 cm). Teel Collection, Boston, Mass.

The late minister of Europeans (Yorogan), who seems to be memorialized here, is shown in a top hat, smoking a long pipe. Two flags, similar to those flown at the European forts and trading houses, frame each side. At his rear is a large Christian cross. A table has been set with an array of liquor (see the calabashes and imported bottles). Several glasses are also shown, in keeping with the minister's role as official receiver of visitors from Europe. The domestic animals positioned to the side refer to offerings which will be made to his memory.

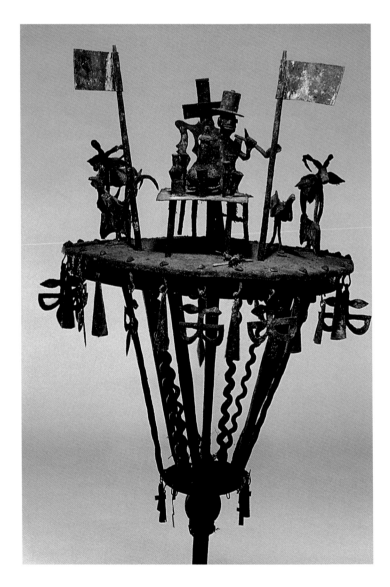

for propaganda purposes, in contrast to King Tegbesu who had helped to isolate the kingship in the course of making it more administratively cohesive and sacrosanct. The importance of integrating the diverse foreign peoples who increasingly comprised the kingdom into a more cohesive polity seems to have been one of Guezo's most pressing concerns. It was during his reign, accordingly, that the name Fon came into wide usage to refer to the people of this kingdom, after the *fon* tree that grew abundantly in the area around Abomey. At the same time, Guezo gave a portion of the land from his princely palace for the construction of a Catholic church, commissioning life-size sculptures of saints from France.

With increasing contact with Europeans, Guezo named a special minister to serve as intermediary and overseer of visiting foreigners. *Yovogan* ("chief of the newcomers"), as he was known, had his main residence in the coastal town of Ouidah near the residence of the wealthy Brazilian slave trader Francisco de Souza (the friend and supporter of the king) and the trading houses of several European nations. A handsome *asen* (FIG. 93) which appears to have come from a Yovogan family shrine and to date to Guezo's reign, shows many attributes of the wealth associated with this office.

Guezo appears to have promoted the use of more figurative and politically charged bas-reliefs in his palace *adjalala* building, many displaying important cultural and political subjects (FIG. 94). Earlier bas-reliefs, as well as those seen today on area temples,

94. Fon (Republic of Benin). Earthen bas-relief from the *adjalala* building in King Guezo's palace, portraying a Dahomey woman warrior carrying the body of a defeated Yoruba, by Cyprien Tokundagba (b. 1939). c. 20¾ x 24½" (c. 53 x 62 cm). J. Paul Getty Trust, Malibu, California.

Female warriors, who assumed increasingly significant roles during Guezo's reign, were prominent themes of palace bas-reliefs. *Ahosi*, "wife of the king," as the women soldiers were called, constituted the first offensive forces on the terrain of battle. The bas-relief portrayals of women warriors, as well as other palace scenes, have recently been restored and repainted by the well-known Tohosu temple painter Cyprien Tokundagba, a local artist who has gained an international reputation through his participation in the Parisian exhibition "Magiciens sur la Terre," in 1989. The multi-portal *adjalala* buildings where these royal bas-reliefs are found served as an architectural backdrop for major court events, including not only enthronement rites for family heads and court ministers but also the annual *huetanu* ceremonies in honor of the royal dead. On such occasions, the palace buildings often were richly festooned with colored appliqués.

appear to have been more iconic (and abstract) in form. The structural and decorative similarities between palace *adjalala* buildings with their bas-reliefs and Tohosu temples underscore the ongoing complementarities between royal prerogative and religion. During the construction process, indeed, the foundation walls of both were sanctified with offerings.

Adjalala bas-reliefs are frequently divided into registers. Running along the bottom of the palace *adjalala* buildings today are portrayals of the monarch's special animal symbol (for Guezo, a buffalo or ram; FIG. 95). Along the top are shown various *makpo* scepters, weapons, and military symbols. Bas-reliefs positioned between these two registers usually portray victories, as well as parables and cultural forms associated with the king's reign. Bas-relief artists, who originally included members of the larger Huntondji family of court jewelers and smiths, also sometimes incorporated images of royal sculptures in the polychrome bas-relief programs.

Dahomey's Lion King and Man of Iron: King Glele

Guezo was succeeded by his son, King Glele (r. 1858–89). Desiring to convey something of his own identity to the palace which he built to the south of his father's, Glele is said to have covered his entrance with mirrors, calling the building *huehonji*, "entrance of mirrors." Riding around the capital in the glass coach created by the Huntondji jewelers for his father, Glele sought to draw attention to himself as the equal of Europe's great monarchs, here specifically Louis XIV of France (r. 1643–1715) as the creator of Versailles. Glele's special interest in lavish building projects was embodied in the twenty or so palace edifices that were said to have been constructed for him. Some, such as one whose walls still stand in Cana, measured a half mile (800 m) wide and deep. In addition to serving as residences for Glele's sizable family and troops, these tall enclosures were used for the preparation of palm oil, an increasingly important trade item in the late nineteenth century.

As with several other Dahomey kings, some of the most important arts of Glele's reign were derived from his Fa divination sign (Fa is the Dahomey equivalent of the Yoruba Ifa). While divination was a vital concern of everyone in Dahomey it was especially critical for kings in determining not only who would rule but also what the reign would hold in store. One of the accounts associated with Glele's Fa divination sign tells how the lion, horn-

95. Fon (Republic of Benin). A necklace with ram decorations, nineteenth century. Silver, length 40½" (102 cm). Musée Historique, Abomey.

Fon jewelers from the royal Huntondji artists' compound fashioned handsome jewelry from silver coins for members of the royal family as well as the devotees of important gods. This necklace is dedicated to King Guezo, whose animal avatar, the buffalo, is also represented in the form of a ram.

bill, and crocodile became kings of their realms, and these animals appear prominently in works commissioned during his reign. Since one of the phrases of his divination sign recounts that "no animal displays its anger like the lion," many sculptures, appliqués, scepters, bas reliefs, and jewels from Glele's reign depict lions.

One of the most beautiful of these lions (FIG. 96) was made by the Huntondji royal smiths, hammering sheet silver onto a carved wooden core. Huntondji family artists using this assemblage technique also made models of foreign objects for the king, and this silver lion shares stylistic features (such as naturalism and surface decoration) with European silverwork of the period.

While functioning as royal icons (dedicated to the king through the worship of Tohosu/Nesuhwe), the lion and other royal silver sculptures were believed to serve as power objects (*bocio*), able both to repel danger and attract well-being to the kingdom. When not displayed publicly during the *huetanu* parades, the works were placed in palace shrines, where they are said to have been the focus of prayers and sacrifices to Gu, the war god, among others, for

96. Fon (Republic of Benin). The lion represents King Glele and was probably sculpted during his reign (1858–89). Silver on wood, length 11¾" (30 cm). Musée Dapper, Paris.

This work represents Glele's "strong" name, Kini Kini Kini (lion of lions). The sheet metal technique enabled artists to produce works of precious metal without the vastly greater expense entailed in casting by the lost-wax method, as was done by Yoruba, Benin, and Asante artists.

97. Fon (Republic of Benin). The throne of King Glele, 1858–64. Wood, height 37½" (95 cm). Musée de l'Homme, Paris.

Although this work was long identified as the throne of his successor Gbehanzin, an engraving of this stool was published in 1864 in the account of the famous nineteenth-century British traveler Richard Burton, thus documenting its use in Glele's reign.

royal success. Empowering materials inserted into the bodies or applied to the surface gave them their religious potency. In the case of the silver lion, these materials were said to have included the skin of a lion with a mixture of leaves, alcohol, oil, and the blood of animals – the whole cooked to a fine powder. In addition to helping to protect the king, royal *bocio* figures were believed to give the ruler the power of metamorphosing into the associated animal so that he could evade enemy attack or surreptitiously spy on people in the countryside. Because of the importance of the lion to Glele, members of Glele's larger family have continued to use this animal as a family crest.

98. Fon (Republic of Benin). A royal door, probably from King Glele's tomb, carved by Sosa Adede, 1860s. Painted wood, 68½ x 37½" (174 x 95 cm). Musée de l'Homme, Paris.

The dog and antelope toward the bottom of this door refer to Glele's "sponsoring" ancestor. A range of tools and weapons are also depicted. Each of the various carved and painted symbols is nailed to the surface of planks in a way that suggests both the European woodworking technologies arriving in the area at this time and the primacy of assemblage in many Fon art works.

SIGN FOR KING GLELE

A gigantic *jandeme* throne (FIG. 97) was commissioned by King Glele. Dahomey kings frequently commissioned a number of stools, each having a special name. This work's unusually large scale reflects a view of the Dahomey king as someone of almost superhuman size. The carving of European palmettes on the sides of the throne not only reveals the influence of European furniture of the period, but also recalls the increasing role of palm oil production in Glele's reign. The shells at the base, modeled after contemporary European furniture motifs, serve also as local references to the sea, the source of royal wealth and the export trade. Both the mixing of styles and the importance of sculptural techniques in this and other Dahomey works complement the cultural assemblage of Dahomey political and social organization. Dahomey kings and their court clearly reveled in and sought to highlight the diverse foreign cultures and traditions with whom they had contact. The experience of social agglomeration witnessed in the course of Dahomey royal expansion was thus strikingly played out in the Dahomey artistic arena.

The pair of doors probably commissioned for the royal tomb (*adoho*) of Glele was created by the assemblage techniques of separately carved and joined pieces (FIG. 98). Most of the subjects displayed on the door derive from Glele's Fa sign, including a hornbill (alluding to the great burden that Glele bore as head of state), an elephant (the feet of which are always heard, also a reference to his father, Guezo), a horse (suggesting that even one whose life appears easy must stop to drink at the spring), eyes and nose (indicating the visual acuity of the kingdom's leader), and eight frogs (symbols of calmness and well-being).

Works associated with King Glele and his Fa divination sign include a life-size sculpture of a warrior (FIG. 99). This piece originally formed part of a palace military shrine (*boho*), where it was encircled with larger than life-size iron swords and machetes set upright in the ground. As a *bocio* (empowerment figure), the sculpture was believed to promote military victory. Offerings were made on the ground in front of the sculpture before important battles. Both the iron figure itself and the giant knives which once encircled it are said to have been commissioned by King Glele soon after his 1858 enthronement. It was first displayed during the memorial ceremonies of his father Guezo, which also commemorated Glele's first military victory. The artist, Akati Akpele Kendo, was a prisoner of war from this battle who had only just arrived in Abomey where he was set up in a smith's compound south of the palace. Found by the French on the Dahomey coast during their conquest of the country in 1894, this iron war god was

99. Fon (Republic of Benin). A warrior figure by Akati Akpele Kendo. Iron, height 5'5" (1.65 m). Commissioned by King Glele (1858–89) and dedicated to his father King Guezo (1818–58). Musée de l'Homme, Paris.

Personifying King Guezo (and by extension his son, King Glele), this work portrays the two rulers in the guise of Gu, the deity of war, smithing, and iron. Striding determinedly forward, as if to trample and destroy all adversity in his path, the figure's war tunic (see FIG. 92) billows around him as he rushes into the fray. Referred to as *agojie* ("watch out above"), this sculpture was brought to the field of battle, purportedly yelling "watch out" whenever danger was near. The sculpture's gnarled hands, which hold two large *gubasa* swords, are raised in anticipation of battle, ready to slice through the air in vigorous attack. On the figure's head is a spikey crown of weapons, tools, and iron icons, miniatures of the large weapons which once surrounded the figure in its palace war shrine. Similar weaponry miniatures are also a prominent feature of shrines dedicated to Gu.

100. Fon (Republic of Benin). An appliqué, from the Yemadje family workshop, twentieth century. Height 5'10" (1.76 m). Collection Curtis Galleries, Minneapolis.

The composition depicts Daguesu, a life-size sculpture of a lightning-spitting ram empowered by the god of thunder, Hevioso, which was brought onto the field of battle to promote military success and protect the troops. Thunder and lightning were compared in this area to the sound and flashes of rifle fire. Around Daguesu's neck is a bell, alluding to the psychological importance of noise in battle. Two small bottle-shaped gourds containing powerful protective medicines are tied to the figure's arms. Positioned around the sculpture are a troop of Dahomey warriors, here shown victorious over the Yoruba (indicated by their facial marks). In keeping with Dahomey artistic traditions, the skin pigment of the Dahomey troops is shown to be red, the color not only of blood and danger, but also of royalty and sacred *vodun*.

identified by them as *bo* (Ebo or Gbo), the local god of victory. The figure may have been brought to the coast by Glele's successor, King Gbehanzin, in anticipation of the French engagement with the intention that it would help to protect the kingdom at this most vulnerable border.

Another handsome war god (see FIG. 20), in this case made of wood and hammered brass, was commissioned by King Glele in conjunction with his divination sign. A 1944 description of the work powerfully evokes its visual power:

Never has war, in the confines of the human figure been illustrated so terrible: with scimitars in both hands this god marches, ready to strike blindly at whatever stands in his way. His powerful jaws are taut with the intensity to kill and his teeth are bared, like those of a wild animal, ready to charge. But most terrifying of all are his big flat feet: wherever he marches everything will be trampled underfoot and squashed.

The sculpture's keen naturalism and monumentality bely its height of only three feet (barely 1 m). Positioned near the main Abomey gate leading into the city from Cana, the figure was identified with the city's protection. Its name, *du su mon majeeto* ("the hole prevents the enemy from passing") refers to its setting next to the dry moat that surrounded the city and helped to keep it secure.

The pierced sword which is held in this (and the previous) warrior's hands refers to a prominent phrase from Glele's Fa divination sign: "The audacious knife gave birth to Gu and vengeance continues." This is said to allude both to Glele's military success, and to the many victories of his father, Guezo. These swords, according to the Fa phrase, empowered Gu, the god of war and iron, and by extension King Glele himself.

A third life-size royal war sculpture, called Daguesu, is known to us through Dahomey bas-reliefs and appliqués. The original was said to be carved of wood and bore an iron thunder axe in its mouth; since the noise and fire of thunder resembles rifle fire, Hevioso, the god of lightning, was believed to empower the work to promote military victory. An early twentieth-century appliqué (FIG. 100) shows an immense Daguesu sculpture in the middle of war, a rifle in one hand and a sword in the other. The first such appliqués are said to have been introduced by King Agaja as espionage maps (the plans of enemy cities being marked out in thread). Under King Agonglo, royal tailors of the Yemadje family took up the appliqué arts and are credited with adding motifs in cloth to royal parasols, hammocks, and cushions. The Yemadje family compound faces the palace's eastern facade and during the mid-nineteenth century they are said to have had 130 workers and apprentices. Royal appliqué arts had important didactic and commemorative functions as, among other things, funerary tableaux for key court members and family leaders. In a related tradition, the Yemadje artists' guild made giant tents (see FIG. 84) called *tokpon* ("see the country"), which were set up outside the palace during the annual *huetanu* ceremonies. The multicolored cloth icons sewn onto these eighteen-feet-high tents

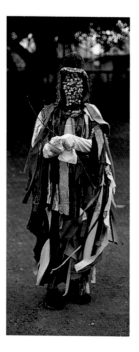

(6 m) incorporated references to royal history and power. Today, commemorative appliqué cloths (see FIG. 79) showing incidents and images from the lives of each king are prominently displayed and sold in the museum which occupies the palace grounds. Strips of bright cloth are also displayed in vibrant *kutito* masquerades (FIG. 101), dedicated to the ancestors of Yoruba people living in or near the Fon capital, Abomey.

The Final Years of Monarchy: Kings Gbehanzin and Agoli Agbo

King Gbehanzin (Behanzin), who came to power in 1889 on the death of his father King Glele, was the unlucky ruler who faced and eventually fell to the French colonial forces. Known as the "shark who made the ocean waters tremble," Gbehanzin (1889–94) was sent into exile in 1894 to the Caribbean island of Martinique. A life-size sculpture of a shark representing Gbehanzin (FIG. 102) was carved by the talented son (or adopted son) of King Agonglo, Sosa Adede. This artist also appears to have carved a stylistically similar life-size wooden lion sculpture representing King Glele. Like many other royal Dahomey figures, the gigantic shark and lion sculptures served simultaneously as royal icons and as power objects which encouraged victory in war. With forward-moving feet and fisted hands, such sculptures, like Glele's monumental iron and brass warriors, were intended to make visible the force and ferocity of the Dahomey troops.

The shark figure's multicolored surface, contraposto posture, and raised arm have interesting roots in European Neoclassical traditions and reflect Dahomey's longstanding interest in foreign art. The most likely source for this pose is the group of life-size sculptures of saints acquired by Glele's father Guezo from the French. The Gbehanzin shark sculpture, with its unusual integration of fish and human features, however, leaves little doubt that this is a work of fundamentally Dahomey artistic vision.

Gbehanzin's brother Agoli Agbo (1894–1900; see FIG. 79) was set up as nominal ruler by the French in 1894 just before the former's forced exile. Although of little financial means, Agoli Agbo played a critical role in helping to preserve and revitalize royal arts, a number of which had been transported to Europe during the conquest. Many of the royal arts collected or commissioned by Agoli Agbo are housed today in the Abomey palace museum. Agoli Agbo's name (which is shortened from his full royal name meaning "Attention Abomey the kingdom stumbled but did not fall") is iconically represented by a foot (or more rarely a shoe).

101. Fon (Republic of Benin). A *Kutito* masquerade performer in Abomey, 1986.

The traditional Yoruba *Egungun* masquerades in Abomey are often referred to as *kutito* (the honored dead). Many Yoruba men and women were brought to the Fon area as a result of wars during the eighteenth and nineteenth centuries. A number of these Yoruba prisoners rose to high, ministerial positions; others became wives of the king. Their families were granted the right to perform religious ceremonies from their home communities, among these *kutito*. As in Yoruba *Egungun* traditions, richly colored textiles make up the costume. In Fon performances these are cut or torn into thin strips to personify the dead.

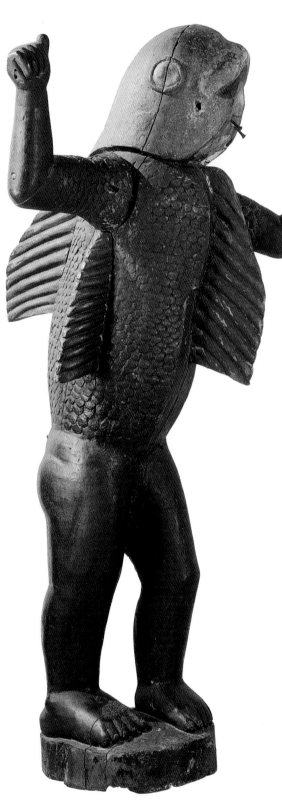

102. Fon (Republic of Benin). A sculpture of a man-shark dedicated to King Gbehanzin (r. 1889–94), by Sosa Adede. Polychrome wood, height 5'3" (1.6 m). Musée de l'Homme, Paris.

Empowered with special materials added to the surface (or secured within), such life-size sculptures are said once to have walked and talked like humans. As a royal war sculpture, it was brought into help to change the course of events for the benefit of the king.

SIGN FOR KING GBEHANZIN

This symbol is intended to suggest that Dahomey suffered from losing to the colonial forces, but the vitality of the kingdom remained. Agoli Agbo's pipe portrays a shoe (FIG. 103). Another of Agoli Agbo's symbols, a serpent biting its tail (see FIG. 87), also refers to the kingdom's durability despite its defeat.

In striking contrast to the sumptuous court arts, small multimedia *bocio* figures (FIG. 104) were used especially by non-royal personages as a means of counteracting problems in the family or village. *Bocio* of this sort played a psychological role as objects of power (*bo*) which helped to thwart danger and death (*cio* means "cadaver"). Serving as surrogates for the individuals who commissioned them, these *bocio* were believed to protect by attracting potential harm away from the person and onto the sculpture through the empowered materials that were added to the surface or interior.

Bocio conveying themes of bondage, silencing, aggression, and danger by their attachments evoke potent ideas of emotional power – power that can enable those of humble birth to gain benefits from others of equal or higher status. In contrast to royal *bocio* figures, characteristically much larger, more polished, and decorated with precious metals or imported polychrome pigments, the commoner *bocio* are small rough assemblages of local materials that are primarily inward-focused. In their expressive features, these works represent striking counterfoils to the more refined forms and physical force of the royal Dahomey arts.

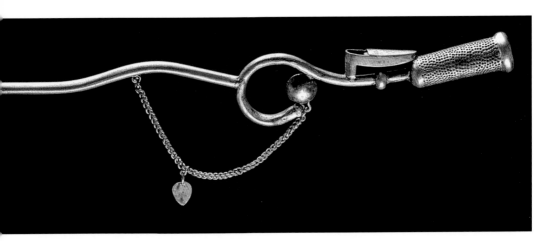

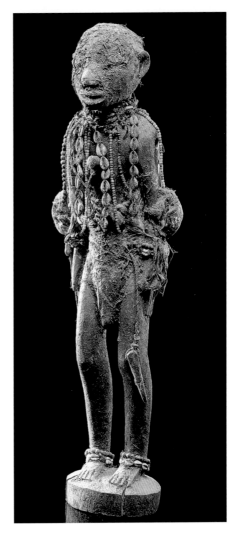

Above and top

103. Fon (Republic of Benin). This pipe decorated with a shoe was dedicated to King Agoli Agbo (r. 1894–1900). Silver, length 15¾" (40 cm). Musée Dapper, Paris.

The delicacy and curving elegance of this pipe suggest stylistic roots in late Portuguese baroque traditions (related forms flourishing much longer in Brazil than in Europe).

Right

104. Fon (Republic of Benin). A *bocio* sculpture, nineteenth–twentieth century. Wood, cowrie, and mixed media, height 32½" (83 cm). Musée Barbier-Müller, Geneva.

The means by which the various materials are attached is important to the figure's meaning. *Bocio* bound with string or cord help to restrain forces of danger. Those displaying pegs or pins are intended to protect, make ineffectual, or relieve body parts. Many sculptures also draw on the imagery and transforming powers of nature. An attached dog skull, for example, provides watchful vigilance; an owl skull offers protection against sorcery.

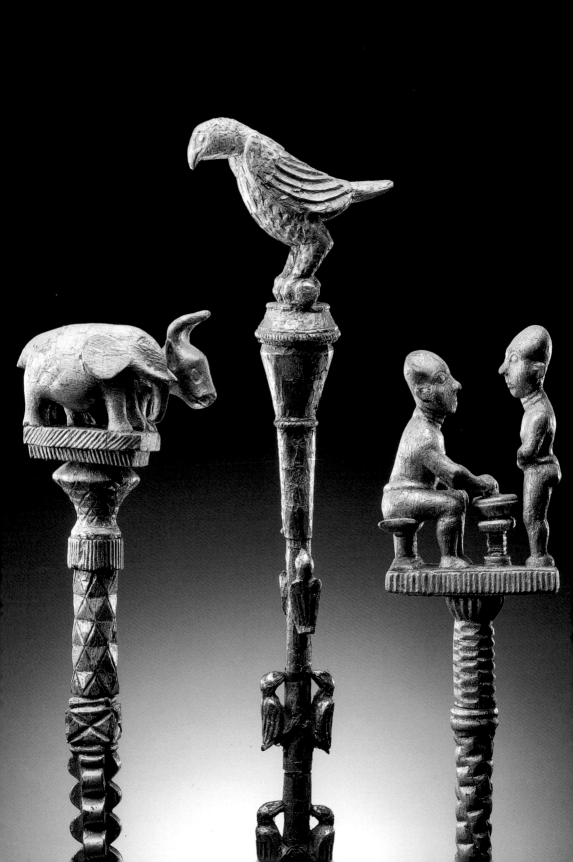

THREE

The Asante Kingdom: The Golden Ages of Ghana

105. Akan (Ghana). Linguist staffs, twentieth century. Wood and gold, heights left to right 5', 5'4", and 4'7½" (1.53, 1.63, and 1.41 m). Musée Barbier-Müller, Geneva.

Court linguists' staffs carved of wood were decorated in goldwork, showing their high status and the power of the ruler they served. Here an elephant with a buffalo represents the adage "If the elephant were not in the forest, the buffalo would claim to be a large animal" – in other words, everyone has a superior. In the finial on the right we see a man eating from a bowl as another watches hungrily, referring to ideas of power and economic difference.

E uropean travelers reaching the West African coast of what is today modern Ghana once called this area the Gold Coast. In this region of abundant gold, a powerful and art-rich kingdom known as the Asante (or Ashanti) rose to power in the early 1680s. The founder of this kingdom, a man named Osei Tutu, defeated a range of local chieftaincies and established his capital in the town of Kumasi. At its height, the Asante polity extended its influence, if not absolute political control, over a diversity of nearby groups and these various peoples, all speaking the language called Akan, today share key art and cultural traditions. Boasting a population of three to five million inhabitants, Asante political hegemony reached some 400 miles (640 km) north–south and 200 miles (320 km) east–west, from the coast, through the central forests, and into the northern savanna.

The Capital's Architecture and the Construction of Status

The Asante capital city of Kumasi is situated on a rise overlooking several streams. While the city had its origins as an early gold trading site, in the eighteenth and nineteenth centuries, Kumasi grew into a vibrant cosmopolitan center of about 20,000 inhabitants. The main north–south avenue through the city was

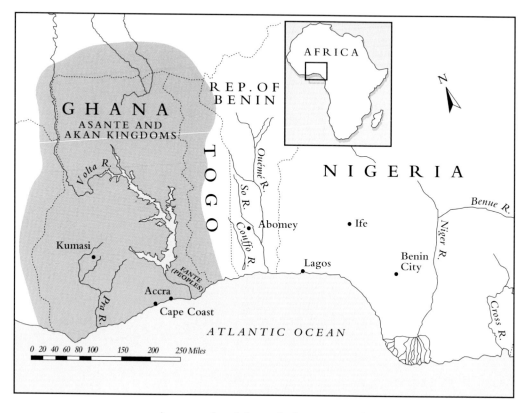

intersected at right angles by narrower lanes or streets which formed blocks, each street being named after its designated chief. Ironsmiths, goldsmiths, court officials, and Muslims lived in distinctive wards or quarters.

The British traveler T. E. Bowdich published a book of his experiences among the Asante in 1817, *A Mission from Cape Coast Castle to Ashantee*, which was illustrated with drawings of Kumasi and other towns. While these illustrations are of course the work of a Western outsider, they still provide invaluable clues to the appearance of Asante art and architecture. In one of these we see Kumasi's Adum Street in 1817 with its richly decorated court officials' residences (FIG. 106). In the foreground Bowdich depicts a street scene. On the left, a market woman sells various wares under the shade of a large canopy as two children play nearby. She holds scales in her left hand to weigh out the gold dust currency. To the right a priestess in a richly patterned skirt waves a horse-tail fly whisk as she performs a dance. On the far right a royal weaver makes a strip of *kente* cloth on a long, horizontal loom.

The houses of important Asante court officials characteristically displayed open porticoes (*adampan*) which were reached by polished clay steps. Here officials received visitors, oversaw business and administrative affairs, observed pageants, and relaxed

106. Asante (Ghana). View of Adum Street in Kumasi, the Asante capital, 1817, from T. E. Bowdich's *A Mission from Cape Coast Castle to Ashantee* (1818).

Like other important avenues in this city, Adum Street was straight and broad – some streets were over 100 yards (91 m) wide, giving them the appearance of large squares. Such streets, which were cleaned daily, served as parade grounds, reception areas, and ceremonial centers. Special platforms were constructed there for royalty to view important events.

In Asante architecture, walls of woven canes were packed with moistened earth, then decorated with geometric or figurative motifs, before being plastered. Patterns were framed in separate design fields that juxtapose solids and voids. Most of the decorative relief work was done freehand, with some use of molds.

in the evening. Inhabitants entered by a small door at the side. The interior space was divided into alternating areas of light and darkness as defined by courtyards, verandas, and rooms. As elsewhere in the Akan-speaking area, wall size, roof height, the degree of decoration, as well as the number and scale of rooms, were important status indicators.

The quality and upkeep of the capital's architecture was a central concern of the Asante royalty. Osei Bonsu, an early nineteenth-century king, promised his captains money from the state treasury after a victory so that they could enlarge and redecorate their houses. He also promised to modernize the capital's streets and to widen and straighten the road to his country residence. Osei Bonsu's architectural interests extended to new designs. Among other works, he is credited with overseeing the construction of a modern "stone palace" (FIG. 107) modeled after European buildings on the coast.

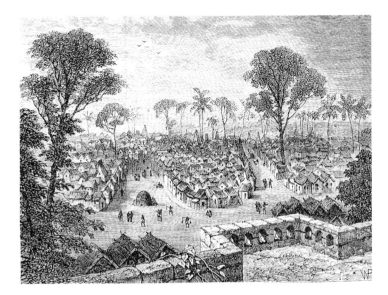

107. Asante (Ghana). View of Kumasi from the king's (or *Asantehene*'s) stone palace, completed in 1822.

The stone palace functioned as a storehouse for royal treasure as well as foreign gifts and curios. This drawing was published in *The Countries of the World*, by Robert Brown, in the nineteenth century.

Historically, Asante architecture – both royal and non-royal – was built through a process analogous to weaving. Cane or palm ribs were placed vertically into the ground and were interwoven by others secured horizontally (FIG. 108). In this technique, which is likened in Akan myth to the web-making of the trickster spider Ananse, the walls were given distinctive decorative shapes by bending the poles into curvilinear or rectilinear patterns and tying them into place with raffia cord.

108. Akan (Ghana). The palace of the paramount chief of Kokofu in the 1880s.

Since many Asante wall-decoration designs suggest the curving patterns of Islamic script, some writers have argued that they derive from this source, possibly a reflection of the important role that Muslims played as scribes and advisers at the Kumasi court almost from its foundation. However, because these motifs show considerably more variation than Arabic calligraphy might indicate, my inclination is to accept Bowdich's suggestion that the designs grew out of the woven patterns of the wall substructure; probably, Islamic elements were added to this indigenous decorative base. The fact that area temples were similarly decorated supports a local source.

The meanings conveyed by the wall designs also point to local origins. Among the various bas-relief themes, indigenous religious and political concerns are common. It has been suggested, for example, that spiral designs symbolize wisdom; looping motifs beneath a horizontal line refer to enemy jaw-bones; hearts symbolize difficulties which must be overcome. One of the most prominent design elements shows a double spiral, alluding both to ram horns (and physical strength) and to the sky god Nyame. This motif on palace buildings may underscore the sacred identity of the ruler. In those few examples in which more naturalistic forms are depicted, ideas of political power predominate. A temple bas relief showing a crocodile biting a mudfish, for example, refers to the proverb "whatever the mudfish acquires ultimately will go to the crocodile," which suggests both that chiefs benefit from their subjects' success, and that the weak are exploited by those in positions of power.

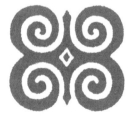

RAM'S HORNS. SYMBOL FOR
HUMILITY, EXCELLENCE,
WISDOM, KNOWLEDGE

Apart from their great size and complexity, the plans of Asante palaces and temples were little different from commoner residences in the area. Most such structures were defined by one or more interior courtyards (*gyase*) circumscribed by four rectilinear rooms (*adampan* or *pato*), whose three-foot high (1 m) earthen plinths faced the center. Adjacent verandas served many functions, including sleeping, relaxing, entertaining, and the storage of regalia, musical instruments, and shrine materials.

With its proliferation of interior courts, the Asante royal palace was a vast labyrinthine structure spreading over five acres (two hectares). In terms of both scale and decoration it constituted by far the most important architectural complex in the capital. The exterior was distinguished by a 600-foot (200 m) passage that ran along the front. The main entrance into the palace was through a corner door large enough to allow open royal parasols. Rooms leading off this passage were occupied by court personnel, with servants residing near the exterior and high-ranking officials situated closer to the interior. The latters' residences were the most extensively decorated. Also gained via this passage was the beautifully ornamented Main Court (*Pramakeseso*), where daily discussions and debates took place. An immense forty-foot-high (12 m) Judicial ("Palaver") Hall nearby was marked by an arcade and exuberant entablatures in fan and trellis work. The king's bedroom (FIG. 109) with its gold and silver filigree wall ornamentations, pillow covered bed, and oval (rather than rectilinear) access doors was also striking.

Housing for the king's wives was located behind the palace. The residences of these women were said by Bowdich to have been

109. Asante (Ghana). The king's sleeping room in the Kumasi palace, from T. E. Bowdich's *A Mission from Cape Coast Castle to Ashantee*, 1819 edition.

One of the most beautiful sections of the palace was the square bedroom of the king. Checkerboard fabrics were hung inside the doors, offering privacy and protection from the elements. In the corner of this compound ritually important trees were planted. "Symbolic trees" taking the form of small staff-like tripods supported offering bowls. Called *nyame dua*, "god's tree" (*nyame* being the name of the sky god), these supports were also positioned in the corners of key residential and temple courtyards. Vessels placed on top of such posts held offerings for the gods.

The Asante Kingdom: The Golden Ages of Ghana 129

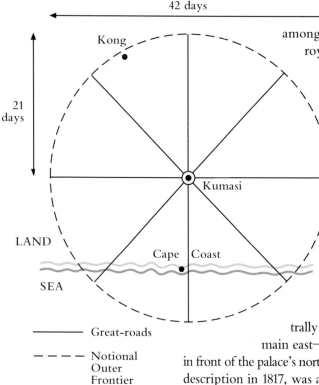

42 days

21 days

Kong

Kumasi

LAND

Cape Coast

SEA

———— Great-roads

— — — Notional Outer Frontier

110. Akan (Ghana). A conceptual map of the Asante state as a disk or wheel with Kumasi at the center.

The width of the state (and conceptually the diameter of the disk) could be traveled in about forty days of walking, a period complementing the Asante forty-two-day month.

among the most extensively decorated in the royal precinct. No doubt it was they who did much of the ornamentation. Since many of these women were brought to Kumasi from conquered northern communities – Dagomba and Gonja among others – it may be that the women introduced their own decorating styles. Behind the wives' quarters at the Kumasi palace were gardens and a marshy area, in accordance with the tradition of locating bathing facilities, houses for menstruating women, latrines, and refuse at the rear of each house.

The Asante palace complex was centrally positioned at the intersection of Kumasi's main east–west and north–south avenues. Directly in front of the palace's north-facing entrance, according to Bowdich's description in 1817, was a royal temple. Nearby were the houses of the king's linguists, goldsmiths, ironsmiths, and parasol makers. The sisters of the king (who had important political roles in this matrilineal society) also had houses in this vicinity. Two broad streets ran from the palace at diagonals. That on the right led to the royal mausoleum at Bantama several miles away; that on the left to the market, the largest open space in Kumasi. Royal trumpeters stationed in the market used to signal the end of each day at midnight. Beyond the market was a sacred grove, and beyond that, the numerous plantations which provided food for Kumasi; artisan villages and communities of prisoners of war completed the outskirts.

With its seventy-seven wards divided by avenues radiating from the palace, the capital (and Asante state generally) is said to have assumed the shape of a disk or wheel (FIG. 110). Further roads extended like spokes to the secondary centers of the realm. Because of the economic importance of these roads, heavy fines were levied if any of the major avenues leading to and from the capital was blocked. This web of spatial organization also had considerable military importance. Armies affiliated with the Asante (FIG. 111) were merged during major battles, as in 1873–74 when an Asante army of 60,000 was massed in the unsuccessful attempt to keep the kingdom independent in the face of the British colonial invasion.

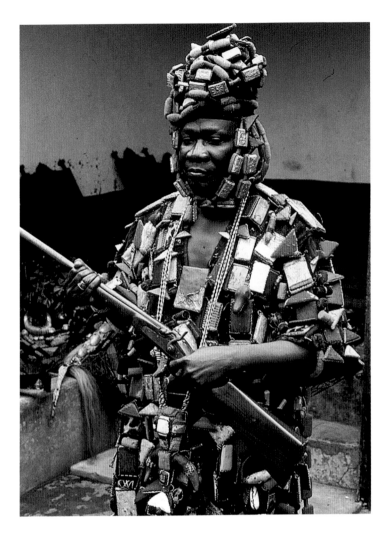

111. Akan (Ghana). The ruler of Ejisu, Nana Diko Pim III, wearing the "great" war shirt and helmet, 1976.

High-ranking individuals in the army wore a special armor of war shirts and helmets covered with thick hardened leather amulets. While the shirts themselves offered considerable protection, so too did the Koranic verses and medicinal materials held by the amulet packets.

Both political and ritual concerns are addressed in Asante (and other Akan peoples') landscaping traditions. Large trees of the *ficus* variety (*gyannua*) were positioned along most roads and streets (see FIGS 107 and 108), providing shade for the many activities which took place outdoors. The name Kumasi (*kum*, a tree; *ase*, under) itself is said to have derived from this tradition. These trees were connected with royalty since each new ruler (who was often referred to as the "shade tree" of the nation) planted a new tree at the time of his accession. The royal oath of office was given under local ancestral trees, because they were important dwelling places for the deceased kings' spirits. Before battle, a ruler would present offerings beneath his tree; after battle, the heads of fallen enemies were buried there. As markers of royal history, other trees were planted to commemorate major events during the reign.

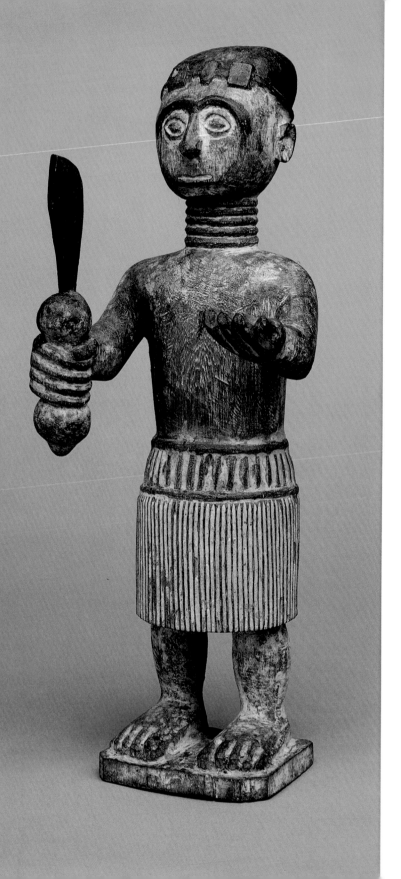

112. Akan (Ghana). Figure of a Tano priest, nineteenth–twentieth century. Wood, 19¼ x 7 x 6¼" (49 x 18 x 16 cm). British Museum, London.

In his right hand he holds a sword with the distinctive Akan barbell-shaped handle and curving blade. The priest extends his other hand to request or receive offerings. The protective headband displays gold amulets similar to those worn by Akan royals; his cloth, in contrast, suggests raffia, a material worn by commoners as well as ritual specialists.

The Role of River Gods in State Religion

Among the most important Asante deities were local river gods, who are referred to as early as the seventeenth century. Because of the life-sustaining local rivers, their gods and the associated priests became vital intermediaries between humans and the higher deities. In the western, central, and northern Akan areas, one of the most powerful river deities was Tano. Although originating with the Bono (Bron), the Asante assimilated Tano worship in the early years of the dynasty and made it into something of a state religion. As with many other gods, this foreign deity (and its priests) was brought to Kumasi in the wake of conquest; warfare accordingly figured centrally in Tano and other river-god worship. Gifts were carried to Tano shrines before major campaigns to ask for the gods' support. Following successful battles, Tano gods and their priests were rewarded with gold and silver regalia, among other riches. These river gods also promoted fertility, well-being, and protection. A wooden shrine sculpture (FIG. 112) suggests these diverse roles.

The Golden Stool: Seating a Sacred King

The foundation of the Asante state was associated with one of its most important ritual objects, the Golden Stool (*sika dwa kofi*, "the Friday-born Golden Stool"; FIG. 113). Legend maintained that on a certain Friday in 1701 the Asante founder Osei Tutu was seated under a tree, when out of the thunder and lightning-filled heavens a golden stool floated down from the abode of the sky god Nyame and came to rest on his lap. Interpreted by Osei Tutu's priest, Okommfo Anokye, as representing the soul or spirit (*sunsun*) of the Asante nation, the stool became a symbol of the kingdom's unity and vitality. The gold used in its construction was said both to represent the essence of the sun and to symbolize life's vital force or "soul" (*kra*), thus making it essential to power and well-being. Gold was further identified with endurance (through the sun's perpetuity) and life (unlike the moon, the sun never "dies"). So sacred was this stool that it could never touch the ground and was always placed on its own special European-style chair (as here) and elephant-skin mat, the ensemble reinforcing Asante ideas of political hierarchy with the ruler being seen to surpass both European and natural forces.

Since the stool carried the soul of the entire nation, no one except the king (or Asantehene) could rest against it, and then only in the course of installation and state ceremonies. Perhaps

113. Asante (Ghana). The Golden Stool displayed sideways on its own *asipim* chair next to the Asantehene (king) during the 1986 Yam Festival in Kumasi.

So important was the Golden Stool to Asante ideas of power and independence that when colonial officials sought to remove it, a revolt was led by the Asante queen mother. The Golden Stool was then buried for protection, only to be unearthed by construction workers, who in turn desecrated it in 1921. The remaining parts of the stool were reworked into a new Golden Stool, the historical, ceremonial, and political importance of which is still considerable today. The current stool has a wooden core and a hammered gold covering.

recalling earlier Akan stools, the base of the Golden Stool is disk shaped. The seat is created by a tripartite support comprised of a cylindrical column and two diagonal arms, like the altars (*dua*) to the sky god Nyame: they perhaps reinforce Asante royal ties to Nyame.

The political significance of the Asante Golden Stool was considerable, with Osei Tutu granting permission to loyal chiefs to purchase new stools. The Golden Stool legend thus played a vital role in unifying the various area chiefs and chieftaincies around the Asante king. The creation of new stools made political loyalty highly visible. Associated with the Golden Stool was a new set of laws, a new national ideology, and a new all-Asante ruling council.

The importance of the Golden Stool is reinforced by the items added to it – among them figurated and plain brass bells and fetters. The bells serve as a means of contacting the dead and were rung during related ceremonies (they were also believed to warn the ruler of portending danger); the fetters symbolize victory and the desire to keep the soul of the nation secure; the hollow human-form bells represent defeated enemies of the state, the first such

sculpture being said to depict the king of Denkyera, whom Osei Tutu vanquished soon after he came to power. This victory meant political independence and economic viability, since the Asante state could then control the coast and its European trade. The central support of the Golden Stool may serve as a symbolic equivalent of the king's dynastic tree, under which the heads of defeated enemies were buried.

Other Akan royal stools (FIG. 114) also assumed political functions. Historically, the right to use certain stool patterns was tightly controlled, the king granting permission to employ them to only a limited number of supporters. Many stools were given as gifts in the nineteenth century to those loyal to the Asantehene: in one case, the queen mother of a northern ally was offered a stool by King Osei Bonsu for her help in bringing about victory by supplying effective war charms. While in the past stools were never sold on the open market, increasingly they have become available to non-royal individuals.

The most common form of stool incorporates five support posts (one at the center and four at the periphery), which suggest the king and four subsidiary chiefs or the zenith sun and four cardinal points. Curving supports (see FIG. 114) are

114. Akan (Ghana). A royal stool, late nineteenth century. Wood and silver, 15 x 23½ x 13¼" (33 x 59.5 x 34.5 cm). The Nelson-Atkins Museum of Art, Kansas City.

Each stool bears a wealth of anthropomorphic symbolism: the support symbolizes the neck, the seat for the face, protrusions at the lower ends of the seat for ears, the bottom of the seat for the back of the head, and the holes carved in the seat top for the mouth. These holes also allude to the ability of ancient stools to communicate power and well-being to living chiefs.

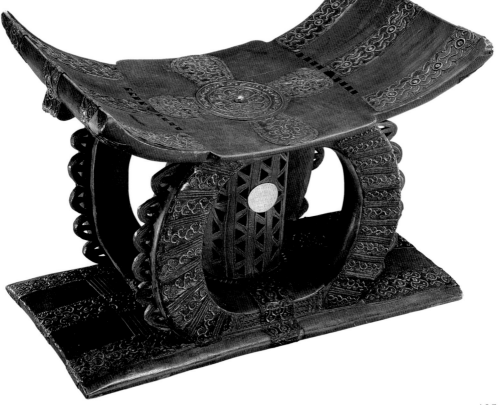

MOON. FEMININE SYMBOL
FOR FIDELITY, PATIENCE,
DETERMINATION

said to suggest rainbows, and more naturalistic supports include such royal animals as the elephant and lion, especially during the twentieth century.

Like the Golden Stool, the thrones of rulers, queen mothers, and chiefs were often covered with precious metal. The choice of metal and variations in size as well as other decorative features served to distinguish rank, gender, occupation, and so on. A range of messages were conveyed through the geometric patterns of the supports, including rainbows, moons, serpents, gunpowder kegs, padlocks, amulets, and references to defeated kings. Other motifs allude to military prowess, and wisdom.

When a new ruler came to power he would lower himself three times over his predecessor's stool, the transfer of power occurring when he lightly touched the seat. In some Akan areas, the new king was led blindfolded into the room containing his predecessors' stools and asked to touch one stool, his selection being viewed as an indication of the type of reign he would have. Offerings were made before the tree used to carve the stool was felled: these included gold dust, which was linked to wealth and the life force, and an egg, which symbolized both long life and the care the ruler needs to take in handling the nation.

The death of a leader was spoken of by saying "a stool has fallen," an allusion to the practice of turning over the ruler's stool when he died. Then the chief's body was washed on his stool before burial and his stool was blackened by special offerings and ritual smoking. Because "blackening" a stool necessitated considerable financial resources, it was reserved for persons of great stature and wealth. This process transformed the stool into a memorial for the deceased and a sacred icon through which the dead could be contacted (smoke and offerings serving as vehicles of this transference). "Blackened stools" (*nkonnua tuntum*) were placed on a clay altar or bench in the family stool room on their sides in order not to wake up the deceased (see FIG. 113).

Non-royal stools were distinguished by their color and decoration. Called generally "whitened stools" (*nkonnua fufuo*), their name derives from the periodic scrubbing of the surface with sand and lime juice to bring out the light wood color. Court officials and ordinary residents were presented with such stools at the time of important transitions. When a child began to crawl, for example, a stool was given to symbolize long life. At puberty, a girl was placed ceremonially on a stool to mark her approaching womanhood. At marriage, a bridegroom would present a stool to his wife as a sign of marital longevity. These stools were generally without the metal covering and complex iconic decoration of royal stools.

Queen Mother Figures and the Power of Gender

The queen mother (*asantehemaa*; FIG. 115) was a key figure in area kingdoms and art. Among the Asante and other Akan matrilineal groups, rulership was determined through the female line. For this reason the queen mother has frequently been described as the most important person in the state. Like the king, the official Asante queen mother was selected from a pool of candidates. She served as both the symbolic mother and sister of the king and the primary kingmaker. She participated in the royal council, and became ruler-in-residence whenever the king was away from the capital. The female complement of the king and Nyame, the queen mother was linked to earth goddesses, playing a ritual role in agriculture, judicial mediation, and procreation.

Sculptures representing Akan queen mothers (FIG. 116) were housed in the royal stool rooms, or were made for shrines dedicated to river gods, among these Atano (or Tano). A large number of sculptures representing royal mothers and children were created between 1870 and 1930, a period when matrilineages witnessed a dissipation of their power as a result of the increasing colonial presence. Political and social disintegration was addressed

115. Akan (Ghana). The queen mother and her court, nineteenth century. The political importance of the queen mother in Asante and other Akan polities is suggested by the rich traditions of gold jewelry, *kente* textiles, state swords, and other regalia which she and her retinue display.

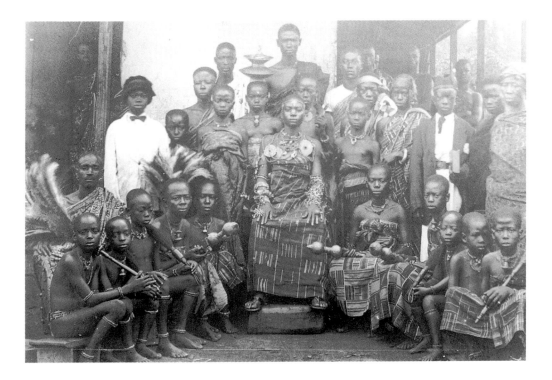

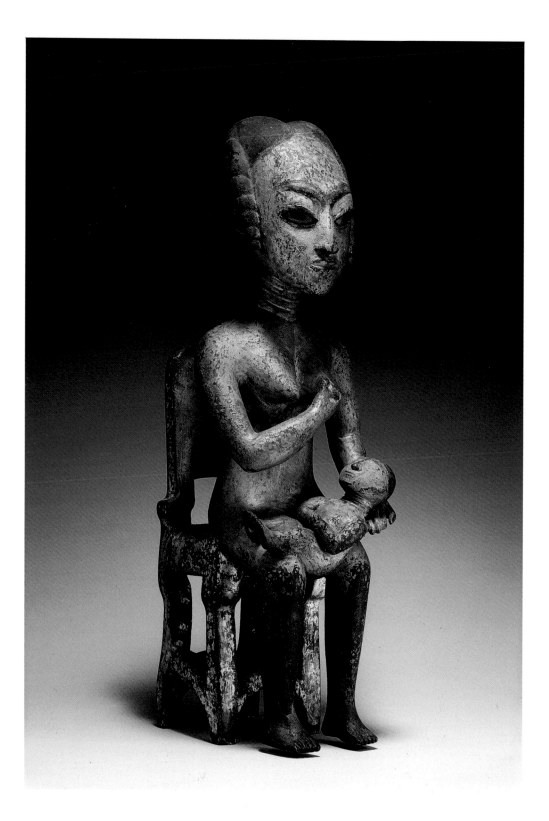

at this time through various antiwitchcraft movements in which members of local matrilineages were accused of stopping fertility within the lineage.

The dominant stress on fertility – and female children in particular – in these figures appears to have reinforced the vital role of local matrilineages in familial well-being and regeneration. The sculptural emphasis on the child's dependence on the mother for nourishment and security (as shown in the mother's gesturing toward her breast and her support of the infant's head) may refer at the same time to the dependence of each individual on the matrilineage. Late nineteenth- and early twentieth-century concerns among the Asante with fertility, the future, and the family may thus be alluded to in this figure. From the 1920s to 1940s popular music groups displayed mother and child figures of this sort at performances. In addition to local patronage, sculptures representing royal mothers were commissioned on the encouragement of a British colonial officer, Robert Rattray, as objects representing Asante culture at the 1924 British colonial exposition at Wembley, London.

In the various queen mother portrayals, the figures are shown naked, perhaps recalling the tradition that rulers remove their clothes during enthronement rituals. Gold body paint reflects not only the use of gold dust as a royal cosmetic but also the historic importance of gold in the local economy. Just as many Akan women today have become wealthy as traders in cloth and other goods, women in the area once took full part in the mining of gold. It was women who monopolized not only alluvial river mining but also the labor-intensive process of prospecting, panning, washing, and transporting this metal. In southern Akan areas, figures were sometimes painted white, complementing the practice of covering one's body with white kaolin as a mark of reverence and devotion on important days of worship. These figures were also sometimes painted black, in keeping with the tradition of blackening stools.

Regalia and the Art of Display

When Asante queen mothers, kings, and other Akan dignitaries appeared in public they were accompanied by large retinues (FIG. 117). The king's youthful sword-carrying "soul" protectors were arranged on *dwa* stools in two flanking rows in front. Linguists, bodyguards, drummers, bell-ringers, and parasol-bearers would be positioned behind the king, those to the left being princely office holders, those to the right non-royal authorities.

116. Akan (Ghana). Mother and child sculpture, by Nana Osei Bonsu, early 1930s. Wood, 17¾ x 5¾ x 6½" (45 x 14.6 x 16.5 cm). Seattle Art Museum.

The prominence of mother and child images in Nana Bonsu's oeuvre is of interest with respect to Asante carvers: it was common to call carvers the "wives" of the chiefs for whom they worked. In the same way that the queen mother served as a transitional figure between the present, past, and future royal line, the carver, because he created vital forms of regalia such as stools, was seen as giving "birth" to important icons of the state. Accordingly, certain social privileges and judicial prerogatives held by women were granted to important Asante artists.

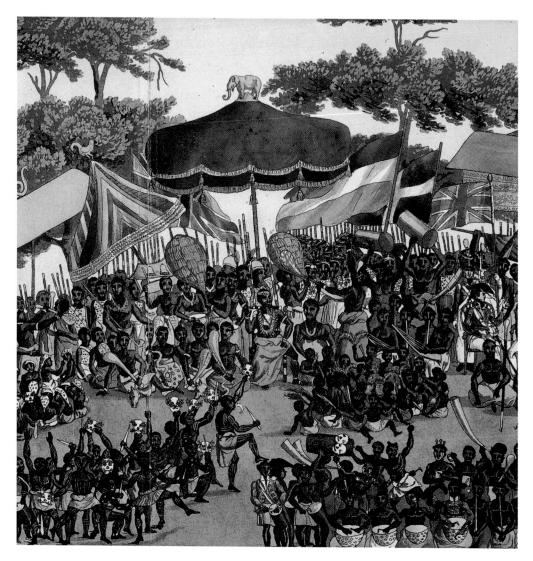

117. Asante (Ghana). The Asantehene Osei Bonsu of Kumasi, seated with officials, from T. E. Bowdich's *Mission from Cape Coast Castle to Ashantee*, 1819.

Gold figures prominently in royal jewelry, each motif carrying its own meaning. Gold animal teeth signify the ruler's aggression; gold eagle talons allude to fearlessness, a hen refers to the ruler's role as guardian. Bell-shaped beads call the attention of the spirits. Sandals, often elaborately decorated with gold, were worn by the king because it was believed that once "enstooled," a ruler's feet could not touch the earth without potentially polluting the soil and causing widespread illness or famine. Other members of the retinue generally went shoeless. Similarly, whenever a king was expelled from office, his decreased status was symbolically marked by the forcible removal of his sandals. Islamic script sometimes was written on the soles of the royal sandals.

Like the sandals, the ruler's umbrella was a potent rulership icon. Such umbrellas served both to shield and "frame" the ruler as he journeyed inside and outside the palace. The carved finials of these umbrellas displayed kingly symbols: here the royal elephant, while others include a bird which turns its head to the rear, a reference to the proverb "Pick it up if it falls behind," meaning that whatever mistakes one has made in the past can be corrected.

Gold assumed an aesthetic and symbolic function in these and other rulership displays. To some degree identified as the sun's earthly complement, the king, like the Golden Stool, represented the soul and vitality of the nation, an idea reinforced by the extraordinary quantity of gold in his regalia. Gold icons were incorporated into royal headdresses (see FIG. 113) and jewelry to display status, protection, and well-being. The tradition that palace goldsmiths originally came from the Denkyira and Akim communities in the south, whose power had been usurped by the Asante monarchy, added to the association of gold with power. That many gold regalia were said to have derived from war booty reinforced their potency. In addition to being the currency, gold had prominent associations with the giving and safeguarding of life. Gold dust, accordingly, was sometimes smoothed over a ruler's face and body before court ceremonies and during the rites preceding burial.

One of the most important Akan gold regalia is the round "soul disk" (*akrafokonmu*, "soul washer's disk"; FIG. 118) worn by the ruler, the queen mother, and certain members of the court (swordbearers, linguists, and military leaders). Like many African gold jewelry forms, these disks were believed to protect the wearer

118. Asante (Ghana). A "soul washer's" disk (*akrafokonmu*), nineteenth century. Gold, diameter 3¾" (9.8 cm). The Cleveland Museum of Art.

This disk once belonged to the Asante king Prepeh I and was made before his exile (forced by the British) to the Seychelles in 1896. Radiating rosette designs on these disks appear to draw their imagery in part from the radiating sun, the ultimate source of each person's *kra*, the spirit essence given to a child at birth and removed at death. Similar radiating patterns also are seen both in the conceptual plan of the Asante state (see FIG. 110) and in African Islamic pectoral traditions such as those worn by the Tuareg and other Sahara groups.

119. Akan (Ghana). A "soul washer" with his disk and state sword, 1986.

As living symbols of the vitality and destiny of the king, "soul washers" (or purifiers) tasted the king's food before he ate to make sure it was safe; historically, when a king died, his "souls" were under obligation to accompany him to the tomb.

from danger. For this reason, similar disk-shaped pectorals were worn by women during puberty rites.

Akan kings frequently employed special "soul" bearers (FIG. 119), whose headdresses and pectorals incorporate disks of this sort. Called *akrafo* ("souls" or "soul washers"), such officials conducted the ceremonies to purify (wash) the chief's soul in the course of renewing it. Selected as children both because their birthdays fell on the same day of the week as the king, and because their physical attractiveness was seen to complement the beauty of the king, the royal "souls" were positioned in front of the king on formal occasions, constituting a symbolic shield.

Class difference was an important part of the "soul washers'" identity. The first "soul" was said to have been a prisoner of war, the nephew of a defeated king (hence a potential heir) brought back to Kumasi by Osei Tutu after his victory over the Dormaa. Bowdich notes that subsequent "soul" bearers were usually slaves, country prisoners of war – the whitened raffia fiber cords that once supported Akan soul-disk pectorals reinforce this rural identity. In addition to symbolizing the sacrosanctity of the ruler as "soul" of the nation, the disks and their "washers" make it clear that a ruler's authority is dependent on status difference. Soul washers would also carry state swords (*afena*; see FIG. 117) in front of the ruler, and would often wear both special gold-decorated leather headdresses, and amulets made of the hides of dangerous animals such as crocodiles and lions.

Afena swords were carried by military officers, ambassadors, and messengers representing the ruler on state business as markers of their official status. With their distinctive curving metal blade and gold foil-covered handles of barbell shape, swords had important political functions, among these the making of oaths. In the late seventeenth century, the king of the Denkyira in the south is said to have sent officials carrying such swords to Kumasi when demanding their gold-dust tribute. Local traditions suggest that Asante kings adopted this type of sword after Osei Tutu's

120. ALBERT ECKHOUT
Akan (Ghana) man from the
Fetu kingdom, 1641. Oil on
canvas, 8'10¼" x 5'6" (2.7 x
1.68 m). Department of
Ethnography, National
Museum of Denmark,
Copenhagen.

The horse-tail decoration on
the sword hilt indicates the
figure as an officer. The red
cockle shell on the
scabbard also marks his
status, for such shells were
imported into the area from
the Canary Islands in
exchange for gold. The sea
shells in the foreground
may allude not only to the
importance of the coastal
Akan people to European
overseas trade interests but
also to the role of cowrie
shells as African currency.
To the figure's left is a palm
tree, a prominent European
symbol for the Gold Coast.
An Akan symbol of eternity,
the palm tree provided local
oil, bark cloth, and the wine
used in various royal and
religious ceremonies. Lying
at the foot of the palm tree
is an elephant tusk, an
important trade good as
well as a key Akan royal
signifier. The vine appears
to be a yam, a vital local
food source.

victory over the Denkyira. Although it was probably in use here
much earlier, this legend is in keeping with other Asante traditions
which credit the creation of key art forms to foreigners brought
into the Asante confederacy, especially through war.

A 1641 painting by the Dutch artist Albert Eckhout shows
an Akan warrior in an indigenous cloth wrapper with a handsome
sword of this type (FIG. 120). The political importance of *afena*

121. Akan (Ghana). Gold ornaments on state swords. State Treasury of Nsutahene Ghana.

These portray a range of royal themes, including royal animals such as the lion (symbolizing a ruler's bravery), powder kegs (suggesting the ability of Asante kings to travel widely with their armies), European serving vessels such as sugar bowls (representing the responsibility of the king for the material wealth of his subjects), a night bird (referring to the dilemma of making state decisions), and a crocodile devouring a mudfish (a symbol of the ruler's strength as war leader).

122. Asante (Ghana). A gold head. Height 7⅛" (18 cm). Wallace Collection, London.

Important enemy leaders slain by the Asante were commemorated by gold portrait heads such as this. They were attached to state swords as ornaments and historic artifacts which honored the military prowess of the victorious Asante monarch and reinforced Kumasi political supremacy over other groups in the area. This head was once part of the treasury of the Asante King Kofi Kakari, the ruling monarch in 1874 when Kumasi was sacked by the British.

swords is reinforced by the various gold ornaments (*abosodee*; FIG. 121) which were sometimes attached to the handle or blade (see FIG. 119). Although each king chose his own sword symbols, one of the most frequently seen comprised a head cast of gold representing a defeated enemy (FIG. 122). Like the sword itself, these supplemental gold heads held special meaning for Asante royal and military history: one of the earliest heads of this type is said to have represented the king of Denkyira, defeated by the Asante founder, Osei Tutu, in the seventeenth century. Such heads, with closed eyes and gagged mouths, recall traditions of decorating swords with skull trophies.

Other types of gold sword ornaments came into use in the period of 1925–40 after the Asante king was allowed to return from forced exile in the Seychelles and an attempt was made to reestablish royal prerogative. Sword ornaments from this period frequently refer to the ruler's authority (see FIG. 119), showing symbols such as two crocodiles sharing a single stomach, meaning that members of the same family should cooperate rather than fight.

Akan court officials were similarly identified through distinctive regalia. Among the most important of these ministers were the court linguists. Called *okyeame*, the linguists were generally non-royal officials who served not only as royal spokesmen but also as valued advisers, military attachés, judicial advocates, translators, instructors in protocol, ambassadors, foreign ministers, historians, and priests. It was their aim to "make the chief's words

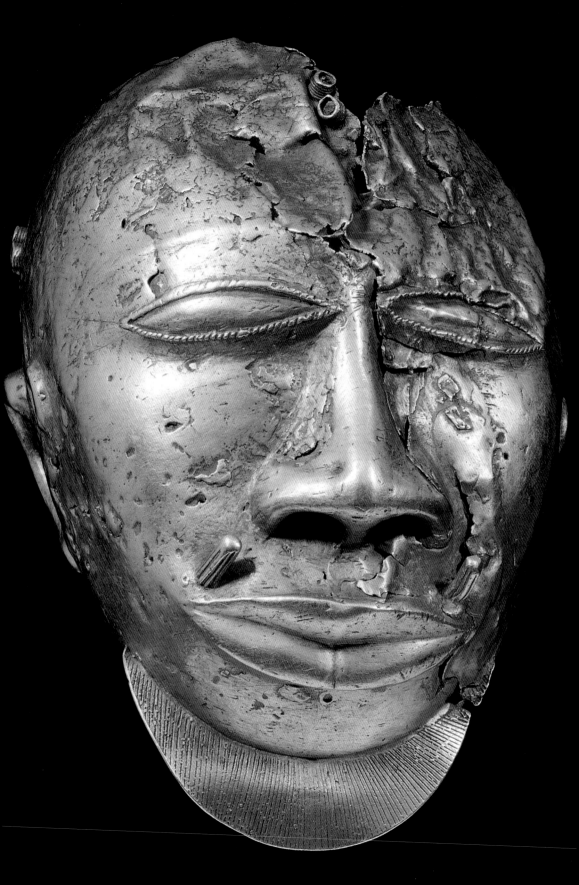

sweet." Reflecting their prominent court positions, each linguist carried a special staff (*kyeame poma*; see FIG. 105), whose three-part structure included an elaborate finial. The form of the linguist staff is said to have evolved from the walking stick used by the first Asante linguist, a man who was lame. Such staffs also incorporate important features of the European canes that were widely imported from the beginning of the eighteenth century.

The elaboration of linguists' staff finials with gold-leaf figurative scenes appears to have occurred relatively late, probably in the nineteenth century. Like many other Akan regalia, most finials have prominent verbal components which refer to the power and prerogative of the ruler, such as a bird pecking a tree, recalling the proverb "Woodpeckers hope the silk cotton tree will die," that is, like woodpeckers, small things can do little but hope that the mighty will fall. In the twentieth century, the tradition is continued by non-royal trade groups such as carpenters and fishermen, with suitably decorated finials.

123. Akan (Ghana). Goldweights, eighteenth and nineteenth centuries. Brass, width c. 1″ (0.4 cm).

The earliest Akan cast weights are said to have conformed to the weighing system employed by Islamic traders to the north, who at this time oversaw the transportation of gold from the region north across the Sahara. These early weights are characterized by their geometric shapes (circles, squares, and pyramids), and abstract patterns of a generally flattened form. As European navigators gained dominance on the coast, the traders of gold also began to use European weighing systems and figural traditions, which slowly replaced the earlier abstract forms as goldweights. The overall shift from abstraction to naturalism complements differences in Islamic and European artistic canons. Abstract weights, however, continued to be produced alongside the more naturalistic ones into the twentieth century.

The Art of Weighing and Storing Gold

The gold which covered the linguist staffs and other regalia was the subject of an artistically rendered weighing system. Originally, seeds were used for this purpose, but eventually they were replaced by small standardized weights of cast brass and other copper alloys. Cast weights of this sort (known as *abramo*; FIGS 123 and 124) were employed to measure the dust or nuggets of gold in economic transactions, fines, and levies.

With the rise of the Asante confederacy, goldweight images became more representational, possibly a reflection of the kingdom's desire to create a new identity for itself through its currency and other arts. This idea is supported by the fact that the earliest representational weights (beginning around 1600) often show simple court regalia such as fans or swords. More three-dimensional and figuratively complex works with animals and humans generally date to the period around 1700 to 1900. Direct castings of seeds, pods, nuts, snails, beetles, locusts, crabs, fish, and other forms from life were also commonplace, demonstrating a keen interest both in natural phenomena and in the nature of casting.

Regardless of form (and weight standard), the Akan goldweights often carry important messages identified with political relationships and social values. Since gold was associated with the soul (*kra*), it is tempting to speculate that processes of weighing gold dust may have helped to reinforce ethics and social values. Because most Akan people knew the proverbs and the political and intellectual bases of their messages, such concerns were continually reinforced through the weighing process, especially the need to work together as a group and the obligation to obey the king. While proverb references are particularly recognizable in the naturalistic weights, abstract forms may also have carried iconic meaning. One abstract weight symbolizing a fern is said to allude to the dangers of "abuse," the term for fern (*aya*) having a similar pronunciation. The fact that people of diverse regions, cultures, classes, and occupations used these goldweights made their imagery all the more significant.

The specific weight that each object represented added to its social and political meaning. Bowdich reports in 1817 that the king's weights were one third heavier than those of others in society. This meant that there was a sizeable and ongoing enrichment for the palace (and court officials) each time that a transaction was made with the royal weights. Such sums were a primary form of payment for court members. Because gifts to the king were weighed with the royal weight set, linguists in their roles as ambassadors and spokesmen benefited through this process. The extra income gave them the added incentive to remain in the king's good graces and make his words "sweet." Whether or not one was actually engaged in the king's business, the widespread knowledge of the enormous differentials in the local gold-

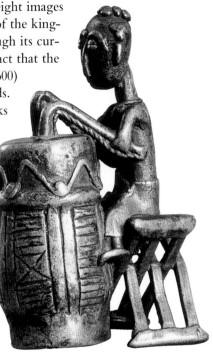

124. Akan (Ghana). A goldweight showing a drummer, nineteenth–twentieth century. Brass, 2¾" (7 cm). British Museum, London.

Kept in a special money bag, such weights belonged not only to rulers, but also to traders and others involved in commercial activities. A man might give his son-in-law a set to help to assure his livelihood.

weights must have made the potential meanings of their proverbs all the more salient. These differences were made wider still by the tradition that one fifth of all gold dust melted down in making jewelry and other objects was set aside for the king.

Small amounts of gold dust and nuggets weighed with these counterweights were sometimes kept in specially cast brass ritual containers called *kuduo* (FIG. 125) along with other valuables and offerings. Manufactured for over five hundred years, beginning around 1400, the largest number of extant *kuduo* were created in the eighteenth and nineteenth centuries, a period of increasing wealth and stratification in Asante society. Similar vessels were used to hold gifts for royalty. As a symbolic container of the soul (*kra*), the *kuduo* featured prominently in soul-washing rites, puberty ceremonies, enthronements, and funerals.

Kuduo visual roots are complex, revealing at once indigenous, Islamic, and European origins. Local pottery vessels used for religious offerings appear to have been an early source. Representational motifs such as leg irons, fetters, and keys reflect the concern with keeping one's *kra* secure. The striking similarities between *kuduo* surface decorations and Arabic script suggest that Islamic traditions were important to their stylistic development. The large number of export vessels from Europe which reached the Asante and other Akan groups in the eighteenth and nineteenth centuries were also important to their manufacture: European brass vessels were frequently used in royal and religious functions.

The lids of some of the royal *kuduo* display complex scenes – a leopard devouring an antelope or a group of court figures is characteristic. Here (see FIG. 125) a king smokes an enormous pipe, surrounded by a group of musicians. While anomalies in this scene (such as the ruler's unusual scarification marks and his lack of sandals) might suggest that the work was made by artists outside the Asante area, it has also been argued that it may represent an "inverse" image of the king during the Odwira yam festival, a yearly court pageant.

The Odwira festival, which took place at the end of the agricultural year in early September, was an event in which the kingship was symbolically "taken apart and put back together." During the Odwira harvest festival, ordinary time was suspended: gold dust was sprinkled on the king to suggest that he had ritually died. Odwira had a larger, political role. During the festival, all court officials and heads of tributary states were required to come to the capital for rites and pageants; key court cases were tried and oaths were taken to defeat enemies of the king. Odwira

125. Asante (Ghana). A *kuduo* vessel, eighteenth–nineteenth century. Brass, height 10" (25.4 cm). Musée de l'Homme, Paris.

While the term *kuduo* refers to a broad range of both commonplace and more elaborately decorated vessels, ornamental ones such as this were largely the prerogative of kings and chiefs. Royal *kuduo* were kept near the royal "blackened stools." Following an important person's death, gold-filled *kuduo* might also be placed on (or in) the tomb.

126. Asante (Ghana). A *kente* textile of the type called Sika Futura ("Gold Dust Aweaneasa"), nineteenth–twentieth century (details). Whole textile 5'10½ x 5'11" (1.79 x 1.8 m). Fowler Museum of Cultural History, University of California, Los Angeles.

Some *kente* designs honor specific people, especially rulers, queen mothers, artists, and their families. Other patterns refer to plants, animals, everyday objects, and themes such as wealth, poverty, peace, and well-being. Still others have their basis in the event or occasion on which the cloth was first worn. Design complexity is an important source for weaving names, as in this cloth called "skill is exhausted."

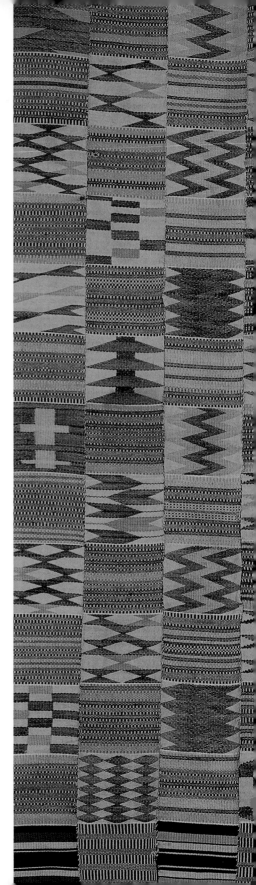

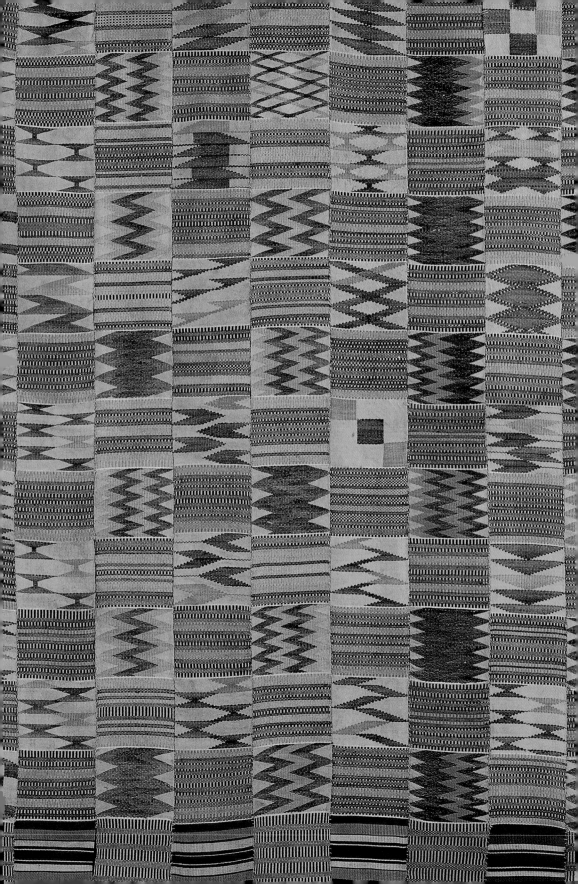

was also a complex rite of purification (*dwira* means to "purify" or "cleanse") in which past kings were honored and the whole nation was cleansed from defilement. At the beginning of the rite, the king went to the royal mortuary house at Bantama to "borrow" gold dust from the associated *kuduo* caskets for the ceremonies. Not surprisingly, Odwira was a time of enormous artistic creativity. During the 1817 Odwira rites all the extant royal gold ornaments were reportedly assembled then melted down and recast into new forms.

The importance of artistic creativity during Odwira illustrates the extraordinary demand placed on Asante kings to promote new artistic works. Not only were rulers expected to safeguard the inherited royal treasures and to exhibit them in the course of public ceremonies such as Odwira, but they also were obliged to add to the whole kingdom's artistic corpus. Failure to do so was sometimes enough to warrant removal from office. In some cases court obligations for artistic creativity became a kingdom-wide endeavor, as when in 1701 at the beginning of the confederacy, previous regalia purportedly were melted down and new ones were created for officials and loyal chiefs. While heavy new taxes and oaths of loyalty necessarily accompanied these and other artistic programs, this process also fostered new artistic forms in the Asante kingdom. Such objects became both icons of prestige and markers of the kings' creativity.

Communicating Value with Cloth: Royal Textile Traditions

The status and ritual associations of regalia are complemented in traditions of royal textiles, among these *kente* cloth (FIG. 126). While the word *kente* is from the south, of neighboring Fante origin (from the word *kenten*, meaning basket), the term has been more generally associated with cloths from the Asante area which Fante traders disseminated along the coast. Despite *kente*'s local associations, its technological roots appear to come from further north, in early textiles such as those found in sites near the Sahara in the eleventh century. Myths link the origins of *kente* to the trickster and wisdom-symbolizing spider Ananse (nature's weaver). The process of narrow-loom weaving was ritually marked: no cloth was initiated or terminated on Fridays and offerings were made to the looms after major transgressions.

While the first *kente* cloths were made of white cotton with indigo-dyed motifs woven in the weft, brightly colored imported silk (the threads derived from unraveling a whole cloth) soon

replaced native cotton and indigo, creating rich and shimmering compositions. Today rayon is more frequently used instead. Distinguished by their design complexity, the most vibrant *kente* patterns were created through the use of a second pair of heddles (the frames of vertical cords on which the warps are threaded). In the finest such cloths, "floating-weave" patterns (called thus from their appearance) conceal many of the warp threads. Under the late Ghanaian president Kwame Nkrumah (who governed from 1957 to 1966), *kente* came to assume a Pan-African identity. A 1966 cloth created in honor of his wife, Fatia, signified "a nation is not built by one person," an aphorism as important to ethnic pride and nation-state building as it is to kingship itself.

Each *kente* pattern has its own name. More than three hundred warp and weft patterns have been documented. Names may derive from visual features of the cloth itself; for example, "liar's cloth" incorporates sharp shifts in the warp design and an alternating movement from right to left. This cloth was said to have been worn when the king held court, as a means of questioning the veracity of the people who came before him. Men usually wore and still wear their *kente* cloth over the left shoulder and upper arm, the left being the arm of potential danger.

127. Asante (Ghana). Making *adinkra* cloth in Kumasi, 1888–96.

Political themes figure prominently in *adinkra* cloth design. A simple cross, for example, is said to represent the two-story house, symbolizing authority and power; a series of concentric circles represents the king and thus ideas of greatness and magnanimity. A Maltese cross refers to the dictum "if the hen steps on its chicks, it does not die," a reference to both the need for royal and familial protectiveness and the reality of power differences. A crescent moon is associated with women and ideas of faith and patience.

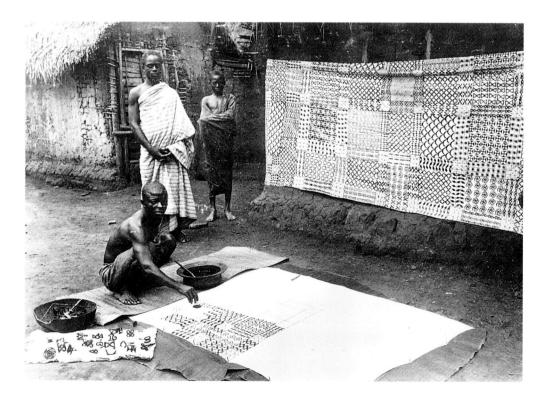

Women generally wear two somewhat smaller cloths as a skirt and bodice.

Asante kings had considerable control over *kente* cloth production and use. Centered at Bonwire, a village twelve miles (19 km) east of Kumasi, royal weaving was established here in the seventeenth century. Historically, kings maintained control over design through a form of royal "copyright." A new *kente* design would be shown first to the king so that he could reserve the pattern for himself if he so wished. Even in recent decades it would be unthinkable for an ordinary person to wear the same cloth as a ruler. The great expense of imported silk meant that many such cloths cost more than a full year's wages. The richness, design complexity, and expenses of *kente* cloth present a striking contrast to the rough bark cloth coverings which were historically worn by hunters, rural residents, slaves, and certain priests. Bark cloth, because it was produced from local materials, was at once far cheaper and more widely available. The bark cloths' visual and monetary contrast with *kente* clearly increased social distinctions.

Adinkra (FIG. 127), another important textile identified with the Asante court, is made of cotton stamped with bark-dye designs. Like many other Asante arts, this cloth was said to have been introduced into the kingdom after a military campaign, in this case following the Asante victory over a king named Adinkra in 1818. When King Adinkra was taken to Kumasi as a prisoner, he is said to have worn a stamped cloth of this type, its pattern chosen to express his great sorrow at his loss of freedom and the deaths of his soldiers. *Adinkra* cloth has continued to be employed by the Asante primarily as a funerary textile. In keeping with this idea, Prempe I chose to wear *adinkra* when he was forced into exile by colonial officials in 1896. While historical evidence indicates that the cloth's use in the area predated King Adinkra's defeat in 1818, the linking of the textile to a military victory shows the need (and drive) of Kumasi rulers to be identified with military prowess and artistic change. There is also an important lesson about royal prerogative in Adinkra's story, for it is recounted that he had commissioned a golden stool for himself, which (with his arrogance and disrespect) so angered the Asante ruler that he forced Adinkra to be brought to Kumasi in chains.

Like many other Asante arts, *adinkra* cloth was seen to carry important messages to its viewers (the term *nkra* itself means message). As with goldweights, such messages were often linked to the soul, and the source of the message and its insight were said to come from the gods. The dye stamps used in *adinkra* cloth

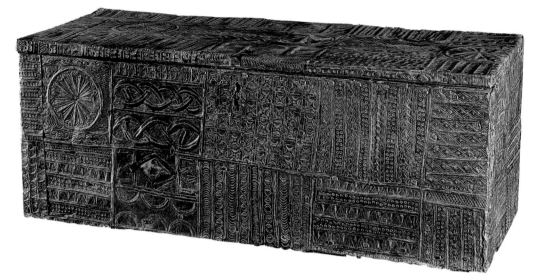

design take both naturalistic and abstract form, many being similar to early Akan goldweights, headgear ornaments, and sandal decorations. The earliest such motifs were said to have been done freehand, but the majority of cloths from recent years are stamped.

Funerary and Fertility Arts: Links between Past and Future

An unusual form of casket (FIG. 128), decorated with repoussé designs of brass similar to those found on kuduo vessels, once functioned as a royal ossuary. The ruler's skeletal remains were placed in this small box after the body had been desiccated and the period of ritual mourning had come to a close. This unique work was housed at the royal mausoleum at Bantama, now a suburb of Kumasi, where each late king had his own enclosure.

Distinctions in the royal afterlife are exemplified in this royal casket. While deceased kings and court officials were said to take up residence with the gods, continuing their life of luxury and renewal, the spirits of lower-class persons were believed to remain on earth at the periphery of the village, living a life of continuing drudgery. Similarities in the royal casket decorations to those found on *kuduo* gold dust containers reinforce these differences between kings and other members of society in the afterlife.

Terracotta vessels and statuary constitute the great part of Akan funerary art. So important were these vessels to rituals of death that the word for tomb, *asensie*, means literally "place of pots." Known as "family pots" or "matrilineage pots" (*abusua kuruwa*;

128. Asante (Ghana). A casket from the royal mausoleum at Bantama, near Kumasi, nineteenth century. Brass, wood, length 31⅞" (81 cm). British Museum, London.

The decoration on the casket reinforces the concern with both social difference and cosmology. Crocodiles figure prominently, in reference to family cooperation, authority, and the watery route to the afterworld. One adage notes that "only when you are safe on the river bank should you tell the crocodile that it has a lump on its snout," (i.e., be wary when in the presence of those who have greater power). Soul washer disks are another widespread motif.

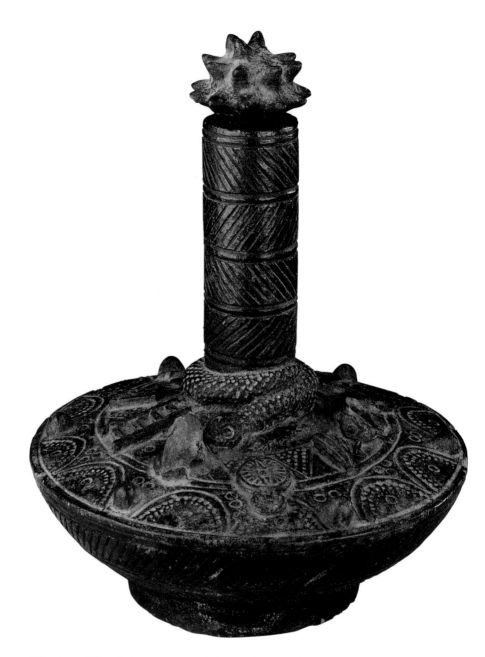

129. Asante (Ghana). A mortuary vessel, nineteenth–twentieth century. Terracotta, height 10"
(25.4 cm). National Museum of African Art, Smithsonian Institution, Washington, D.C.

Themes of death are, of course, prominent on Akan funerary vessels. Nearly all "family pots"
display a "ladder of death" to signal death's universality. As noted in a proverb, "it is not only one
man who climbs the ladder of death." Locks and keys allude to the soul and ideas of security.
Other common motifs – snakes, lizards, frogs, and crocodiles – represent creatures of the earth in
whose realm the deceased now rests. These animals also have proverbs associated with them. A
python encircling the vessel's neck, for example, refers to the proverb "the rainbow of death
encircles every man's life." Like the ladder, this motif alludes to the fact that death forgets no one.

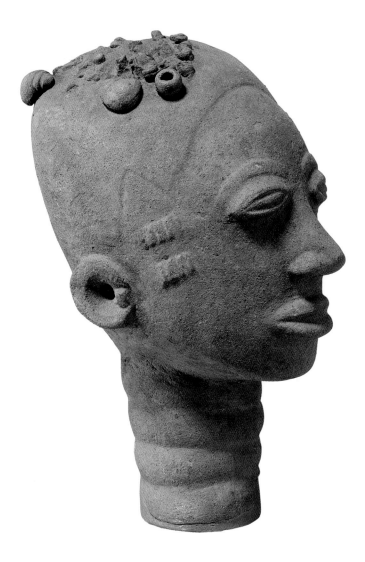

130. Akan (Ghana). A funerary head (*mma*) from the Adanse area, probably nineteenth century. Terracotta, height 9⅛" (23.2 cm). British Museum, London.

The features and styles of terracotta funerary heads show striking regional variations. Most, however, have a number of distinctively Akan attributes such as a somewhat flattened face, a wide forehead, protruding narrow eyes, and curving brows. Many also incorporate prominent neck rings, a characteristic sign of beauty in this part of Africa. Made after living models *mma* include individuating features such as distinctive coiffures, beards, scarifications, crowns, and amulets. The shaved head pattern and additive shell ornaments seen here were characteristically worn by paramount chiefs and court elders at the end of the nineteenth century.

FIG. 129), the most prestigious of these terracotta vessels are distinguished from domestic pottery by their more complex decorative patterns. Terracottas of this sort were used both as tomb markers and to serve the concluding meal of the funeral, an occasion when the family brought food to the deceased. They suggest through their motifs that in the end, kings are no different from commoners, for they too eventually will die.

Portrait heads constitute a distinctive grouping of Akan funerary terracottas (FIG. 130). These heads, as well as busts and full figures, were largely reserved for rulers, queen mothers, senior chiefs, and respected court officials. Works of this sort appear to underscore the links between royalty and values placed on individuality and identity. The earliest of the terracotta portraits

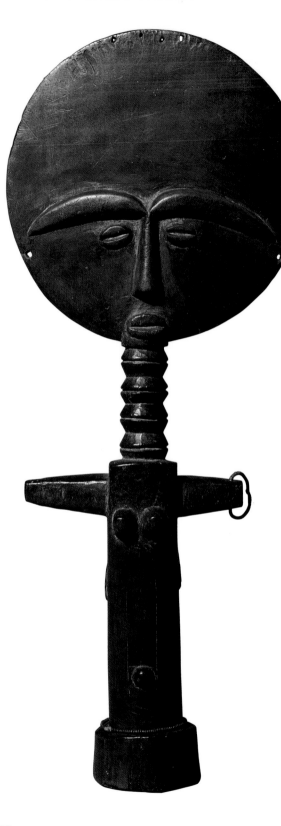

131. Akan (Ghana). An *akuaba* figure, nineteenth–twentieth century. Wood, height 13⅝″ (34.7 cm). British Museum, London.

If an Akan woman had difficulty conceiving she would be encouraged to visit a local shrine accompanied by a senior woman in her family. There she might purchase a figure such as this, which would be placed for a period on the altar, later to be reclaimed by the woman along with certain medicines. The sculpture was then carried, fed, bathed, and otherwise cared for by its commissioner as if it were a living baby. Once the woman conceived and had a successful delivery, she would return the figure to the shrine as a form of offering. If the child died, the *akuaba* would be kept by the woman as a memorial. In some areas, larger *akuaba* were commissioned specifically as shrine figures. The rigid and highly stylized features of the *akuaba* complement the idea that the fetus and infant are still incomplete and devoid of identity and personality. Early types of *akuaba* are particularly highly stylized, showing rudimentary arms but generally no hands, legs, or feet. The thinness of the *akuaba* carving derives from the fact that they were carried on a woman's back.

date to around 1600, but Akan portrait heads and figures continued to be produced into the middle of the twentieth century, mainly in the southern Akan areas of both Ghana and the Ivory Coast (among the Anyi, Kwahu, Adanse, Twifo, Wassa, and other cultures).

Terracotta funerary portraits were generally unknown in the northern Akan area of the Asante and their neighbors, but there is little doubt as to the figures' prominent court and status associations. In his 1602 description of the artistic traditions, Pieter de Marees observed that the rulers and those that served them commissioned various "pictures" of clay. According to scholars working in the area more recently, artists specializing in the terracotta figures would often be called to an ailing person's death bed to gaze at the face, later working from memory to make an associated "likeness." Known as *mma* ("infants") or *nsodie*, works of this sort sometimes represented several generations of rulers, along with members of their courts and priesthoods. In addition to serving as memorials, the *mma* were said to help promote fertility. With this in mind, women who had trouble conceiving often tended the grave sites near where the vessels were placed and presented food offerings to the deceased, the dead being encouraged to intercede on their behalf through this means.

When full figures were made, emphasis was generally given to the head, reflecting the importance of this body part to ideas of identity and rulership. It has been suggested in this light that figures with complete bodies and fully articulated arms, hands, legs, and feet represent persons of greater status than those portrayed through simple heads. Whatever their features, *mma* were often decorated with paint and special clothes. Like kings and queen mothers, they were sometimes displayed under the protection of a multicolored umbrella. More rarely they were placed on European-style chairs, suggesting the royal entourage. Miniatures of food vessels, musical instruments, and other necessities were presented nearby. The importance of the funerary terracottas (and the role of their images) was such that without this sculpture and the funeral rites it was thought that no deceased person could enter Asaman, the land of the dead.

Mma terracotta figures share striking similarities with Akan figures in wood known as *akuaba* ("Akua's child;" FIG. 131). These sculptures were named after a woman called Akuua, who, unable to bear children, commissioned a wooden image. Soon this woman became pregnant and because her first child was a daughter, *Akuaba* largely represent girls. (The political prominence of women in this matrilineal society is also reflected in this tradition).

132. Fante (Ghana). A coffin in the form of a cocoa bean, by Kane Kwei (1924–92), early 1970s. Wood and enamel paint, length 8'9" (2.66 m). Fine Arts Museums of San Francisco.

The cocoa plant and pod represented here are a subject of economic significance, particularly for local farmers. During the 1950s, when Ghana was the world's largest producer of cocoa, many Ghanaian families became rich with this crop, offering them new avenues for status and well-being. Like other coffins by Kwei, this contrasts with and continues the traditional royal funerary art forms such as caskets and terracotta figures.

Akuaba identity and meaning are conveyed in part through color. Black, the most frequent *akuaba* color, links these works to the ancestors ("blackened stools"), and to night, the period of spiritual power. The vital connections between *akuaba* and the ancestors are important to this symbolism, for deceased family elders are believed to promote conception, since they serve as intermediaries between the unborn and the living. The similar features of *akuaba* and some terracotta funerary heads (whose name *mma*, we recall, means "infant") thus reinforce the prominent role that the ancestors play in bringing new children into the family.

In addition to promoting childbirth, the *akuaba* figures convey ideals of beauty, for such works are thought to encourage beauty in infants. Like the *akuaba*, round or oval heads are considered ideal, and women would sometimes help to shape the heads of their babies with warm compresses in order to achieve a high, wide, flat forehead. Stylistic variations between *akuaba* from different areas suggest that aesthetics are not the only basis for their head and body shapes, however. Disk-shaped heads predominate among the central Akan, rectangles or cone shapes often distinguish the heads of Fante and Brong *akuaba* in the south. Although the first descriptions of *akuaba* appear relatively late – in 1885 – works of this type clearly existed before this time. Nonetheless, with increasing colonial power, and its consequent social disruption, in the late nineteenth and early twentieth centuries the production of *akuaba* may have increased, as concerns for family and social order and continuity became pronounced.

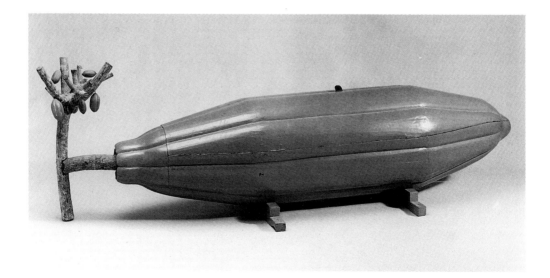

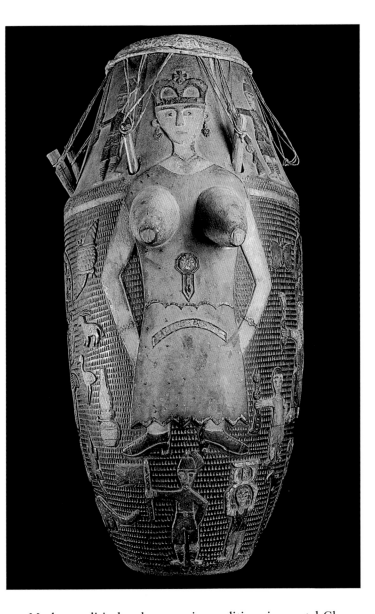

133. Fante (Ghana). This drum represents Queen Victoria, produced c. 1920. Wood and fiber, height 40″ (101.7 cm). Fowler Museum of Cultural History, University of California, Los Angeles.

As in the carvings of Asante queen mothers and other women, Victoria's breasts are prominent. Symbols of colonial power depicted on the drum include a rifle, bugle, key, and handcuffs. Fez-wearing police affiliated with the colonial authorities appear around the top of the drum. Below are displayed other figures, among these a local chief in *kente* cloth who is seated on a stool under an umbrella. Nearby are members of his court – a linguist, swordbearer, stool keeper, umbrella holder, and trumpeter.

Modern political and economic conditions in coastal Ghana led to the development of other art traditions. A carpenter named Kane Kwei (1924–92), who lived near Accra, created caskets (FIG. 132), royal palanquins, and linguist staffs. In the mid-1970s, Kwei's dying uncle requested that he make a special canoe-form coffin to commemorate the uncle's life as a fisherman. The coffin was much admired and other individuals came to Kwei requesting that he create special coffins for them as well. Among his more interesting shapes were a Mercedez-Benz (for the head of a taxi fleet), an airplane (for a frequent traveler), a hen and

134. Fante (Ghana). A flag, 1978. Silk appliqué, length 4'5⅛" (1.35 m). British Museum, London.

In contemporary flag decoration, the elephant is often shown, as here, with its trunk around a palm tree (an important source of revenue and a symbol for eternity). The motif calls to mind several local proverbs which convey ideas of power – "only the elephant can uproot the palm tree" and "Unable to defeat the palm tree, the elephant made friends with it." The elephant and palm tree motif also became a common European symbol for the Gold Coast. The Union Jack refers to the importance of the British trade (and foreign trade generally) on the coast.

chicks (for a woman with many children), and a traditional stool (for a chief). Though expensive (each costing the equivalent of the average per capita annual income), these coffins have become important symbols of status in Ghana.

Popular Traditions: Drums and Banners

During the twentieth century, richly carved drums were created in the Fante area of coastal Ghana by dance bands wishing to display distinctive drums as well as music. As with many other Akan arts, verbal complements to the drum's music were a central part of the drum's meaning. Because drums served as instruments of kingly commands, communicated through their rhythmic speech, they conveyed ideas not only of history and social mores, but also honor and status. Elaborately sculpted drums also underscore the shifting power balance in the colonial era (FIG. 133). In part reflecting the above, the drum shown here portrays Queen Victoria. Her Golden and Diamond Jubilees in 1887 and 1897 respectively saw an influx of related imagery in Ghana and other parts of Anglophone Africa.

Bright appliquéd flags and sculptures of cement identified with social groups which gained prominence in Fante communities along

the coast during the twentieth century display a complex mix of royal and colonial motifs (FIGS 134 and 135). The banners served both as religious shrine markers and as objects of display during parades. One of the most widespread flag symbols is the elephant, a symbol of royal power. An elephant-tail fly whisk was a key Akan status symbol and ceremonies accompanying the acquisition of an elephant's tail required a vast quantity of wealth.

The Asante kingdom was characterized not only by a striking diversity of arts, but also by a real sense of history in the linking of new art forms – stools, cloth, decorative sword elements and the like – to events of the past. Whether or not artistic changes were drawn specifically from these contexts, the practice of crediting actual (often foreign) individuals with these innovations is a recurring theme. The promotion of artistic creativity in the course of yearly festivals such as Odwira and in conjunction with royal events is longstanding. The continuing importance of status differences in the arts of this area is revealed in local architecture, funerary arts, textiles, jewelry, and gold weighing traditions. In the colonial and post-colonial eras, the shift in patronage from the court to local dance groups, military associations, and trade organizations saw similarly striking iconic changes incorporated into their arts.

135. Fante (Ghana). Asafo company cement military shrine (*posuban*), 1952.

The shrine displays local and foreign imagery, including royal power sumbols such as leopards, a crown-like compostion of Western-styles arches and columns, and a powder keg. These fanciful monuments serve as meeting places for male and female Asafo members. Historically, the Asafo of this area have helped in the selection of local rulers and played an important role in the enstoolment rites.

FOUR

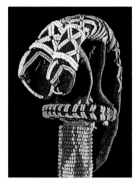

Cameroon Grasslands: Royal Art Patronage in Contexts of Change

136. Bamum (Cameroon). The throne of King Nsa'ngu, late nineteenth century. Wood, glass beads, and cowries, top 68⅞ x 37⅛" (175 x 95 cm), base 46 x 15¼" (117 x 39 cm). Museum für Völkerkunde, Berlin.

Richly decorated with beads, as is characteristic of royal thrones, the Bamum royal seat was called *mandu yenu*, "richness of beads." Njoya gave this throne to the German emperor Wilhelm II in 1908 in thanks for German help in bringing back the head of Njoya's father, which before this time had been retained by enemy N'so.

The beautiful, once heavily forested volcanic mountains of the Cameroon grasslands are home to a diversity of kingdoms, chiefdoms, and independent villages that, while largely autonomous, display considerable political, religious, and artistic unity, including complementary architecture, regalia, sculpture, and masks. The most important Cameroon grasslands kingdoms include, in the east, Bamum; in the south, the Bamileke circle (Batcham, Bandjoun, Bangwa, and others); and in the northwestern highlands, the Kom, Bali, N'so, Oku, Aghem, Bafut, Mankon, and Babanki-Tungo. Migration histories suggest that many of these groups arrived in the grasslands from the Tikar region to the east from the sixteenth to eighteenth centuries. Numerous trade routes criss-crossed the area, carrying people, art works, and ideas. Longstanding traditions of royal gift-giving and conquest also led to the striking stylistic fluidity that characterizes this region's arts.

King Njoya: Royal Visionary and Artistic Mentor

One of the most extraordinary of the various grasslands' rulers (or Fon, as they were widely known) was the Bamum king Njoya (c. 1870–1933; FIG. 137). Between 1885 and 1887, while still in his early teens, he was thrust into power following the death of his father

Nsa'ngu in battle. Assuming the throne officially between 1892 and 1896, after his first son was born, Njoya proved to be a brilliant, energetic, and forward-thinking ruler. King Njoya, shown here seated on a royal throne, understood his crucial position at Bamum's cultural and temporal crossroads, and helped to usher in great change. He oversaw a number of cultural and artistic innovations, converting at various times to Islam, while also maintaining close ties with the new European Christian missions in the area, and creating his own religious doctrine drawn from both foreign and indigenous rituals. The written language that Njoya invented similarly drew on Arabic and Western forms, as well as perhaps local divination signs. This new writing system was promoted by Njoya as a means to document pre-colonial Bamum history, medicinal knowledge, religious practice, and valued forms

of court etiquette. In order to educate his people better, Njoya established a school where his invented script was taught along with drawing, history, and other subjects.

Njoya's reign was a period of artistic flourishing. In clothing, for example, Njoya employed foreign fashions (in particular Islamic, and German) as a changing model for dress at court. Another of his artistic achievements was an extraordinary series of palaces. As is characteristic of his art and architectural patronage generally, Njoya readily drew from a range of sources, finding delight in his own innovative contributions as well. One of his palaces, built in 1917 under the direction of the artistically talented Prince Ibrahim Njoya, was a three-story structure made out of local earthen bricks (FIG. 138). Njoya resided in this palace until 1931, when he was exiled by the French colonial authorities, dying two years later under house arrest in the colonial capital, Yaounde.

In a photograph from 1912 (see FIG. 137), King Njoya wears a locally embroidered robe, turban, and high leather boots, all of which he modelled after the dress of the Islamic Hausa-Fulbe rulers to the north, who had aided him in winning a crucial battle against the neighboring N'so at the beginning of his reign.

137. Bamum (Cameroon). King Njoya in 1912, seated on a throne and giving audience in front of the palace of his father Nsa'ngu, which he renovated.

Njoya was a great patron of the arts, introducing new technologies of building, metalworking, and textile manufacture. His interests extended to the invention of new design motifs which were displayed on the palace walls as models for court artists. He pressed for increases in artistic production, abolishing long-standing royal monopolies on certain prestige materials (e.g. ivory) and subjects.

138. Bamum (Cameroon). King Njoya's palace at the capital Foumban, built under the direction of Ibrahim Njoya in 1915–17, photographed in 1976.

The design of this unusual palace completed after various scale models, was partly inspired by the German governor's residence in Buea on the coast. The elaborate throne hall in the interior reflects Hausa-Fulbe building traditions to the north and west.

It was following this victory that Njoya first converted to Islam. In this photograph, court retainers are shown standing in several lines to the side. A single man similarly attired (and barefoot) approaches Njoya, his body bowed at a right angle and his hands pressed together, the latter gesture commonly used here when speaking to the king, in order to prevent one's breath or saliva from touching the ruler.

In this and other forms of grasslands' court etiquette, status and distance are made explicit through body postures, gestures, and other features. Whether covering one's mouth with one's hand (as is commonly shown in sculptures of court retainers, servants, and officers), or as here positioning one's hands beneath the chin, the meaning is the same: when in the awesome presence of the ruler one must both temper one's speech and avert one's face from the ruler's gaze. Such actions reinforced the underlying power and prestige of the ruler, visually reinforcing the tradition that illness could strike a person who came too close to the king and either touched his body or stood on his shadow. Titles used when addressing grasslands kings – leopard, great animal, antelope, world umbrella, sun, god – suggest the ruler's vast power as well.

Behind Njoya in this photo we see the renovated palace facade of his father, Nsa'ngu. Njoya renovated this palace extensively

when his own palace building burned down four years after its completion in 1905. One of the most striking features of Njoya's renovations was his introduction of double pillars of male and female figures to replace Nsa'ngu's non-figural veranda supports. The tall, lean yet muscular bodies and prominent royal headdresses of the new palace caryatids reinforce ideas of royal power, prestige, and history.

Thrones: A "Richness of Beads"

Historically, royal thrones such as the one that once belonged to Njoya's father, Nsa'ngu (see FIG. 136), were brought outside during court ceremonies and visits of important guests. This throne stands over five feet (2 m) high and, while carved from a single piece of wood, is divided into three distinctive parts. The back is formed by two standing figures; the curvilinear seat is supported by intertwined double-headed serpents; and the rectilinear footrest or base includes armed men at each corner.

FROG MOTIF

As a visual statement of kingly prerogative, this throne is one of the most important artifacts of the Bamum court. Only the ruler could sit on a seat depicting humans or animals. The two standing figures at the back represent court twins: in the palace, specially designated twins guarded the king's burial ground and supervised coronations. The male twin on the left holds a beaded drinking horn in one hand; the other hand is placed below his chin in the gesture of respect or deference. The female twin on the right carries a calabash bowl, recalling those used to hold kola nuts, water, and food offerings. Kola nuts – chewed as a source of caffeine – grow extensively in the grasslands area and were an important trade item in Bamum. They were also offered to persons visiting the palace or participating in ceremonies. Themes of royal engendering are central to the meaning of these throne figures: they are twins; their headdress patterns symbolize frogs, themselves symbols of fertility and increase; the female's bowl takes the shape of a womb and the male's drinking horn suggests a phallus. Their prominence on the throne proclaims the king as prolific father of his people.

The two figures frame the royal sitter, visually recalling the tradition that the king never appeared outside alone. Scale here is important, as in other grasslands works, with the two court functionaries dwarfed by the seated ruler. Further motifs on the throne underscore ideas of royal authority. The spiders carved into the ends of the footrest are a reminder of the king's commitment to be prescient, judicious, and wise. At the top of the base two

SPIDER MOTIF

warriors are positioned with rifles. Relief carvings of court officers are shown along the front, these representing counselors or senior servants in court governance.

The middle area of the throne with its tightly knotted double-headed serpents is a reference to Njoya's ancestor, the great Bamum military king Mbuembue (r. c. 1820–40). Bamum kings would sometimes wear a beaded belt in the form of a two-headed serpent as a symbol of their combat strength. The richly textured cowrie and bead covering which conceals the throne's wooden core alludes to the role of the king in bringing prosperity to his people, since cowries were an important form of currency and beads were highly prized and expensive.

As with the thrones of Njoya and his father, stools elsewhere in the Cameroon grasslands are prominent political symbols. Although stools were frequently given by rulers as gifts to loyal chiefs, generally small circular stools fulfilled this role, and similar stools were used by rulers when traveling. A royal stool might display a hybrid animal, a leopard-elephant (FIG. 139). Such thrones reinforce the symbolic relationship between rulers and powerful animals, as did the tradition that for daily court hearings in the Bamum capital, the queen mother and others often sat on the skulls of buffalo, hippopotami, and other animals. The combining of two animals may allude to the king's power as a sorcerer, someone who could use four-eyed sight for both positive and negative ends. The lower and upper perimeters of this throne incorporate stylized cowrie shells. Only kings and queen mothers had the right to use stools decorated with beads or cowries. Frogs, symbols of dynastic fertility, are represented in the upper band of the seat perimeter by a series of elliptical forms, which alternate with rectangular patterns.

Thrones were ritually empowered before they were used. In the Bamum capital when a new throne was brought into the palace, it was taken to a special "house of the earth (or gods)" where a ram was sacrificed on its surface and a sacred bag containing the royal relics was walked around its circumference. Often, powerful substances were rubbed onto the throne. These medicines drew on the sacrosanct authority of both the ancestors and the king and were believed to make the throne so dangerous that no one other than its intended royal sitter would dare to use it. Sacred empowerment made it difficult for a usurper to "claim the throne" and attempt to legitimate his position by presenting himself on the seat of his ousted predecessor. Accordingly, nobody was allowed to touch a stool that the ruler had sat on except the special court stool carriers, and every time

139. A royal stool with a leopard-elephant caryatid, collected before 1908. The elephant is at the back in this view. Wood with tin overlay, height 17″ (43.5 cm), diameters 18¼″, 15″ (46.5 cm, 38.8 cm). Museum für Völkerkunde, Berlin.

Leopards and elephants are two of the most prevalent symbols of dynastic power in African royal art. In covering the stool with expensive imported materials, the work is not only made more powerful visually but also promotes status difference as defined by both wealth and accessibility to foreign trade.

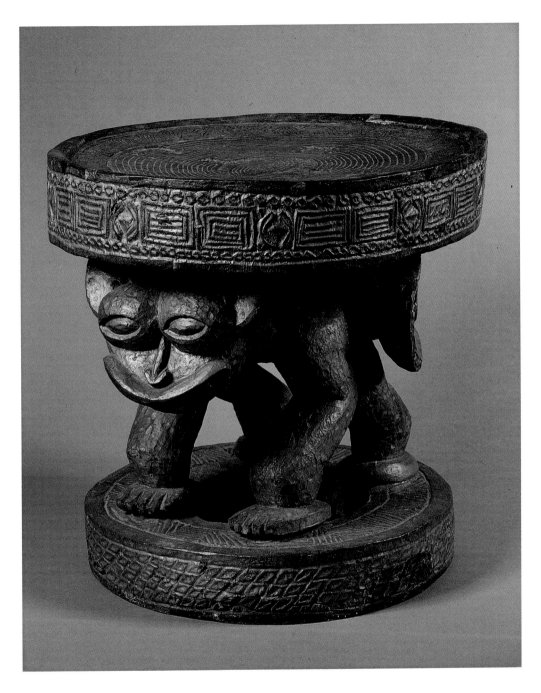

they carried it they had to swear an oath of fidelity. Because certain royal stools belonging to past rulers continued to be employed as memorials to late rulers and important members of their families, thrones also appear prominently in portrayals of dynastic history.

140. IBRAHIM NJOYA
The Chronology of Bamum Kings,
1915–32. Watercolor and colored
crayon on paper, 21½ x 29¼"
(54.5 x 74.5 cm). Musée
d'Ethnographie, Geneva.

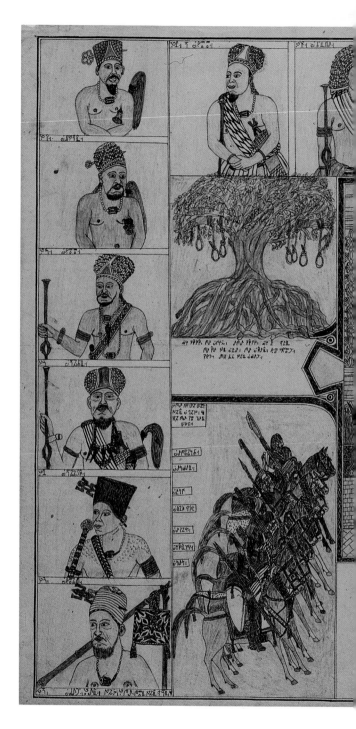

In this detailed Bamum illustrated
history, King Njoya is shown standing
in front of the portal of the palace
which Ibrahim Njoya created for him
(see FIG. 138). The star and crescent
displayed above the door refer to
Njoya's reconversion to Islam in the
decade after the German departure
from Bamum in the wake of the First
World War. Two large ivory tusks
frame the entrance, representing the
tusks in Njoya's possession that were
often positioned so as to form an arch
around Njoya's throne. In the
grasslands, images (and tusks) of
elephants were the exclusive right of
kings. As musical instruments, ivory
horns helped to sound directions to
royal warriors in the heat of battle.

 Njoya is distinguished not only
by his central positioning, dress, and
physiognomy, but also by his carrying
the book of Bamum history that he
had written during the last years of his
life. In a cartouche beneath his feet is
a drawing of one of his invented
alphabets. In the right foreground is
the sacred, beaded bag containing
royal relics – a key symbol of Bamum
rulership legitimacy. In the left
foreground is the royal gong, the two-
part structure of which (see FIG. 17) is
said to represent the king and queen.
This gong, whose sound is described
as a personification of the ruler's
voice, was commissioned by each
king when he came to the throne.
The gong was then buried with the
ruler or placed next to his tomb at
death. The mounted guards of honor
in Islamic dress flanking Njoya
represent the Hausa-Fulbe guards
which Njoya adopted early in his
reign.

A Bamum Dynastic Chronology

Bamum royal history was the subject of a striking colored drawing (FIG. 140) made in 1932 by Prince Ibrahim Njoya, probably at the request of a French administrator. Positioned at the center of this drawing is King Njoya. Because Njoya was forced from the throne in 1931, it is probable that this work was intended to serve in part as a commemoration of him, a loving prince's remembrance of his now distant king.

Other Bamum kings are portrayed in cartouches along the sides and top of the picture. The chronology begins at the lower left, with the kingdom's seventeenth-century founder, Share Yen (or Nsha'ro), a man from the Tikar area who took both the Bamum kingdom's name and the site of its future palace from an opposing king whom he defeated at Foumban. Share Yen is shown in a beaded brass necklace (a royal insignia also worn by his successors); he carries a beaded raffia relic bag identical to the one displayed near Njoya. Above Share Yen is his successor and sister Nguopu, portrayed here in male dress as she is said to have appeared, so that her sex would not be discovered. Like the depiction of other early rulers, both her features and dress have probably been generalized, but an attempt has been made to give each ruler a sense of individuality through distinctive postures and headdresses.

As we move up and over to more recent Bamum rulers, they are shown to be larger, more animated, and more individualized. This is particularly clear in the portrait of King Mbuembue (r. c. 1820–40; in the upper right corner). Mbuembue is described in Bamum history as a successful warrior who expanded the kingdom more than twentyfold (to about 125 square miles or 400 square kilometers), conquering over forty-eight chieftaincies in the process. Through these many victories he brought vast new wealth into the Bamum heartland and was able to gain control over long-distance trade, thereby assuring future prosperity. His victories also brought new art works, rituals, and social forms into the capital. Men and women who came to Foumban from the defeated lands included not only artists but also builders and field laborers.

In life, King Mbuembue is said to have been a wise and generous man of great physical height and force. Ibrahim Njoya portrays him as an individual of striking dynamism and strength. Among other attributes he wears a stylized beard-form collar of beads and a chain of leopard teeth, signifying his enormous wealth and leopard-like force. He is seated on an elaborate throne

MOTIF SYMBOLIZING WEALTHY PERSON

whose two rear figures are similar to those that surmount the throne of Nsa'ngu (see FIG. 136). Perhaps Mbuembue's throne served as a partial model for Nsa'ngu's; the prominence of Mbuembue's double-headed serpent in the throne supports this possibility.

Mbuembue's successors, apart from Njoya, are shown in this illustrated history to have accomplished far less. Certain identifying traits may be detected, nonetheless: Mbuembue's immediate successor, Gbetngkom (r. c. 1840–45), who is described as having been small and cruel, clasps a number of arrows or spears in his somewhat diminutive hand. King Mbiengkuo (r. c. 1845–50), who came to the throne as a youth and died soon after, is depicted (at left second from the bottom) in a manner appropriate to his age. Beneath him, Nguwuo (r. c. 1850–60), the non-royal court official who succeeded him, is shown with his body inclined in a slight bow, a possible reference to his humble origins. Njoya's father, Nsa'ngu (r. c. 1885–87), with the latter's mother (Setfon, r. c. 1887–94), who by right should have ruled before Nsa'ngu, are positioned between Nguwuo and Njoya. While she, a strong supporter of Njoya, is shown in the more characteristic frontal pose, Nsa'ngu is depicted in profile, his features at once framed and dissipated by the complex patterns of the indigo and white cloth behind him. On Njoya's other side is the tree from which those who broke local laws were hanged – a reference perhaps to the princes who had killed King Nsa'ngu.

This figurated royal chronology clearly draws on Western art traditions in the materials of its manufacture and such stylistic conventions as the contraposto stance of Njoya, the use of perspective in the alignment of horses, and the vanishing point of the palace entrance. At the same time, however, local attributes are prominent, including the programmatic movement from bottom to top, the "horse-shoe" positioning of figures so as to suggest the carved frame surrounding many palace entrances, and the striking turns and twists of the chronology (up, across right, down, up left at a diagonal, and across left), seen also in the movement patterns in palace architecture and portal relief decorations. In addition, the royal chronology is highly animated by the differentiated figural poses, the compositional asymmetry, variations in cartouche size, and the unequal grouping of figures on the composition's right and left. These attributes are all in keeping with Cameroon grasslands artistic conventions. Physiognomies also follow grasslands stylistic canons, including accentuated eyes, dominant pupils, and the opening of the mouth, as if to suggest speech.

Palace Architecture: The Patterning of Space

Palaces in the grasslands varied considerably with respect to form, siting, and both political and artistic importance. One of the most impressive was the Bamum palace at Foumban (FIG. 141), which covered more than 70,000 square meters. Two to three thousand people lived in this palace during the reign of King Njoya,

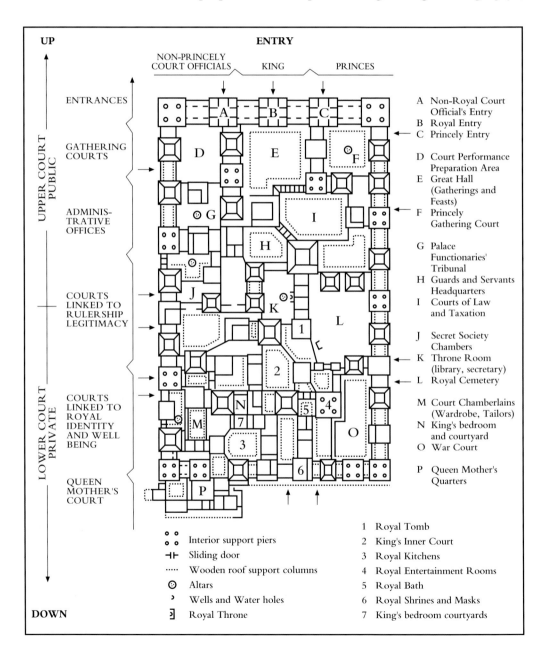

of whom about 1,200 were his wives and 350 his children. An additional 2,000 people, principally court officials and servants, also resided here. The palace was originally built for King N'sare in the 1860s or 70s and was itself constructed on King Mbuembue's palace foundation. Situated at the center of the Bamum capital, this massive palace of over one hundred buildings was afforded some protection by the 16½-foot high (5 m) circumscribing wall which Mbuembue had had constructed around the city. Then as now, the town of Foumban with its 15,000 to 20,000 inhabitants was known as an important center of art, architecture, and learning.

Three portals, referred to as the "mouth of the king" pierce the palace facade. Groups of bodyguards were positioned in adjacent chambers inside. Along the vertical (north–south, up–down) axis from these doors toward the back, the palace is divided into three broad sections. On the right are the areas associated with the princes; the center is identified with the king; the left is linked to non-royal functionaries and activities, including court officials and palace-based regulatory societies. Stretching toward the back, the interior is further divided along its horizontal (east–west) axes into a series of upper and lower sections. The program of movement through the palace is maze-like, requiring zigzagging shifts across, around, and through courtyards, verandas, and enclosed spaces, in an aesthetic of change reinforced by contrasting areas of intense light and darkness.

In the upper (front) section of the palace are the more public rooms and courts dedicated to governance, among these the great hall and banquet court in the center, the princely meeting rooms to the right, and to the left, the masquerade changing areas used by the court regulatory societies. As one moves progressively back one reaches (right in the plan) the courts of law, the tribute houses, and the prison; on the left are the areas for the punishment of royal infractions. Positioned behind this section, at the junction of the vertical and horizontal axes in the palace, is the courtyard (*lumu*) where the throne was placed. Here, near the royal library and secretarial offices, the king spent much of his day in official audiences or tribunals.

Directly beside the throne area are rooms where the highly valued and religiously important palm wine was stored. And next to them, entered by a guarded chamber, is the royal burial ground (the royal skulls were kept in a separate sacred court to the rear). The non-royal area directly opposite the royal tomb is used by the most important palace regulatory society (*mbansie*). The throne room, royal cemetery, and rooms of this powerful society all represent the vital center of the palace and kingdom.

141. Bamum (Cameroon). Plan of the late nineteenth-century palace at Foumban, based on a plan drawn up by Nzi Mama in 1917–18.

Like other royal buildings in the Cameroon grasslands area, this palace is defined by the spatial variation of its chambers, verandas, courtyards, and passageways. The plan reveals both the complexity of palace design and the enormous labor required for construction and maintenance, a need doubly felt due to frequent fires. All Bamum subjects, royal and non-royal, were required to provide construction help, offering not only time but also the building materials of raffia, grass, and wood.

To reach the more private palace sections in the "lower palace" one must cross a "court of kings," where the ruler held his private meetings. Beyond this court lie the armament storage halls and the king's bedchamber, the latter close to his bathing court and a room where he entertained his wives. In there a small orchestra of musicians performed, discreetly facing away from the king. To the left of the king's bedchamber (along the "non-royal" axis) are rooms dedicated to the king's wardrobe, with tailors' and court embroiderers' residences. The kitchen, butcher's court, and related structures are directly behind the king's sleeping room.

The palace section considered to be the most sacred, along with the royal cemetery and throne room, is positioned to the back of the king's bedroom, separated from the latter by a narrow passage. In this room (called *ngu*) the royal ancestral skulls and relics were preserved and a fire was kept perpetually burning by the wives of the late king. As a royal shrine, this chamber also housed the ritual objects employed in court ceremonials. To the right is the war room, to the left the residence of the king's mother, which extends beyond the perimeter of the palace back wall. The queen mother (or the woman who replaces her when she dies) supervises the ruling king's wives and daughters and serves as an important adviser and critic of the king. The queen mother's positioning on the "non-royal" left side of the palace underscores her role as an intermediary between royalty and commoners, since it was commoners who gave their daughters to be wives to the king, and it was their children from whom subsequent kings were selected.

142. Bamileke (Cameroon). The palace at Bandjoun, in 1992.

Historically, most such buildings were made of decoratively lashed raffia poles and packed earth in a technique recalling basketry. In modern times, cement and corrugated iron have replaced local materials and construction methods. As here, several geometric shapes may be joined within the same building, cone-shaped roofs and square or rectangular bases being particularly common.

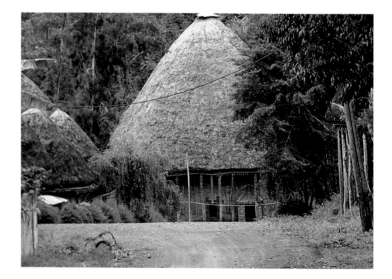

Capitaline Plans, Social Spaces, and Spider Divination

The high-pitched thatched roofs of this and other Cameroon grasslands palaces (FIG. 142) both complement and counterbalance the undulating landscape of mountain peaks and tall trees. Symbolic distinctions between high terrain and low are important in many Cameroon grasslands royal buildings. The most important of these – palaces, regal tombs, and seats of lineage-based secret societies – are usually built at the bottom of slopes; less important structures are positioned on higher ground. Reflecting associations of uphill with lower status and downhill with higher status, an important part of the enthronement rites in the neighboring Bamileke area required that the king travel downward through the capital to reach the palace and sacred burial ground and then back up, moving through political, religious, and terrains in the process.

Cameroon grasslands architecture is defined by landscape in other ways also. In the Bamileke chieftaincy of Batufam (FIG. 143), we can see the symbolic (and social) importance of palace positioning in particularly striking ways. The first area that one comes to after one enters the royal precinct from above is the market and ceremonial dancing ground, the latter incorporating enclosures for royal sculptures, gongs, and drums. As one leaves this dancing ground one descends into increasingly more restricted spaces, reaching the quarters of the royal wives and the residences of the lower (dependent) court officers. Finally one arrives at the buildings of higher (free) court officers, with the houses of the palace regulatory societies at the periphery. Next is the palace, at the rear of which is the royal ancestor temple and the grove of trees which shelters the initiation grounds. Nearby are the royal gardens and spring. Spatially opposing the

143. Bamileke (Cameroon). A schematized drawing of the palace area at Batufam.

Large stones in the palace precinct serve as seats, altars, grave monuments, and places where oaths and royal investiture rites are undertaken. Many such stones were initially used as anvils, their presence reinforcing longstanding ties between royalty and iron smithing. Spatially opposing the palace in the upland slopes were the houses of the king's sons and heirs representing, at once, potential competition and the dynastic future.

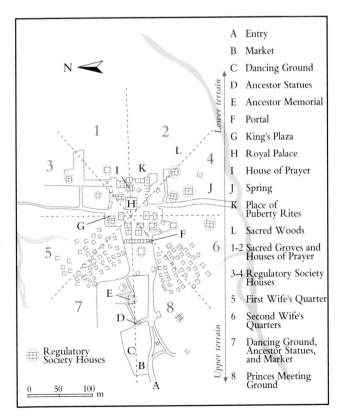

A	Entry
B	Market
C	Dancing Ground
D	Ancestor Statues
E	Ancestor Memorial
F	Portal
G	King's Plaza
H	Royal Palace
I	House of Prayer
J	Spring
K	Place of Puberty Rites
L	Sacred Woods
1-2	Sacred Groves and Houses of Prayer
3-4	Regulatory Society Houses
5	First Wife's Quarter
6	Second Wife's Quarters
7	Dancing Ground, Ancestor Statues, and Market
8	Princes Meeting Ground

Regulatory Society Houses

0 50 100 m

palace in the upland slopes were the houses of the king's sons and heirs representing at once potential competition and the dynastic future.

Since springs and rivers are especially abundant in the lowlands where grassland palaces were built, the royal grounds often took on the appearance of a fertile garden. This reinforced the identity of the ruler not only with fertility but also with the water-associated earth and underworld deities and the royal ancestors who are believed to travel to the afterworld along water courses.

Plantations of sacred raffia palm trees (an important source of wine and building materials) separate the court from other areas. Many trees in palace landscaping are believed to have special protective properties, among these *ficus* (linked to water and peace), *euphorbia* (whose sap is thought to "cool" lightning), and the *markhamia tormentosa*, a tree which is believed to counter war and sorcery. The royal dancing ground, where key public court rituals were held, is ringed by a group of gigantic *kapok* ("false cotton") trees, which were the exclusive right of rulers; each king planted a kapok at the beginning of his reign..

The cruciform plan of the palace precinct, along with its diagonal sub-divisions into left and right regulatory society meeting-houses, and opposing primary and secondary royal wives' quarters, suggests a visual complement to the earth spider *heteroscodra crassipes* that plays a critical role in local divinations. This spider, whose shape is represented in art by a cross, "X," rosette, and a six- or eight-star pattern, is associated with divine knowledge. Because it lives underground, the earth spider is viewed as a vital link between this world and that of the ancestors. In the course of spider divination, special palm-leaf chips are marked with different ideographic signs. These signs are then positioned over the earth spider's hole. After the spider has moved across and dispersed the chips, their changed configuration is read by the diviner to reveal insights into local problems and their resolution (FIG. 144). Like a spider in the center of the divination chips, the king and his palace may be thought of not only as the locus of sacred and cosmological knowledge, but also as the means for resolving problems.

144. Spider divination in the Cameroon grasslands, July 1940.

Toward the left of the grouping of divination chips is one with a circle of triangles which is intended to represent the sun, daylight, and fire.

145. Bamileke (Cameroon). The palace at Bandjoun.

The Bandjoun palace, like others in the area, was distinguished by its tall, carved roof supports, whose prominent figurated compositions enlivened the landscape by personifying individuals of present and past eras.

Sculptural Programs and Court Society

The complexity of grasslands architecture is shared in many palace sculptural programs. Exterior palace walls and enclosing fences were embellished with painted or woven geometric patterns; during festivals the inner walls and support posts in turn were draped with beautiful indigo-dyed tapestries or beadwork. Among the most artistically significant of the palace facade decorations are the roof supports (FIG. 145) and the intricate carvings which frame the entrance (FIG. 146). The figurated frames (as in FIG. 140) often include poignant references to the king, the power of the state,

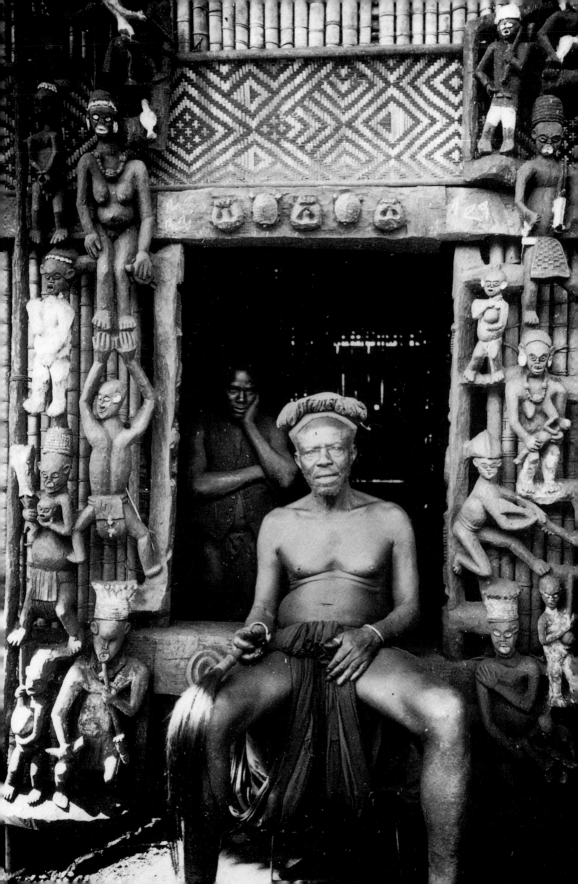

local history, and religion. Portal reliefs of this sort also convey important ideas of status. Bamileke royal palaces usually have four entrances, each displaying a range of human and animal scenes. Other high-ranking Bamileke dignitaries, however, generally only have three such doors, demarcated by geometric patterns. Two undecorated doors characterize the houses of low-ranking Bamileke officials; commoners usually have but a single undecorated door.

The Bamileke door frame gives a sense of the complexity of portal sculptural reliefs. The figures are intended to be read from bottom to top, but not in a linear fashion: rather, like a festival, one's eye focuses on both the details (the individual scene) and the larger composition simultaneously. The most frequently depicted subject of Bamileke portals is the ruler himself, who is shown in various poses – as a musician (with a flute), as a priest (holding a calabash of wine), as a judge (drawing his hands to his chin), and as a warrior or executioner (brandishing a weapon or the head of a defeated enemy). All are meant to convey the diverse identities of the king.

Displayed across the top of the palace portal of the Bamileke ruler Kamwa Mars' (early twentieth century, seen here directly above his head) are alternating skulls and turtles, the latter alluding to water, the world of the ancestors, and ideas of spatial transition in general. The skulls represent trophy heads (enemies killed in battle). They also suggest the iconic importance of royal ancestor skulls in Cameroon grasslands royal ritual and coronation ceremonies. At the door's lower perimeter, partly obscured by the ruler's fly whisk, is a coiled python. This snake serves as a visual counterpart to the skull and turtle frieze on top. Pythons refer both to dynastic foundation myths and to military power.

A range of figures decorate the portal's side frames. At the lower left is an enthroned ruler in a loincloth who carries in his right hand a royal drinking horn and in his left a long-stemmed

146. Bamileke (Cameroon). The ruler Kamwa Mars of Baham in front of his palace decor in 1930.

In characteristic grasslands style, the wooden door frame takes the form of an extended grid. The lower frieze elevates the door-sill, slowing access to the interior and requiring those who enter to take in the surrounding sculptures. Here, Kamwa Mars wears the traditional loin cloth, cloth cap, and horse-tail fly whisk of a Bamileke ruler. A court functionary stands just behind him in the palace, his humble dress belying his probable identity as an important court official. This official's hand rests underneath his chin in respect to the ruler. On the picture's right we can see the hands of another court official holding the figurated bowl of an elegant royal pipe.

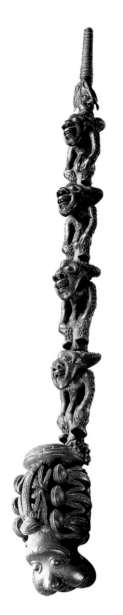

147. Bamum (Cameroon). A pipe once belonging to the Bamum king Njoya, which he gave to the German Captain Glauning in 1906. Terracotta and brass, length 5′6⅞″ (1.7 m). Musée Barbier-Müller, Geneva.

The art of smoking was a vital part of royal ritual.

tobacco pipe. The ruler's open mouth, pointed teeth (a mark of beauty) and feline ears suggest a leopard, the forest complement to the grasslands ruler. The prominent open mouths of many court figures is said to connote sacred power, specifically, royal saliva and breath. Beside this figure stands a court official with a calabash of sacred palm wine. Above him we see the ruler as a victorious war leader, his right hand holding the royal double-edged sword used in hand-to-hand combat; his left hand grasping a trophy head. A nearby man raises his arms in jubilation. A woman of towering size and carved almost fully in the round stands above this scene. She probably portrays the mother of the king or an important wife. Whatever her identity, her prominence underscores the powerful roles of women in Cameroon grasslands courts. Another woman and a bound prisoner stand nearby.

In the lowest register of the portal's right side is a seated ruler holding a bound prisoner. Above him a soldier kneels, his rifle ready to fire. Two royal wives are shown next, the larger one nursing a child; the other encircling her pregnant stomach with her arms. Together these women reinforce the role of the king as court progenitor. Another figure of the king stands above these women. Like Kamwa Mars, he wears a loincloth and carries a horse-tail fly whisk. The dynamic postures, gestures, and facial expressions of these figures complement values of action and movement which are important in court life and ritual, recalling among other things the prominent place of the royal dancing ground at the entry to grasslands palace precincts. This kinetic emphasis is also underscored by the boldly asymmetrical woven matting which runs along the doorway just above the lintel.

The stress on action within grasslands sculptural and architectural aesthetics is much in evidence in royal tobacco pipes (FIG. 147). These were among the most visible of royal regalia, the length, size, and iconography of the pipe being closely identified with an individual's overall status, some pipes being over four feet (1.5 m) long. For both status and religious reasons, persons of lesser rank were not permitted to see the king smoke or to smoke in front of him. Pipe bowls, whether made of terracotta or brass (the latter historically being limited to rulers), thus reinforce the political and sacrosanct power of the king.

The bowl of this pipe, which once belonged to the Bamum king Njoya, portrays a face, and in many Bamum pipes, these faces are said to represent the heads of defeated enemy rulers. The full puffy cheeks are both characteristic of Bamum and functional. Positioned above this face are seven chameleons or saurian lizards, key symbols of fertility because they have many offspring.

Encircling the pipe bowl is a python and an earth spider, the latter symbolizing royal wisdom and prudence. A python head also appears at the top of the pipe stem. Pythons are said to symbolize the military prowess of the early nineteenth-century king Mbuembue, who was likened to a two-headed python because he could effectively strike out in two directions at the same time during military campaigns. Extending up the stem of the pipe are the figures of four court retainers, their superimpositioning suggesting palace veranda pillars and door frames. The identities of these figures as retainers are made clear by their distinctively stooped postures and special headdresses. Together these pipe motifs underscore the ruler's obligations to promote fertility, protection, knowledge, and effective administration.

Kings as Sculptors: Portraits of the Court

The importance of regalia in defining royal status can be seen in a photograph of the Kom king Jinaboh II (FIG. 148), taken in January 1976 on the occasion of his presentation to the population a year after he came to the throne. King Jinaboh displays his drinking horn in his right hand. The occasion is marked by red camwood powder being smoothed over his body, in part to symbolize his transition from an ordinary person into an empowered

148. Kom (Cameroon). The enthronement of Fon Jinaboh II, on January 10, 1976. He invokes the support of dynastic sculptures (called *ngoyou*) which are positioned behind him. They depict a ruler (center), his first wife (left), and the queen mother, all dressed for the occasion in factory-made cloths. These figures are attributed to the artist-king Fon Yu (1865–1912). The continuing significance of such figures may be judged by the history of the ruler figure: it was sold in the 1960s but returned in 1974 after public outcry; since problems and difficulties in Kom had been attributed to its absence, its return was greeted by great celebration.

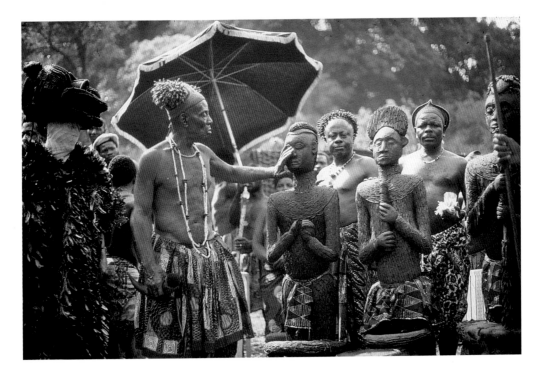

149. Bangwa (Cameroon). Left: Bangwa (Cameroon). Figure of a king. Wood, height 35" (88.9 cm). Right: Statue of a mother of twins, nineteenth century. Wood, height 32¼" (82 cm). Courtesy of Sotheby's, New York.

The woman's mouth is open as if to suggest royal speech (or breath) and the song which is the obligation of every mother of twins to learn. She would perform this song along with other twins' mothers during funerals and other ceremonies.

The man's richly textured headdress, leopard claw necklace, and palm wine container are important symbols of royal power.

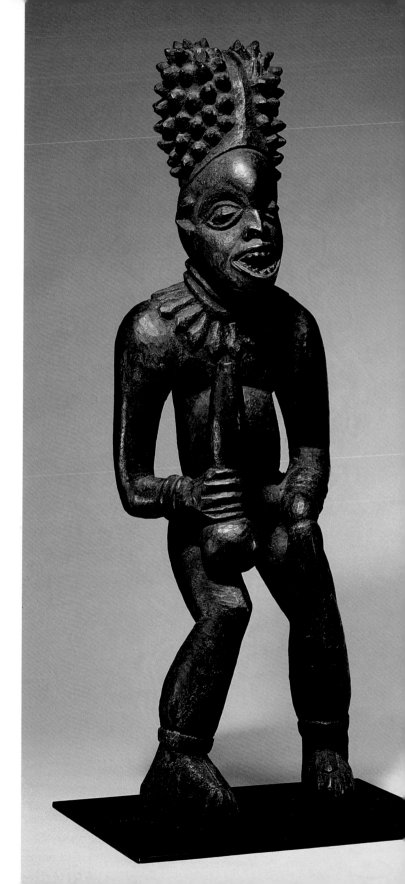

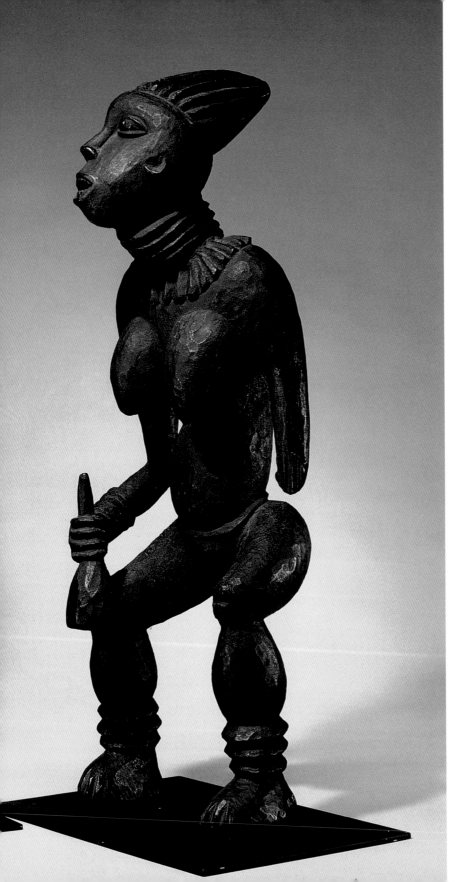

187

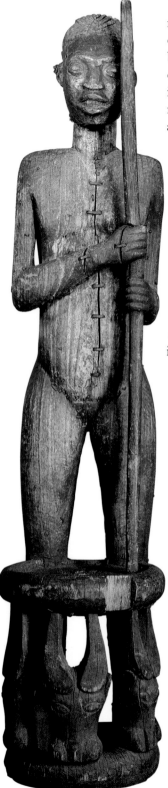

ruler. It is also rubbed over the ruler's body before burial, one of the many medicines said to help keep his soul from troubling the living. This powder is an important grasslands signifier of peace, group solidarity, and dispute resolution. Its red hue is identified with good health and with complementary ideas of morality and well-being. In conjunction with marriage, women are similarly bathed in a thick coating of camwood and palm oil to promote conception and youthfulness, the red oiliness of their bodies being said to contrast with the whiteness and dryness of old age and death.

The sculptures behind the king were carved by Fon Yu (1865–1912), an extraordinarily talented king who was also an artist. They are considered to be among the most sacred objects of the Kom court, symbolizing among other things the importance of dynastic continuity. Holes in the figures' backs may have once contained empowering medicines. Each sculpture is carved with a distinctive icon or gesture. The queen on the left cups her hands in front of her chest. The queen mother on the right holds a digging stick which is used by local women in planting, referring to the importance of grasslands women in agricultural production. A figure of a Kom queen by the same artist (FIG. 150) is shown with a similar planting stick. Whether as field laborers, cooks, mothers, or priestesses, royal women at Kom played critical roles, leadership itself being traced here to a female foundress.

The stools of these sculptures display royal symbols, including the buffalo. Because these stools are said to belong exclusively to the sculptures, they are never sat on by living persons. Though devoid of sitters, such stools recall the importance of seating generally in Cameroon grasslands enthronements and court life. In the Kom area, when a ruler died, his sons and those of earlier kings were invited to the palace. Here the kingmakers would designate their choice among the candidates, rubbing him with empowering medicines, then seating him on a royal stool. The Kom throne figures shown here represent in this way both the power of the individual ruler and the status and viability of the office.

150. Kom (Cameroon). The figure of a queen, is by the artist-king Fon Yu, collected in 1905. Wood, height 6′2¾″ (1.9 m). Museum für Völkerkunde, Berlin.

The phenomenon of artist-kings is widespread in the grasslands, particularly among the Bamum, Bali, Babanki-Tungu, and Bangwa peoples. Like the royal emphasis on fathering children and commissioning new palaces, artistic creativity was seen to be a vital part of a king's prerogative.

Motherhood, Vessels, and Ideas of Royal Fecundity

Throughout the grasslands kingdoms, memorial statues were exhibited publicly not only during enthronements but also in royal funerals, agricultural ceremonies, and commemorative festivals. They were set up in front of the palace or on the royal dancing ground as icons linked to royal history, authority, and legitimacy. The subjects carved included not only royalty but also palace ministers, and ritually powerful persons such as the mothers of twins. Shown in a dancing stance, a Bangwa female figure (see FIG. 149) wears a cowrie necklace and bracelet that mark her as a mother of twins. As a mother of twins, she also carries a rattle. Mothers of twins appear prominently in annual agriculture processions to bless the land, holding in one hand a branch which connotes peace.

As a mother of twins, this woman, like the king, is linked at once to ideas of increase and empowerment. Such sculptures are referred to as *nyui ndem,* "mother of god," in part for this reason. Since any twin born in the kingdom was brought to the palace and adopted by the king, mothers of twins were accorded high political status in the Cameroon grasslands. In a related tradition, all female twins became royal wives, thus increasing the odds that a king would himself become a father of twins. Assumed to have preternatural gifts, twins were believed to grant rulers supernatural power.

Themes of abundance and ritual authority are closely identified with the genre of figures who hold large bowls (FIG. 151). It has been argued that one of the primary roles of grasslands rulers was in redistributing wealth derived from war, tribute, and other means; the large bowls which were kept filled for guests complement this tradition. In exchange for this monetary support, the king provided various ritual goods, among them camwood for funerals and the king's own fertilizing saliva (which was incorporated into the palm wine). Keeping material wealth in the hands of the king and court featured prominently in grasslands palace life. The moat around the city, it has been suggested, helped as much in containing goods and people (prisoners of war included) within the kingdom as it did in protecting the king from outside threats. The ritual placement of medicines along roads leading to the palace served a related function. Themes of containing predominate in regalia, too, as exemplified in the royal beaded relic bag, palm-wine gourds, buffalo-horn drinking "cups," and

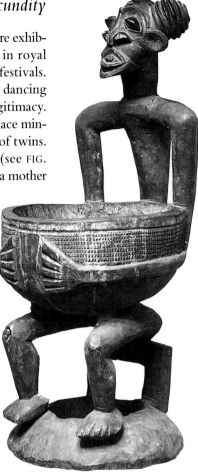

151. Bafoum-style (Cameroon). A bowl-carrier figure from Békom, in the northwestern grasslands, collected in 1908. Wood, height 21½" (55 cm). Museum für Völkerkunde, Berlin.

Beautifully carved vessels such as this were filled with valuable kola nuts and other consumables intended for visitors. The vessel both complements and serves as a substitute for the stomach.

152. Bamileke
(Cameroon).
A figure with large belly,
nineteenth–twentieth
century. Wood and mixed
media, height 6¼" (15.9
cm). Jean and Noble
Endicott Collection, New
York.

The Bangwa, Bandjoun
and other Bamileke groups
in the Cameroons have a
tradition of diminutive
sculptures with large
protruding bellies. The
figures were associated
with sufferers of various
psychological illnesses.
Powerful medicines were
inserted in the stomach.

the holes that were sometimes cut into royal sculptures and
filled with empowering materials.

Ideas of containment and plenty take on new meanings in the
light of traditions of slavery in the area. By the end of the nine-
teenth century, nearly two thirds of the Bamum population
was estimated to have been slaves working at the palace or the
estates of royal and lineage-heads. Women were in particular
demand not only as wives but also as farm laborers. Over half
of the male population at this time is said to have consisted of adult
men who were obliged to forego both sexual partners and chil-
dren. The hollow vessel as stomach, represented so strikingly in
this sculpture, suggests a visual corollary to the widespread lack of
food, partners, and offspring associated with war captives and non-
royal men, an image made all the more trenchant by the local asso-
ciation between stomachs and both rage and witchcraft.

Throughout much of the Cameroon grasslands, the anger,
resentment, and acts of sorcery which accompany personal wrongs
are believed to cause one's abdomen to swell and sometimes even-
tually burst, a striking oppositional corollary to the expansive ves-
sel–stomach motif of many palace sculptures. Certain sculptures
which portray individuals with malformed, swollen stomachs (FIG.
152) recall this suffering and pain.

Court Masquerades: Extending Royal Power through Performance

Power is embodied in other ways in grasslands royal masquer-
ades (FIG. 153). In some courts, masking societies incorporated the
heads of major lineage groups, with the king representing one such
lineage. These societies constituted one of the most important
political bodies in the area. Members served as allies of the king
and as a vital means of control, based on the tradition that mem-
bers could deprive the king of services and support and bring a
judgment against him if he did not perform his duties well. Part
of the regulatory dance society's power also derived from the
potent medicines which they possessed. As delimited by these
masking societies, hereditary leaders were under obligation both
to rule the kingdom and to be subservient to the people. The dance
societies (whose larger membership included non-royal individ-
uals and distant princes) provided key opportunities for advance-
ment in the court based on merit rather than birth. Since their
masks were usually carved by foreigners who had been brought
into the kingdom as prisoners of war, these performances also
served to integrate populations from the defeated lands into the

153. Babanki (Cameroon). A mask with spider headdress. Wood, height 27" (69 cm). The Field Museum, Chicago.

The spider, the symbol of divinatory knowledge, appears prominently in grasslands masquerades, as do frogs, snakes (suggesting the healing power of medicine), lizards (representing household tranquility), bats (wisdom), elephants (royal strength), and buffaloes (force). In the Kom area, masked persona representing various humans are prominent, among these, the chief or family leader, his wife, the warrior, the old man, and the dignitary. In these works, all of which were owned by the king, costumes, props, and choreography together reinforce the identity of the masquerade character. Up to thirty different masks might perform in an event, which thus might take on the character of a competition or contest.

154. Bamileke (Cameroon). A mask in the form of a buffalo, nineteenth century. Wood, 16⅞ x 33½" (43 x 85 cm). The Field Museum, Chicago.

Buffaloes were among the most numerous mask figures in the Bamum area, and were worn by palace regulators in their roles as market police, apprehenders of wrongdoers, and court judges. Some of the masked performers were perceived to be so wild and dangerous that they had to be restrained by ropes to prevent them from doing harm, a display that would have reinforced the original functions of these court maskers in punishing those guilty of criminal acts. When these animals were killed in the wild, their meat was distributed among regulatory society members.

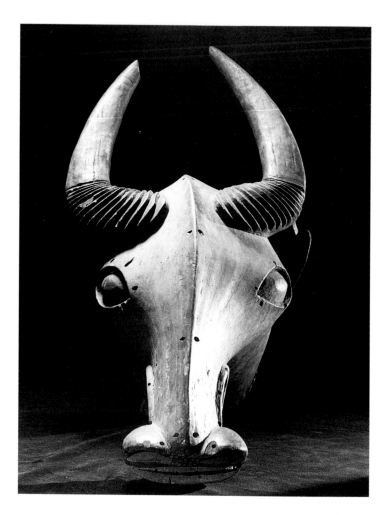

kingdom. Differences in style add to the richness of these works and to their cultural importance in reinforcing social diversity.

Members of these palace regulatory societies assumed a masked persona during both religious ceremonies and policing functions. The buffalo's (FIG. 154) distinctive physical power and endurance was viewed as a particularly appropriate metaphor for the force of palace law. Among the most important masked celebrations in the grasslands were harvest festivals (known by various names, including the Bamum rite Nja and the Bafut festival Lele). This rite, which took place in November, December, or early January, celebrated abundance (both food and material), solidarity, achievement, and beauty. Masked performers presented dramatizations which were intended to convey ideas of political power and cosmological order while at the same time helping to distance illness, drought, and other forms of

malevolence. Maskers also performed at the funerals of important society members.

A striking grasslands mask representing the royal elephant as symbol of power and wealth is made from bead-embroidered cloth (FIG. 155), with large circular ears and a prominent panel-like "trunk." Membership in the Kuosi society, who wore such elephant masks during funerals and public ceremonies, included royalty, wealthy title holders, and ranking warriors. The masks' expensive beadwork indicates the considerable wealth of society members. Color symbolism in these and other beaded works is important. Black, the color of night, suggests the relationship between the living and the dead. White, the color of bones, is linked to the ancestors and is important in medicinal contexts. Red, which is associated with blood, symbolizes life, women, and kingship in general.

Ndop Cloth: Festival Textiles

Throughout the Cameroon grasslands, beautiful blue and white cloths were often displayed at important ceremonies draped over the outer palace walls or set up as portable space dividers. Ibrahim Njoya's use of textile patterns as a spatial framing device (see FIG. 140) suggests a visual complement to these. Known variously as *ndop*, *doma*, and *duop* (among others), boldly patterned indigo-dye cloths (FIG. 156) of this type originated with the

155. Bandjoun (Cameroon). The king and society members in beaded elephant masks, 1930.

Here members of the royal Bandjoun regulatory society called *Kuosi* perform in the market. The king of Bandjoun, Fon Nkanga, wears a mask at the center of the group, his high status being marked both by the fly whisks in his hands and by the leopard pelt attached to his back.

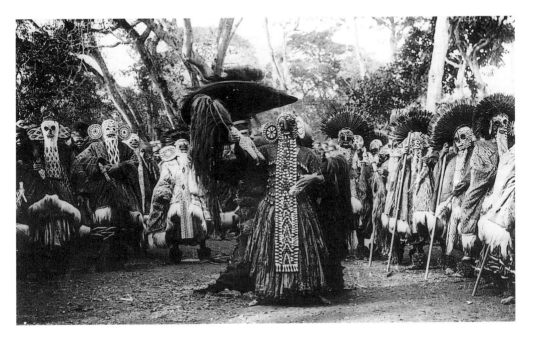

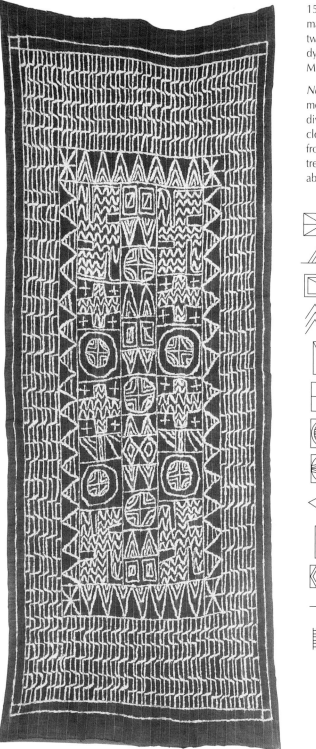

156. Bamum (Cameroon). *Ndop* textile map of the Bamum palace grounds, twentieth century. Cotton and indigo dyes, 18 x 6′ (5.49 x 1.82 m). Portland Art Museum, Oregon.

Ndop cloth designs draw on a variety of motifs, including (it would appear) divination signs. This boldly patterned cloth replaced an earlier textile made from the pounded bark of *ficus mucosus* trees, whose production was largely abandoned at the turn of the century.

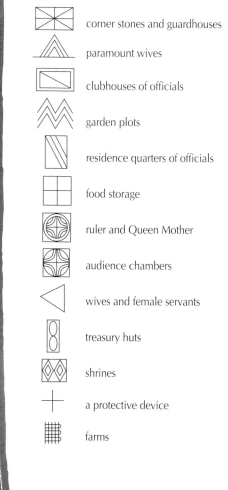

corner stones and guardhouses

paramount wives

clubhouses of officials

garden plots

residence quarters of officials

food storage

ruler and Queen Mother

audience chambers

wives and female servants

treasury huts

shrines

a protective device

farms

politically powerful Hausa and Jukun peoples and their neighbors in northern Nigeria, where it is used in both funerals and masquerades. Woven in narrow two-inch-wide (5 cm) strips which are then sewn together, these cloths are tied and stitched with dye-resistant raffia thread before being bathed in a rich, dark blue, indigo dye.

Among the most important of the ceremonies in which the cloths were displayed was the annual harvest dance celebration. On this occasion, the royal thrones and ancestor sculptures were brought out of doors to the dance ground or center of the plaza where, decorated with strips of this royal cloth, they served as both witnesses and ceremonial protectors. Another important transition ceremony in which this cloth played a role was the funeral of the king, when the cloth was sometimes used to line the royal grave shaft. In the Bali-Nyonga area it was folded into a bundle to serve as a surrogate for the deceased.

The intricate designs incorporated into the *ndop* cloth are sketched by men, then sewn by women, with a single cloth taking up to several months to complete. Because first the weaving, then the actual dyeing historically were done by northerners, each cloth had to be transported over 1,500 miles (2,500 km) during the course of its completion. To avoid such transport and foreign labor costs, King Njoya set up 310 looms and six dye vats in the Bamum palace around 1912, thereby establishing a royal monopoly in local cloth production. Reflecting their continuing importance as signifiers of status, strips of this cloth were worn as sashes by royal wives and retainers, and were given to loyal court followers.

A drawing attributed to Ibrahim Njoya illustrating Bamum court artists at work (FIG. 157) incorporates a range of textile motifs in its frame. *Ndop* motifs such as these draw on both spider divination symbols (which, as we have seen, incorporate circles, semicircles, squares, V's, X's and other patterns) and palace architectural forms (which emphasize contrasting square, rectangular, circular, triangular, and cruciform shapes). Striking shifts in movement along horizontal and vertical axes and contrasting areas of dark and light suggest architectural complements. The Bamum *ndop* cloth (see FIG. 156) is said to represent a "map" of the old Bamum palace grounds. Although probably created for a Western patron, this cloth demonstrates longstanding concerns with conceptualizing and reconfiguring space within a two-dimensional frame. In this textile plan, the residences of the king and queen mother are represented by a cross inside a double circle; meeting halls are indicated by a cross inside a single circle; in divination

contexts circles and crosses similarly refer to the court. Other symbols include the palace regulatory society meeting houses (rectangles with diagonal bar lines), food storage structures (a square in a square), shrines (nested diamonds), and the houses of the royal wives (seriated or nested triangles, signifying the paramount wives). Zigzag lines symbolize the palace gardens. The meander pattern along the outer border indicates farms adjacent to the palace. While the idea of creating a textile map may have roots in Western cartographic forms, other royal cloths as well as palace wall paintings and woven facade decorations often reveal similar architectural features.

Artists' Workshops and the Art of Drinking Palm Wine

In each of the six scenes in Ibrahim Njoya's tableau (see FIG. 157, the artists are shown in a locale appropriate to the art. The first two scenes portray female artists at work inside the palace walls: on the upper left, a potter finishes a vessel while other examples lie on the ground waiting to be fired. In the next scene, a woman sits on a bed weaving a basket. The third scene portrays

157. Bamum (Cameroon). A detail from an illustration of court artists, by Ibrahim Njoya, c. 1920. Watercolor and crayon on paper, 21½ x 52¾" (54.5 x 134 cm). Musée d'Ethnographie, Geneva.

Textile motifs form the frame of this lively portrayal represent from upper left: flowers (whose diamond forms also suggest frogs), lozenges (a crocodile's back), a cross in a rectangle (a female loincloth), chevron or zigzag motifs (a sign for serpents), a checkerboard (representing a turtle's back), a maze meander (the turtle's shell), petals (a hair style).

two sculptors preparing carvings in a remote rural setting. Utilitarian sculpted goods along with the necessary tree trunks and tools are shown in the foreground. Both the foreign style of their houses (circular and thatched) and the artists' tall stature and thin physiques suggest that these carvers are foreigners, presumably from groups subjugated by the Bamum in war. The human heads carved into the base of the drum or throne being sculpted also are prominent references to war victory.

In the following scene (bottom left), two artists are at work covering palm-wine gourds and other objects with precious beads. They are positioned within an enclosed palace courtyard where the expensive beads were stored. The artists shown here are male, but palace women also did this work. The sizable girth of these bead workers suggests their economic well-being and the relative ease of life at court. The next scenes show artists outdoors next to the palace: on the left, two male artists prepare and carve drinking horns, the horned skull of a buffalo at their feet; in the final scene three men attach rope handles and stoppers to water containers and other vessels. Many of the art forms portrayed in this tableau figure prominently in the grasslands royal corpus. One is particularly significant from the standpoint of royal symbolism.

Beaded palm-wine containers (FIG. 158) are among the most ritually important of the palace arts. These vessels held the sacred palm wine used by the king and high-ranking guests on ceremonial occasions. Royal drinking containers of this sort were used not only during court audiences but also on ceremonial occasions such as harvest rituals, when lineage chiefs were called on to swear allegiance to the king. Like tobacco smoking, drinking palm wine was viewed as a sacrosanct activity and was held to have important life-giving properties for both the ruler and the populace. Among the most important rites in which palm wine was consumed were those dedicated to deceased rulers. Reinforcing this use, as well as the king's sacrosanct identity more generally, was the Bamileke tradition that certain bones from the ruler's predecessors were placed inside these containers, thereby conveying sacral potency. The centrality of palm wine in royal ritual contexts is underscored by the intricate beaded patterns which cover the vessel's surface. The beaded stoppers of the vessels represent animals such as the leopard (shown here) or the elephant, key referents to royal authority, both political and religious. In this work and others, isosceles triangles suggest leopard pelting; and the checkerboard pattern may refer to the turtle, with its links to water and hence to the watery world of the ancestors.

MOTIF OF CROCODILE BACK

MOTIF OF TURTLE'S BACK

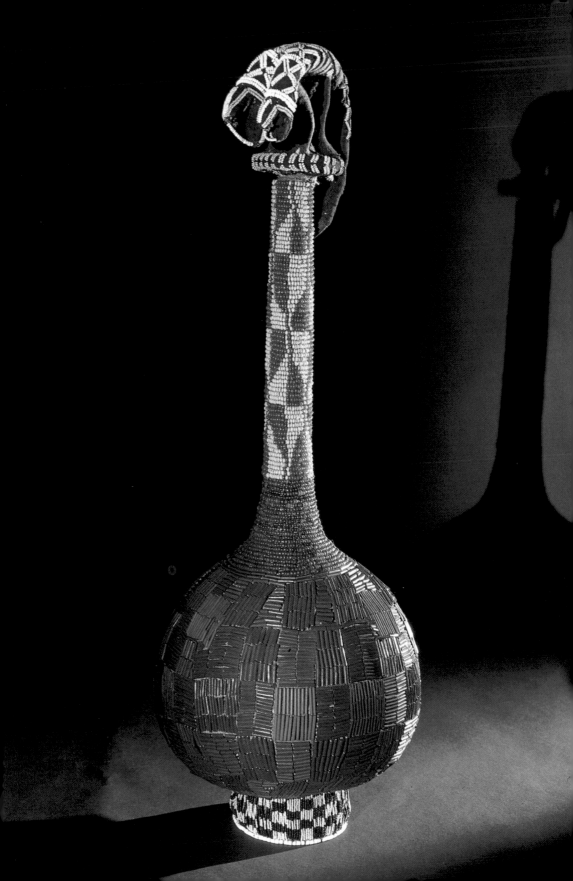

In the arts of the Bamum king Njoya and other Cameroon grasslands kings we have seen the striking ways that politics, religion, history, and art intersect. Status and social differences are played out provocatively in palace architecture, capitaline planning, and sculpture; and primacy is placed on royal creativity in art and other domains. In the same way that Cameroon grasslands court arts reveal the dynamism of traditional design, these royal settings also exemplify the unique ways in which Islam, Christianity, and indigenous ritual forms have been brought together to produce works of great beauty.

158. Bamileke (Cameroon). A beaded palm-wine container with a double leopard stopper, collected before 1914. Gourd and beads, height 23½" (60 cm). The Field Museum, Chicago.

The serving of royal palm wine in vessels which also contained the bones of important royal ancestors reinforced the identity of the king as someone who could "see," that is, someone who could use his "sorcery"-like power to counter (and, in some cases, effect) malevolence in the kingdom. This idea is reinforced by the four-eyed Janiform leopard which surmounts the top of this vessel.

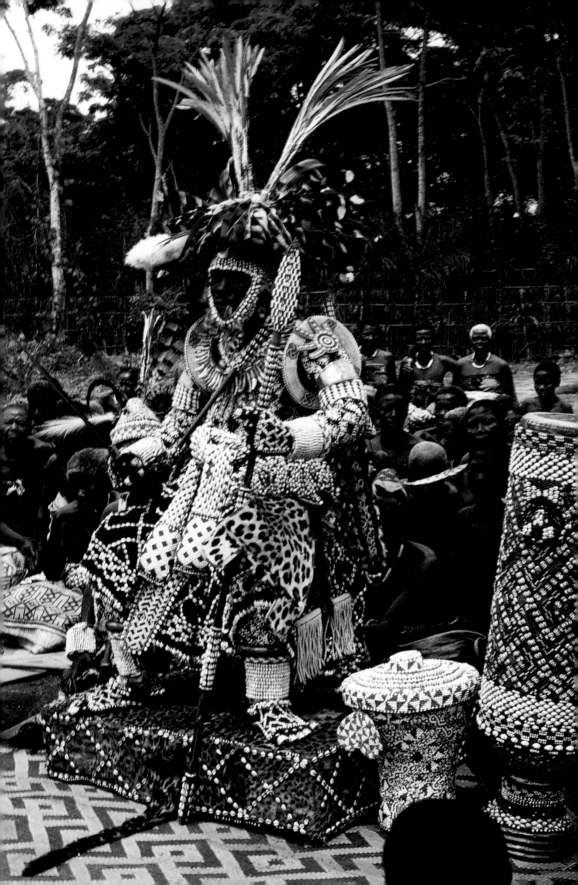

FIVE

Kongo and Kuba: The Art of Rulership Display

159. Kuba-Bushoong (Dem. Rep. of Congo). King Kot a-Mbweeky III in his royal attire, 1971.

At the center of the royal headdress (and those of other regional rulers) a shell spiral (*myuush*) is displayed to symbolize authority, chieftaincy, and power. The concentric circle design worn on the king's shoulders is said to allude to a gourd stopper to keep the king's spiritual essence from leaving. Another important feature of regalia is the carapace of a weevil secured in a decorative oval surround. This insect alludes to the sacrosanct nature of the dynasty since the term for weevil (*ntshyeem*) is also the name for the supreme deity.

THE KONGO KINGDOM

The powerful kingdom of the Kongo, founded by a hunter named Nimi a Lukeni perhaps as early as 1400, had its hilltop capital at Mbanza Kongo (now in Angola; FIG. 160). In 1556 the Kongo was described by Camões as "the greatest of kingdoms" of Africa's west coast. Known for its beautiful ivories, sumptuous textiles, powerful sovereigns, and its well-organized state structure, the Kongo retained its symbolic importance long after it had lost its identity as a unified state in the eighteenth century. The kingdom of the Kuba, which developed to the east in the savanna−forest area of the Democratic Republic of Congo, east of the Kongo states, not only was a much smaller polity, but also was still a thriving monarchy when it was first visited and described by Westerners at the end of the nineteenth century. These two kingdoms, though distinct culturally and politically, display royal artistic idioms which in certain ways are complementary.

At its height, the Kongo kingdom was vast, spanning between 50,000 and 115,000 square miles (130,000 and 300,000 sq. km), its economy based on a complex system of exchange between the coast, the interior, the equatorial forests to the north, and the broad savanna plains to the south. Today, the affiliated cultures − not only the Kongo but also the related subdivisions of the Sundi, Yombe, Bwende, Vili, Woyo, Lwangu, Kunyi, Mbata, Kamba, Nkenge, Boma, and Bembe among others − live in the modern

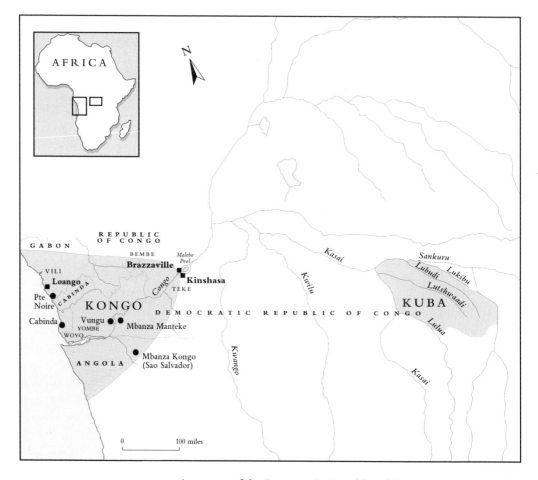

nation states of the Democratic Republic of Congo, Angola, Republic of Congo, Cabinda, and Gabon. Despite periods of declining political authority and changing social factors, the Kongo sub-areas share important art and cultural traditions.

The Architecture of the Capital: Framing Time and Place

One of the many shared beliefs in the Kongo concerned the world of the dead. It was widely held that after leaving the earth, a person who died would travel across a great body of water to reach the place of the ancestors, an area submerged in the water beneath the earth. Conversely, the residence of the Kongo king was positioned at the top of the highest mountain in the realm, where the humid equatorial climate was somewhat tempered by cooling breezes. With its two to three million inhabitants, the capital city of Mbanza Kongo (*mbanza* means residence of the king) was a royal center of striking visual interest.

A. *Palæis des Koningæ.*
B. *Slaven en Slavinne die uit de Reviere water na de Stadt brengen.*
C. *Kerken.*
D. *Krygæs-veſting of Sterkte.*
E. *Spring-bron, met zeet zeet water.*

B A N S A offe de Stadt S A L V A D O R
Hooft-ſtadt van het Ryk
C O N G O.
BANSA ou S.S.ISVADOR Capitale de CONGO.

A. *Palais du Roy.*
B. *Esclaves qui vont puiser de l'eau dans la rivieres.*
C. *Eglises.*
D. *Citadelle.*
E. *Source d'eau douce.*

The River Lelunda

D E R I E V I E R E L E L U N D A.

In addition to royal residences, Mbanza Kongo (which was renamed Sao Salvador by the Portuguese) also included a forested hilltop cemetery where former kings were buried. On the south side of the palace was a large square where people gathered to honor the king and to attend various dances or military reviews. Justice, a central component of Kongo society, was dispensed within a special royal court called the *mabazi a mambu* (*mambu*, "argument"). By the end of the sixteenth century, a separate quarter for the Portuguese had been established in Mbanza Kongo along with a number of churches; by 1665, internal conflict, invasions, and increased Portuguese intervention in the area resulted in the fragmentation of the kingdom and the abandonment of its capital. The memory of this ancient religious and political center nonetheless remained strong.

Security was an important concern at Mbanza Kongo as well as at regional chieftaincy centers. Not only were most towns built on hills or away from the main roads, but in the capitals, guards and trumpeters marked the gates. And, according to Cuvelier's description of Mbanza Kongo, straight lines of access were avoided in favor of maze-like roads running in all directions; while a mass of plants and trees surrounded key residences to hide them. These trees also had important economic and ritual functions.

160. Kongo (Angola). View of the royal capital of Mbanza Kongo (known to the Portuguese as Sao Salvador), published in Olfert Dapper's *Déscription de l'Afrique*, 1686.

The Kongo royal house, built at the apex of the mountain here, served as a potent center from which the king could address social and religious concerns. Because of his role in promoting births through his ties to the ancestors, one of the king's many titles was Matombola, the "one who summons spirits from the land of the dead." This illustration well conveys the importance of height in royal architectural planning.

Kongo and Kuba: The Art of Rulership Display 203

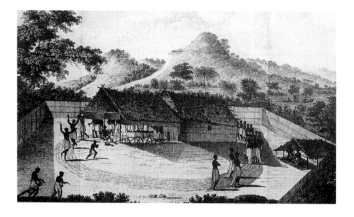

161. Kongo (Cabinda). The house and funeral of the court minister of commerce, the Ma-Kayi, of Cabinda, c. 1787, from L. Degrandpré's *Voyage à la Côte Occidentale d'Afrique Fait dans les Année 1786 et 1787*.

Fences or screens (called *lumbu*) of poplar and other trees delimited the external spaces of palaces and the homes of provincial governors and dignitaries. Indeed, the term for the royal court (*luumbo*) takes its name from these screens. The house of a high-ranking individual became that person's tomb, for which a *lumbu* fence served as a boundary marker separating the house-tomb from the land which surrounded it, as here in a 1787 engraving showing the funeral of a powerful local minister of commerce, the Ma-Kayi of Cabinda. Over the years trees would cover the entire area of an abandoned site, eventually transforming it back to forest.

Among the more widespread were figs (*ficus*, linked to fertility and hence propagated in every new village), palm trees (an important source for cooking oil, textiles, cosmetics, and wine), and various medicinal plants ("male" species being planted on one side of the town, "female" on the other). Scale and distance from the palace defined social status, with the most important dignitaries living nearest the palace. Among the many residents were the sons of Kongo nobility from around the kingdom who came to the capital in order to learn about judicial procedures, public affairs, court etiquette, and military arts.

Royal residences like most other domestic structures in the Kongo were rectilinear (FIG. 161). Traditionally, the roofs and walls were made of woven raffia palm which covered a substructure of poles. Architectural construction in this way shared key attributes of both basketry and weaving with the verb *tunga* meaning at once "to build" and "to weave." Entire houses could be disassembled and reassembled on relatively short notice, for example when a prince was traveling. Although made of similar materials to commoner houses, the residences of nobility were distinguished by their increased height and more solid construction. Beautifully interwoven designs often marked the gable ends. Carved support poles and elaborate wall paintings or matting sometimes embellished the interiors and sleeping areas of princely houses.

Kongo Kings as Leopards: Rulers of the Forest

The ever dangerous king of the forest, the leopard, was the most important symbol of Kongo royal authority and military might, signifying the real and sacred violence associated with rulership. Like the leopard, the king had the power to take human life, most importantly in war and by capital punishment. Human and leopard attributes are joined in royal staffs such as the Yombe ivory staff, cane, or fly-whisk top (FIG. 162). Both the king's real and potential danger are suggested by this open-maw feline. The inlaid eyes allude to the ruler's physical and metaphysical power, and royal prestige is conveyed through the cowrie necklace, a reference to wealth. The bracelet carved in relief on the

162. Yombe (Dem. Rep. of Congo). A cane finial in the form of a human-leopard, nineteenth–twentieth century. Ivory, height 17¾" (19.6 cm). Former collection of Paul Tishman.

The leopard's snarling jaws, prominent fangs, and protruding tongue suggest royal force as being ready to devour (stop) any and all opposition. The ivory from which it is made also suggests power, for elephants (the source of ivory) are at once large, dangerous, and linked to plenty.

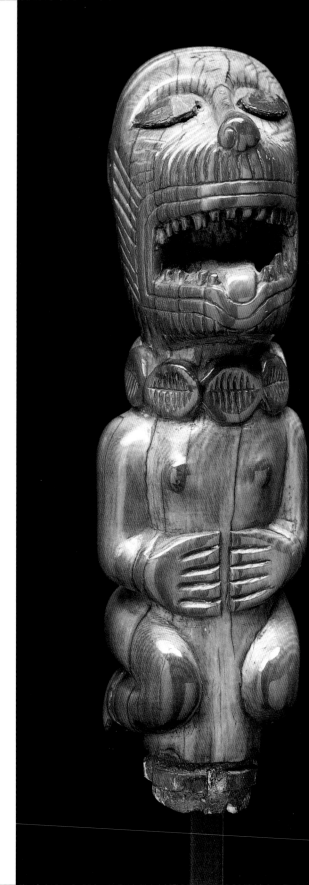

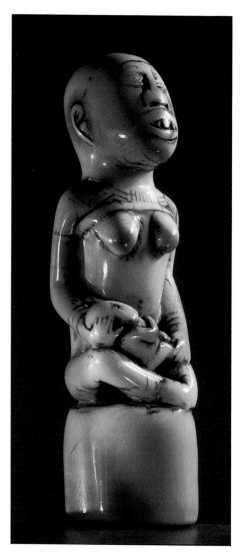

figure's two wrists suggest the iron bracelets commonly worn by kings.

Elite cane finials (such as this and FIG. 163) complement in certain respects Kongo royal staffs known as *mvwala*; such objects draw on the power of the earth and the ancestors to aid the ruler in governance. When the chief placed the staff in the ground, those around him became quiet, a sign of his authority and control over occult forces. The pointed iron shaft of the *mvwala* reinforced the close ties between kingship, smithing arts, and ideas of penetrating the earth to gain access to the power and knowledge of those now dead. The staffs were primarily used in judicial proceedings and in ceremonies for rain and investiture.

From the inception of the kingdom, Kongo royalty were linked with the arts of smithing: the sounds of smithies and foundries were especially audible in and around the capital, as iron was being shaped into hoes, axes, and weapons; the strength of the Kongo kingdom was compared to iron, with both chiefs and smiths undergoing similar initiations; and before building any new royal residence, a smith purified and protected the site with forge water and blasts from his bellows.

An illustration of a Loango king from the coastal area published by Olfert Dapper in 1668 (FIG. 164) shows prominent Kongo regalia symbols of authority and power. In this engraving the king wears a leopard skin over a cloth garment and a cap crown (*mpu*); he sits on a special fabric-covered box throne, so that he can be seen clearly by all in attendance. Similar box thrones (which also contained royal relics) are depicted in many forms of Kongo sculpture. The king's throne rests on locally manufactured textile mats, in accordance with the tradition that rulers should not touch the ground. *Lumbu* mat screens also demark the space. An animal-skin banner is positioned behind the king's head and fly whisks made of the tails of buffalo and other powerful animals hang from a standard to his right. In front of the king a man prostrates himself on yet another leopard skin, which covers several elephant tusks. Standing nearby are guards and an escort of musicians, who play bells, ivory trumpets, and drums.

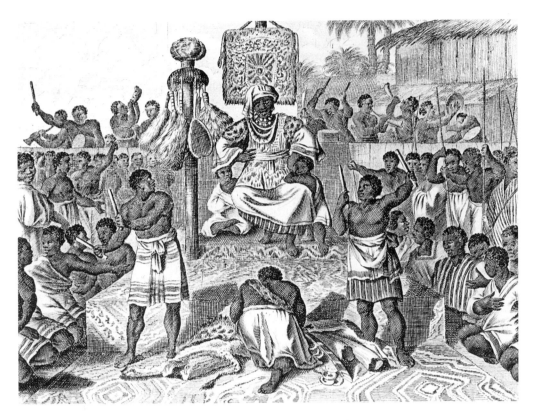

Early Missionary Contacts: Kongo Crosses and Saint Figures

Following the conversion of local kings and dignitaries to Christianity by the Portuguese beginning in the fifteenth century, the cross – a prominent indigenous symbol of transition between earthly and otherworldly realms – took on new meaning. Christian icons such as crucifixes (*kuluzu*, *klistu*, or *nkangi*; FIG. 165) and saint sculptures (*santu*) were used for both political and spiritual purposes. Kongo rulers, as the earthly representatives of the sky god Nzambi Mpungu, employed Christian arts as another, potentially more direct, route of contacting both gods and ancestors. In keeping with this, on visits to the graves of the royal dead, the crosses were washed in sacred palm wine and presented to the people. Indigenous and Christian crosses in this way marked the sacred locus where humans and spirits came together in ritual and prayer. Cruciform icons were used in judicial decisions, rainmaking, and as talismans to assure favorable outcomes, in the last case for such activities as hunting, conception, and travel.

The Kongo linking of Christian ritual with power is evident in the arts of religious revitalization movements. In the early

164. Loango (Dem. Rep. of Congo). The king and his court, c. 1668, published in Olfert Dapper's *Déscription de L'Afrique*, 1686.

While most of the royal symbols in this illustration are indigenous, Kongo regalia early on incorporated a range of Portuguese and other European elements. These include crowns, chairs, candelabra and textiles.

165. Vili (Dem. Rep. of Congo). A crucifixion plaque, from the Loango area of Pointe Noire, collected in 1874. Ivory, 3¼ x 2¼" (8.5 x 5.5 cm). Museum für Völkerkunde, Berlin.

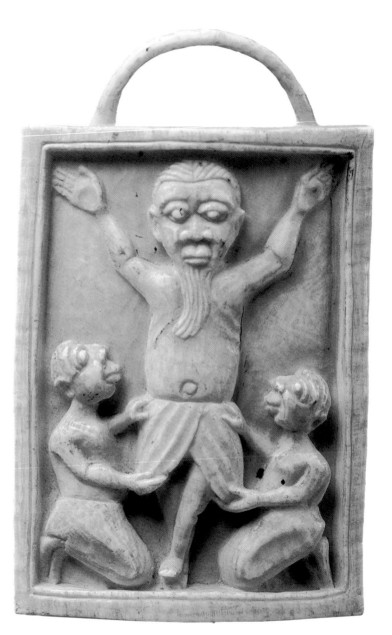

Kongo crucifixes, while based on Portuguese models, show indigenous attributes in the treatment of the hair, physiognomy, and body type, as well as in the deeply cut eyes and navel. Here, the linear pattern of the hair, which is draped behind the ears, and the long flowing beard recall local coiffure traditions. The beard in particular is a sign of eldership, high status, and the transmission of wisdom. The prominent demarcation line between Jesus' face and coiffure complements the forehead bands worn by Kongo nobility as a symbol of authority and wisdom, and to beautify the face by visually shortening and rounding it. The textile wrapper worn by Jesus recalls the royal manner of wearing cloth. The two subsidiary kneeling figures who hold this garment are presented in the Kongo pose of respect, alluding to the tradition of kneeling upon entering or leaving the enclosure of an important person. In raising their hands to touch the cloth of Jesus, they draw our attention to the importance of textiles as Kongo symbols of wealth, status, and regeneration.

years of the eighteenth century, a young Kongo princess named Kimpa Vita promoted a new form of Christianity in order to bring the Kongo kingdom back into prominence after a long period of disintegration. Under the baptismal name of Dona Beatriz, Kimpa Vita began a religious and political movement later called Antonianism. This sect was focused on St. Anthony of Padua (1195–1231; a Portuguese-born saint) as both intercessor and the source of Kongo salvation. St. Anthony in his role as the traditional protector of children and mothers no doubt had special

saliency in the Kongo where themes of motherhood had important religious and political significance.

Kongo images of St. Anthony (FIG. 166) show this saint carrying a cross in his right hand and a seated or standing infant Jesus in his left. Made out of ivory, brass, or wood, *toni malau*, as these Kongo personal guardians were called, helped to safeguard users from ill health and other problems. The figure of Jesus carried by St. Anthony is seated on a box throne, similar to those used in royal Kongo art and ceremonies (see FIG. 164); this replaces the book that supports Jesus in European versions. The asymmetrical posture of Jesus, the left foot positioned above the right, is also characteristic of Kongo art. In his right hand Jesus holds a royal fly whisk, and his other hand crosses over to touch his shoulder, a place where medicine bundles were sometimes secured.

These sculptures complement the role of Kimpa Vita in promoting the reunification and strengthening of the Kongo. Kimpa Vita asked her followers to discard imported cloth and to wear indigenous fig-bark textiles to promote fertility and well-being. Predicting a new golden age, she called for a rebuilding of the then largely abandoned capital of Mbanza Kongo, hoping to recreate there a revitalized civilization that would be free of discord. Yet Kimpa Vita was opposed by both the local nobility and the Christian church and was eventually burned at the stake for heresy. Her efforts nonetheless did bring about a certain resettlement of Mbanza Kongo, a renewed interest in local textiles, and a short-lived reunification of the Kongo kingdom – which required an army of 20,000 soldiers to suppress her many followers.

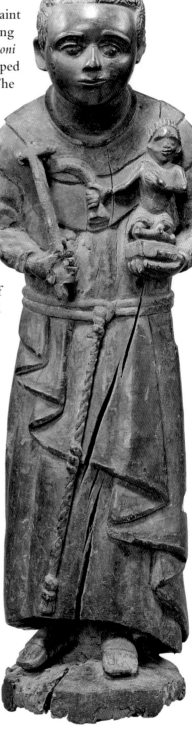

166. Kongo (Dem. Rep. of Congo). A figure of St. Anthony with Christchild, possibly nineteenth century. Wood, height 20⅛" (51 cm). Museum für Völkerkunde, Berlin.

St. Anthony's face has been smoothed with red palm oil, in conformity with local cosmetic practice. The wide religious shawl around St. Anthony's neck suggests the special net capes that were worn by Kongo nobles. The cross in his right hand is similar in shape to the iron swords (modeled on sixteenth-century Portuguese types) that served as Kongo political symbols. Dancers in ceremonies to renew allegiance to the king and his governors brandished these swords.

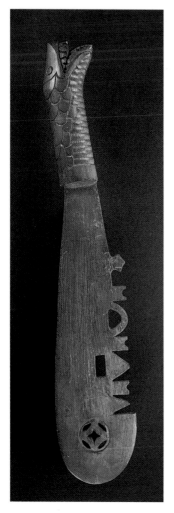

Left

167. Woyo (Angola). A chieftain's knife (*cimpaba*), collected in 1878. Wood, length 20¾" (53 cm). Sociedade de Geografia, Lisbon.

The articulated blade of the *cimpaba* shows a range of chiefly symbols: on the tip is a circular design punctuated by four outer shapes and a central hole, a widespread symbol of chieftaincy in its broadest sense of comprising both the ruler and his people. This meaning is partly supported by the identification of similar motifs as signifying the four corners of the chief's domain. Lightly incised in many *cimpaba* blades are other symbols of political power, including radiating stars (the chief as the light of his people), concentric circles (among the Woyo suggesting generational succession, with the ancestors at the center), and triangles (referring to the ruler and to death).

Right

168. Woyo (Angola). A chief holding his silver *cimpaba*, twentieth century. This knife, closely modeled on local knives, was given to a Woyo chief by the Portuguese king Dom Carlos at the end of the nineteenth century. Other royal signifiers are the chief's textile cap and his woven cape and wrapper.

The Language of Royal Knife Scepters and Vessels

One of the most important forms of regalia in the coastal Woyo area of the Kongo consists of elaborate knife scepters called *cimpaba* (or *tshimphaaba*; FIGS 167 and 168). At one time these knives were the most precious objects in a ruler's possession. Their ivory or wooden handles incorporate images of female lineage founders and serpents, both of which allude to royal succession and regeneration. As markers of authority and judicial process, *cimpaba* knives are complemented by the Woyo tradition of carving the lids of serving vessels (*taampha*) with icons of cultural and political importance (FIG. 169) symbolizing, among other things, the power of the ruler. Similar vessel tops incorporating proverb images were used by women to transmit messages to their husbands about social concerns and family problems.

169. Woyo (Angola). The lid of a royal serving vessel, nineteenth or twentieth century. Wood, diameter 7″ (18 cm). Afrika Museum, Berg en Dal, The Netherlands.

The motifs incorporated into the vessel lid all serve to reinforce the status of the ruler. In the center is a double gong (compare FIG. 17) which symbolizes royal authority. Starting with the cross and moving clockwise are portrayed the following objects: the bellows of a forge, a weapon, two shells, a seed, the moon and sun, a chief's knife (see FIG. 167) a drum, a seed, and a forked stick. The forge and weapon indicate the links between royalty and ironworking, and drums refer to the authoritative voice of the ruler because they were used in court announcements.

Ancestral Music and Horns of Ivory

Among the earliest objects sent by the Kongolese king to the king of Portugal in the early sixteenth century were horns of carved elephant tusk (called *mpungi*; FIG. 170); they were played at court and were placed on royal graves. They were also sounded in war, both as signals to the warriors and as a means of calling up supernatural aid in this dangerous endeavor. A chronicle written in 1491 on the occasion of a Portuguese missionary expedition to the Kongo provides insight into the early use of these royal ivory horns. According to Cuvelier's account of this source, when the Portuguese arrived, a group of local musicians played ivory trumpets in order to "sing the praises of the king of Portugal and the great ones; "produce[ing] a sound so melancholy that its like has never been heard." These Kongo horn players, naked to the waist and their bodies painted white in memory of the ancestors, repeated their song twelve times in order to honor the twelve generations of kings since the kingdom's inception. As this concert reveals, the early Kongo thought of the Portuguese as voyagers from the land of the dead, with the Portuguese king assuming the part of the Kongo ruler's otherworldly complement. As musical instruments whose notes were believed to be understood by the dead, these beautiful ivory horns offer insight into the ritual importance of court music.

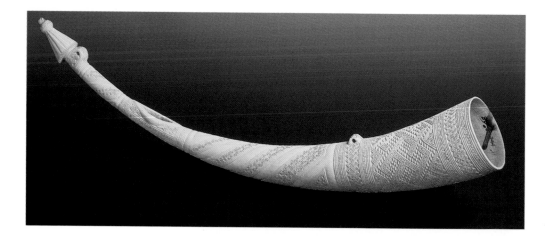

Above

170. Kongo (Dem. Rep. of Congo). An ivory horn, collected before 1553. Length 32½" (83 cm). Museo degli Argenti, Florence.

In this and other early Kongo horns, several features stand out, particularly the framing devices, which recall the architectural and ritual importance of woven *lumbu* fences; and the compositional use of an open spiral or serpentine form, suggesting perhaps the winding route to the world of the ancestors. In certain ceremonies, the horns were used to call up important ancestors in the royal line. When the horns were portrayed in other arts, such as royal vessel lids (see FIG. 169), they are said to indicate that the king is all-knowing.

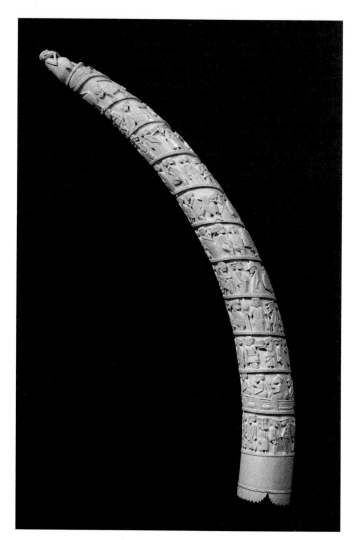

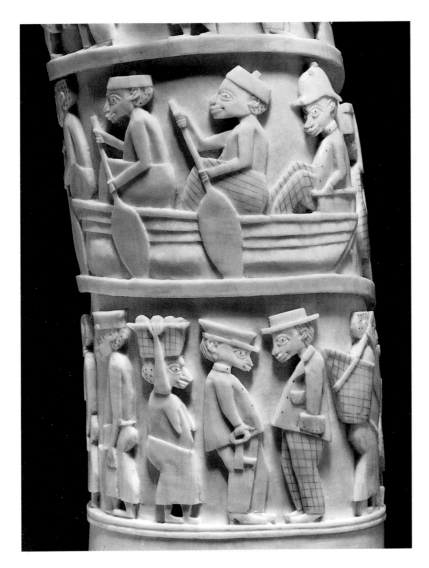

Left and above

171 and 172. Loango/Kongo (Cabinda/Dem. Rep. of Congo). A souvenir, ivory, collected in 1914. Length 27" (68.5 cm). Staatliches Museum für Völkerkunde, Munich.

A range of individuals, both local and foreign, are represented here. Together they suggest an *imago mundi* (world view) in this colonial Kongo setting. In the bottom register, a woman carries a produce-filled basket on her head as two formally attired Europeans (perhaps a trader and a missionary) converse. In the scene above a European colonial officer in a pith helmet is transported upstream in a long canoe by local oarsmen. Moving higher, we see other activities and interactions involving Africans and Europeans, including the transportation of elephant tusks and huge fish. Near the top are several scenes of elegantly attired women with bolts of cloth. At the summit, a lively group of animals surveys the scene under the weight of a monkey who eats an ear of corn. The rotund and somewhat comical monkey is an appropriate cap to the tableau, pointing up the forces of economic consumption (and, indeed, sometimes gluttony) that shaped the Kongo world at this time.

Kongo and Kuba: The Art of Rulership Display 213

173. Kongo (Dem. Rep. of Congo). Terracotta vessels, collected c. 1910. Fired clay, heights 9½ and 4¼" (24 and 11 cm). British Museum, London.

The beautiful swirling surfaces of these pots are achieved by splashing them with vegetable materials while the yellow clay is still hot from the kiln; these leave a wood-like grain as the vegetable matter rapidly boils away. While the patterns may be purely decorative, they are shared by other Kongo arts associated with spirit world and the land of the dead.

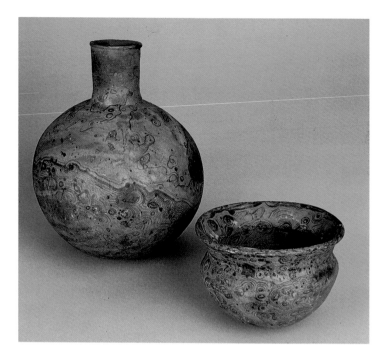

Spiraling compositional lines are prominent both in such early horns and in eighteenth- and nineteenth-century Kongolese ivories, which were made for wealthy local or European patrons as souvenirs (FIGS 171 and 172). They incorporate figural scenes from everyday life and ceremony, suggesting an *imago mundi* (world view). Similar spiraling patterns cover local pottery (FIG. 173).

Textile Arts and Themes of Transition

Like ivory horns, the hats (*mpu*) of Kongo kings and chiefs (FIG. 174; see also FIGS 164 and 168) embody a spiral composition. Each hat is constructed from a single thread worked in a helical pattern, beginning at the center of the crown and moving in enlarging circles to the edge. Kongo rulers may have sought to reinforce ideas of health and longevity through the wearing of these caps, the word for spiral, *zinga*, also meaning long life. In some hats, including the one worn by the king of the Soyo at his meeting in 1490 with the returning Portuguese, themes of life, longevity, and renewal are reinforced by representations of snakes. Not only is the serpentine rainbow an important marker of fecundity, but certain exceptional babies are believed to be brought to life through the intervention of spirits (*simbi*), who are sometimes represented as snakes. In addition to serpentine patterns, icons of physical force such as leopard claws are also incorporated in these caps.

174. A royal Kongo hat, collected before 1674. Fiber, height 7¼" (18 cm).
Department of Ethnography, The National Museum of Denmark, Copenhagen.

The cruciform icon here, similar to that found on royal knives, symbolizes chiefly
authority. In other caps, the fangs or claws of leopards were attached to the crown to
suggest not only the cardinal directions but perhaps also the open maw or readied
talons of this powerful feline.

175. Yombe (Dem. Rep. of Congo). Textile, eighteenth century? Raffia palm, 19⅝ x 20⅛" (50 x 51 cm). Staatliches Museum für Völkerkunde, Munich.

Europeans compared these textiles to fine silk, velours, and brocades, as in a description by Father Laurent de Lucques at the beginning of the eighteenth century: "The fabrics of these regions ... are truly beautiful ... Some of them closely resemble velvet, others are so richly adorned with various decorations and arabesques that it is a wonder that anyone working with leaves ... could make such fine and beautiful fabrics, which are every bit as good as silk." In addition to being beautiful, these raffia textiles were lightweight and waterproof.

Beautifully decorated raffia cloths (*lubongo*; FIG. 175) were of critical significance in Kongo daily and ritual life. Closely associated with royalty – kings wore the richest weavings as shawls and wrappers (see FIG. 168) – Kongo textiles served as a form of currency and taxation. Their red color and raffia construction reinforced royal power: so politically and symbolically important were these textiles that kings were once prohibited from wearing imported fabrics. In addition to being markers of status, they were associated with spatial and social transition. According to legend, chiefs were once able to cross rivers on raffia mats, and ceremonies of marriage and death were not complete without raffia cloths. Several hundred cloths might be used to cover the body of an important person before burial, in a royal expression of conspicuous expenditure; they were intended to show the dead that a newly deceased person was rich and should be treated well.

In the nearby Teke traditions, northeast of the Kongo heartland in the Republic of Congo, textiles functioned as symbolic maps to guide the deceased to the afterworld. Constructed of three pieces of cloth suggesting the sky, earth, and water, such textiles were folded and rolled before being placed in the tomb as instructive seats for the dead. Textile imagery in horns and other arts may also have functioned like symbolic maps. It is explained for the Teke accordingly: "Thanks to this cloth, the deceased is rich in words of the ancestors' and guided by them he knows the route to follow to rejoin directly the village of the dead. This cloth is also an assurance of the living against the dead: showing them the road they must follow, so they will not join the errant spirits who come to torment men."

Royal Mannequins and Memorials to the Dead

In the northern Kongo area, among the Bwende, special textile-enclosed funerary mannequins known as *niombo* (FIG. 176) were made. These works, and miniature versions of them known as *muzindi* or *kiimbi* ("reliquary mannequin"), commemorate impor-

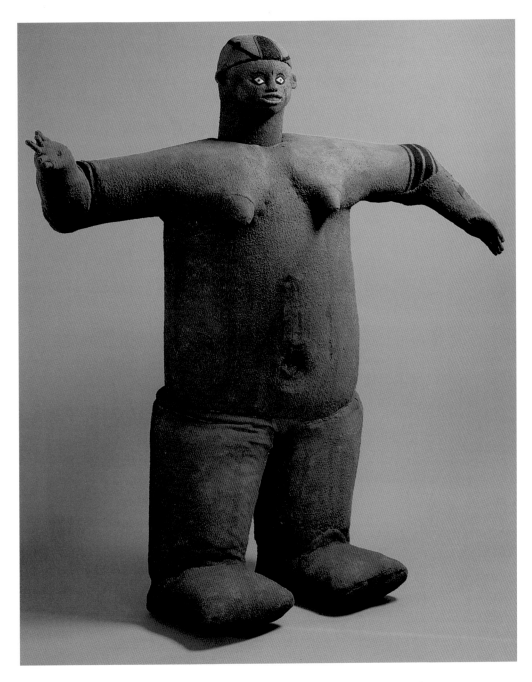

176. Bwende (Dem. Rep. of Congo). A funerary mannequin, called *niombo*, by Makoza of Kingoyi, acquired in 1938. Height 5'10⅞" (1.8 m). Göteborg Museum, Sweden.

Niombo and their miniature complements were made in great numbers in the first decades of the twentieth century. Makoza was one of the most famous artists of these works. He went to the bedside of a dying person to note distinguishing facial features such as tattoos or filed teeth, later building the sculpture over the mummified cloth-covered body of the deceased.

Kongo and Kuba: The Art of Rulership Display 217

tant men and women. Funerary figures of this sort are comprised of a thick mummy-like wrap of textiles enshrouding either the bodies or exhumed relics of high-ranking individuals. The status of the individual portrayed within the *niombo* is marked in part by the amount of textile covering, persons of greater power having works of larger size. The chiefly hats and brass armrings indicated in these works serve as markers of status as well. These empowered royal images were thought to be able to communicate with the living; the movement or shifting of the figure was said to indicate a last goodbye or the deceased's views about those who might have been responsible for the death. Some of these cloth sculptures display tears to suggest the sadness at the loss of loved ones. The chests sometimes incorporate encircled crosses or circumscribed X's, identified variously as the cycle of time and the authority of rulers over lands in all directions.

Royal guardian sculptures called *ntadi* (*mintadi* in the plural; FIGS 177 and 178) also served an important commemorative role. These works of soft dense schist were carved under aristocratic patronage. After the ruler died, the new sculpture (and others) was placed on the burial grounds to represent the deceased and his retinue. The steatite employed in these works may allude to the permanence of chieftaincy, for on his death the founder of the chiefdom was said to have become embodied in stone. Important Kongo tombs were thus often marked by blocks of granite or hard rock.

Ntadi sculptures served as a sort of portrait (originally they were painted); indeed, legends maintained that *ntadi* once were able to walk and talk. Chieftains' caps, jewelry, and throne plinths are among the many *ntadi* status attributes. Persons of lower rank were often shown kneeling in the position of devotion or submission. The visual power of these *ntadi* rests to a large degree on their combined elements of monumentality and compositional asymmetry, the latter indicated by features such as a tilting head or the diagonal alignment of arms and legs. Here, the chief is seated, his head resting heavily against an uplifted hand in a characteristic Kongo posture of sadness or sorrow. Gestures from royal adjudications are also displayed in *ntadi* sculptures, thus underscoring both the prominent functions of rulers as judges and the royal tomb as a court of last appeal. Related to this idea, the eyelids of *ntadi* are often shown lowered as if in deep thought.

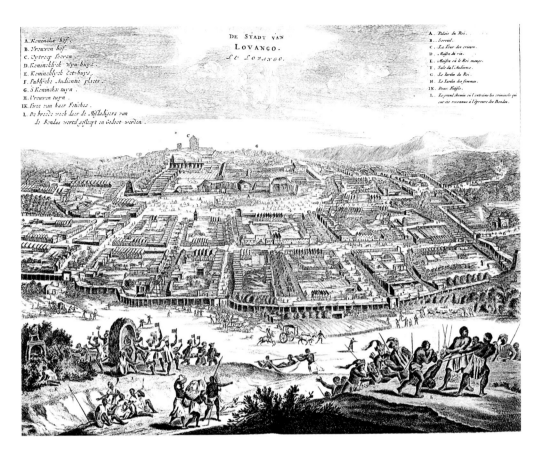

Opposite

177. Kongo (Dem. Rep. of Congo). A guardian figure (*mintadi*) representing a mourning ruler, nineteenth century? Stone, height 16¼″ (41.3 cm). The Metropolitan Museum of Art, New York.

The hat worn by the ruler displays four inward-curving claws or fangs of the royal leopard, suggesting the feline's readied talons and teeth. The Kongo chief Patrice Loemba suggests that the four perimeter claws/fangs may refer to the quadripartite structure of Kongo political rule, composed most importantly of: 1) the ruler as earthly potentate; 2) the ruler as final arbiter of the state judiciary; 3) the ruler's eldest son as future monarch; and 4) female lineage heads (and women generally) as holders of knowledge about family secrets. The center of the *ntadi* royal headdress thus may be seen to represent the ties between the ruler and the invisible world of the ancestors and spiritual forces.

Above

178. The Kongo regional capital of Loango, c. 1668, with royal altars in the foreground, published in Olfert Dapper's *Déscription de l'Afrique*, 1686.

In the left foreground, a shrine with the requisite memorial sculptures appears to be depicted on a wooded hilltop sanctuary outside the capital. This shrine locale, which in principle represents the home of a past Loango ruler, is here the focus of a lively ceremony. Other details of the drawing include the palace (A), the royal wives' quarter (B), the storage house of the king's (palm) wine (D), the royal dining house (E), and the public audience hall (F).

Portraits of Royal Women in Stone and Wood

Some of the most extraordinary Kongo stone funerary monuments are the stele found in the Solongo area (FIG. 179). They, like *ntadi*, convey ideas of chiefly power through the steatite from which they are made. But certain visual disjunctures, with their heads in profile but their bodies frontally posed, and the spatial compression, add to their emotional power. If the contained and largely frontal postures of the seated *ntadi* figures suggest stability and the distancing of danger, the stela shown here, in contrast, appears to display instability and peril, which is appropriate for the stela's function of commemorating those who died in pregnancy or childbirth.

As royal mothers, Kongo women played critical roles in family and local politics, foreign relations, and ritual affairs, and their frequent depiction in Kongo royal art reflects this. Handsome wooden figures of women (FIG. 180) were carved as memorials and symbols of chiefly power. They represent women as founders of the dynasty and regents who temporarily replaced deceased kings. Since the Kongo word for mother was applied to chiefs and other male heads of descent groups within this matrilineal society, these female images assumed important cross-gender identity. They became particularly popular in the coastal Yombe area in the nineteenth century in conjunction with an association called *pfemba*, which addressed female reproduction concerns.

Both female and male memorial figures show elaborate scarifications. While the forms vary, some patterns suggest through their "eternal knot" motifs and angular line-and-dot designs themes of life, death, and renewal. Crosses terminating in angled arms are said to signify the jaws of a crocodile, an animal identified with the watery realm of the dead and hence the ancestors.

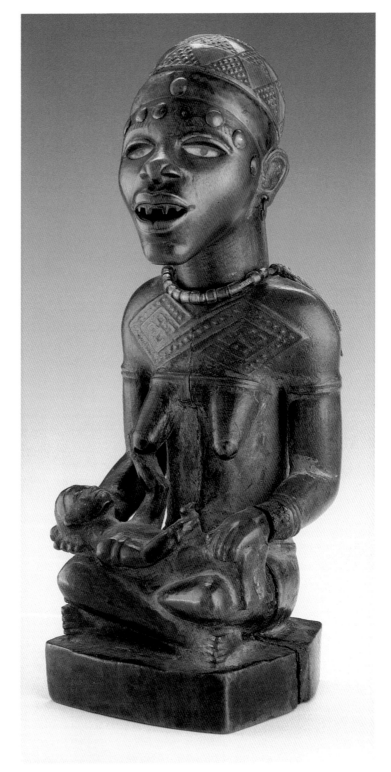

Opposite

179. Solongo (Angola). A funerary stela, excavated in 1904. Steatite, 24½ x 8½" (61.5 x 21.5 cm). Rijksmuseum vor Volkenkunde, Leiden.

These work's were positioned near the tombs of women who died while pregnant or during childbirth and served as their memorials.

Right

180. Yombe (Dem. Rep. of Congo). A mother and child effigy figure, nineteenth century. Wood, and mixed media, height 10¼" (25.7 cm). National Museum of African Art, Smithsonian Institution, Washington, D.C.

The prominent icons of royal power on this maternity sculpture include the royal cap, leopard-claw necklace, and raised box throne. The cross-legged, seated posture is said to evoke respect, continuity, and stability.

Sculptures such as this generally represent women who are either nursing or holding a child (shown either living or dead), themes linked to married women and their roles in assuring continuity in the lineage. In life, cowries or other shells filled with empowered substances were often attached to the back of the cloth (*dika*) above the breasts to augment fecundity and lactation. When a woman was working she would lower the cloth; while nursing it was raised.

Themes of family continuity are suggested through body scarification in other ways. The first such markings were generally made on a young girl to encircle the navel. After her first sexual relationship, the area above the breasts was decorated with further marks to promote conception. These and other body patterns were linked to the strength and pain that women must bear in delivery. The rich red surfaces of these carvings comes from the use of camwood powder and palm oil, used as a cosmetic in life from the age of puberty to make the skin soft, shining, and healthy-looking. Red camwood, which was expensive because it came from the interior of Africa, was a symbol of transition in chiefly and funerary rites of passage. Rank and wealth are suggested by the number of brass bracelets, anklets, and neck rings which are worn, these in life sometimes weighing up to 25 pounds (12 kg).

Whereas figures in stone, cloth, and wood served as high-status memorials in many Kongo areas, terracotta cylinder jars, called among other terms *sa kya boondo* ("drum-shaped pot"; FIG. 181), marked the tombs of wealthy and socially important individuals in the Boma and Yombe areas. Like the royal ivory horns, these works emphasize compositional registers, architectural *lumbu* frames, and textile patterning, all of which may be associated with transition and the afterlife. Many of these terracotta cylinders incorporate cruciform motifs associated with the passage from the living to the dead. Cylinders that include representations of human figures are called *fikula* and identify the deceased by particular physical traits, occupations, or talents, such as drums, guns, and musical instruments.

181. Kongo (Dem. Rep. of Congo). A funeral cylinder, nineteenth–twentieth century. Terracotta, height 18⅛" (46 cm). Peabody Museum, Harvard University, Cambridge, Mass.

The richness of the patterning on such vessels shows the wealth of the deceased. A large interlace pattern is said to symbolize the python, linked to renewal and regeneration. Scales refer to the skin of a serpent or fish, both associated with the watery world of the dead, and animal tracks indicate the path to the afterworld followed by the deceased.

Arts of Power, Protection, and Popular Response

Healing was linked to chieftaincy in many parts of the Kongo area, with the investiture of a ruler assuming key features of a treatment or cure as various medicines were applied to him. Chiefs, in turn, used their healing prerogatives to combat malevolent forces, among these sorcery, for both themselves and their subjects. A striking relationship thus exists between chieftaincy and the empowered sculptures known as *nkisi* (plural *minkisi*), meaning "medicine" (FIG. 182). At royal investitures *minkisi* not only safeguarded the new ruler but also helped to assure that the ancestral laws were followed. Historically, there were two types of *nkisi*, public and

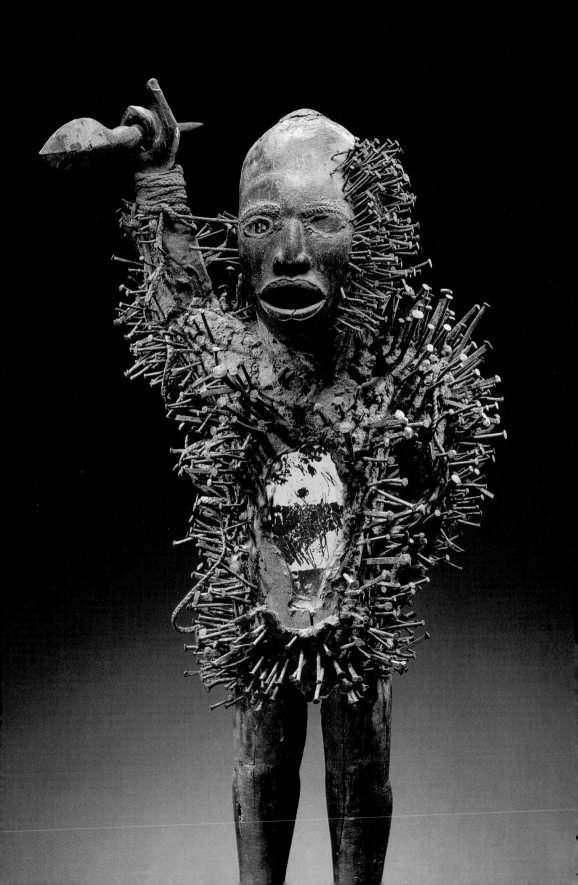

182. Yombe (Dem. Rep. of Congo). A *nkisi* empowered figure of the *nkondi* type, collected c. 1905. Wood, metal, glass, and mixed media, height 38⅛" (97 cm). Barbier-Müller Collection, Geneva.

The medicine pack on the belly of this *nkondi* identifies the stomach with both well-being and sorcery (since sorcery is said to swell the intestines). The enclosing mirror or shell is sometimes said to serve as a portal into the world of sorcery and anti-sorcery. Loss of will may be suggested by the binding of the figure's hands or feet. The open mouth refers to the "feeding" of the *nkisi* to arouse it to undertake a particular action. Although male *nkisi* are considered more dangerous than female, most objects are shown sexless.

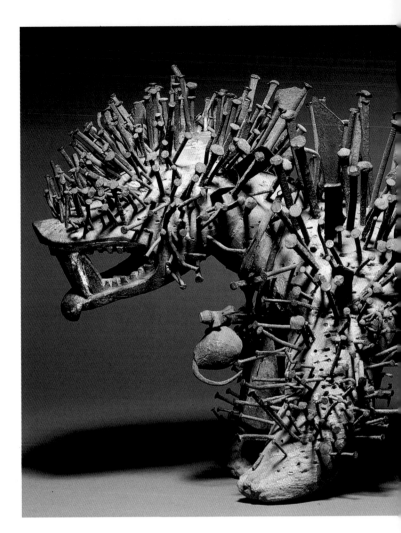

private, with some having vital democratizing roles, as sources of empowerment for rural residents and individuals outside the court.

At its most basic, the *nkisi* represents a container of empowering materials or "medicines" (*bilongo*). In figural *minkisi* the "medicines" are generally secured in cavities in the stomach, head, or back to activate the work with an empowering agent, usually an ancestor or the spirit of a person who had died. Tomb earth, river clay, camwood, and objects with a characteristic shine were especially important. The cavity was closed with a mirror or more rarely a cowrie. When incorporated into effigies and other figures, mirrors, cowries, and medicines indicated that these sculptures also functioned as empowered *minkisi*. Mirrors served divinatory functions, with *nkisi* specialists looking into their reflective surfaces to determine the source of a given problem.

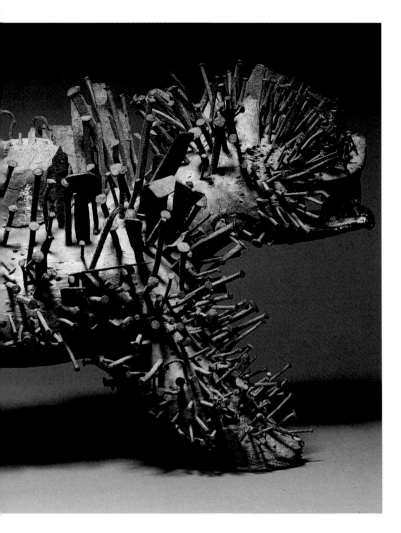

183. Vili (Angola/Dem. Rep. of Congo). A double-headed *nkondi* animal figure collected before 1912. Wood, iron, and mixed media, length 5'8½" (1.74 m). Staatliches Museum für Völkerkunde, Munich.

Dog *nkondi* call to mind the ways in which *nkisi* spirits, like hunting dogs, track their prey. Because dogs are identified as mediators not only between humans and animals but also between the realms of the living and the dead (they are believed to have four eyes) it is assumed that they readily communicate with the human and spiritual realms. In such works, empowering medicines are added to the animal's back, ears, and mouth.

Sculptures known as *nkondi* (plural *zinkondi*), from the word for hunt (*konda*), constitute a special class of *nkisi* figures thought of as particularly effective hunters of danger. Distinguishing *nkondi* features include a raised arm in whose clenched hand a lance or knife is held. This gesture suggests challenge and readiness to attack. In human *nkondi* and other *nkisi* arts, the face is often intentionally threatening, an expression thought to be both defensive and aggressive. The drawing back of the lips (and the extended tongue in some works) underscores this powerful image, suggesting devouring and the spiritual cannibalism in related cases of harm. Reinforcing this idea, the chin is often thrust forward to indicate readiness to attack a problem. Some of the most striking of these figures depict animals, especially dogs (FIG. 183), with either single or double heads.

Among the most important of the additive materials in both animal and human *minkisi* are the piercing pieces of metal (blades, then later nails or screws) and wooden peg or thorns. The type, number, and placement of these additions refer to empowerment and the intended function of the work. Each piercing element connotes a particular commitment and desire for action. When the nail is wrapped or knotted with fiber it is said to serve as a reminder to the *nkisi* of a pressing problem.

The process of making and employing *nkisi* necessarily brought together the talents of both the carver and ritual specialist. The latter, called *nganga*, was an expert in medicines and ritual power. Because *minkisi* are empowered by potentially lethal spirits, the process of making these sculptures was fraught with danger: when an element was inserted, it activated the figure and signified a desire for protective or aggressive action. Speech and saliva assume critical empowerment roles, with individuals being asked to lick the figure's eye, brow, or iron blade so that the empowering spirit will be able to respond to any broken vows. This emphasis on speech and saliva is underscored by traditions of carving the mouth open, sometimes emboldened by red pigment.

Although the aims of a *nkisi* vary considerably, social and psychotherapeutic concerns predominate. The most common functions include ending a dispute, making an agreement permanent, creating a mutual aid pact, healing oneself of an affliction, distancing or disempowering an enemy, protecting oneself against or finding out thieves, and assuring security when traveling away from home. As objects of personal battle, *nkisi* attributes often incorporate military attire such as feather headdresses, thick iron chains, and bells attached to belts; similarly, before use, each *nkisi* was "awakened" by the ignition of gunpowder.

Special masks called *tombula* ("to bring up the spirits"; FIG. 184) were sometimes worn by *nganga* during divinations, healing rites, and adjudications. Costumes were fabricated from dried leaves, recalling the belief that maskers represent powerful spirits of the earth. This mask is said to have once been linked to a water *nkisi* and may have been used for witchcraft detection. In the course of the choreographed swirling movements of related dancers, the leaf costumes helped to sweep away dirt (and danger) from the community. Feathers of vultures and other powerful birds are sometimes placed around the edge of the masks, recalling the attire of both warriors and ritual experts and thereby evoking both death and well-being. In their judicial functions masks might be employed by an all-male institution called Ndunga that intervened as a royal counsel, most importantly to punish

184. Vili (Angola). A mask, nineteenth–twentieth century. Wood, pigment, cloth, and mixed media, height 10¼″ (26 cm). Museu Nacional de Etnologia, Lisbon.

Color served in part to convey meaning in these masks, whose faces are defined by bold, brightly painted patterns. Black has been identified with the land of the living (referring to the family and the fireplace). Red is generally associated with blood, danger, war, sorcery, and rites of transition. White suggests the powers of the ancestors, along with spirit force. Together these colors may refer to the seen and unseen worlds of Kongo existence. The extended tongue displayed in some masks, like those on royal staffs (see FIG. 162) and *nkisi*, suggests the sacred role of speech and ideas of devouring associated with malevolence. A button is secured in the center of the forehead of this mask, a part of the body closely associated with authority and intelligence.

wrongdoers at the behest of the ruler. Ndunga maskers appeared at chiefly investitures, at funerals of important individuals, and during crises such as epidemics or the upheavals accompanying an interregnum.

Since the 1950s concerns with colonial history and nation state politics have proved to be an important source of artistic inspiration. Like Kimpa Vita, Mobotu Sese Seko, the former president of Zaire (now the Democratic Republic of Congo), pressed for models of authenticity (FIG. 185). At the same time, however, he opposed all local cultural and political forms that he saw as a threat. Appearing in public in a leopard-skin hat and serpent cane that recalls the *mvwala* staff, Mobotu drew on a range of royal Kongo power motifs to promote his own authority. From the 1960s, abuse of the population by both colonial and governmental authorities has been an increasingly important focus of popular paintings. Men and women are often shown as subordinate to a largely predatory state for which there seems to be no way out. The themes of power and political abuse also hark back to the often sad history of Kongo and European relations in which slavery, missionary activity, and colonial interests were closely interrelated.

THE KUBA KINGDOM

Competing for Status in Courtly Art

East of the Kongo heartland, at the interface of forest and savanna in the central Kasai area of the Democratic Republic of Congo, lies the kingdom of the Kuba. This monarchy comprises various groups (Ngeede, Ngongo, Kete, and others), of whom the Bushoong (or Bushong) were accorded the privilege of choosing the paramount king (*nyim*), to whom the others paid tribute. The vast majority of royal Kuba arts thus more accurately could be called Bushoong or Kuba-Bushoong; similar forms were shared by several unrelated but nearby groups (Shoowa, Leele, and Kel, to name a few).

The Kuba kingdom reached its apex in the years 1870–90, deriving much of its wealth from the export of ivory, along with raffia, camwood, and a diversity of local arts. A dynamic ruler named Shyaam the Great (Shyaam aMbul a Ngoong) founded the present Kuba–Bushoong dynasty around 1625, overthrowing a rival chief and unifying the area's chieftaincies into a more cohesive polity. While Shyaam's origins are debated (there are some suggestions that he was the son of a slave adopted by a local queen),

185. TSHIBUMBA KANDA-MATULU (d. c. 1980) *Les Dirigents Africains* (The African Leaders), 1970s. Paint on flour sack, 17¾ x 14⅛" (45 x 36 cm). Collection Bogumil Jewsiewicki, Quebec City.

Here, the artist shows Mobotu, the former president of Zaire (now the Democratic Republic of Congo), with key attributes of a king, as part of his "Histoire du Zaire" series. A sense of irony and despair is evidenced both in the composition itself (Mobotu's back is to us and his people) and in the text written along the bottom, which reads (in translation): "'Hunger in Africa:' African leaders at risk of dying through politics."

186. Kuba-Bushoong
(Dem. Rep. of Congo). A
statue attributed to Prince
Myeel, seventeenth
century? Iron, height 17¾"
(19.5 cm). Musée
Ethnographique d'Anvers.

One of the most famous
royal Kuba artists was the
seventeenth-century prince
Myeel who became a smith
after taking charge of the
royal iron mines. Although
the attribution of this forged
iron sculpture to Myeel has
rightly been questioned, the
endurance of royal legends
linking Kuba kings to artistic
production makes it a work
of continuing interest. The
enormous size of the
figure's hands in
relationship to the rest of
the body in this work is
striking. While the scale of
the hands may reinforce
ideas of the smith's artistic
primacy, it also calls to
mind the importance of
metal hands as symbols of
protection in Kuba royal
costuming.

royal accounts maintain that early on he traveled to foreign courts, including the Kongo and Pende. After being fortified there with new mystical powers, he made a reappearance in full regalia to claim the throne. His sudden arrival in the royal robes was said to have so shocked the Bushoong ruler that he fled the capital without a fight, leaving the throne to Shyaam.

Artist Kings: Expressions in Iron and Costume

Artistic creativity was a vital Kuba royal concern. As in the Cameroon grasslands, several of the kings are said to have been artists themselves, working in media as diverse as smithing (FIG. 186), weaving, and carving. One such royal artist, King Mbopey Mabi-intsch ma-Kyeen (1939–69), is said to have created his own por-trait sculpture (*ndop*) because he had little faith in the artists of his period. Each Kuba king commissioned or helped to design art works specific to his reign – drums, masks, costumes, objects of daily use, as well as one or more design patterns.

During important royal ceremonies, Kuba kings appeared in an elaborate attire (see FIG. 159) comprised of expensive fabrics, beads, metals, and cowries. The prominent display of cowries in the royal costume emphasizes the ruler as by far the wealthi-est person in the kingdom, so wealthy indeed that he purportedly ate pulverized cowries as part of his diet. With costumes con-stituting an important part of the royal wealth, their weight some-times reached around 185 pounds (84 kg). Parts of rare and pow-erful animals, birds, and plants were integrated into the costume, including a leopard-skin wrap, leopard-tooth necklace, and the feathers of eagles and parrots.

Each king owned a wide variety of costumes which com-plemented his diverse royal functions as warrior, priest, and head of the judiciary, to name but a few. Because many cos-tume elements were buried with the king, his successor had to cre-ate new ones at the beginning of his reign, aided by the royal tailor. Not surprisingly, costumes were critical to the Kuba enthrone-ment, the king being ritually dressed in stages by his brothers after first being robed in a simple white cloth. The 130 titled individ-uals at court also had their own costume forms. The extraordinary richness of Kuba courtly costumes was made possible by a com-bination of relatively high living standards and the considerable free time accorded Bushoong nobles by the labor of non-royal vil-lagers and slaves. They supplied the palace with essential ser-vices and goods (most importantly water, food, wood, and palm wine) as a form of tribute.

Dynastic Myths and the Symbolism of Thrones

Kuba royal prerogative was reinforced by complex mythic narratives, whose meanings and importance have been hotly debated by anthropologists, historians, and others. In the creation myths, the king is usually linked to the creator sky god (Mbwoom) and to the first man (Woot), whose incestuous union with his sister (Mweel) brought forth not only the first children but also illness, death, and disunity. Woot is said to have fled the area after this sexual act, taking with him the vital "basket of knowledge" which held the necessary knowledge and emblems for rule. A Pygmy found this basket and gave it to a Bushoong man, thereby according him and all Bushoong thereafter the right to rule. In keeping with this tradition, each Bushoong-Kuba king was identified with two such baskets (see FIG. 159), one red and one blue, the surfaces of both beautifully decorated with cowries and beads. The

187. Kuba-Bushoong (Dem. Rep. of Congo). Throne from the capital Nsheng, collected in 1909. Wood, height 17¾" (45 cm). British Museum, London.

This royal Kuba throne is elegantly supported by a branching pedestal with a looped handle. It was draped with a leopard-skin before being used.

red basket was passed down within the royal line, the blue basket, which each king commissioned for himself, was buried with him.

The Kuba royal throne (*ipon*; FIG. 187) incorporates a figuration of the sun on its upper surface, a motif that appears frequently in other Kuba royal arts, serving as an icon for Woot, kingship, and social well-being. The base of this throne displays a cluster of palm fronds secured together at the center and splaying outward at both ends, the latter suggesting the importance of raffia palms in Kuba myth and economy. This tree provides essential raw materials for textiles, buildings, cooking oil, and wine. Dynastic associations are also important: in the same way that the Kuba hero Woot's mythic inebriation with palm wine is said to have introduced a series of catastrophes which led ultimately to the foundation of the Kuba kingship, the dynastic founder, Shyaam, is said to have climbed a raffia palm then named himself after it (*shyaam* means raffia palm). Shyaam noted that just as the palm tree never stops producing wine, so the king's knowledge is inexhaustible.

MOTIF FOR WOOT (THE FIRST MAN)

Royal Portrait Sculptures

The dynastic symbol of King Shyaam the Great is the game of *lele*, the well-known African game of capture (known as *mankala* in the West). It was purportedly introduced to help diminish disputes in the kingdom: the person who repeatedly won the game was acknowledged to have good decision-making capabilities. Shyaam is credited with discovering this game during his early travels to courts outside the area. Other innovations include new textiles, a plan for the capital, and a range of new court positions, among these the leaders of important artist compounds, especially sculptors, smiths, and costume designers.

The earliest extant Kuba portrait sculptures date to the beginning of the eighteenth century when the genre (known as *ndop*) is believed to have been introduced by King Misha mi-Shyaang a-Mbul. Following his example, each subsequent king oversaw the creation of his own *ndop* portrait. In later years, similar works were created to personify earlier dynastic rulers. As a group, however, they share a relatively consistent form. One of the most beautiful of these royal figures represents Shyaam (FIG. 188). Shyaam's identity as hero and Woot complement is denoted by the inclusion of three rows of cowrie shells in his belt (in many *ndop*, only one or two cowrie rows were indicated) and by the incorporation of an open square pattern known as "Woot" on the upper surface of the royal cap.

WOOT PATTERN

188. Kuba-Bushoong
(Dem. Rep. of Congo). A
royal portrait figure (ndop)
commemorating the early
seventeenth-century
dynastic founder King
Shyaam the Great, late
eighteenth century. Wood,
height 21½" (54.5 cm).
British Museum, London.

Kuba *ndop* figures show the
king seated crosslegged,
supported on a square
platform (*yiing*). This
platform recalls the
decorative box thrones
employed by both Kuba
and Kongo rulers. The
design along the base of
this platform is known as
nnaam (creeper vine).

The king's headdress
represents the royal *shody*
hat. Its unusual hoe shape
and cowrie decorations
suggest an incident in the
founding myth when some
of the sons of Mbwoom
who were disputing power
wore a hoe on their heads
in order to be recognized
by their supporters. Since
Mbwoom is identified as a
Pygmy in Kuba royal
performances, it is tempting
to speculate that the hoe-
form royal headdress
alludes to the power
struggle which took place
between agriculturalists
moving into the area and
the indigenous Pygmy
hunters, with the former
eventually assuming the
leadership and the latter
retaining ritual authority.

Royal *ndop* portraits owe much to Kongo *mintadi* effigies (see FIG. 177) as suggested by similarities in pose and platform. Kuba traditions that Shyaam visited the coast underscore the likelihood of this source; that a number of the new crops Shyaam is said to have introduced came from the Americas (corn, manioc, tobacco, for example) also supports Bushoong connections with the coastal Kongolese rulers.

Rigidly frontal and symmetrical, with arms positioned tightly against the sides, these portraits evoke ideas of composure, calmness, immobility, solidity, dignity, and detachment. The closed eyes and general lack of expression adds to this quality of majestic distance. In visual terms, the *ndop* sculptures suggest interesting counterfoils to the intense competition for titles and jealousies which helped to produce the boldly innovative designs that characterized many Kuba courtly arts. In the *ndop*, we see the king as someone who through his office and spiritual power is largely above the fray. The avoidance of individualizing features in these works – a quality of African portrait arts in general – suggests the privileging of office over individual.

In the *ndop* portrait, the king is shown to be full-bellied and breasted. The head is also proportionately larger than the rest of the body, a feature consistent with the importance of the head in much African art. The distinctive cowrie shape of the eyes reinforces ideas of royal wealth. Key regalia are also shown, with a few small elements suggesting the larger whole. The royal *ndop* shaving of the coiffure at the temples replicates the hair patterns worn by royals on important ritual occasions. The sword in the figure's left hand represents the short knife carried by the king in major ceremonies. Other distinctive *ndop* elements include a circular neck ring, cane shoulder hoops known as "hippopotamus teeth," a cloth plaque covering the buttocks, and the unusual forward-extending royal headdress.

During the enthronement rites, when each king announced his formal name, he also delineated his personal symbol (*ibol*) in the form of a proverb. This *ibol* is prominently displayed at the front of the *ndop*: Shyaam's is the game of capture, *lele*, as we have seen, which obliquely refers to Shyaam's cunning and intellect in gaining the throne. Other *ibol* include an anvil (for the late eighteenth-century blacksmith king, Mbopelyeeng a-Ntshey), drums (for three eighteenth-century kings – Misha mi-Shyaang a-Mbul, Kota Ntshey, and Kota a-Mbul), a slave (the nineteenth-century king, Miko mi-Mbul), and a flywhisk and "basket of knowledge" (the nineteenth-century ruler Mbopey Mbiintsch ma-Mbul).

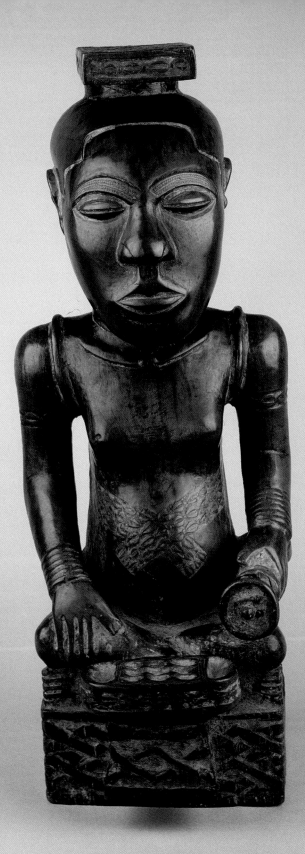

Placed next to the dying king, *ndop* were said to be empowered with the ruler's soul or life force. Before investiture, the new king would sleep beside his predecessor's *ndop* sculpture so that its power would pass to him. Another important *ndop* audience comprised the ruler's wives. Kept in the women's area of the palace, these sculptures were positioned near a woman during childbirth to help her in the course of delivery. Rubbing the surface of the work appears to have served as a means of activation. The red palm oil applied to the *ndop* (which has helped to preserve the sculptures over time), is associated with ideas of fertility, increase, and nobility. In other contexts, these sculptures functioned as substitutes for the ruler when he was away from court. After his death they became memorials. A Kuba king explained the function of these works: "When they look at this statue they will be able to remember me, and think that I watch over them, consoling them when they are sad, giving them inspiration and courage anew."

Initiation and Funerals: The Art of Dynastic Masking

Kuba rulers underwent a complex initiation (*nkaan*) as part of the larger process in which knowledge related to the environment, religion, and history was revealed to them. After his own initiation, the king supervised the initiation of the youth of the capital, appearing himself in the mask known as Mwaash aMbooy (or Moshambwooy or Mukenga; FIG. 189). The mask also personifies Woot, the first human, bringer of civilization, and complement to Shyaam. Chiefs presenting themselves in this mask thus symbolized the continuity of the royal line. The masks were worn during important funerals in the Kuba area and were placed on the royal mannequin representing the ruler at his death.

Created from leather, such masks are distinguished by their rich display of surface beads, shells, feathers, leopard skin, and textiles. Color is an important part of the mask meaning, with red being said to suggest at once suffering and increase, white referring to mourning and religious purity, and blue suggesting high rank and the contributions of individual leaders. As the property of the king, these "friends of the king" masks, as they were known, were guarded in the palace.

Before being worn, the masks were enthroned with ritual chants. Each ruler "performed" a new mask the first time it was worn and when he died it was sometimes buried with him. After the initial performance, the ruler would then lend the

189. Kuba (Dem. Rep. of Congo). A royal elephant mask called Mwaash aMbooy, twentieth century. Mixed media, height 15¾" (40 cm).

Mwaash aMbooy masks represent the ruler as an elephant, the trunk and tusk appearing at the mask's upper surface. The red feather shown often at the end of the "trunk" mirrors the feather carried in the mouth of the king in important rites (see FIG. 159). Said to represent water or forest spirits, such masks underscore the mystical liaison between rulers and the forces of nature. The elephant is also important as an animal of great size, strength, and financial resource, for much of the royal wealth was derived from the ivory trade. In the southern Kuba area, this elephant mask (known as Mukenga) appeared in the funeral dances of aristocratic members (generally worn by the dancer personifying the deceased), and the rich display of beads and shells underscored their status. Important symbols of leadership such as the interlace pattern also appear prominently in the mask decoration.

190. Kuba (Dem. Rep. of Congo). A royal mask called Mbwoom, late nineteenth–early twentieth century. Wood, shell, and beads, 11½ x 15" (29.2 x 33 cm). The Brooklyn Museum, New York.

Such masks are distinguished by their huge copper-covered foreheads, a feature which is also said to commemorate a prince distraught after killing his predecessor's son. In Kuba royal myth, Mbwoom is identified with the Pygmy.

191. Kuba (Dem. Rep. of Congo). A mask representing the woman Ngady aMwaash, nineteenth century. Wood, pigments, beads, cowrie shells, and fiber, height 13" (33 cm). Peabody Museum, Harvard University, Cambridge, Mass.

As is characteristic of the Ngady aMwaash, her face is painted in a bold pattern of white and black triangles, said to suggest hearthstones and domesticity. The tears displayed prominently on her cheeks are thought to evoke the importance of such masks in funerary contexts and the hardship of woman's life (particularly as a pawn, who is pledged to work).

During divination, the flat back of this beautifully carved "rubbing oracle" called *itombwa* (from *itoom*, "diviner") was moistened with an oil and water mixture, then rubbed by the diviner with a wooden disk; when the disk "stuck" it signified an affirmative response. Whatever was being referred to by the diviner at the moment the disk stopped was thought to be significant for the client. If, after turning the *itombwa* upside down, the disk still adhered to the oracle, the truth of the statement was reinforced.

These divination figures have important visual and functional complements with Kingo/Vili animal-form power figures (see FIG. 183); both draw on the power of local nature spirits to aid humans in locating and distancing potential problems. And, like the royal Kuba-Bushoong *ndop* sculptures (see FIG. 188), the primary means of *itombwa* activation is through "rubbing," a process which encourages users to insert themselves more fully into the art viewing experience.

mask to other dancers, although especially talented performers were given the right to commission works on their own. In southern Kuba areas, a huge wall was built during initiation at the periphery of the town. Here masks, figures, and other *nkaan* arts were displayed alongside important insignia.

Another mask in this performance, called *Mbwoom* (FIG. 190), personifies a Pygmy, the king's younger brother, and commoners in general. Performing usually during men's initiation rites, Mbwoom engages in a mock fight with the king (Mwaash aMbooy) for the affections of his sister. She is personified by a masked persona known as Ngady aMwaash ("pawn woman of Mwaash"), who represents the sister (alternatively, mother) of Woot, the wife (and sister) of the king, and women in general (FIG. 191). In the context of Kuba masquerade performances, this work is the subject of a vivid and essentially incestuous rivalry between Mwaash aMbooy and his brother Mbwoom. This woman's paradoxical role

in attracting followers for her master while also being suspected of posing a witchcraft threat may be alluded to by the tears on her cheeks. These three royal masks together form a performance triptych that acts out the mythic story of royal power, deception, and conflict.

Royal Divination Arts: Communicating Nature's Insights

The important place of both myths of origin and nature spirits in the lives of the Kuba finds expression in divination objects in the shape of animals – mainly crocodiles (FIG. 192), dogs, lizards, and warthogs. Problems addressed through these objects range from illnesses and their related treatments to the discovery of thieves. Diviners were called on to interpret the wishes of the wisdom-filled yet fickle *ngesh* nature spirits for humans. Because they

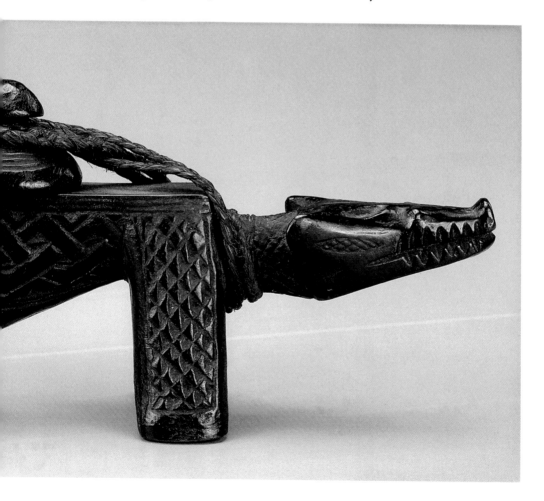

193. Kuba-Bushoong (Dem. Rep. of Congo). The plan of the royal capital, by King Mbopey Mabiintsch ma-Kyeen (1939–69).

Originally conceived as a square, the plan was extended in time into a rectangle, associated measurements being made by an official known as the "chief of the rope." Protective charms were planted at the corners and center of the capital, which spanned an area of around 12,000 square feet (3,657 sq. m). The main entrance, which faced east, was guarded by two war chiefs. When the king died, his palace became his tomb and burial precinct. While some buildings were transported from the earlier site (the mat walls – like those of the Kongo – were quite transportable), others were constructed new in the subsequent ruler's own capital.

The houses of royal subjects were located in the upper area of the capital and toward the east of the palace; the royal guards' residences were positioned "below" and toward the west. Underscoring these spatial divisions, here, as in grasslands Cameroon, one entered the royal city conceptually from above, moving downward toward the palace and the houses of the king's close family members. Positioned beside the palace entry was a residence set aside for twins.

are especially linked to streams and springs, water animals are thought to assume key roles as emissaries of the other *ngesh*. Another animal appearing prominently in divination is the dog because of its ability to sniff out prey during the hunt.

The Architecture of Weaving: Palaces and Spatial Patterns

In addition to creating masks, portrait sculptures, drums, baskets, and other arts, each king also designed his own capital (*nshyeeng*; FIG. 193). After selecting the site and providing it with a distinctive name and slogan, the king supervised the construction of the new palace. In the 1880s the Kuba capital had a population of roughly 10,000. Lushly patterned mat-like walls separated the

1 Place of royal wives away from palace
2 Place where kings are humiliated during enthronement
3 First war chief
4 Second war chief
5 Place of Council
6 Public meeting place and dance ground
7 King's seat during ceremonies
8 Tribunal and restricted meetings
9 House of king's mother
10 Harem official
11 Place of twins
12 Place honouring deceased children
13 House of King's son
14 House of King's successors

different sections of the capital, defining perspectives, and framing areas in a play of horizontals and shifting axes which emphasized at once successive vistas and the harmonious demarcation of open spaces. The main avenue leading into the palace was the dominant focus, traversed by smaller streets, at the junctions of which were positioned the houses of the main court officials.

So important was the royal building program that the new king's enthronement rites were timed to coincide with the inauguration of his capital. On this occasion the king was carried around the new city on a special palanquin. (Sometimes the king moved the palace site during his reign in response to serious problems such as epidemics.) Although impermanent (many buildings lasting only about ten years), key buildings in the palace were carefully maintained so that they would remain standing for more than thirty years. The relative fragility of this architecture necessitated a ready supply of workers, these largely provided by the affiliated non-royal villages, who also supplied the essential raw materials. The prominent place of mats in Kuba capital

194. Kuba-Bushoong (Dem. Rep. of Congo). The king's sleeping room (*mwaan ambul*).

The walls of the palace and other capital buildings provided a rich backdrop for court ceremonies. The geometric designs complement textiles and body decorations. Each pattern had a unique title and meaning. Some recalled the names of the kings who invented them, reflecting the pressure on rulers to demonstrate their creativity through the invention of new designs.

buildings (FIG. 194) finds conceptual parallels in mythic accounts that the creator god Mbwoom laid a mat flat in the sky to organize space and fix the cardinal directions. Because the capital plan faced east, the rising sun would first illuminate the residence of the king. Not only was the king believed to control sunlight and life, but through his use of potent charms he was thought to be able to transform himself into a force of nature who could take human life.

Generally positioned along a stream, the royal city also was divided into upstream and downstream segments, each under the supervision of a noble. This upstream–downstream positioning complements both migration histories in which the royals are said to have arrived in the area from a place "downstream"

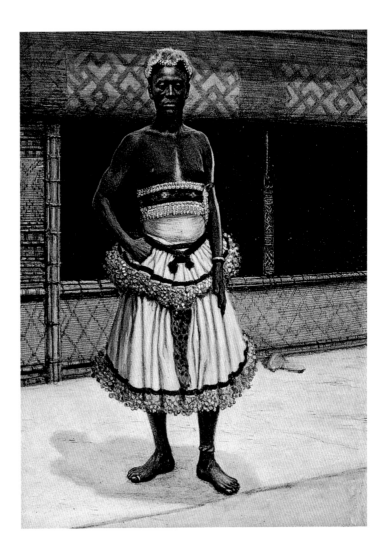

195. Kuba-Bushoong (Dem. Rep. of Congo). King Kot aPe, painted by Norman Hardy from a photograph, published in E. Torday and T. A. Joyce, *Notes Ethnographiques*, 1910–11.

King Kot aPe stands in front of one of his interior palace buildings with its rolled-screen closure and broad threshold panel which provided a degree of privacy; similar threshold panels are used in Cameroon grassland palaces (see FIG. 146).

196. Kuba-Bushoong (Dem. Rep. of Congo). A raffia pile cloth, twentieth century. 28¼ x 25½"
(72 x 65 cm). Fowler Museum Museum of Cultural History, University of California, Los Angeles.

The number of distinct textile patterns is extraordinarily high: one study of Kuba patterns suggests
that two-thirds of all the formulaic variations possible in design are represented in the Kuba textile
corpus, which suggests the primacy placed on artistic innovation in this area. Textile names refer
to individuals such as the king or the talented embroiderer who first created a design. Others (like
the wall patterns) recall elements in nature such as smoke, fish, crocodile backs, and eyebrows.
The most elaborate Kuba cloths were worn at court funerals; the corpses of royals and important
officials were also wrapped in long lengths of cloth.

and ritual traditions that the king's soul returns "downstream" following his death. The Kuba practice of burying the king in a canoe also reflects this idea.

As in Kongo and many other African royal capitals, the palace (*yoot*) was decidedly like a maze, necessitating continual shifts in direction when moving through the interior. The palace was divided into two main sections, that of the king at the south and rear, the houses of his wives toward the front and north. The women's residences occupied roughly a third of the palace and it was here that the king was eventually buried. From the entrance at the southeast corner one passed through two successive courts between which were placed cages of living eagles, symbols of royal power, that complemented the vital political roles that local "eagle feather chiefs" (*kum aphoong*) played in court affairs. From this second court, one passed into a larger court shaded by a tree with commemorative and protective functions. Here was located the throne room and behind it the king's sleeping room. There were no windows but a sizable central door allowed light as well as access into the interior. For greater privacy, the king's portal also sometimes included blinds and/or a broad lintel panel, this latter feature recalling grassland Cameroon forms (FIG. 195).

The decoration of the palace buildings shares important features with textiles known as *mbal* or *nimm* (FIG. 196); here too virtuosity and originality were highly prized. These rich, velour-looking Kuba cloths were made from the young shoots of raffia palm dyed to warm earthen colors ranging from deep red to rust, ochre, and black. While the Kuba king Shyaam is credited with introducing these textiles (purportedly from the Pende in southwestern the Democratic Republic of Congo), close parallels can be seen in Kongo cut-pile textiles (see FIGS 164 and 175). Accordingly, the Kuba term *ncak* ("woman's dress") is a Kongo loan word. To create a woman's wrapped skirt, several cloths were sewn together. For men, only a strip of this material was used as a border.

Weaving throughout the Kuba area was done by men, but it was women (historically, princesses and the wives of the king; FIG. 197) who both designed and sewed the complex embroidery designs, working exclusively from memory. They also cut the surface to give the textiles the soft pile. One of the most striking features of these beautiful and iconically complex fabrics is their variation in design. Whereas the Bushoong prefer balance and relatively regularized

197. A Bangongo-Kuba royal woman in one of the court dance costumes. Painted by Norman Hardy after a photograph, published in E. Torday and T. A. Joyce, *Notes Ethnographiques*, 1910–11.

Women were among the most important artists in Kuba art, particularly in the fabrication of richly patterned textiles. The undulating patterns at the lower and upper periphery of her garment add to its striking sculptural interest.

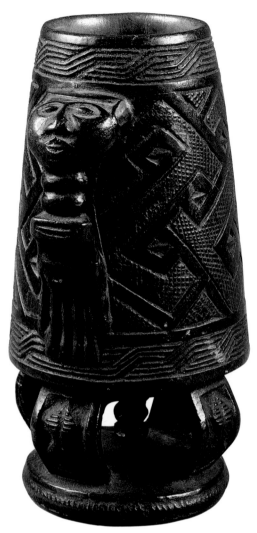

Left

198. Kuba (Dem. Rep. of Congo). A palm-wine cup in the shape of a drum, nineteenth century. Wood, height 7¼" (18.5 cm). Museum für Völkerkunde, Berlin.

The royal drum depicted in this palm wine cup represents a type known as *bukit.* A similar drum appears on the *ndop* sculpture of King Kot a-Mbul, the warrior king who ruled at the end of the eighteenth century.

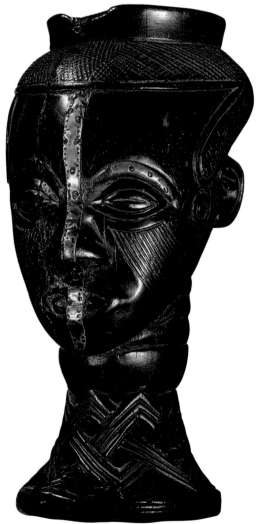

Right

199. Kuba (Dem. Rep. of Congo). A palm-wine cup, nineteenth–twentieth century. Height 7½" (19 cm). Werner Forman Archive, London.

Visual puns are a prominent feature of many such cups. Here a human head serves as a vessel. In other cases, an image of an arm or hand is added to the handle, or the vessel itself takes the shape of a stomach.

patterns, the nearby Shoowa tend to prefer irregular, unexpected, and even juxtaposed designs. Frequently, several quite different patterns are placed side by side, as if competing for our attention and praise.

Two important art forms identified with competition between titled court members are carved palm-wine drinking cups (FIGS 198 and 199) and elaborate boxes (FIG. 200) for razors, costume items, jewels, and the red camwood paste smoothed on the body during ceremonies. With half of all Bushoong men holding titles in the 1880s, competition for influence was sometimes fierce, and found expression in the elaboration of these essentially commonplace household objects into works of extraordinary beauty. Because Kuba individuals of high status signaled their largesse by distributing great quantities of palm wine to their friends and affiliates to attract a following, the complexity of such art came under public scrutiny. If, as the myths maintain, the inebriation caused by drinking palm wine led eventually to the formation of the royal line, drinking thus provided the social setting in which office holders were able to play out through art the precariousness of their own positions within this heatedly contested milieu.

CONCLUSION

The Continuing Vitality of Africa's Courtly Arts

The accounts of sixteenth- and seventeenth-century European travelers to Africa are replete with descriptions of sumptuous palaces, lavish courts, powerful kings, and handsome artifacts. Art works from these African kingdoms became the prized possessions of Europe's most discerning collectors, among these Cosimo I de' Medici of Florence, Eleonora of Toledo, and King Gustavus Adolphus the Great of Sweden. The complex art histories of associated African kingdoms are known to us today not only through such collections and early travelers' narratives, but also detailed oral histories maintained at the African courts themselves, contemporary palace rituals based on earlier royal traditions, and, where available, archeological evidence from dynastic centers.

Many African royal art works themselves helped to preserve the memory of important individuals and incidents from the past, and iconically complex graphic forms were widely used for documentation as well. Visual symbols, however, generally addressed ritual and philosophical issues rather than historical events, a feature shared by the first writing systems in Mesopotamia and several other areas of the world. In those parts of sub-Saharan African where Arabic came to have early and widespread usage, the scripts frequently had ritual, healing, and protective functions in addition to standard record-keeping.

African arts of dynastic history and ritual are but two of the issues addressed in this book. In the Introduction, key paradoxes of African rulership prerogative were examined, among

these notions of the sacred king as sinner king, and the all-knowing king as fool. The chapters explored the arts of important sub-Saharan African kingdoms dating from the sixteenth to the twentieth centuries through an examination of political, social, and religious concerns with their arts. Rather than serving exclusively as a mirror of royal institutions and patrons, these arts, as we have seen, were important agencies of dynastic power in their own right.

Each of the African monarchies discussed here sought to create a distinctive image of itself through its arts. While Africa's monarchs today often assume the roles of ambassadors and cultural representatives at national and international events, members of royalty are not the only ones who have sought to define themselves in the present era through dynastic art forms. Africa's new national leaders and economic elites have also become important "royal" art patrons.

Most of these African kingdoms would have left little if any material evidence of their elite identity and broad political power, which should indicate the complexity of understanding what has remained with respect to kingships. The frequent moving of African royal palaces and capitals suggests that archeological studies which focus as much on spatial breadth as on temporal depth are essential here.

With land and shrines in Africa historically being controlled by ancient community-based trusts rather than individuals, deep-seated socio-economic differences between rulers and those they ruled tended to be somewhat mitigated over time. The societal divisions could also be bridged through the promotion of non-royals to positions of authority in the court. Kingmakers (many of whom were non-royal) played a critical role both in designating future monarchs and in removing unsuccessful leaders from power, so that Africa's rulers had to be responsive to local needs.

The royal arts addressed in this book offer their unique insight not only into Africa's rich artistic heritage and institutions of royal authority, but also dynastic art and political concerns in a wider sphere: our understanding of earlier and later African communities in the Americas is thus enriched by this study. A number of African men and women brought to the Americas during the tragic era of international slavery were members of royal families, such as the mother of the nineteenth-century King Guezo of Dahomey, who ended up in Brazil. Today, African scholars are largely in agreement that Yoruba, Fon (Dahomey), and Kongo traditions have had an especially significant impact on social and religious life in the African-American diaspora. In this light it is

interesting to consider the importance that indigenous African royal arts and political structures may have had in the creation of new cultural forms in the communities where these individuals came to reside. These include not only striking rituals, but also smithing, textile production, woodcarving, basketry, music, and dance. While these arts occasionally refer to kingship, more frequently they address complementary issues of power, leadership, social inter-action, cosmological order, and personal well-being, providing knowledge not only about individual and community identity, but also about the means through which prevailing authority could be mitigated. The continuing importance of African royal arts in transplanted communities in the Americas comple-ments the long history that these arts have had in Africa in the expression of political hegemony, cultural identity, religious beliefs, and artistic creativity.

	Benin	Yoruba and Dahomey
before 1400	**1000** Vast network of linear earthworks at Benin indicate widespread occupation **c. 1200** Ogiso kings, first Benin dynasty; terracotta heads later distinguish their altars **13th century** Oranmiyan, prince from Yoruba kingdom of Ife, founds present Benin dynasty	**11th C** Intensive settlement of Yoruba site of Ife; ear[ly] pavements of Ife **1100** Ife produces works of bronze, glass, stone, and terracotta
1400–1500	**early 15th–mid-16th C** Warrior kings period; casting of early brass trophy heads **c. mid-15th C** Reign of King Ewuare: rebuilds Benin city with a centralized plan; establishes new rituals, laws, and ministers; institutes use of aquamaniles and cult of hand altars First direct contact with European traders	Early Yoruba site of Owo at its height on tra[de] route between Ife and Benin
1501–1600	**mid-16th C** King Esigie creates title of Queen Mother in honor of his mother, Idia, and establishes tradition of casting bronze heads; Esigie introduces ivory masks and possibly the first brass plaques **1553** British visit Benin for the first time **c. late 16th C** Reign of King Ehengbuba, military leader who creates elaborate court rituals **late 16th–18th C** Middle period of bronze heads and plaques	Later Ife artworks; Yoruba trade and military center established at Old Oyo lastin[g] until 1700
1601–1700	**1668** Illustration of Benin capital published by Olfert Dapper **c. 1690–1713** Reign of King Ewuakpe I: comes to power during civil war; his altarpiece illustrates the economic hardships of his reign	**1620–45** Area of future Dahomey capital controlled b[y] local Guede chiefs, Ganye Hesu and Dako Donu **1645–85** Kingdom of Dahomey founded by Huegbad[ja] **c. 1650** Rise of Oyo Yoruba empire; Yoruba style Ifa divination board produced in Ayizo town of Allada **1685–1705** Reign of Akaba, Huegbadja's son: complete[s] conquest of Abomey plateau
1701–1750	**c. 1715–35** Reign of King Ahenzua I: wrests control from rebel Town Chiefs; portrayed atop an elephant to symbolize his victory **c. 1735–50** Reign of King Eresonyen, one of the wealthiest kings; elaborate throne and altar of the hand alludes to his wealth; introduction of brass *Ododua* masks	**1705–1708** Reign of Tassi Hangbe Akaba's sister **1708–32** Reign of Dahomey king Agaja: defeats Ayizo capital of Allada and gains access to coast in 1727-29; redesigns capital city of Abomey with centralized plan; builds new palace; initiates use of appliqués; institutes the annual *huetanu* ceremonies **1732–74** Reign of Dahomey king Tegbesu: reorganize[s] state religion and court ministerial positions **1730s** Oyo Yoruba seize Dahomey capital, Abome[y]

Asante	Cameroon grasslands
1000–1300 Gold, kola, and other goods traded with Muslims to the north **14th C** Small states develop between gold fields and middle Niger; commercial ties established with Djenne and other Mali cities to the north	**11th C** Rulers of Kanem, north of grasslands, convert to Islam **14th C** Kanem reduced to tribute status, superceded by Bornu; major trade routes established to north, east, west, and south
1471 Portuguese navigators reach Akan coast; Dutch, French, and British follow **1482** Portuguese build Elmina Castle on the coast	Portuguese explore coastal area
Trading sites around late Asante Capital of Kumasi grow **c. 1600** Early Akan terracotta heads; tradition continues into 20th century	Westerly migration of Tikar peoples into grasslands area Spanish, Dutch, and British trade begins
1680 Future Asante kingdom develops **1661–1700** Asante states consolidate; Asante adopt *afena* state swords following their defeat of Denkyira **c. 1700–1750** Asante of Kumasi under Osei Tutu establish supremacy over Akan peoples	**1601** Bamum kingdom founded by Share Yen (Nsha'ro) from Tikar Nguopu succeeds her brother, Share Yen
1700s Early geometric-form goldweights conform to Islamic weighing system **1701** Golden Stool appears before Osei Tutu; Asante Kingdom founded **1705** Reign of Osei Tutu begins: intoduces new rulership rituals and stool forms; establishes tradition of "soul washers"	Early palaces in Bamum and Bamileke areas; iron working

	Benin	Yoruba and Dahomey
1751–1800	**mid-18th–late 19th C** Late period bronze heads	**1760** Yoruba empire of Oyo at height of its power **1774–89** Reign of Dahomey king Kpengla: tries to break Yoruba yoke over the area **1789–97** Reign of Dahomey king Agonglo: initiates new artistic programs in weaving, throne design, royal *makpo* scepters, and other art forms
1801–1900	**1815–50** Reign of King Osemwende: introduces winged extensions to the royal crown **c. 1830** Chiefs accorded the right to use wooden altar heads **1888–97** Reign of King Ovonramwen, last Benin ruler before colonial overthrow **1897** British Punitive Expedition **1900** British Southern Nigeria Protectorate formed	**1810s** Muslim Fulani conquer Ilorin in northern Yoruba area **1839** Old Oyo sacked by Fulani **1818–58** Reign of Dahomey king Guezo: overthrows King Adandozan; gains economic and military independence from the Yoruba; commissions European artwork and initiates new figural emphasis in palace bas reliefs; signs commercial treaty with France; builds catholic church in capital **1858–89** Reign of Dahomey king Glele: commissions war sculptures in brass and iron to commemorate his father; initiates use of silver nose mask; promotes palm wine production Court artists Sosa Adede, Akati Akpele Kendo, and Ganhu Huntondji produce artistic masterpieces for King Glele **1861** British colony established in Yoruba city of Lagos **1889–94** Reign of Dahomey king Behanzin: loses against French takeover of kingdom and is exiled to Martinique **1889–94** Reign of Dahomey king Agoli Agbo: placed on throne by the French; helps to preserve and revitalize court art traditions
1900s	**1933–78** Reign of King Ahenzue II: embellishes palace and commissions the carver Ovia Idah (1908-68) to decorate façade with reliefs of Benin dynasty **1960** Nigeria gains independence	**1910–14** Yoruba palace sculptor, Olowe of Ise complete large commission for Ekiti palace; Yoruba sculptor Arowogun also at his height **1950s** Beginning of modern Yoruba artists group in Oshugbo, Nigeria **1960** Nigeria gains independence; Dahomey gains independence **1963** Republic of Nigeria created **1975** Dahomey becomes the Republic of Benin

Asante	Cameroon grasslands
1775 Asante empire at its height; Europeans refer to it as the Gold Coast **1800–20th C** Goldweights become more figurative and conform more closely to European weighing system	
1817 King Osei Bonsu visited by British traveler T.E. Bowdich: promotes architectural projects; enlarges and renovates the capital; commissions a "stone palace" **1818** Asante victory over King Adinkra leads to establishment of *adinkra* cloth in Kumasi; gold sword ornaments **1870** Dissipation of indigineous power, due to colonial presence; prominent use of sculptures showing mother and child themes and increasing number of *akuaba* sculptures **1874** British defeat 60,000-strong Asante army under King Kofi Kakari; gold head and other arts from his treasury confiscated **1887–97** Queen Victoria's jubilees lead to importance of lion and other European imagery in courtly and non-courtly arts **1896** British exile King Prempe I	**c. 1820–40** Reign of Bamum king Mbuembue, great military leader: expands the kingdom; brings vast new wealth and art forms to Bamum; builds moat around capital **c. 1840–45** Reign of Bamum king Gbetngkom **c. 1845–50** Reign of Bamum king Mbiengkuo **c. 1850–60** Reign of Bamum king Nguwuo, originally a non-royal court official **c. 1860–70s** Reign of Bamum king N'sare: builds his palace on site of Mbuembue's palace at Foumban **1865–1912** Reign of the Kom Artist-King Fon Yu: carves a corpus of stool figures **1884** Bismarck proclaims German protectorate of Kamerun **1885–87** Reign of Bamum king Nsa'ngu; elaborate throne created which King Njoya later gives to Germans; Nsa'ngu killed in battle by his brothers **c. 1887–92** Reign of Bamum female ruler, Setfon, who serves as regent for her teenage son Njoya **c. 1892–1933** Reign of Bamum king Njoya, an important patron of art and architecture: creates a written language; establishes court art schools; encourages textile production; writes a Bamum history and ritual guide
1921 Golden Stool which had been buried for safe keeping is desecrated, then reworked into new Golden Stool **1924** Prempe returns from exile **1925–40** New court arts are encouraged in attempt to reestablish royal prerogative; popular music groups and trade associations among Fante and other Akan cultures become important patrons of the arts **1957** Ghana created by amalgamating British Gold Coast and Togoland under President Kwame Nkrumah (1957–66) **1960** Ghana gains independence **1970s** Kane Kwei creates first figurative coffins	**1905** Njoya's first palace burns down **1909** Njoya renovates palace of Nsa'ngu **1914** French take over German Kamerun **1915–17** Prince Ibrahim Njoya designs three-storey palace for Njoya **1920s–30s** Ibrahim Njoya creates illustrated court history and tableaux of artists at work; helps form new written language **1931** French exile King Njoya **1960** Cameroon gains independence **1960–82** Ahmadun Ahidjo as President of Cameroon **1976** King Jinaboh II comes to Kom throne

Kongo and Kuba

before 1400

11th–12th C Kisalian culture in southeast; iron and brass working, complex pottery; political hierarchy indicated in burials

1300 In Shaba, copper cast into cross-shapes as a form of currency

14th–15th C Extensive copper mining and trade in southeastern Congo

1400– 1500

c. 1400 Kongo kingdom founded by Nimi a Lukeni; ironsmithing

1482 Portuguese reach Congo estuary

1490 King of the Kongo is baptized as Joao I

Ivory horns used to sing praises of the dead; carved ivories and other arts become valued objects among European nobility

1556 Kongo described as "the greatest of kingdoms of Africa's west coast"

end 16th C Separate Portuguese quarter established at the Kongo capital of Mbanza Kongo

1501– 1550

Other areas in Africa

000	Stone buildings in Kumbi Sahel, capital of ancient Ghana (Mauritania, Mali) and center of cross-Saharan gold trade (West Africa)
	Bronzecasting center of Igbo Ukwu (Nigeria)
	Clay figures of cattle; copper and iron working in south-eastern Zimbabwe
100	Rise of Zagwe dynasty in Ethiopia; Ethiopian rock-cut churches
te 12th C	Gold foil animal figures, glass beads, copper and gold jewelry (East Africa)
200	Rise of Kilwa and Swahili coast to commercial wealth and power (East Africa)
230	Sundiata, king of Mandinka state of Kangaba, founds early state of Mali (West Africa)
250–80	Great Zimbabwe, Shona center: stone enclosures, gold working, cotton weaving (East Africa)
255	First Kanem Bornu empire near Lake Chad (West Africa)
312	Mansa Musa comes to power in Mali and expands kingdom
330	Christian Ethiopian empire flourishes
331	Moroccan writer, Ibn Battuta visits east African coas

Europe/Americas/Asia

960–1279	China ruled by Sung Dynasty
1066	Norman conquest of Britain
1056–1147	Reign of the Almoravids in North Africa and Spain
1215	Magna Carta signed by King John of England
1337–1453	Hundred Years' War between England and France
1375	First detailed map of West Africa by Cresques of Majorca

400	Kilwa (Tanzania) at its height; dominates gold trade with Arabia and Far East
443	Tuareg occupy Timbuktu and Oualata (West Africa)
465-92	Reign of Sunni Ali, emperor of Songhai (Mali); conquers Niger Valley (West Africa)
468	Sunni Ali recaptures Timbuktu from Tuareg (West Africa)
493	Askia Muhammad becomes emperor of Songhai (Mali); growth of Timbuktu and Djenne as trading centers; expansion of gold trade to the south (West Africa)

1417	Chinese fleet reaches East Africa
1420	Ming dynasty moves capital to Beijing; builds Forbidden City; increases contact with West
1434	Portuguese establish largely peaceful trade with West African coastal communities
1469	Death of Cosimo de' Medici, ruler of Florence; height of the Italian Renaissance
1483	Portuguese make contact with Kongo king
1492	Christopher Columbus reaches Bahamas, Cuba, and Haiti; expulsion of Jews from Spain and of Muslim rulers from southern Spain; Pope divides New World between Spain and Portugal
1497–8	Vasco da Gama voyages round the Cape of Good Hope (South Africa) to India; his companions learn of East Africa empire of Monomotapa
1500	Islamic world extends west to Bosnia, north to Volga River, northeast to Central Asia, south to sub-Saharan Africa and East African coast, and southeast to India and Indonesia

505	Portuguese sack Kilwa and Mombasa
517	Ottomans conquer Egypt and expand west along North African coast
520	Peoples in Angola repel Portugusese invasion and are not defeated until the mid-17th C
585	Swahili towns revolt against Portuguese control (East Africa)

1520	Beginning of Trans-Atlantic slave trade
	Spanish conquests in Caribbean and Central America
1520s	Martin Luther generates Protestant Reformation in Europe
1520–66	Reign of Sulayman the Magnificent over the Ottoman empire
1526–1858	Reign of Mughal emperors in India
1550	Trading ties established between European sea merchants and African coastal communities
1556–98	Reign of Philip II of Spain, champion of the Counter Reformation; the "Golden Age" of the Spanish empire

Kongo and Kuba

1551–1600

1601–1700

c. 1625	Shyaam the Great founds Kuba-Bushoong Kingdom; introduces new textiles and crops to the coastal areas
1650s	Kingdom of Kongo splintered by Portuguese invasions and slave trade; regalia incorporate many European motifs
17th C	Kuba prince Myeel takes over iron mines and gains fame as a blacksmith

1701–1800

1701	Kuba king Misha mi-Shyaang a-Mbul initiates tradition of *ndop* portrait sculptures
c. 1710	Kongo princess Kimpa Vita (Dona Beatriz) begins religious and political movement to revitalize Kongo kingdom; Mbanza Kongo is resettled and local textile manufacture is promoted; Kongo images of St. Anthony introduced; Kimpa Vita is defeated by local nobility and church
18th C	Kingdom of Kongo loses its identity as a unified state

1801–1900

19th C	Kongo "tourist" ivories are widely available
1870–90	Kuba kingdom at its height; ivory, raffia, and camwood exports grow
1878	King Leopold of Belgium funds the explorer Henry Morton Stanley in Congo basin
1880	French control northern Congo
1885–1908	Belgium establishes Congo Free State in central and southern areas

1900s

1908	Congo Free State renamed Belgian Congo
1908–58	Congo known as "Middle Congo" in French Equatorial Africa
fl. 1930s	Kongo artist Makoza of Kingoyi produces *niombo* and *muzindi* figures
1950s	Civil war begins in Angola under Portuguese rule
1960	Congo gains independence; Belgian Congo gains independence
1960s	Brazzaville Bloc formed to aid newly independent states
1965	General Mobotu seizes power in Belgian Congo; re-elected as President in 1977 and 1984; ousted in 1997 by Laurent Kabila
1970s	Kuba king Kot a-Mbweeky III in power; "Histoire du Zaire" political series by artist Tshibumba Kouda-Matula (1970s)
1971	Belgian Congo becomes Zaire; fall in copper prices
1997	Zaire renamed Democratic Republic of Congo under Kabila

Other areas in Africa	Europe/Americas/Asia
592 Songhai army defeated by army of Moroccan sultan (West Africa)	**1588** English victory over Spanish Armada fleet **c. 1590** Flemish metallurgy given impetus by trade with West African coast; slaves exchanged for bronze; Dutch, English, and French compete with Portuguese and Spanish for overseas trade and conquest
7th C Decline of Monomotapa (East Africa) **640** Rise of Buganda (East Africa) **651** Dutch arrive in South Africa and establish Capetown (South Africa) **670** End of the Mali empire; foundation of Bamana Kingdom at Segu (West Africa)	**1602** Dutch East India Company incorporated, initiates Dutch colonies in southeast Asia **1620** The Mayflower lands in Massachusetts Bay **1620s–30s** Dutch West India Company in Caribbean established **1651–1715** Reign of Louis XIV of France; Dutch sea empire at its height; trade competition in India with English, French, and Portuguese; West Indies sugar highly prized by Europeans vying for control of production and trade **1684** Huge expansion of sugar and tobacco cultivation in Caribbean and Americas by Europeans, with increased demand for slave labor
728 Earliest known writing in Swahili: the *Utendi wa Tambuka* (East Africa) **779** Beginning of Kaffir wars between the Dutch and Bantu (South Africa)	**1713** British become the biggest buyers and carriers of slaves from Africa **1730–1800** British industrial revolution; profits from slave trade help to make it possible **1789** French Revolution **1791** Toussaint L'Ouverture, black revolutionary leader, declares Haiti independent from France
804 Fulani conquest of Hausa kingdoms and Usman's foundation of the Muslim empire (West Africa) **806** Rise of Zulu empire (South Africa) **810** Dakar (Senegal) gains independence under Diop family (West Africa) **816–28** Reign of Zulu king Shaka **821** Foundation of Liberia (West Africa); 1847 Liberia gains independence **870** German botanist George Schweinfurth reaches Mangbetu court of Mbunza (East Africa) **899–1902** Boer War	**1807** Slave trade outlawed by British in their colonies **1820** British continue to build empire in India **1841–73** David Livingstone explores South and East Africa **1856** American Civil War; 1863 Emancipation Proclamation declaring the freedom of all slaves in the Southern states **1884** Berlin Conference delineating European partition of Africa; beginning of armed penetration by Europeans into every region of Africa
909-13 H. Lang and J. Chapin expedition from the American Museum of Natural History collect massive cultural and natural materials from Mangbetu (East Africa) **910** Union of South Africa formed **914** Boer uprising (South Africa) **995** President Nelson Mandela, first black president of South Africa	**1906–1907** "Discovery" of African art by Braque, Picasso, and Matisse **1914–18** First World War; African batallions recruited to fight; Allies divide up former German colonies; collapse of Ottoman empire **1917** Russian Revolution **1920s** The Depression in the Western world **1931** French mission to Dakar-Djibouti **1939–45** Second World War **1947** Indian independence from Britain **1949** People's Republic of China founded; Mao becomes Chairman **1960s** African independence movements against European colonial authorities

Glossary

abramo alloy weight (Asante)

abusua kuruwa family pots (funerary vessels, Asante)

adampan portico (Asante)

adinkra cloth (Asante)

adjalala reception hall (Dahomey)

afena state sword (Asante)

aflefle pendants (Dahomey)

agbo hole, moat (Dahomey)

ahianmwen-oro ideophone (Benin)

ahosi king (Dahomey)

akrafo "soul washer" (Asante)

akrafokonmu "soul washer's disk" (Asante)

akuaba "Akua's child" wooden figure (Akan)

amufi acrobat (Benin)

ase sacred power (Yoruba)

asen memorial sculpture (Dahomey)

asensie tomb, "place of pots" (Asante)

atinkpato sculptor (Dahomey)

ayido hwedo the rainbow (Dahomey)

ayizan earthen mound (Dahomey)

babalawo diviner (Yoruba)

bilongo empowering materials (Kongo)

boho military shrine (Dahomey)

bukit a drum type (Kuba)

bwaantshy "python," royal costume (Kuba)

cimpaba (tshimphaaba) knife scepters (Woyo, Kongo)

dadasi "female kings" (Dahomey)

dan serpent (Dahomey)

dika cloth strip (Kongo)

djeho soul house (Dahomey)

dua altar (Asante)

dwira to purify (Asante)

edan staff (Yoruba)

ekete stool-throne (Benin)

epa mask (Yoruba)

ewa beauty (Yoruba)

fikula funerary cylinders (Kongo)

fuon-toh statues (Kom, Cameroon)

gbedu drum (Yoruba)

gyase courtyard (Asante)

home stomach or middle (Dahomey)

hotogantin finial (Dahomey)

huehonji "entrance of mirrors" (Dahomey)

huetanu annual ceremonies (Dahomey)

ibeji twins (Yoruba)

ibol king's symbol (Kuba)

itombwa divination animal figure (Kuba)

iwa character (Yoruba)

jandeme throne (Dahomey)

kabaka king (Uganda)

kente type of cloth (Akan)

keteke stool (Dahomey)

kpoge cane (Dahomey)

kra life force or soul (Asante)

kuduo ritual brass vessel (Asante)

kyeame poma linguist staff (Asante)

laba shango leather bags (Yoruba)

lubongo raffia textile (Kongo)

lumbu fence or screen (Kongo)

lumu palace central courtyard with throne (Bamum, Cameroon)

luumbo court (Kongo)

mabazi a mambu court of justice (Kongo)

mabolo dance (Mangbetu, Dem. Rep. of Congo)

makpo "staff of fury" scepter (Dahomey)

mandu yenu "richness of beads" (Bamum, Cameroon)

mani secret society among Azande (Dem. Rep. of Congo)

mbal textile type (Kuba)

mbansie palace regulatory society (Bamum, Cameroon)

mma "infants" funerary terracotta figures (Akan)

mpu cap crown (Kongo)

mpungi ivory horn (Kongo)

muzindi (also kiimbi) mini-funerary figures (Kongo)

mvwala royal staff (Kongo)

myuush shell spiral pattern (Kuba)

ndyeemy balweky "sorceror's fingers" costume **name** (Kuba)

nganga ritual specialist (Kongo)

ngesh nature spirit (Kuba)

ngoyou beaded headdress (Kom, Cameroon)

nimm textile type (Kuba)

niombo funerary figure (Kongo)

nkaan initiation (Kuba)

nkisi (pl. minkisi) empowered statue (Kongo)

nkondi (pl. zinkondi) subclass of nkisi

nkonnua fufuo whitened stools (Asante)

nkonnua tuntum blackened stools (Asante)

nnaam creeper vine (Kuba)

nsodie see mma

ntadi guardian sculpture (Kongo)

nyim paramount king (Kuba)

nyui ndem "mother of god" mother of twins statue (Kom, Cameroon)

oba ruler (Benin and Yoruba)

ododua masquerade (Benin)

odu divination sign (Yoruba)

Ogboni Yoruba society dedicated to the earth god

okyeame linguist (Akan)

oogun ase powerful medicine (Yoruba)

ori destiny (Yoruba)

orisha god (Yoruba)

osun nature spirit (Benin)

otadee metal disk "like a pool" (Asante)

Pramakeseso Main Court in the Asante palace

sa kya boondo "drum-shaped pot" funerary vessel (Kongo)

sinuka calabash container and sculpture (Dahomey)

suman amulet (Asante)

sunsun soul or spirit (Asante)

taampha serving vessel (Woyo, Kongo)

tombula "to bring up the spirits" mask (Kongo)

uzama founders of the first dynasty (Benin)

vodun supernatural powers (Dahomey)

weke cosmos (Dahomey)

yiing sculpture platform base (Kuba)

yoot palace (Kuba)

Yovogan title of nineteenth-century foreign minister (Dahomey)

zinga spiral, long life (Kongo)

zinkponon owner of the stool (Dahomey)

Bibliography

INTRODUCTION
Paradoxes of Rule

GENERAL ART HISTORY

BEUMERS, E., and H.-J. KOLOSS (eds), *Kings of Africa: Art and Authority in Central Africa* (Maastricht: Foundation Kings of Africa, 1992)

BLIER, S. P., "Enduring Myths of African Art," in *Africa: The Art of a Continent: 100 Works of Beauty and Power* (New York: Guggenheim Museum, 1996): pp. 26-32

COOMBES, A. E., *Reinventing Africa: Museums, Material Culture, and Popular Imagination* (New Haven: Yale University Press, 1994)

COLE, H. M., *Icons: Ideals and Power in the Art of Africa* (Washington, D. C.: National Museum of African Art, 1989)

FRASER, D., and H. COLE (eds), *African Art and Leadership* (Madison: University of Wisconsin Press, 1972)

HULL, R. W., *African Cities and Towns Before the European Conquest* (New York: W. W. Norton and Co., 1976)

KARP, I., and S. D. LEVINE (eds), *Exhibiting Cultures: The Poetics and Politics of Museum Display* (Washington, D. C.: Smithsonian Institution Press, 1991)

LIFSCHITZ, E., *The Art of West African Kingdoms* (Washington, D.C.: National Museum of African Art, Smithsonian Institution Press, 1987)

NOOTER, M. (ed.), *Secrecy: Art that Conceals and Reveals* (New York: Museum for African Art, 1993)

Picton, J., and J. Mack, *African Textiles, Looms, Weaving and Design* (London: British Museum Press, 1979)

Ross, D. H. (ed.), *Elephant: The Animal and its Ivory in African Culture* (Los Angeles: Fowler Museum of Cultural History, UCLA, 1992)

RUBIN, A. G., *African Accumulative Sculpture: Power and Display* (New York: Pace Gallery, 1974)

SIEBER, R., and R. A. WALKER, *African Art in the Cycle of Life* (Washington, D. C.: National Museum of African Art, Smithsonian Institution Press, 1988)

VOGEL, S. (ed.), *For Spirits and Kings* (New York: Metropolitan Museum of Art, 1981)

AFRICAN KINGSHIPS - HISTORICAL, SOCIAL, AND THEORETICAL ISSUES

Arens, W., and I. Karp (eds), *The Creativity of Power: Cosmology and Action in African Societies* (Washington D. C.: Smithsonian Institution Press, 1989)

BEIDELMAN, T. O., "Swazi Royal Ritual," *Africa* 36 (1966): pp. 373-405

CANNADINE, D., and S. PRICE (eds), *Rituals of Royalty: Power and Ceremonial in Traditional Societies* (Cambridge: Cambridge University Press, 1986)

Feeley-Harnick, G., "Issues in Divine Kingship," *Annual Review of Anthropology* 14 (1985), pp. 273-313

Frazer, J. G., *The Golden Bough: A Study in Magic and Religion* (London: 1890)

HOCART, A. N., *Kingship* (Oxford: Oxford University Press, 1927)

—, *Kings and Councillors* (Chicago: University of Chicago Press, 1970)

GARLAKE, P., *The Kingdoms of Africa: the Making of the Past* (New York: Peter Bedrick, 1990)

MAIR, L., *African Kingdoms* (Oxford: Oxford University Press, 1977)

THORNTON, J., *Africa and Africans in the Making of the Atlantic World 1400-1680* (Cambridge, England: Cambridge University Press, 1992): esp. pp. 104-105

BUGANDA AND MANGBETU

RAY, B. C., *Myth, Ritual, and Kingship in Buganda* (Oxford: Oxford University Press, 1991)

SCHILDKRAUT, E., and C. A. KEIM, *African Reflections: Art from Northeastern Zaire* (Seattle: University of Washington Press, 1990)

SPEKE, J. H., *Journal of the Discovery of the Source of the Nile* (Edinburgh: 1863)

PARADOXES IN AFRICAN ROYAL ART

DOUGLAS, M., *Purity and Danger: An Analysis of Concepts of Pollution and Taboo* (London: Routledge and K. Paul, 1969)

GEERTZ, C., "Centers, Kings, and Charisma: Reflections on the Symbolics of Power," in J. Ben-David and T. Nichols (eds), *Culture and Its Creators; Essays in Honor of Edward Shils* (Chicago: University of Chicago Press, 1977): pp. 150-71

KANTOROWICZ, E. H., *The King's Two Bodies: A Study in Mediaeval Political Theology* (Princeton: Princeton University Press, 1957)

KILSON, M., "Taxonomy and Form in Ga Ritual," *Journal of Religion in Africa* 3 (1970): pp. 45-66

MEILLASSOUX, C., *The Anthropology of Slavery: The Womb of Iron and Gold* (Chicago: University of Chicago Press, 1991)

ONE *The Benin Kingdom: Politics, Religion, and Natural Order*

BAKER, R. ST-B., "Magie au Benin," *Revue de Paris* (April, 1949): pp. 127-39

BEAUVOIS, A. M. F. J. P. DE, "Notice sur le people de Benin," *Décade Philosophique* 12, *année* 9 (1801): pp. 144-51

BEN-AMOS, P. G., "Men and Animals in Benin Art," *Man*, N.S. 2, no. 2 (1976), pp. 243-52

—, "Professionals and Amateurs in Benin Court Carving," in D. F. McCall and E. G. Bay (eds), *African Images: Essays in African Iconology* (New York: Africana Publishing Co., 1975)

—, "Who is the Man in the Bowler Hat? Emblems of Identity in Benin Royal Art," *Baessler-Archiv*, N. F. 31 (1983): pp. 161-83

—, *The Art of Benin* (London: Thames and Hudson, 1980. Revised edition, Washington, D. C.: Smithsonian Institution Press, and London: British Museum Press, 1995)

BEN-AMOS, P, and A. RUBIN (eds), *The Art of Power/ The Power of Art. Essays in Benin Iconography* (Los Angeles: Fowler Museum of Cultural History, UCLA, 1983)

BLACKMUN, B., "From Trader to Priest in Two Hundred Years: The Transformation of a Foreign Figure on Benin Ivories," *Art Journal* 47,

no. 2 (Summer, 1988): pp.128–38

—, "Who Commissioned the Queen Mother Tusks? A Problem in the Chronology of Benin Ivories," *African Arts* 24, no. 2 (1991): pp. 54–65, 90

BLIER, S. P., "Imaging Otherness in Ivory: African Portrayals of the Portuguese ca. 1492," *The Art Bulletin* 75, no. 3 (1993): pp. 383–86

BRADBURY, R. E., 'Ezomo's "Ikegobo" and the Benin Cult of the Hand,' *Man* 61, no. 165 (1957): p. 131

—, *The Benin Kingdom and the Edo Speaking Peoples of South Western Nigeria* (London: International African Institute, 1957)

—, *Benin Studies*, P. Morton-Williams (ed.) (Oxford: Oxford University Press, 1973)

DAPPER, O., *Description de l'Afrique* (Amsterdam: 1686): pp. 308–13. Reprinted in T. Hodgkin, *Nigerian Perspectives: An Historical Anthology* (London: Oxford University Press, 1960): pp. 122–30

DARK, P. J. C., *An Introduction to Benin Art and Technology* (Oxford: Clarendon Press, 1973)

—, "Benin Bronze Heads: Styles and Chronology," in D. F. McCall and E. G. Bay (eds), *African Images: Essays in African Iconology* (New York: Africana Publishing, 1975): pp. 25–103

DENNETT, R. E., *At the Back of the Black Man's Mind* (First printed, London: 1906. Reprinted Frank Cass, 1968): pp. 182–92

DMOCHOWSKI, Z. R., *Introduction to Nigerian Traditional Architecture*, vol. 2: *South-West and Central Nigeria* (London: Ethnographica, 1990): Chapter I

DUCHÂTEAU, A., *Benin: Royal Art of Africa* (Munich: Prestel Verlag, 1994)

EGHAREVBA, J. U., *A Short History of Benin* (First published, 1934. 4th edition, Ibadan University Press, 1968)

—, *Descriptive Catalogue of Benin Museum* (Benin City: Eribo Printers, 1969)

EZRA, K., *The Royal Art of Benin: The Perls Collection in the Metropolitan Museum of Art* (New York: Metropolitan Museum of Art, 1992)

FREYER, B., *Royal Benin Art in the National Museum of African Art* (Washington D.C.: Smithsonian Institution Press, 1987)

LANDOLPHE, J. F., *Mémoires du Capitaine Landolphe contenant l'histoire de ses*

voyages pendant trente-six ans aux côtes d'Afrique et aux deux Amériques (1778), J. S. Quesné (ed.), 2 vols. (Paris: Arthus Bertrand, 1823): pp. 54–6

MELZIAN, H., "Zum Festkalender von Benin," in J. Lukas (ed.), *Afrikanische Studien* (Berlin: Deutsche Akademie der Wissen zu Berlin, Institut für Orientforschung, 1955)

—, *A Concise Dictionary of the Bini Language of Southern Nigeria* (London: Kegan Paul, Trench, Trubner and Co. Ltd., 1937)

NEVADOMSKY, J., "Kingship Succession Rituals in Benin, Part 3: The Coronation of the Oba," *African Arts* 17, no. 3 (1984): pp. 48–57

—, "The Benin Bronze Horseman as the Ata of Idah," *African Arts* 19, no. 4 (1986): pp. 40–7, 85

—, "Brass Cocks and Wooden Hens: Benin Art," *Baessler Archiv*, N.S. 35, no. 1 (1987): pp. 221–47

NYENDAEL, D. VAN, "A Description of Rio Formosa, or, The River Benin," in W. Bosman, *A New and Accurate Description of the Coast of Guinea* (London: J. Knapton, 1705): pp. 491–93

ROTH, H. L., *Great Benin: Its Customs, Art and Horror* (1903. Reprinted New York: Barnes and Noble, and London: Routledge and Kegan Paul Ltd., 1968)

RYDER, A., *Benin and the Europeans 1485-1897* (New York: Humanities Press, and London: Longman, Green and Co. Ltd., 1969)

SYDOW, E.VON, "Kunst und Kulte von Benin," *Atlantis* 10 (1938): pp. 48–55

TUNIS, I. L., "The Benin Chronologies," *African Arts* 14, no. 2 (1981): pp. 86–7

—, "Note on Benin Plaque Termination Dates," *Tribus* 32 (1983): pp. 45–53

VOGEL, S. M., "Art and Politics: A Staff from the Court of Benin, West Africa," *Metropolitan Museum Journal* 13 (1978): pp. 87–100

WILLETT, F., "The Benin Museum Collection," *African Arts* 6, no. 4 (1973): pp. 8–17

Two *Yoruba and Dahomey: Divine Authortiy and the Arts of Royal History*

THE KINGDOM OF YORUBA

ABIMBOLA, W., *Ifa: An Exposition of Ifa Literary Corpus* (Ibadan: Oxford University Press, 1976)

ABIODUN, R., *et. al.* (eds), *Yoruba: Art and Aesthetics* (Zurich: Museum Rietberg, 1991)

—, *The Yoruba Artist* (Washington D. C.: Smithsonian Institution Press, 1994)

BASCOM, W. R., *The Yoruba of Southwestern Nigeria* (New York: Holt, Rinehart and Winston, 1969)

—, *Ifa Divination: Communication Between the Gods and Men in West Africa* (Bloomington: Indiana University Press, 1969)

BEIER, H. U., *Yoruba Beaded Crowns: Sacred Regalia of the Olokuku* (London: Ethnographica, 1982)

BLIER, S. P., "Kings, Crowns, and Rights of Succession: Obalufon Arts at Ife and other Yoruba Centers," *The Art Bulletin* 67, no. 3 (1985): pp. 383–401

Carroll, K., *Yoruba Religious Carving: Pagan and Christian Sculpture in Nigeria and Dahomey* (New York: Praeger, 1966): p. 55

DREWAL, H. J., "Art and Divination among the Yoruba: Design and Myth," *Africana Journal* 14, 2–3 (1987): pp. 139–56

—, "The Meaning of Oshugbo Art: a Reappraisal" in B. Englebrecht and B. Gardi (eds), *Man Does Not Go Naked* (Basel: Beitrage zur Ethnologie, 1989): pp. 151–74

DREWAL, H. J., and T. Margaret, *Gelede: Art and Feminine Power among the Yoruba* (Bloomington: Indiana University Press, 1983)

DREWAL, H. J., J. PEMBERTON III, *et. al.* (eds), *Yoruba: Nine Centuries of African Art and Thought* (New York: Harry N. Abrams, 1989)

DREWAL, M. T., "Projections from the Top in Yoruba Art," *African Arts*, 11, no. 1 (1977): pp. 43–49, 91–92

—, "Art and Trance among Yoruba Shango Devotees," *African Arts* 20, no. 1 (1986): pp. 60–67, 98–99

—, *Yoruba Ritual; Performers, Play, Agency* (Bloomington: Indiana University Press, 1992)

DREWAL, M. T., and H. J. DREWAL, "An Ifa Diviner's Shrine in Ijebuland," *African Arts* 16, no. 2 (1983): pp. 60–67, 99–100

FAGG, W. B., and J. PEMBERTON III, *Yoruba Beadwork* (New York: Rizzoli, 1980)

—, *Yoruba Sculpture of West Africa* (New York: Knopf, 1982)

FROBENIUS, L., *The Voice of Africa*, 2

vols (New York: Benjamin Bloom, 1913. Reprinted, 1968)

HALLEN, B., "The Art Historian as Conceptual Analyst," *Journal of Aesthetics and Art Criticism* (1979): pp. 303–13

HOULBERG, M., "Ibeji Images of the Yoruba," *African Arts* 7, no. 1 (1973): pp. 20–27, 91–92

—, "Yoruba Shrine Placement," unpublished paper presented at the African Studies Association (n.d.)

LAWAL, B., *The Gèlèdè Spectacle: Art, Gender, and Social Harmony in an African Culture* (Seattle: University of Washington Press, 1996)

MORTON-WILLIAMS, P., "The Yoruba Ogboni Cult in Oyo," *Africa* 30, no. 4 (1960): pp. 362–74

—, "An Outline of the Cosmology and Cult Organization of the Oyo Yoruba," *Africa* 34, no. 3 (1964): pp. 243–60

OJO, G. J. A., *Yoruba Palaces* (London: University of London Press, 1966)

PEMBERTON III, J., "Eshu-Elegba: The Yoruba Trickster God," *African Arts* 9, no. 4 (1975): pp. 20–7, 66–70

—, *Yoruba Royal Art* (Washington D.C.: Smithsonian Institution Press, 1996)

SMITH, R., *Kingdoms of the Yoruba* (London; James Currey, 1988)

THOMPSON, R. F., "The Sign of the Divine King: An Essay on Yoruba Bead-Embroidered Crowns with Veil and Bird Decorations," *African Arts* 3, no. 4 (1970): pp. 8–17, 74–80

—, *Black Gods and Kings: Yoruba Art at UCLA* (Bloomington: Indiana University Press, 1971)

—, "Yoruba Artistic Criticism," in W. d'Azevedo (ed.), *The Traditional Artist in African Societies* (Bloomington: Indiana University Press, 1973): pp. 19–61

WESCOTT, J., and P. MORTON-WILLIAMS, "The Symbolism and Ritual Context of the Yoruba Laba Shango," *Journal of the Royal Anthropological Institute* 92 (1962): pp. 23–37

WILLIAMS, D., "The Iconology of the Yoruba *Edan Ogboni*," *Africa* 34, no. 2 (1964): pp. 239–66

WITTE, H., *Earth and the Ancestors: Ogboni Iconography* (Amsterdam: Gallery Balolu, 1988)

THE KINGDOM OF DAHOMEY

ADAMS, M., "Fon Appliquéd Cloths," *African Arts* 13, no. 1 (1980): pp. 28–41, 87–8

ADANDE, A., "Les récades des rois du Dahomey", *Ifan* (1962)

ADANDE, C. E., *Les grandes tentures et les bas-reliefs du Musée d'Agbome. Mémoire de Maîtrise d'Histoire* (Université Nationale du Benin, 1976–77)

——, "Les sieges des rois d'Agbome et le siege Akan," (Doctorat de 3ème Cycle, Université de Paris, I, 1984)

AKINJOGBIN, I. A., *Dahomey and its Neighbours: 1708–1818* (Cambridge: Cambridge University Press, 1967)

ARGYLL, W. J., *The Fon of Dahomey: History and Ethnography of the Old Kingdom* (Oxford: Clarendon Press, 1966)

BAY, E. G., "Cyprien Tokudagba of Abomey," *African Arts* 8, no. 4 (1975): pp. 24–9

——, *Asen: Iron Altars of the Fon People of Benin* (Atlanta: Emory University Museum of Art and Archaeology, 1985)

——, "Metal Arts and Society in Nineteenth and Twentieth Century Abomey," in N. R. Bennett (ed.), *Discovering the African Past: Essays in Honor of Daniel F. McCall* (Boston: African Studies Center, Boston University, 1987): pp. 7–31

BLIER, S. P., "Melville J. Herskovits and the Arts of Ancient Dahomey," *Res: Anthropology and Art* 16 (1988): pp. 124–42

——, "King Glele of Danhomè: Divination Portraits of a Lion King and Man of Iron (Part I)," *African Arts* 23, no. 4 (1990): pp. 42–53, 93–4

——, "King Glele of Danhomè: Dynasty and Destiny," *African Arts* 24, no. 1 (1991): pp. 44–55, 101–3

——, "Faces of Iron: Media, Meaning, and Masking in Danhomè," in *Bulletin du Musée Barbier-Mueller* (Geneva, 1991): pp. 19–41

—,"The Musée Historique in Abomey: Art, Politics, and the Creation of an African Museum," *Arte in Africa*, vol. 2 of *Quaderni Poro*, (Milan: Centro Studi di Storia delle Arti, 1991)

—, "The Path of the Leopard: Motherhood and Majesty in Early Danhomè," *Journal of African History* 36, no. 3 (1995): pp. 391–417

—, "Vodun Philosophical and Artistic Roots in West Africa," D. J. Cosentino (ed.) in *The Sacred Arts of Haitian Vodou* (Los Angeles: Fowler Museum of Cultural

History, UCLA, 1995)

—, *African Vodun: Art, Psychology and Power* (Chicago: University of Chicago Press, 1995)

BURTON, R. F., *A Mission to Gelele, King of Dahome*, 2 vols (London: 1864. Reprinted London: Tinsley Brothers, 1966)

FORBES, F. E., *Dahomey and the Dahomeans, being the Journals of two Missions to the King of Dahomey*, 2 vols (London: 1851. Reprinted London: Longman, Brown, Green, & Longmans, 1966)

GLELE, M. A., *Le Danxome* (Nubia: 1974)

HERSKOVITS, M. J., *Dahomey: An Ancient West African Kingdom*, 2 vols (New York: J.J. Augustin, 1938)

HOUSEMAN, M., et. al., "Note sur la structure evolutive d'une ville historique, l'exemple d'Abomey," *Cahiers d'études africaines* 26, no. 4 (1986): pp. 527–46

MAUPOIL, B., *La géomancie à l'ancienne Côte des Esclaves* (Paris: Musée de l'Homme, Institut d'Ethnologie, 1988): p. 422

MERCIER, P., "Les Asen du Musée d'Abomey," in *Institut Français d'Afrique Noire. Catalogue*, VII (Dakar: 1952)

—, "The Fon of Dahomey," in D. Forde (ed.), *African Worlds* (London and New York: Oxford University Press, 1976): pp. 210–34

MERCIER, P., and J. LOMBARD, *Guide du Musée d'Abomey* (Republic of Dahamey: 1959)

SAVARY, C., *La pensée symbolique des Fo du Dahomey* (Geneva: Editions Medecine et Hygiene, 1976)

SKERTCHLY, J. A., *Dahomey as It Is* (London: Chapman, and Hall, 1874)

WATERLOT, E. M. G., *Les bas-reliefs des batiments royaux d'Abomey (Dahomey)* (Paris: Institut d'Ethnologie, Université de Paris, 1926)

THREE: *The Asante Kingdom: The Golden Ages of Ghana*

ADLER, P., and N. BARNARD, *Asafo! African Flags of the Fante* (London and New York: Thames and Hudson, 1992)

—, *African Majesty: The Textile Art of the Ashanti and Ewe* (London: Thames and Hudson, 1992)

BOWDICH, T.E., *A Mission from Cape Coast Castle to Ashantee* (London: John Murray, 1819)

BRAVMANN, R., *Open Frontiers: The Mobility of Art in Black Africa* (Seattle: University of Washington Press, 1973)

COLE, H. M., and D. H. ROSS, *The Arts of Ghana* (Los Angeles: Fowler Museum of Cultural History, UCLA, 1977)

GARRARD, T. F., *Gold of Africa* (Munich: Prestel Verlag, 1989)

GILBERT, M., "The Person of the King: Ritual and Power in a Ghanaian State," in D. Cannadine and S. Price (eds), *Rituals of Royalty: Power and Ceremonial in Traditional Societies*, (Cambridge and New York: Cambridge University Press, 1987)

—, "The Leopard who Sleeps in a Basket: Akuapem Secrecy in Everyday Life and in Royal Metaphor," in M. H. Nooter (ed.), *Secrecy: African Art that Conceals and Reveals* (New York: Museum for African Art, and Munich: Prestel Verlag, 1993): p. 132

KYEREMATEN, A. A. Y., *Panoply of Ghana* (New York: Praeger, 1964)

McLEOD, M. D., *The Asante* (London: British Museum Press, 1981)

—, "Mother and Child Figure," in S. Vogel (ed.), *For Spirits and Kings: African Art from the Paul and Ruth Tishman collection* (New York: Metropolitan Museum of Art, 1981)

PRUSSIN, L., *Hatumere: Islamic Design in West Africa* (Berkeley: University of California Press, 1986)

QUARCOOPOME, N. O., "Agbaa: Dangme Art and the Politics of Secrecy," in M. H. Nooter (ed.), *Secrecy: African Art that Conceals and Reveals* (New York: Museum for African Art, and Munich: Prestel Verlag, 1993): pp. 113–20

RATTRAY, R. S., *Religion and Art in Ashanti* (London: Oxford University Press, 1927)

ROSS, D. H., *Fighting with Art: Appliqued Flags of the Fante Asafo* (Los Angeles: Fowler Museum of Cultural History, UCLA, 1979)

—, "The Verbal Art of Akan Linguist Staffs," *African Arts* 16, no. 1 (1982): pp. 56–67

—, "The Art of Osei Bonsu," *African Arts* 17, no. 2 (1984): pp. 28–40, 90

—, "Queen Victoria for Twenty-five Pounds: the Iconography of a Breasted Drum from Southern Ghana," *Art Journal* 47, no. 2 (1988): pp. 114–20

—, "More than Meets the Eye: Elephant Memories among the Akan," in D. H. Ross (ed.), *Elephant: The Animal and its Ivory in African Culture* (Los Angeles: Fowler Museum of Cultural History, UCLA, 1992)

ROSS, D. H., and T. F. GARRARD (eds), *Akan Transformations Problems in Ghanaian Art History* (Los Angeles: Fowler Museum of Cultural History, UCLA, 1983)

SCHILDKROUT, E. (ed.), *The Golden Stool: Studies of the Asante Center and Periphery*, (New York: American Museum of Natural History, 1987)

SWITHENBANK, M., *Ashanti Fetish Houses* (Accra: Ghana University Press, 1969)

WILKS, I., *Forests of Gold: Essays on the Akan and the Kingdom of Asante* (Athens, USA: Ohio University Press, 1993)

FOUR: *Cameroon Grasslands: Royal Art Patronage in Contexts of Change*

BRAVMANN, R. A., *Open Frontiers: The Mobility of Art in Black Africa* (Seattle and London: University of Washington Press, 1973)

BRAIN, R., and A. Pollock, *Bangwa Funerary Sculpture* (Toronto: University of Toronto Press, 1971)

GEARY, C. M., "Bamum Thrones and Stools," *African Arts* 14, no. 4 (1981): pp. 32–43; pp. 87–8

—, "Bamum Two-Figure Thrones: Additional Evidence," *African Arts* 16, 4 (1983): pp. 46–53

—, *Things of the Palace* (Wiesbaden: Franz Steiner Verlag, 1983)

—, *Images from Bamum: German Colonial Photography at the Court of King Njoya* (Washington, D.C.: National Museum of African Art, Smithsonian Institute Press, 1988)

GEBAUER, P., *Spider Divination in the Cameroons* (Milwaukee: Milwaukee Public Museum Press, 1964)

—, *Art of Cameroon* (Portland: Portland Art Museum, and New York: Metropolitan Museum of Art, 1979)

HARTER, P., *Arts Anciens du Cameroun*, supplement to *Arts d'Afrique Noire*, 40 (Arnouville-les-Gonesse: 1986)

KABERRY, P. M., "Retainers and Royal Households in the Cameroons Grassfields," *Cahiers d'Etudes Africaines* 3, no. 10 (1962): pp. 282–98

LAMB, V., and A. LAMB, *Au Cameroun: Weaving-Tissage* (Roxford, Hertfordshire: 1981)

MALAQUAIS, D., "You are What you Build: Architecture as Identity Among the Bamileke of West Cameroon," *Traditional Dwellings and Settlements Review* 5, no. 11 (1994): pp. 21–35

NORTHERN, T., *Royal Art of Cameroon, the Art of Bamenda-Tikar* (Hanover: Dartmouth College, 1973)

—, *The Art of Cameroon* (Washington, D.C.: Smithsonian Institution Press, 1984)

—, *Palaces and Chiefly Households in the Cameroon Grassfields*, special issue of *Paideuma*, 31 (Wiesbaden: F. Steiner Verlag, 1985)

PERROIS, L., *Arts Royaux du Cameroun* (Geneva: Musée Barbier-Mueller, 1994)

SAVARY, C., "Situation et histoire des Bamum," *Bulletin Annuel du Musée d'Ethnographie* 20 (1977): pp. 117–61

TARDITS, C., *Le Royaume Bamoun* (Paris: A.Colin, Publications de la Sorbonne, 1980)

—, "The Kingdom of Bamum," in *Kings of Africa* (Utrecht: Foundation Kings of Africa, 1992): pp. 51–3

—, "Royal Gift of Bamum: A Pipe/Cadeau Royal Bamoum: Une Pipe," *Art Tribal* (1993): pp. 47–62

WARNIER, J.-P., "The King as a Container in the Cameroon Grassfields," in *Paideume* 39 (Frankfurt: 1993): pp. 303–19

FIVE: *Kongo and Kuba: The Art of Rulership Display*

KINGDOM OF KONGO

BALANDIER, G., *Daily Life in the Kingdom of the Kongo: From the Sixteenth to the Eighteenth Century* (New York: Pantheon Books, 1968)

BASSANI, E., "A Note on Kongo High-status Caps in Old European

Collections," *Res* 5 (Spring, 1983): pp. 74–84

BASTIN, M.-L., *Sculpture Angolaise: Mémorial de cultures* (Lisbon: Museu Nacional de Etnologia, and Milan: Elekta, 1994)

BLIER, S. P., "Imaging Otherness in Ivory: African Portrayals of the Portuguese ca. 1492," *The Art Bulletin* September 75, no. 3 (1993): pp. 375–400

CORNET, J., *Pictographies Woyo* (Milan: 1980)

CUVELIER, J. B., *L'Ancien Royaume de Congo* (Bruges: Desclée de Brouwer, 1946)

DETOURBET, A. M., "Le tissage du raphia chez les Batéké (Moyen Congo)," *Journal de la Société de Africanistes* 27, no. 1 (1957): pp 67–79

FABIAN, J., *Remembering the Present: Painting and Popular History in Zaire* (Berkeley: University of California Press, 1996)

GRANDPRÉ, L. DE, *Voyage à la Côte Occidentale d'Afrique Fait dans les années 1786 et 1787*, 2 vols (Paris: Dentu, 1801)

JANZEN, J. M., and MACGAFFEY, W., *An Anthology of Kongo Religion: Primary Texts from Lower Zaire* (Lawrence: University of Kansas Publications in Anthropology, 1974)

JEWSIEWICKI, B., "Painting in Zaire: From the Invention of the West to the Representation of Social Self," in S. M. Vogel (ed.), *Africa Explores: 20th Century African Art* (Munich: Prestel Verlag, and New York City: Neues Publishing Company, 1991): pp. 130–51

LEHUARD, R., *Les Phemba du Mayombe* (Arnouville-les Gonesse: 1976)

—, *Fétiches à clous du Bas-Zaire* (Arnouville: 1980)

—, *Art Bakongo: Les centres de style*, 2 vols (Arnouville: 1989)

LAMAN, K. E., *The Kongo*, 4 vols (Uppsala: 1957–68)

MACGAFFEY, W., *Custom and Government in the Lower Congo* (Berkeley: University of California Press, 1970)

—, *Religion and Society in Central Africa: the Bakongo of Lower Zaire* (Chicago: University of Chicago Press, 1986)

—, "The Eyes of Understanding: Kongo *minkisi*," in *Astonishment and Power* (Washington, D.C., and London: Smithsonian Institution Press, 1993): pp. 21–103

RANDLES, W. G. L., *L'ancien royaume du Congo des origines à la fin du XIXe siècle* (Paris: La Haye, Mouton, 1968)

THOMPSON, R. F., and J. CORNET, *The Four Moments of the Sun* (Washington, D.C.: National Gallery of Art, 1981)

—, "Grand n'Konde de Detroit," *Arts d'Afrique Noire* 56 (1985): pp.17–26

THORNTON, J. K., *The Kingdom of the Kongo: Civil War and Transition 1641–1718* (Madison, Wisconsin: University of Wisconsin Press, 1983)

—, "The Regalia of the Kingdom of Kongo, 1491–1895," in E. Beumers and H.-J. Koloss (eds), *Kings of Africa: Art and Authority in Central Africa* (Utrecht: Foundation Kings of Africa, 1992): pp. 57–63

WIDMAN, R., "Le culte de Ôniombo' des Bwende," *Arts d'Afrique Noire* 2 (Summer, 1972): 12–41

KINGDOM OF KUBA

ADAMS, M. J., "Where Two Dimensions Meet: The Kuba of Zaire," in D. Washburn (ed.), *Structure and Cognition in Art* (Cambridge, and New York: Cambridge University Press, 1983): pp. 43–8

BINKLEY, D. A., "Avatar of Power: Southern Kuba Masquerade Figures in a Funerary Context," *Africa* 57, 1 (1987): pp. 75–97

—, "Masks, Space and Gender in Southern Kuba Initiation Ritual," *Iowa Studies in African Art* 2, no. 3 (1990): pp. 157–76

CLAERHOUT, A., "Two Kuba Wrought-Iron Statuettes," *African Arts* 9, no. 4 (1976): pp. 60–64

CORNET, J., *Art Royal Kuba* (Milan: Edizioni Sipiel, 1982)

CROWE, D. W., "The Geometry of African Art I: Bakuba Art," *Journal of Geometry* 1, no. 2 (1971): pp. 169–82

DARISH, P. J., "Dressing for the Next Life: Raffia Textile Production and Use among the Kuba of Zaire," in A. B. Weiner and J. Schneider (eds), *Cloth and HUman Experience*

(Washington, D.C.: Smithsonian Institution Press, 1989)

—, "Dressing for Success: Ritual Occasions and Ceremonial Raffia Dress Among the Kuba of South-Central Zaire," *Iowa Studies in African Art* 3 (1991): pp. 179–91

DARISH, P., and D. A. BINKLEY, "Headdresses and Titleholding among the Kuba," in M. J. Arnoldi and C. Mullen Kreamer (eds), *Crowning Achievements: African Arts of Dressing the Head* (Los Angeles: Fowler Museum of Cultural History, UCLA, 1995): pp. 159–69

HEUSCH, L. DE, *The Drunken King, or, The Origin of the State* (Bloomington: Bloomington University Press, 1982)

MACK, J., "Animal Representations in Kuba Art: An Anthropological Interpretation of Sculpture," *The Oxford Art Journal* 4, no. 2 (November, 1981): pp. 50–56

—, *Emil Torday and the Art of the Congo 1900-1909* (London: British Museum Press, 1990)

ROSENWALD, J. B.,"Kuba King Figures," *African Arts* 7, no. 3 (1974): pp. 26–31, 92

Torday, E., and T. A. Joyce, *Notes ethnographiques sur les peuples communément appelés Bakuba ainsi que les peuplades apparentés: les Bushongo* (Brussels: 1910)

—, *On the Trail of the Bushongo* (London: Seeley Service and Co., 1925)

VANSINA, J., *Les tribus Ba-Kuba et les peuplades apparantées* (Tervuren: 1954)

—, "Initiation Rituals of the Bushong," *Africa* 25 (1955): pp. 138–53

—, "Les croyances religieuses des Kuba," *Zaire* 12 (1958): pp. 725–58

—, *Le royaume Kuba* (Tervuren: Musée Royal de l'Afrique Centrale, 1964)

—, *The Children of Woot: A History of the Kuba Peoples* (Madison: University of Wisconsin Press, 1978)

—, "The Kuba Kingdom (Zaire)," in E. Beumers and H.-J. Koloss (eds), *Kings of Africa: Art and Authority in Central Africa* (Maastricht: Foundation Kings of Africa, 1992): pp. 71–8

Picture Credits

Collections are given in the captions alongside the illustrations. Sources for illustrations not supplied by museums or collections, additional information, and copyright credits are given below. Numbers are figure numbers unless otherwise indicated.

frontispiece, detail of figure 149 Courtesy Sotheby's New York © 1990 Sotheby's, Inc

1 Photo by John Pemberton III, Amherst MA

page 11 detail of figure 28 © British Museum # 1911.6-201 (Collection Her Majesty the Queen on loan)

3 Courtesy Department Library Services, American Museum of Natural History, New York # 90.1/3696, photo Lynton Gardner neg. 338133

4 Photo © Joseph Nevadomsky, December 1980

5 Photo Heini Schneebeli, London, by permission of the Museum für Völkerkunde, Berlin # III C 8514

6 Werner Forman Archive, London

8 Photo by Peter Garlake, London & Zimbabwe

9 Copyright © Pres. & Fellows of Harvard College 1997. All Rights Reserved. Peabody Museum, Harvard University, Cambridge MA # 14294, photo by Hillel Burger

10 Staatliche Museen zu Berlin - Preußischer Kulturbesitz, Museum für Völkerkunde # III C 23970, photo Dietrich Graf

13 Courtesy Department Library Services, American Museum of Natural History, New York, photo by Herbert Lang 1913, # 111806 (from the Lang and Chapin Expedition 1909-14)

15 © British Museum, London # Benin 191

16 Völkerkundemuseum der Universität, Zürich # 11012

17 Courtesy Department Library Services, American Museum of Natural History, New York # 90.1/5130a, photo by Lynton Gardiner

18 The University of Iowa Museum of Art, The Stanley Collection, # X1986.502

19 Musée Historique. Republic of Benin. Ab 45-8-41, photo by Suzanne Preston Blier

20 Archives Musée Dapper, Paris, photo Hughes Dubois

21 © British Museum, London # 1909.5-13.9.

22 Museum für Völkerkunde, Vienna # 64.743

23 Musée Historique, Republic of Benin # AB-45-8-111, photo by Suzanne Preston Blier

24 Photo © Joseph Nevadomsky, February 1997

26 Werner Forman Archive, London

27 © British Museum, London 1904.2.19.3

28 © British Museum # 1911.6-201 (Collection Her Majesty the Queen on loan)

29 British Museum, London # 1903.7-18.12

page 43 detail of figure 48 © British Museum, London # 1910, 5-13.1

30 University of Pennsylvania Museum, Philadelphia # AF 2064B

31 © British Museum, London # 97.12-17.2

32 Werner Forman Archive, London

33 © British Museum, London # 1897.10-11.1

34 Staatliches Museum für Völkerkunde, München # 81-301484, photo S.Autrum-Mulzer

35 © British Museum, London # 1956 Af 27.294

38 Courtesy Frank Willett, Glasgow

39 British Museum, London # 1949.Af38.1

41 Staatliche Museen zu Berlin - Preußischer Kulturbesitz, Museum für Völkerkunde # III C 8488, photo D. Graf

42 Bird drawings from: Sénégal, Mali, Mauritaine, Niger: Guides touristiques de l'Afrique (Paris, Hatier, 1975) p.18

43 © British Museum, London # 98,1-15.46

44 The National Commission for Museums and Monuments, Lagos/Werner Forman Archive, London

45 above Staatliche Museen zu Berlin - Preußischer Kulturbesitz, Museum für Völkerkunde # III C 10879, photo Dietrich Graf

45 below Hamburgisches Museum für Völkerkunde # C.2434, photo Foto Partner

46 © British Museum, London # 1963.Af 4.1

47 Drawings by Suzanne Preston Blier

48 © British Museum, London # 1910,5-13.1

49 Courtesy The British Museum, London, Photo # Benin 015

50 Museum für Völkerkunde, Vienna # 98.162

51 University of Pennsylvania Museum, Philadelphia # AF 5107

52 Photo by Eliot Elisofon, 1970. Slide # I BNN 2.4.3 (7590) Eliot Elisofon Photographic Archives, National Museum of African Art, Smithsonian Institution, Washington, D.C.

53 Staatliche Museen zu Berlin - Preußischer Kulturbesitz, Museum für Völkerkunde # III C 8165, photo Dietrich Graf

54 The Metropolitan Museum of Art, New York # 1974.5 (Blumenthal Fund, 1974)

55 © British Museum, London # 1897.10.11.2

56 Staatliche Museen zu Berlin - Preußischer Kulturbesitz, Museum für Völkerkunde # III C 20296

57 © British Museum, London # 1944 Af 4.12

58 Photo © Joseph Nevadomsky, December 1979

59 © British Museum, London # 1948 Af 9.1

60 © UCLA Fowler Museum of Cultural History, Los Angeles # X69.66/X69.67, photo by Denis J. Nervig

page 79 detail of figure 98 Musée de l'Homme, Paris # M.H.93.45.4

61 Musée de l'Homme, Paris # M.H.36.21.62

62 Courtesy of the artist and Mbari Institute for Contemporary African Art, USA (tel: 1 202 362 0532)

64 Photo by C.T. Lawrence, "Photographs of Nigeria c. 1907-1912." vol. 16. Foreign and Commonwealth Office, Library and Records Department, London.

66 Major Acquisitions Centennial Fund, 1984.550, photograph © 1997, The Art Institute of Chicago. All Rights Reserved, photo by Robert Hashimoto

67 © UCLA Fowler Museum of Cultural History, Los Angeles # X69.66/X69.67, photo by Denis J. Nervig

68 Weickmann Collection, Ulmer Museum, Ulm

69 Courtesy Indiana University Art Museum, Bloomington, Raymond and Laura Wielgus Collection # 87.24.2, photo by Michael Cavanagh & Kevin

Montague
70 Musée de l'Homme, Paris # M.H.97.4.1
71 Photo A.C.Cooper, London
72 © UCLA Fowler Museum of Cultural History, Los Angeles # X70.139A/B, photo by Don Cole
73 Photographed by Leo Frobenius in 1910, photograph courtesy of the Frobenius Institute, Frankfurt
74 Photo A.C.Cooper, London
75 © UCLA Fowler Museum of Cultural History, Los Angeles # X88.2 a,b
76 Photograph © 1996 The Detroit Institute of Arts, Founders Society Purchase, Friends of African Art Fund # 77.71
77 Werner Forman Archive, London
78 Photograph by William Fagg, 1949-50/23/10. © Royal Anthropological Institute Photographic Collection, London
79 Photo by Jean Gabus, reproduced by permission of the Musée d'Ethnographie, Neuchâtel, Switzerland
80 Photo © Suzanne Preston Blier, 20 January 1986
81 Musée Historique, Abomey # Ab-45-8.10, photo by Suzanne Preston Blier 27 May 1986
82 Musée Africain, Lyon, photo A.Guillard/Ville de Nantes, Musées du Château des Ducs de Bretagne
86 Photo © Suzanne Preston Blier
87 Archives Musée Dapper, Paris, photo Hughes Dubois
89 © Musée d'Ethnographie, Neuchâtel, Switzerland # 54.3.181, photo Alain Germond
90 1997 Indianapolis Museum of Art # IMA 1989.683, Gift of Mr.and Mrs. Harrison Eiteljorg
91 The Metropolitan Museum of Art, New York # 1979.206.73 (The Michael C. Rockefeller Memorial Collection, Bequest of Nelson A. Rockefeller, 1979)
92 Musée de l'Homme, Paris # M.H.36-21-103
94 Photo by S. Middleton. © J. Paul Getty Trust # ABO.94.3.17.sd
95 Photo by Suzanne Preston Blier
96 Archives Musée Dapper, Paris, photo Hughes Dubois
97 Musée de l'Homme, Paris # M.H.95.16.8
98 Musée de l'Homme, Paris # M.H.93.45.4
99 Musée de l'Homme, Paris # M.H.94.32.1, photo D. Ponsard
101 Photo © Suzanne Preston Blier, 15 December 1985
102 Musée de l'Homme, Paris #

M.H.93.45.3
103 Archives Musée Dapper, Paris, photo Hughes Dubois
104 Musée Barbier-Müller, Geneva # 1010-33
105 Musée Barbier-Müller, Geneva # 1009-52, 1009-56, 1009-128, photo by Pierre-Alain Ferrazzini, Geneva
page 125 detail of figure 121 Photo © Doran Ross, 1976
108 Photo © Doran Ross
111 Photo © Doran Ross, 1976
112 British Museum, London # 1980 Af 17.2
113 Photo © Rene David, Galerie Walu, Zurich
114 The Nelson-Atkins Museum of Art, Kansas City, Missouri. Purchase: Nelson Trust # 65-5
115 Photo Collection Historisches Museum Berne
116 Seattle Art Museum. Gift of Katherine White and the Boeing Company # 81.17.323, photo Paul Macapia
118 © The Cleveland Museum of Art, 1997, Dudley P.Allen Collection # 1935.310
119 Photo © Rene David, Galerie Walu, Zurich
120 The National Museum of Denmark, Department of Ethnography # N.38A7
121 Photo © Doran Ross, 1976
122 The Wallace Collection, London # OA.1683
123 Photo © Doran Ross
124 © British Museum, London # 1922.10.20
125 Musée de l'Homme, Paris # M.H.65.17.1
126 UCLA Fowler Museum of Cultural History, Los Angeles # X86.1988, © photo Don Cole
127 Photo by fitz Ramseyer, 1888-96 © Basel Mission Archive #QD-30.043.0078
128 © British Museum, London # 1954.+23.640
129 National Museum of African Art, Smithsonian Institution, Washington D.C. Gift of Emil Arnold # 69-35-36, photo by Franko Khoury
130 © British Museum, London # 1933.12-2.1
131 © British Museum, London # 1940 Af 1.1
132 Fine Arts Museums of San Francisco, Gift of Vivian Burns, Inc. # 74.8
133 © UCLA Fowler Museum of Cultural History, Los Angeles # X85.321
134 © British Museum, London # 1978 Af 22.1
135 Werner Forman Archive, London
136 Staatliche Museen zu Berlin - Preußischer Kulturbesitz, Museum für Völkerkunde # III C 33341 a,b

page 165 detail of figure 158 The Field Museum, Chicago # 174366
137 Rautenstrauch-Joest Museum, Cologne # 19336, photo by Marie-Pauline Thorbecke, January 1912
138 Photo © Claude Savary 1976, Musée d'Ethnographie, Geneva
139 Staatliche Museen zu Berlin - Preußischer Kulturbesitz, Museum für Völkerkunde # III C 23814, photo Dietrich Graf
140 Musée d'Ethnographie, Geneva # 33559, Gift of M. J. Rusillon 1966
142 Photo © Dominique Malaquais, 1992
144 Photo by Paul Gebauer. The Metropolitan Museum of Art, New York (Bequest of Paul Gebauer, 1978)
145 Photo © Dominique Malaquais, 1992
146 Photo by Christol 1930, Musée de l'Homme, Paris # D 66-4391.730
147 Musée Barbier-Müller, Geneva # 1018-8, photo by Pierre-Alain Ferrazzini, Geneva
148 Photo © Hans-Joachim Koloss, Berlin
149 Courtesy Sotheby's New York © 1990 Sotheby's, Inc
150 Staatliche Museen zu Berlin - Preußischer Kulturbesitz, Museum für Völkerkunde # III C 20682
151 Staatliche Museen zu Berlin - Preußischer Kulturbesitz, Museum für Völkerkunde # III C 24952
152 Photo by Gilbert Graham, New York
153 The Field Museum, Chicago # 175596, photo A109111
154 The Field Museum, Chicago # 175620, photo A109109
155 Photo by Christol 1930, Musée de l'Homme, Paris # D.66-4300.730
156 Portland Art Museum, Oregon, The Paul and Clara Gebauer Collection # 70.10.81. Drawings by Paul Gebauer and his informants: Custodian Mose Jejab of the Sultan's household (1933/36); Scribe Filip N. Njoya of the Bafreng Community (1947); Council Member Salefour Mbetnkom of Fumban City (1949/50)
157 Musée d'Ethnographie, Geneva # 33556
158 The Field Museum, Chicago # 174366
159 Photo by Eliot Elisofon, 1971. Slide # C KBA 4 (2140) Eliot Elisofon Photographic Archives, National Museum of African Art, Smithsonian Institution, Washington, D.C.
page 201 detail of figure 162 © Jerry L. Thompson, New York, courtesy The Metropolitan Museum of Art, New York
162 Jerry L. Thompson, New York, courtesy The Metropolitan Museum of Art, New York
163 Werner Forman Archive, London

165 Staatliche Museen zu Berlin - Preußischer Kulturbesitz, Museum für Völkerkunde # III C 585

166 Staatliche Museen zu Berlin - Preußischer Kulturbesitz, Museum für Völkerkunde # III C 44072

167 Sociedade de Geografia de Lisboa, Portugal # AB-201, photo Carlos Ladeira

168 Photo by Benjamin Pereira, Museu Nacional de Etnologia, Lisbon, courtesy Arquivo Nacional de Fotografia, Lisbon

169 Afrika Museum, Berg en Dal, Holland # 29.636

170 Museo degli Argenti, Florence # 181, photo by P. Tosi courtesy Index, Florence

171 & 172 Staatliches Museum für Völkerkunde, Münich # 14-32-3

173 British Museum, London # 1910.10-26.1 and 3

174 The National Museum of Denmark, Department of Ethnography # De.123, photo Kit Weiss

175 Staatliches Museum für Völkerkunde, Münich # 895, photo S.Autrum-Mulzer

176 Etnografiska Museet i Göteborg, Sweden # GEM 38.27.1

177 The Metropolitan Museum of Art, New York, Michael C. Rockefeller Collection, Gift of Nelson A. Rockefeller, 1969 # 1978.412.573

179 Rijksmuseum vor Volkenkunde, Leiden # RMV 2668-803

180 National Museum of African Art, Smithsonian Institution, Washington D.C. Purchased with funds provided by the Smithsonian Collections Acquisition Program # 83-3-6, photo by Franko Khoury

181 Peabody Museum, Harvard University, Cambridge MA # 50/12045 981.11, photo Hillel Burger

182 Musée Barbier-Müller, Geneva # 1021-5, photo Roger Asselberghs

183 Staatliches Museum für Völkerkunde, Münich # 57-13-5

184 Museu Nacional de Etnologia. Lisbon # 6738, photo by José Pessoa, Arquivo Nacional de Fotografia - Instituto Portuguàs de Museus, Lisbon

187 © British Museum, London # 1909.5-13.3.

188 © British Museum, London # 1909.12-10.1

189 Werner Forman Archive, London

190 The Brooklyn Museum, New York # 73.178 Gift of Mr. and Mrs. John McDonald

191 Peabody Museum, Harvard University, Cambridge MA # 17 41 50 - B 1960, photo Hillel Burger

192 Photo © Hughe Dubois, Paris/Brussels

194 Photo © Angelo Turconi, Casciago, Italy

196 © UCLA Fowler Museum of Cultural History, Los Angeles # MCH X86-936

198 Staatliche Museen zu Berlin - Preußischer Kulturbesitz, Museum für Völkerkunde # III C 19764, photo Dietrich Graf

199 Werner Forman Archive, London, Courtesy Entwistle Gallery, London

200 © British Museum, London # 1908 Ty41

page 249 detail of figure 6 Werner Forman Archive, London

Index